Elastic Architecture

Elastic Architecture

Frederick Kiesler and Design Research
in the First Age of Robotic Culture

Stephen J. Phillips

The MIT Press
Cambridge, Massachusetts
London, England

This book was set in Minion Pro by The MIT Press. Printed and bound in the United States of America.

Publication is made possible in part by a grant from the Barr Ferree Foundation Publication Fund, Department of Art and Archaeology, Princeton University.

Every effort has been made to contact copyright holders of images and material published in this book. The author would appreciate being informed of any omissions in order to make due acknowledgment in future editions.

Library of Congress Cataloging-in-Publication Data

Names: Phillips, Stephen John, 1967- author.
Title: Elastic architecture : Frederick Kiesler and design research in the first age of robotic culture / Stephen J. Phillips.
Description: Cambridge, MA : The MIT Press, 2017. | Includes bibliographical references and index.
Identifiers: LCCN 2016028475 | ISBN 9780262035736 (hardcover : alk. paper)
Subjects: LCSH: Kiesler, Frederick—Criticism and interpretation. | Design—History—20th century.
Classification: LCC N6537.K5 P49 2017 | DDC 720.92—dc23 LC record available at https://lccn.loc.gov/2016028475

10 9 8 7 6 5 4 3 2 1

Dedicated to Joy

Contents

Friedrich Kiesler (1890–1965) in Berlin, 1920s. © 2017 Austrian Frederick and Lillian Kiesler Private Foundation, Vienna.

Preface

The age of mankind is over. A new world has begun! The rule of Robots!
—Karel Čapek

In 1920, the Czechoslovakian playwright Karel Čapek coined the term "robot" for his play *R.U.R.* (*Rossum's Universal Robots*), crediting his brother Josef for inventing the term. Austrian architect Friedrich Kiesler, working with Čapek in 1922, designed the sets for *R.U.R.*, and their work together announced a turning point in cultural history.[1] Symbolizing the ultimate incorporation of the human body in its surroundings, both exciting and discomforting, androids or living machines came to reflect society's obsession with modern industry and the impact technology was having on everyday human life.

A preoccupation of the human imagination since antiquity, the concept of living machines reached a new level of interest in the early twentieth century. Leonardo da Vinci's first humanoid plans (1495) and Jacques de Vaucanson's famous automatons the duck, flute player, and pipe player (1738–1739) had already revealed humanity's ambivalence toward automated technology. Was it possible that one day machines might become self-motile and breathe life? What would that mean for the future of humankind? Despite society's enthusiasm for the conflating of humanity and machines, E. T. A. Hoffman's classic

short story "The Sandman," Mary Shelley's *Frankenstein*, and Auguste Villiers de l'Isle-Adam's *The Future Eve* reflected the chilling anxiety people felt about the possibility of inanimate life. These stories, among others, foretold Čapek's humorous vision of a time when robots would supplant humanity and indeed take over the world.

Whether or not humans were really becoming machines or vice versa was not the point to Čapek's fantastical story. What the play offered was an opportunity to work through and question human fears and fantasies about living machines, androids, and robots. In questioning the cultural fears surrounding labor, production, and technology, Čapek's robot tale proved an inspiration to writers, artists, and architects alike as they developed new forms of creative and speculative research across the twentieth and twenty-first centuries. Providing visions of the future, authors and designers created fictional spaces of experimental fantasy that have opened up toward new worlds.

Although it was not the traditional role of the architect, after meeting Čapek Kiesler spent the rest of his life exploring the relationship between the animate and inanimate through diverse forms of creative research. Effectively merging the field of architecture with automatist fantasies of science fiction, Kiesler dedicated his practice to advancing new forms of speculation, imagining futuristic environments that he hoped would motivate and enliven the building profession. Kiesler was a visionary not only for the ideas he investigated and the forms he produced, but for the means and methods he sought to realize his innovative and dramatic design ambitions.

Elastic Architecture is a study of Kiesler's contribution to the history and theory of modern design research, with an emphasis on the extraordinary quantity of media and methods he employed to pursue cultural and material innovation during what I describe as the first age of robotic culture, prior to the advent of cybernetics.

Acknowledgments

The historian, the historian of architecture especially must be in close contact with contemporary conceptions.
—*Sigfried Giedion*

The Czech word *robota* means "heavy labor." I had no idea when I began researching and writing about Kiesler's work that I would devote over a decade of my life to studying modern theories of automatism, automation, and human habitation, let alone perhaps the most creative, visionary—if eccentric—architect the twentieth century had seen. I credit my advisor Beatriz Colomina and thank her for introducing Kiesler to the Princeton School of Architecture, where I completed my dissertation, as well as Hal Foster for first suggesting I consider pursuing the study of Kiesler's work. I am grateful also to my other committee members—Stan Allen, Michael Jennings, Spyros Papapetros, and Mark Wigley—for providing invaluable readership throughout this journey. Professors Giorgio Agamben, Christine Boyer, Rodolphe el-Khoury, Mario Gandelsonas, Mark Hansen, Thomas Levin, Anson Rabinbach, John Rajchman, and Georges Teyssot all provided guidance and reassurance while I was at Princeton. Felicity Scott, Branden Joseph, Kathleene James-Chakraborty, Sarah Whiting, Detlef Mertins, David Cunningham, Greig Crysler, Lisa Iwamoto, Therese Tierney, Joan Ockman, Eva-Liisa Pelkonen, Antoine Picon, Mohsen Mostafavi, Ben van Berkel, Caroline

Bos, Elizabeth Grosz, Dora Epstein Jones, David Rifkind, Harrison Fraker, John Lang, Tom Fowler, Tom Gunning, Sarah Hamill, Nancy Perloff, Dawn Ades, Gail Feigenbaum, Andrew Perchuk, Thomas Gaehtgens, Wim de Wit, Katja Zelljadt, Nancy Lutkehaus, Tristan Weddigen, Cynthia Mills, Dana Byrd, Alexandra Davis, Simon Sadler, Laura McGuire, David Erdman, Marcelo Spina, Georgina Huljich, Marcelyn Gow, Thom Mayne, Neil Denari, Eric Owen Moss, Michael Rotondi, Jeff Kipnis, Joe Day, Hernan Diaz Alonso, Herwig Baumgartner, Tom Wiscombe, Greg Lynn, Heather Roberge, Jason Payne, and Patrick Tighe, among others, all offered valuable insight or shared in discussions that have proven particularly helpful to my work as it developed. Fellow Princeton PhDs who have generously supported this writing include: Jeannie Kim, Roy Koslovsky, Tamar Zinguer, Branden Hookway, Annemarie Brennan, Ingeborg Rocker, Emanuel Petit, Beatriz Preciado, Shundana Yusaf, Rafi Segal, Ernestino Osorio, Jasmine Benyamin, and Daniel Lopez-Perez. Dialogue supported by former professors David Leatherbarrow, Marco Frascari, Karsten Harries, Patricia Roberts, and Kent Bloomer also enhanced this work. I am indebted to Sylvia Lavin for her educational support and for providing an opportunity to develop my work as a visiting professor at the University of California, Los Angeles (UCLA); in addition, I would like to express my deep appreciation to my colleagues, friends, and/or students at California Polytechnic State University, San Luis Obispo (Cal Poly), Southern California Institute of Architecture (SCI-Arc), UCLA, California College of the Arts (CCA), University of California, Berkeley (UCB), and University of Southern California (USC)—your kindness, support, and interest have been absolutely vital. I am particularly grateful to Henri T. de Hahn for his support at Cal Poly, as I am also indebted to all my staff at Stephen Phillips Architects (SPARCHS) who have assisted me along the way.

In appreciation for invitations to lecture on chapters of this book, I thank: the Princeton University School of Architecture; the J. Paul Getty Research Institute; the Smithsonian American Art Museum; KU Leuven Department of Architecture; McGill University School of Architecture; the Canadian Centre for Architecture; Cornell University School of Architecture; Cal Poly; SCI-Arc; Bauhaus University, Weimar; the International Alvar Aalto Research Conference on Modern Architecture, Jyväskylä, Finland; the Akademie der bildenden Künste Wien Institute for Architecture; UCB, Department of Architecture; the Society

of Architectural Historians, Rhode Island Conference; and the AHRC Research Centre for Studies of Surrealism and its Legacies, Manchester, England.

I would like to especially thank the Austrian Frederick and Lillian Kiesler Private Foundation in Vienna. Dieter Bogner, Valentina Sonzogni, Harald Krejci, Monika Pessler, Eva Kraus, Annika Werner, and most recently Gerd Zillner, Peter Bogner, and Jill Meißner have all proven stellar colleagues whose knowledge of and interest in the history and theory surrounding Kiesler and his works have proven enormously helpful. This book would not have been possible without their generosity and contribution to the discipline. I would also like to thank Barbara Lesák for her insights on Kiesler and the theater.

Furthermore, I want to thank Princeton University School of Architecture, Cal Poly, San Luis Obispo, the MuseumsQuartier in Vienna, and the Canadian Centre for Architecture for their financial contribution through grants and funds that supported my dissertation research. My revision of this manuscript was substantially sponsored by Residential Postdoctoral Fellowships from the J. Paul Getty Research Institute in Los Angeles and the Smithsonian American Art Museum in Washington, DC; Cal Poly, San Luis Obispo provided a sabbatical to complete this work, and the Graham Foundation for Advanced Studies in the Fine Arts and the Barr Ferree Foundation provided substantial publication grants. I would also like to recognize Felicity Scott and Branden Joseph for supporting, editing, and publishing chapter 3 of this book in *Grey Room* for the MIT Press. Additionally, I would like to thank Thomas Mical for publishing part of chapter 5 in his edited anthology *Surrealism and Architecture*, and Beatriz Colomina, Jeannie Kim, Annemarie Brennan, and the Princeton Architectural Press for publishing my first thoughts on this book project in my article "Plastics" in our anthology *Cold War Hothouses*. I am sincerely grateful to Roger Conover, Victoria Hindley, Emily Gutheinz, and Matthew Abbate for working with me to edit, design, and publish this book through the MIT Press. Their support solidifies the value of this work and Kiesler's significance to the history, theory, and practice of art and architecture design.

Finally, in addition to the Austrian Frederick and Lillian Kiesler Private Foundation in Vienna, the staff of numerous archives, museums, and libraries have assisted this research, including: the Archives of American Art, Smithsonian Institution, in Washington, DC, San Marino, and New York; the Harvard University Theater Collection; the Mellon Research Collection, Philadelphia

Museum of Modern Art; The Getty Research Library, Special Collections; Yale University Beinecke Rare Book and Manuscript Library; Columbia University, Avery Architectural Drawings and Columbiana Archives; the Museum of Modern Art, New York; the Little Review Records, University Manuscripts Collection, University of Wisconsin-Milwaukee; and the Sigmund Freud Foundation, Vienna. Most of all, I thank my family for their kindness, love, and incredible endurance, and particularly my daughter Elysia for adding so much happiness to my life.

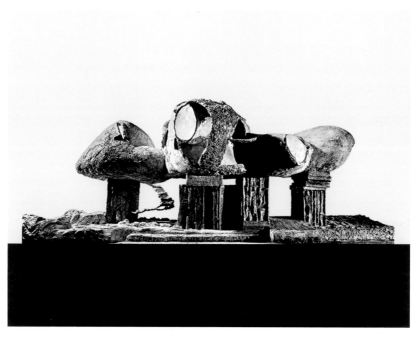

Figure 0.1 Frederick Kiesler, Endless House, 1959. Model. Courtesy of Harvard University Theater Collection, MS Thr 729, Houghton Library, Harvard University, Cambridge, MA.

Introduction
Design Research: The Non-building Architect

Frederick Kiesler's career spans the entire history of modern architecture. … [H]e is the greatest non-building architect of our time.
—*Philip Johnson*

In 1960, Philip Johnson, Chairman of the Department of Architecture for the Museum of Modern Art, introduced three emerging great architects in his article in *Art in America*: Paul Rudolph, Louis Kahn, and Frederick Kiesler. Rudolph and Kahn were in the midst of constructing significant buildings that would soon make them world-famous; Kiesler, on the other hand, had yet to complete a single freestanding building, despite his extensive career in architecture since the 1920s. Kiesler was included, according to Johnson, because he was a visionary whose ideas, if difficult to construct, were "enormous" and "profound."[1] Johnson considered Kiesler's Endless House, for example, to be one of the most original spatial conceptions of modern times. For Johnson, an architectural career was not to be valued on the success of built work alone, but on the impact and magnitude of the architect's conceptual innovation within the field.

Fundamentally challenging what it meant to be an architect, Johnson glamorized Kiesler for not compromising his design ideals to meet the normative demands of the construction industry. Instead, Kiesler set a new career trajectory, in which architects might be not master builders but research practitioners

who use alternative means and methods to advance architectural ideas outside accepted traditions. In utilizing extraordinarily diverse media—furniture, stage, film, sculpture, exhibition, building, drawing, and writing projects—to pursue new ideas, Kiesler developed a complex and synthetic design practice that radically transformed disciplinary boundaries between art, architecture, theater, philosophy, and science during the mid-twentieth century. His innovative model for experimental design research has proven inspirational for generations of architects who followed.

This book tells the story of Kiesler's pioneering design ideas and visionary research that formatively challenged the architecture profession to invent new design, education, and building practices.

Research Background

Spanning the entire history of modern architecture, Kiesler's career as a research practitioner began as a stage designer, exhibition coordinator, and theater architect in Berlin, Vienna, and Paris during the 1920s. Receiving critical acclaim for his stage designs within avant-garde circles, Kiesler became very close to members of the Dada and De Stijl movements. Moving to New York in 1926, he established himself as a prominent stage designer and educator—cofounding the International Theatre Arts Institute in Brooklyn, and working as director of scenic design at the Juilliard School of Music from 1934 to 1957. His notable successes in theater, advertising display, furniture, and exhibition design led to faculty positions as a research director and visiting critic of architecture at Columbia and Yale universities between 1936 and 1952. At Columbia and Yale, Kiesler created one of the first design research laboratories committed to the exploration of the arts and sciences in architecture. Combining ideas from the fields of morphology, biology, psychology, and aesthetics to develop new spatial building practices, in his research laboratory Kiesler invented a unique body of work that supported his achievements as a celebrated Surrealist exhibition, housing, and theater architect from the 1940s to the 1960s.

With his diverse and alternative approach to design research and its education, Kiesler contributed to what architectural critic Douglas Haskell in the 1950s described as a "second 'modern' order" that opposed normative modern

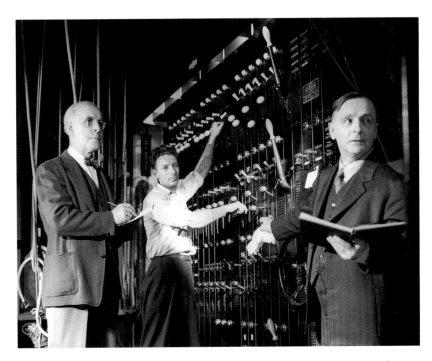

Figure 0.2 Frederick Kiesler and Director Alfredo Valenti, Juilliard School of Music. Photograph. Courtesy of the Harvard University Theater Collection, MS THr 729, Houghton Library, Harvard University, Cambridge, MA.

panel-and-frame rectilinear glass and steel construction in favor of advanced technologies that might achieve continuous and more naturalized organic constructions.[2] Kiesler invented new ways to *modulate* the built environment as a response to the evolving spatial habits of bodies perceiving in time and motion. His architectural projects were designed to be "elastic"—mobile and flexible—able to expand and contract to perform multiple dwelling tasks. One of a small number of counterfigures in architecture during the twentieth century, Kiesler's innovative approach to design research and its education developed themes and strategies fundamentally different from the major protagonists of modern design.

During his lifetime, however, Kiesler remained on the periphery of the profession. Often associated with a countermodernist movement due in part to the nonrationalized shapes he produced, Kiesler became best known for his "Endless" concept, whose importance, according to Johnson, lay "in the original conception of folding spaces around the viewer."[3] The Endless embodied a new spatial form that challenged modern perceptions; if built, Johnson believed, "the continuous space moving in complex ways would open vistas unknown to the architects."[4] Envisioning the viewer enveloped within a continuous and dynamically flowing environment, Kiesler invented designs that could expand and contract in response to the movements and perceptions of the human body. His interest in the Endless spanned his entire career, from his earliest explorations for his Endless Theater in the 1920s to his Endless House and Universal Theater projects of the 1960s.

Theater and the stage framed the trajectory of Kiesler's life and work, informing his research in the design and construction of new and adaptable building structures. Aiming to construct what he described as "elastic" architecture, Kiesler endeavored to create more socially conscious and economically viable building environments that might ensure the ease and fluidity of human interactions within their evolving technological surroundings. Kiesler proposed to design architecture with an elasticity similar to that of the natural human body, hoping to synthesize humanity, nature, technology, and machines within one continuously adaptable and sustainable organic environment.

Elasticity served as the central metaphor for his work, guiding his practice beyond the limited scope of fixed static structures toward the invention of more flexible topological conditions and organizational planning strategies.

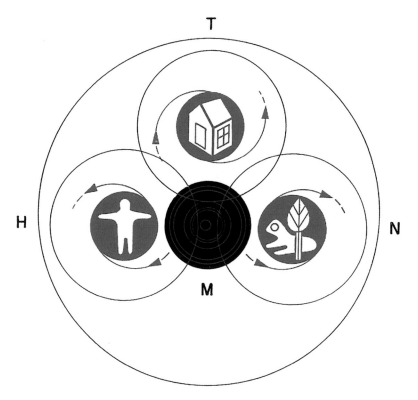

Figure 0.3 Frederick Kiesler, Correalism diagram, 1938: H = human environment; N = natural environment; T = technological environment; M = man-heredity. © 2017 Austrian Frederick and Lillian Kiesler Private Foundation, Vienna.

Extending his theories on expandable stage environments to the construction of housing and museum designs, among other building typologies, elasticity remained an essential study throughout Kiesler's life and is the guiding theme for this book.

Deriving his environmental design concepts from ideas embedded in the history and theory of modern drama and theater performance, Kiesler invented a unique architectural language that he studied and developed for over forty years. His designs aimed to facilitate multiple scenic actions, geared to the changing speeds of modern industry. He constructed staging devices that, unlike the static painted backdrops of nineteenth-century theater, might better respond to the technological dynamism of the modern machine age with its desire for actorless stages, inanimate marionettes, and futuristic robots.

Kiesler became part of a revolution in stage design associated with the constructivists and futurists, one that embraced the promise of science, media, and technology for developing new theatrical forms that might best train modern audiences to adapt to an evolving industrial society and world culture. Machines had become part of everyday human experience, and Kiesler's theater designs endeavored to habituate both actors and spectators to changes occurring in modern apperception. Notably, the invention of moving pictures had an enormous impact on everyday visual experience during the early twentieth century, challenging if not supplanting the theater's role in educating mass audiences. Kiesler was one of the first stage designers to embrace the potential of the new film industry within stage design by applying experimental animation and film projection technology in conjunction with building form. Creating innovative spatial effects with new multimedia technologies, Kiesler began to radically reconstitute the limits of stage design and theater architecture, forming an affective space—an illusory mise-en-scène.

This book thus critically examines Kiesler's transformation of *theatrical space* into the architecture of a total work of art of effects (the *Gesamtkunstwerk*) that fuses viewers, spectators, structure, light, rhythm, and sound into one cohesive spatial atmosphere. Advancing animation techniques to create contracting and expanding cinematic environments that explode any notion of architecture constructed with walls that define space, Kiesler instrumentalized the optic and haptic techniques of film—through the tactile habits of viewer perception—to motivate audiences and spectators to actively engage with their surroundings.

He brought these spatiotemporal strategies to bear on his commercial display designs in the 1920s to advance mass consumer markets, employing time-motion studies similar to Étienne-Jules Marey's early chronophotographic investigations within his design strategies. Through his inventive laboratory research, he experimented with new ergonomic systems geared to evolving situations, and his work proved paradigmatic of new aesthetic and biopolitical practices emerging in the arts and sciences throughout the twentieth century that have impacted spatial perception and body culture relative to the production of our built environment. In an effort to construct structures readily adaptable to the temporal needs of a constantly changing advanced capitalist society, Kiesler derived new techniques to support more flexible environmental systems that could modulate in response to everyday actions, human desires, and bodily needs.

Kiesler's elastic constructions, with their innovative organic architecture of expanding (*détente*) structures with free-flowing surfaces, can be seen to operate similarly to the interiors of the Art Nouveau. Nineteenth-century interiors, as critical theorist Walter Benjamin argued, used the plasticity of wrought iron and concrete as a naturalized casing to "confront the technologically armed environment."[5] Similarly, Kiesler's continuous forms of architecture performed in response to the body-in-motion to parry the shock of modern media and the intensive impact of machine industry on everyday working lives.

Aiming to generate immersive atmospheres that guided audiences and viewers alike to participate more fluidly and naturally—if unconsciously—within their surrounding technological environments, Kiesler's continuous spaces and ergonomic structures effectively seamed over any interval between what philosopher Henri Bergson might have described as the conscious snapshots of human perception. Performing a restorative operation, Kiesler's continuous structures sought to smooth out disturbing differences, separation, and disjunction in both the *physis* and the *psyche* of the dweller by modulating architectural surfaces in correlation to everyday human motions, with hopes of eliminating all nonessential actions. Continuous architecture thus served as a strategy for naturalizing the harsh, jarring, and discomforting affects of twentieth-century technology in order to ensure, for better or worse, more satisfyingly productive working lives; it creates spaces that induce the perceiving body to move about more freely and habitually—if not autonomically—unobstructed by abrupt

changes in the environment. In studying Kiesler's continuous forms of art and architecture, modulated to the actions and perceptions of everyday moving bodies and systems, this book ultimately examines the dialectical effects of adaptable elastic structures on the construction of modern subjectivity and the training of everyday human habits.

Contemporary Preoccupations

Kiesler's fascination with the Endless, elasticity, and continuity is echoed in more recent preoccupations that have emerged in contemporary architectural culture. Since the 1990s, Kiesler's designs have resonated formally and spatially with intellectual and technological interests that had developed in the academy and the architecture profession. Intellectually, many architects, academics, and their students found formative inspiration in the writings of French philosophers Gilles Deleuze and Félix Guattari. In his *Bergsonism, Thousand Plateaus,* and *The Fold,* for example, Deleuze had promoted architectural forms and ideas that, like those of the baroque, could unfold, evolve, and envelop, to create a labyrinth of contracting and expanding continuous elastic surfaces.[6] Deleuze's explicit call for "endless" architecture in his 1988 book *The Fold* unwittingly resonated with Kiesler's endless research project, and by the turn of the twenty-first century, generations of architects were experimenting with digital technologies that they believed might achieve complex curvilinear if not continuous organic spatial forms.[7] As digital design architect Greg Lynn fully acknowledged, Kiesler's concept of the Endless was the best historic precedent for the unfolding of curved space, and Kiesler's work proved extremely topical in light of computer animation technology now becoming more readily available to architects.[8]

Kiesler's association with digital architecture, however, was not altogether new. As early as 1965, architects had predicted that computers would eventually be used to generate and construct continuous complex curvilinear surfaces similar to Kiesler's designs.[9] The aerospace industries had been using computers to create calculable warped surfaces, and as industrial design student Raphael Roig realized in response to their work, it would only be a matter of time before computer technology would "be able to reduce to constructible

Figure 0.4 Boeing Company, computer drawings, c. 1965. From "Will the Computer Change the Practice of Architecture?" *Architectural Record*, January 1965.

Figure 0.5 Greg Lynn Form, Room Vehicle House, 2012. Prototype. Courtesy of Greg Lynn Form.

terms the inherent intricacies of [forms similar to] Kiesler's multiple-warped surfaces."[10] Artists and architects—Antoni Gaudí, Erich Mendelsohn, Frei Otto, Kiyonori Kikutake, and Kiesler among many others—had conceived and modeled complex structures, objects, and forms with varied degrees of technical proficiency during the early to mid-twentieth century. Roig recognized that the new computer technologies could assist the design and construction of similar innovative building structures. Roig's thesis, although brief and unpublished, established a connection between complex curvilinear forms, continuous spaces, and the use of computer technology. With further advances over the next thirty years, alongside intellectual sociopolitical interests in reviving endless spaces, by the beginning of the twenty-first century Kiesler's seemingly impractical building vision began to take shape.

My own study of Kiesler began not with the beauty or detail of his work, but with the depth and richness of his spatial vision alongside his provocative ideas, as they seemed to correlate to the architectural interests of the early twenty-first century. Kiesler's theoretical, practical, and laboratory research in organic design, endlessness, vitalism, morphology, affect, media, technology, elasticity, flexibility, multiplicity, time and motion, automation, and living machines—robotics—were in my opinion all suspiciously similar to contemporary preoccupations. As Kiesler's project appeared unfinished and inordinately topical, it seemed important and beneficial to better understand his work.

As architect Ben van Berkel observed in the late 1990s, "often to understand our ambitions and secret desires, we revert to history. And if we don't others will do it for us, point us out which architects of the past were already engaged in the subjects that intrigue us now. In this individuated approach to history Frederick Kiesler has achieved a special significance in recent years."[11] Digital design architects either took an interest in Kiesler's work or denied any comparison. Van Berkel was not reticent about aligning himself with Kiesler's ideas, and "while the full extent of Kiesler's spatial aspirations is unknowable," as van Berkel surmised, "the computational techniques now at our disposal enable the deepest understanding of Kiesler ever possible."[12] Over the next decade in architecture, we saw computer animation strategies used to incorporate urban growth analysis, epigenetic and morphogenetic scripting techniques, material and visual effect experiments, digital fabrication, alongside extensive

integration of complex structural, environmental, and ecological building practices. The computer has achieved nonlinear complexity in architecture beyond the limits of human capacity. How then have these new computer-animation-generated design practices and more recent developments in contemporary robotics advanced our understanding of Kiesler and his effect on twentieth-century modernism?

As I researched Kiesler and his work, it became clear that embedded in the history and theory of animate machines and automated technologies are a series of suppositions that resurfaced at the turn of the twenty-first century in light of new computer practices. Similar ideas and rhetoric that pervaded contemporary design, as well as Kiesler's interests, led me to dig more deeply into areas of his research not before seen or discussed, from his interest in time-motion studies and early experimental animated films to his vast study of the scientific, philosophic, and even pseudo-psychoanalytic debates surrounding the contracting and expanding perceptions of continuous forms and enfolding spaces. This led me to study Kiesler's endless spatial concepts more fully in relation to modern media and technology. The Endless was an architectural innovation that, although embedded in the reactions and experiments surrounding modern theater and film technology since the 1920s, was not the simple by-product of new techniques or new materials alone. Kiesler's spatial innovation was at the forefront of modern architecture because it was an *intellectual endeavor* as much as it was ever a practical, technological, or spatial enterprise.

Kiesler's projects were enormously profound, even though they were almost all impossible to construct in his lifetime. As Roig was well aware, Kiesler's visionary ideas exceeded the technological capacities of the twentieth (and perhaps even the twenty-first) century. His theaters, for example, were considered speculative experiments that failed at the time to garner mainstream appeal. And although the continuous forms and folding spaces of his Endless House would prove, as Johnson believed, "a work of art the 20th century would be proud of," at an estimated cost of more than one million dollars in the 1950s, Johnson and other potential clients chose not to take the risk of trying to build the Endless House; and nothing like its space or structure, despite the best efforts, has been successfully built today.[13] Kiesler's Endless concept instead remains a provocation—a visionary idea outside normative building traditions.

Figure 0.6 Frederick Kiesler, Endless House, 1959. Model. © 2017 Austrian Frederick and Lillian Kiesler Private Foundation, Vienna.

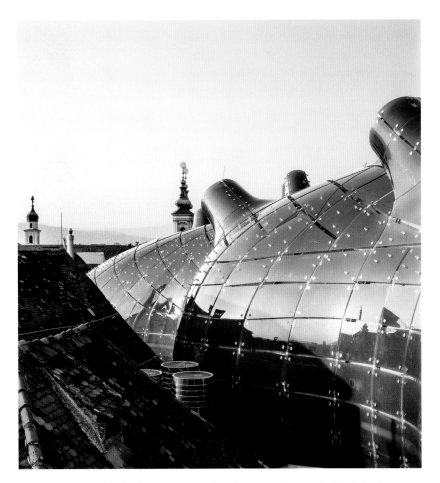

Figure 0.7 Peter Cook and Colin Fournier, Kunsthaus Graz, 2004. Photograph. © Paul Ott, Graz.

The Provocateur

Often slighted by artists, critics, and architects alike for his radical constructions, Kiesler was dubbed "Design's Bad Boy" for challenging the profession with his sinuous organic forms and complex curvilinear tension-shell structures.[14] Kiesler moved outside dominant trends in modern architectural practice with a theoretical approach neither readily accepted nor easily understood. He did not prove to be a great architect in his lifetime, but instead survived on the periphery of the profession as a sculptor, stage designer, writer, and occasional university professor and lecturer. He was a minor figure who did not receive substantial recognition from most architectural writers or his peers. He was, however, his own greatest historian and publicist; he crafted many articles, essays, and two substantial books that established a clear historical progression of his "Life's Pursuit" to dwell *Inside the Endless House*.[15] If not for his own knack for self-promotion, resilient talent for creative production, and strong support from avant-garde friends, family, and a handful of very influential admirers, Kiesler would not have achieved his now remarkable historical presence.

Scholars had already begun to study his life and work before his passing in 1965, and there have been several art historical surveys, articles, dissertations, and monographs on Kiesler since.[16] In these studies, Kiesler at first became a popular subject of postmodern reconstruction that sought to promote his elusive artistic oeuvre of De Stijl, constructivist, Dada, expressionist, and Surrealist preoccupations. Perhaps best defined by Lisa Phillips in her exhibition catalog for the Whitney Museum in 1989, the perception of Kiesler's work at the time was that it was "neither stylistically consistent nor bound by the limitations of single medium or discipline." Kiesler had "always been difficult to categorize," she attested, because he was "an enigmatic, elusive figure," and "in our Postmodern era it is precisely this interdisciplinary quality and multidimensionality that make Kiesler so intriguing."[17] As an artist, architect, theorist, and stage designer who participated in so many modern movements, Kiesler appeared eclectic and elusive—a bit of something for everyone.

Receiving acclaim for his inconsistencies rather than for any substantive focus or enduring interests, Kiesler appeared fairly irrelevant to the history of modern architecture. This began to change, however, after a 1996 exhibition at the Centre Georges Pompidou on Kiesler's work, alongside a publication

featuring several highly focused theoretical texts.[18] In a review of the Pompidou's effort in the *Architects' Journal*, Denis Connolly noted that Kiesler was "little known" at the time but was considered "a seminal influence on Archigram, Hans Hollein, Coop Himmelblau and a whole generation of utopian 'paper architects.'"[19] Following the exhibition, several architectural critics, writers, and historians would soon become more interested in Kiesler's many unique individual objects and works.[20]

Instead of similarly concentrating on any one architectural project or object or on his postmodern art historical relevance, this book examines Kiesler and his practice through a study of his theoretical research as it affected his broader architectural language and discourse. Although I investigate each of Kiesler's wide-ranging interests, I have not intended to see Kiesler in terms of individual projects in a paratactic fashion. I have focused instead on the relationships between what might appear on the surface as divergent ideas developing in his theater, art, exhibition, theory, and educational practices as they informed his architecture career and the broader field of building design. In fact, I argue that it is precisely Kiesler's investment in such an extraordinarily wide range of multimedia design practices that has supported his original thinking and innovation in the field.

The threads that began to tie this study together formed through analysis and observation of his consistent use of terminology in his varied projects. As I am both a practicing architect and theorist interested in rhetorical analysis—the art of communication—Kiesler's use of words such as "contraction and expansion," "elasticity," "continuity," and "endless," to name only a few, became perhaps the strongest indicator of a series of consistent interests that had evolved in all his work since the 1920s.

Architects and artists are notorious for finding inspiration from varied words or expressions. I chose to write about Kiesler with the knowledge that his designs engaged dialectically with his written works. From the speed with which he produced most of his designs, I suspect Kiesler spent at least as much of his time writing as he did drawing and modeling. In effect, he left an extensive archive of written work—much of which has yet to be published; he also left behind a library of books and a multitude of newspaper and magazine clippings for study. To understand Kiesler therefore means to read his drawings, his clippings, his models, his writings, and his library books with a view to the

cultural milieu he participated in. The correspondence between those different materials, I argue, affords original insight into Kiesler and the modern period in which he produced. As he was an intellectual architect with visionary ideas and provocative artistic sensibilities and insights, reading his work provides an opportunity to understand a unique historical trajectory, one that has proven to resonate with architectural debates today.

As renowned architectural critic Herbert Muschamp argued in 2001, in his obituary for Kiesler's second wife Lillian Kiesler in the *New York Times*:

> [Kiesler] is a model for those who wish to pursue architecture as an "alternative practice." Somehow, he made a go of it. Diller and Scofidio, Raymund Abraham, Greg Lynn, Wolf Prix and Eric Owen Moss are among many independent architects today who stand on Kiesler's shoulders. … Many architects are proceeding on the route he opened up. Besides those I've mentioned, the group includes Tod Williams and Billie Tsien, Steven Holl, Frank Gehry, Philippe Starck, Lebbeus Woods and Thom Mayne.[21]

Kiesler's life and work are exemplary in the history of modern and contemporary architecture, as his practice has provided a new paradigm for architects to build their careers through design research prior to and/or in conjunction with substantively engaging in building practice—a methodology that has since arguably led to the greatest built works of contemporary times.[22]

The Early Years

Because of the limited material available, and the sometimes inaccurate historical record he left behind, there has been little success in reconstructing Kiesler's youth and early background. Gaps and discrepancies in the archive have often fueled unsubstantiated controversy about his work. Kiesler was born September 22, 1890, in Czernowitz (Chernivtsi, Cernăuți), a polyglot city on the frontier of the Habsburg empire, now Chernivtsi in western Ukraine, to Dr. Julius Kiesler and Rosemarie (Maria) Meister. He later claimed to be from Vienna, however, and offered varying birth dates for no apparent reason, in addition to a variety

of other misleading information about his background.[23] Kiesler's mother died when he was only one or one and a half years old; his father and nursemaid-housekeeper, who allegedly "took better care of his body than his soul," raised him alongside his older brother and sister.[24] Conflicting opinions surround the nature of his upbringing. Lillian Kiesler suggested that his father "held great affection for his youngest child [Kiesler]"; showing interest in his "marked involvement with drawing," Kiesler's father had arranged "for him to draw at Vienna's Spanish Riding School when he was six [years old]."[25] On the other hand, it also appears that Kiesler broke away from the "tyrannical rule" of his older brother, the "birch rod" of his nursemaid, and the "strict disciplinarian" attitude of his father, to become a revolutionary artist.[26] Although his father was "chief magistrate of Vienna," and supported Friedrich's youthful interests in art while he studied at the Academy of Fine Arts (Akademie der bildenden Künste Wien) and Viennese School of Technology (Technische Hochschule), it has been stated that Kiesler "survived on scholarships and prizes," and that "his years as a student in Vienna (1908–1910) were marked by penury—the habit of living on next to nothing." Kiesler's father apparently wanted him to pursue a career in business, and their disagreement fractured Kiesler's relationship to his family.[27]

Little correspondence is available between Kiesler and his relatives to verify his past. Although his nephew did move to the United States and there are letters from several family members seeking Kiesler's assistance in immigrating to America, Kiesler was not close to his relations and did not provide them much support. Neither Kiesler nor anyone else stated much about his childhood, except curiously in a 1949 French editorial in *L'Architecture d'Aujourd'hui* that "due to a painful childhood he retained an almost maladive nervousness and an exaggerated sensitiveness."[28] In any event it is clear that Kiesler preferred to state that he was from Vienna and that he had few financial resources, and it is often suggested that he had a "painful childhood" which marked his physical and psychical being, perhaps in an attempt to explain the intensity of his work.

Kiesler lost most of his artwork produced prior to 1926 following his move to the United States, so there is little material to trace his early interests and ideas.[29] Although he did attend art school, and Lillian Kiesler stated that he received his diploma from the Academy of Fine Arts, Vienna, research indicates that he left without graduating.[30] Kiesler also claimed to have served in the First World War after leaving school. Drafted, he served on the front and in the press

corps, and his participation in the war reportedly played an influential role in shaping his interests. Following the war's end, he created the ideas behind what would later become his "galaxial" projects. Although no images of them have survived, Kiesler described a fragmented series of portraits rising to the infinite, which, veiled in white, trace in grisaille "a vast field of human bodies whose proportions grew larger and larger the higher they were placed."[31] About twenty pieces of irregularly shaped gray cardboard illustrations were seemingly nailed to the wall at different intervals with a covering of white tracing paper. Kiesler proposed that these traumatic fragmented images brought together in continuity were fundamental to his thinking and his interest in a universal language. However, as there is no actual evidence that these images existed, and as he would later argue that his interest in continuity formed while he was producing his stage designs in 1922 to 1923, it is difficult to draw a relevant conclusion.[32]

Kiesler provided much of his historical record in his writings and interviews. In a remarkable explication of his life project and its development, he outlined the nature and formative history of his work in a 1961 interview with Thomas Creighton of *Progressive Architecture*.[33] In this interview, Kiesler explained how Otto Wagner's early Art Nouveau buildings, and the general lively atmosphere in cavernous Viennese cafés of the late 1910s and early 1920s, most affected his developing ideas.[34] With little money, eating "rice chiefly and mushrooms," he met in various cafés and museums around the city, which he called "the caves of the artists for the germination of their ideas."[35] Although he never specified anyone he spoke with in these cafés, Kiesler elaborated on the exceptional architecture of Adolf Loos, Josef Hoffmann, and Wagner and the varying daily gatherings of Loos, Alban Berg, Alfred Adler, Robert Musil, Albert Ehrenstein, and Franz Kafka. Despite the vibrancy of Vienna's architectural culture, Kiesler's purported "curiosity and restless temperament" eventually took him from Vienna to Berlin, where he began experimental research using multimedia technology for modern performance spaces.[36]

Structure

Our story of Kiesler and his work begins with these first visits he made to Berlin in the 1920s, where his career as a stage designer and experimental theater

architect began. Although not entirely diachronic, this study explores how these early research investigations were developed and applied within his innovative housing, museum, and theater designs through to the 1960s. I am interested here not in all of Kiesler's work but in a particular strain of ideas, which I structure around his first and last proposals for theater architecture—his Endless Theater (1925–1926) and his Universal Theater (1959–1961). Divided into seven chapters, this text covers Kiesler's interests in stagecraft, display, education, gallery design, housing, and theater. Through these topics, I investigate a series of synthetic themes and strategies that surround his study of the Endless, elasticity, continuity, and modern design culture as his research practice in general. All these themes, I propose, are intimately related to his first preoccupations with animation and automation in Berlin, Paris, and Vienna in the 1920s—ideas and interests he brought to the United States when he moved to New York City in 1926. Such topics closely relate to his fascination with automatism, the human body, and scientific advances in machine technology. A conflation of the body and the machine comes to bear on his understanding and development of new building forms that engage more continuously with the surrounding natural and built environment in response to the dramatic needs of a newly forming robotic culture with its automated mobile and flexible structures and transformative, evolving and resilient laboring systems.

Chapter 1 on modern stagecraft thus begins by investigating Kiesler's formative relationships to the European avant-garde and their use of machine technology relevant to his conception of the Endless. The chapter provides a close examination of his involvement with stage design from a variety of sources including constructivism, Dadaism, and futurism. Capable of melding varied, seemingly antithetical ideas into a unique spatial practice, Kiesler found inspiration from the plastic arts, early experimental animation, automatons, marionettes, and the radical interests of postwar European theater to evolve a unique spatial concept—Endlessness. This idea he notably derived outside building practice through comprehensive research on modern theater for a series of exhibition designs in Europe and America from 1924 to 1926. My first chapter outlines how Kiesler used exhibition design to substantively investigate the resources and materials needed to conceptualize his architectural innovation, and poses exhibition design as a substantive new medium for architects to engage in experimental design practice.

The second chapter pursues Kiesler's adaptation of avant-garde stage and film to create atmospheric spaces in New York City during the late 1920s. There he applied radical theories of the modern stage to his urban display commissions. In his show window designs for Saks Fifth Avenue, for example, Kiesler introduced a wide range of Dadaist, constructivist, De Stijl, and Surrealist practices to the American advertising industry. Employing an array of visual and material effects, he constructed automatist spatial environments that blurred the distinctions between interior and exterior urban life; his designs aimed to draw people from the street into his commercial stores and buildings. Interested in ways of controlling viewer participation, Kiesler similarly constructed his Film Arts Guild Theater, at 52 West Eighth Street, to display stimulating optical patterns on the ceilings, walls, and floors that would motivate audiences to move down the hall and in front of the screen, where focused attention set to the rhythm of distraction performed to expand the limits of the architectural body.

Further investigating these visual and tactile techniques, chapter 3 looks at the pedagogical exercises Kiesler assigned in his courses at Columbia and Yale universities between 1937 and 1952. Inspired by his research in stagecraft, film, and display, he extensively engaged artistic and scientific studies to invent new forms of architecture. To this end, he gave his students assignments that challenged standard educational practices and advanced experiments to construct his Mobile Home Library and Vision Machine projects.

Examining the naturally elastic processes of growth and form in biology, anatomy, and physics, and applying his studies to manufacture responsive organic building systems tailored to changing environmental conditions, Kiesler invented a unique biotechnological design methodology inspired by animal and plant morphology. Expanding on these laboratory investigations, he generated and tested new forms of architecture structured not on the static "universal man" promoted by Le Corbusier, for example, but instead on the possibility of an "evolutionary" man in motion. Kiesler applied his research to derive innovative structures that could move, shift, and adapt or "modulate" to evolutionary changes occurring within the natural and built environment to invent architecture as a "living machine."

Adapting the results from his Design-Correlation Laboratory experiments to a series of gallery exhibition and museum designs from the 1940s to 1960s, Kiesler constructed more liberatory environments that began to resist the

Figure 0.8 Frederick Kiesler, Endless Theater, 1925–1926. Plan drawing. © 2017 Austrian Frederick and Lillian Kiesler Private Foundation, Vienna.

Figure 0.9 Frederick Kiesler, The Art of This Century Gallery, 1942. Sketch. © 2017 Austrian Frederick and Lillian Kiesler Private Foundation, Vienna.

controlling effects of his original biotechnological research. Working with the Surrealist inner circle, including André Breton and Marcel Duchamp, Kiesler invented modern gallery exhibitions in New York City and Paris that utilized psychoanalytic and natural-scientific ideas to advance his designs. This chapter provides an analysis of how his alternative display tactics created more dynamic and interactive spaces, in stark contrast to the functionalist mystique of the white painted box for gallery exhibitions. Kiesler's new ideas favored a synthetic and theatrical approach to display and museum design, as demonstrated in his World House Gallery in New York City, 1957, and his final built work—the award-winning museum for the Dead Sea Scrolls in Jerusalem, the Shrine of the Book, in 1965. Designed as a series of architectural elements correlated along a path of travel—similar to a scroll—the Shrine of the Book formed a mythical narrative that unfolded through ritual passage. Kiesler's museum, perhaps the first postmodern building ever constructed, memorialized through iconographic gesture and image the history, meaning, and significance of a series of tattered and effectively illegible strips of ancient parchment that carried enormous social, political, and cultural value for the Jewish people. The Shrine of the Book embodied Kiesler's lifelong study of exhibition design and display, and formed a challenging national icon riddled with Surrealist psycho-sexualized symbols and gestures designed to liberate modern sensibilities.

From his Nucleus House and Space House of the 1930s to the cavelike primitive rock formations of his 1947, 1950, and 1960 Endless houses, in chapter 5 I discuss how Kiesler advanced upon his research from his stage, exhibition, show window, furniture, education, gallery, and museum design practices to invent unique housing forms. Opposing the modern use of panel-and-frame rectilinear construction in favor of new organic structures, Kiesler's invention of a "Second Modern Order" created more adaptable-flexible environments using continuous-tension-shell technology. A house, Kiesler believed, was not to be fixed in time but should be intended to transform to the needs of human dwelling keyed to the changing and evolving necessities of the inhabitant. Kiesler's continuous-tension-shell "elastic" structures were thus designed to facilitate more fluid human interactions. Geared to our everyday actions, his houses aimed to exercise, train, and comfort the body. The Endless house ideally worked to regenerate the *physis* and *psyche* of the modern dweller.

An avid reader of Sigmund Freud and William James and a close friend to Wilhelm Reich, Kiesler elaborated his housing investigations to systematically question and challenge the stasis of modern living in order to improve our mental and physical well-being. Instrumentalizing the automatisms of everyday life, Kiesler's houses simulated a state of auratic communication of deep release with the cosmos. Forming elastic building constructions that ideally interact seamlessly with the human body, the Endless House enacted a most primal expression; it was designed to perform as a bodily supplement, a fetish object, for its inhabitants. Within the contracting and expanding apertures of surreal dwelling, the Endless House conformed to the body to enact modern pleasure in the hope of releasing repressed pain. Kiesler created a living machine, a dream machine, that could be used, inhabited, and engaged by the body for curative effect—to strengthen the ego for discharging individuals back into the sensual world of men—digested, regenerated, and redeemed. Challenging Kiesler's ambitions to unify humanity, technology, and the environment, chapter 5 explores contradictions between his humanist efforts and his emerging twentieth-century interests to engender a technologically enhanced posthuman society.

Chapter 6 provides a final examination of Kiesler's visionary approach to building practice through a collection of his theater and urban design projects. Here, I analyze how he systematically developed a new spatial order from De Stijl roots that was at once continuous and free-flowing, while at the same time able to shift and evolve with the changing temporal parameters of urban site, user, and program. Such ideas are best described in the "elastic spatial planning" strategies of his most compelling work, the Universal Theater (1959–1961), a competition design for a thirty-story skyscraper. The Universal Theater provides an important concluding study to Kiesler's research investigations. A complex organic building structure, it was to be constructed as an endless array of spatial contiguities situated within a highly controlled multimedia environment that supported vast revolutionary opportunities within an economically viable and sociopolitically complex corporate milieu. The Universal Theater proves to be Kiesler's greatest ethical proposal, aimed at merging theater, art, and business in support of a new open and inclusive building program and organizational strategy that challenged functionalist modern dogma in favor of multiplicity as a new spatial order. From his original response to the impact

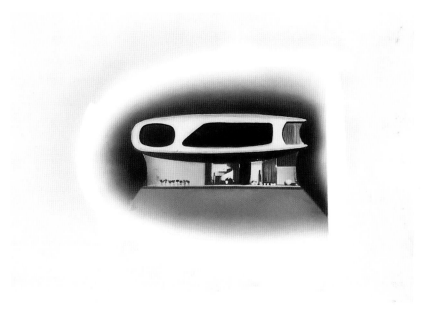

Figure 0.10 Frederick Kiesler, Space House, 1933. Collage, 1939. © 2017 Austrian Frederick and Lillian Kiesler Private Foundation, Vienna.

of modern industry at the birth of the first age of robotic culture (the *R.U.R.* stage sets), Kiesler elaborated a complex elastic architecture that aimed to support humanity's desire for flexibility, adaptability, and freedom amid the controlling, organizing, and delimiting automated systems and laboring practices of modern times.

Ultimately, as I conclude in chapter 7, what makes Kiesler's work so compelling and necessary to revisit today is not simply the fact that he was one of the first twentieth-century architects to actively engage in artistic, scientific, and design research in an academic laboratory environment, but the impressive impact his ideas have had on contemporary interests in responsive systems, resilient strategies, adaptive technologies, affective spatial environments, and more recent architectural studies in contemporary robotics and postmodern human perception. Studying a wide range of complex interests on the fringe of modern architecture—deeply invested in the shifting biopolitical terrain of the mid-twentieth century—Kiesler wrestled with his desire to create architecture that could produce a controlled and sustainable environment, while at the same time providing greater flexibility and adaptability necessary to an evolving, more inclusive temporal world culture. Inspired by the very nature of animated moving systems—robots—Kiesler's solution to create elastic architecture by forming a continuous open series of heterogeneous spaces simultaneously resonates with the challenges facing contemporary architecture practices today.

Architecture continues to have a profound effect on the human condition, beyond the purely formal, functional, and pragmatic; for better or worse, buildings and objects remain intimately engaged in the ever-changing tactical operations that affect, if not train, the human condition—structuring, if not defining, our customs, discourses, and habits. In forging one of the most creative, nuanced, and compelling research practices of modern times, Kiesler—with his specific focus on the correlation between humanity, technology, and the built environment—proves a brilliant precedent to our own contemporary ambitions that seek to understand the complexity of shifting power structures—fluctuating between control and liberation—which impact subjectivity within a constructed global environment. As a visionary architect, Kiesler challenged these subjects with intelligence, sensitivity, and curiosity, and the nuance of his practice offers credible insights for further research and study today.

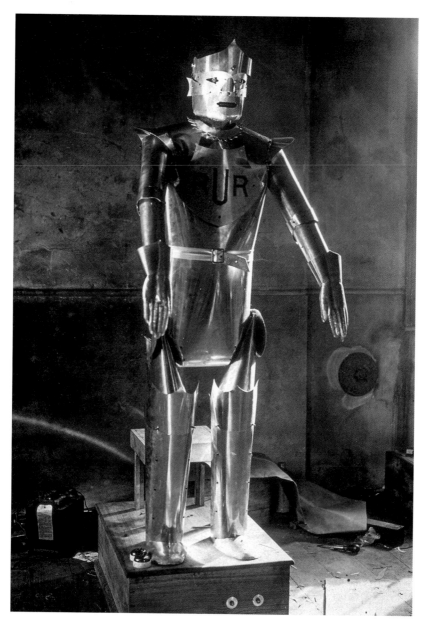

Figure 1.1 R.U.R. / Eric the Robot. Constructed by Captain William H. Richards, London, 1928, to characterize the concept of a robot as inspired by Čapek's play *Rossum's Universal Robots (R.U.R.)*. Photograph by Topical Press Agency. © Getty Images.

1 Actorless Stages and Endless Theaters

Just as the vanguard in plastic art looks for its inspiration in the shapes created by modern industry, ... so theatrical technique gropes towards the plastic dynamism of contemporary life, i.e., action. The fundamental principles which animate the <u>futuristic scenic atmosphere</u> are ... <u>the dynamism, simul[taneity] and the unity</u> of action between man and his environment.
—Enrico Prampolini

"The Theater is Dead," declared Kiesler in his exhibition catalog for the International Theater Exposition held at the Steinway Building in New York City in 1926.[1] Moving pictures had supplanted the need for traditional representational scenic techniques. The proscenium stage with its static relationship between actor and spectator had become obsolete. "The time [was] ... ripe for the open play," he contended, which demanded "an elastic space" for "freedom of movement."[2] Kiesler's radical statements supported the exhibition of his Endless Theater project, an ideal modern performance space that incorporated multiple open platforms suspended with elastic cables encased within a double-shell, glass-and-steel, spheroid-matrix-shaped structure upon which images and films could be projected. The theater was to be built without columns using tension-shell construction, so that interaction between actors and spectators could circulate freely, almost automatically, along spiral ramps and stairs. Theater had evolved dramatically during the early twentieth century, which inspired Kiesler's mobile and flexible architecture that was designed to respond to the drama of the event—the motion of the crowd. His Endless Theater created

engaging and inclusive relationships between actors, spectators, and their staged environments, as inspired by a variety of international sources presented at the exposition.

Co-organizing the exposition with Jean Heap of the Little Review Gallery and journal, Kiesler attempted to persuade American audiences to embrace the value and necessity of new modern theater. After the First World War, theater had created a new training ground to educate mass audiences to the speed of an evolving modern industry and world culture. By employing new technologies, European theater designers aimed to incorporate human beings more fully within their surroundings, hoping to create environments more in sync with the dynamic actions of modern times. Cognizant of diverse social, political, and cultural agendas pursued throughout Europe during this postwar period, in the exposition Kiesler attempted to present a wide range of international stage practices and developing design ideas.

The most extensive show of modern stagecraft held at the time, the International Theater Exposition comprised virtually the entire theater section from the 1925 Exposition des Arts Décoratifs in Paris, in addition to significant current stage work from Europe, Asia, and America. Originally planned for Madison Square Garden, the exposition filled two gallery floors at 113 West Fifty-Second Street with an astounding 1,500 to 2,000 models, drawings, sketches, and stage constructions by notable theater artists Enrico Prampolini, Vsevolod Meyerhold, Alexander Tairov, Liubov Popova, Pablo Picasso, Alexandra Exter, Georges Braque, Fernand Léger, Nathan Altman, Norman Bel Geddes, Robert Edmond Jones, Lee Simonson, James Reynolds, Joseph Urban, Cleon Throckmorton, and Woodman Thompson, among many others. A series of daily lectures and off-site film screening events also accompanied the exhibition.

Attracting record crowds, the exposition was extended for two weeks amid vigorous discussions and disagreements. Hammered extensively in the press for its "melodramatic pathos," "pompous prophets," and "amusing puzzlelike agglomerations," critics argued that the event channeled the rantings of "radical thinkers and experimenters" who believed the war had sounded a "death knell" to "old realistic-intellectual theater."[3] Others argued that the work appeared extremely "powerful," "suggestive," and "prophetic."[4] "So great," in fact, was "the divergence of opinion brought out … at the exposition," as one journalist explained, that a debate was held titled "Is American Stage Scenery Obsolete?"[5]

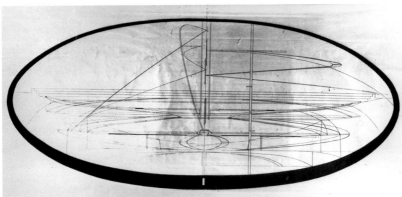

Figure 1.2 Friedrich Kiesler, Endless Theater, 1925–1926. Model. © 2017 Austrian Frederick and Lillian Kiesler Private Foundation, Vienna.

Figure 1.3 Friedrich Kiesler, Endless Theater, 1925–1926. Section drawing. © 2017 Austrian Frederick and Lillian Kiesler Private Foundation, Vienna.

Actorless Stages and Endless Theaters

Central to the controversy and "causing more talk and speculation, perhaps, than any other single exhibit," as a *Brooklyn Eagle* journalist explained, was Kiesler's Endless Theater.[6] The Endless Theater proved the culminating figure of the exposition. Showcased with a great deal of space, as one journalist explained, it featured a "stadium in which spectacles of every kind may be held … through which the life of the city may pass unhindered … [and] the promenader would be himself at once spectacle and spectator."[7] Incorporating a vast program of gardens, hotels, cafés, theaters, and parking within one immense spatial atmosphere, the Endless Theater included "a battery of slide and film projectors" beamed on the shell's interior surface to provide an "illusion of the infinite"—an uninterrupted "*disclosure*" of space where "Die Kulisse explodiert" (the scenery explodes).[8] The Endless Theater was designed to dissolve the limits and boundaries of theatrical production, providing a new multifarious forum for numerous simultaneous public events to unfold.

Although it was "doubtful," as one critic insisted, whether Kiesler's design was "meritorious enough to ever substitute for the modern theatre," it piqued curiosity and garnered significant attention, for it was easy to grasp; as one journalist explained, "here was a theatre grander in conception than anything ever before projected in this field, made possible only by the development of building in steel and glass."[9] To accommodate greater inclusivity, autonomous interactions, and free distribution of space, Kiesler had invented a large-scale theatrical structure planned as a flattened sphere, the meridian of which was a circle and its longitudinal section an ellipse. The design relied on new structural theories for long-span construction, forming, as Kiesler contended, "the first continuous shell construction scheme with no foundation [needed] to support it."[10] Elaborating Bruno Taut's innovative dual-shell glass and steel structure for the 1914 exposition of the Koelner Werkbund to envision his design, Kiesler's Endless Theater proved a speculative experiment—similarly to Ludwig Mies van der Rohe's proposal for the Berlin Friedrichstrasse competition of 1920–1921, Erich Mendelsohn's expressionist sketches of 1914 to 1920, and Antonio Sant'Elia's futurist cities of 1912 to 1914—that aimed to challenge accepted building conventions.

The Endless Theater posed a new conceptual solution to theater design, and it incorporated a rich history of modern stage practices, as presented at the exposition. Proving to be the initiating diagram of an idea that opened further

lines of experimentation and production, it acted as a spatial provocation to an evolving world culture interested in new forms of theater organization. These new forms were derived through extensive research from a wide range of international art, architecture, theater, and film sources. Also inspired by constructivism, expressionism, Dada, De Stijl, and futurism, Kiesler's Endless Theater incorporated broad multimedia practices to achieve synthetic resolve.

Originality

Though original in concept, the Endless Theater (as notably observed by the critics) appeared strikingly underdeveloped in percept. Shaped outside of specific context—without site or detail—its structure involved no significant formal, programmatic, technological, or site research. It lacked the methodological rigor of a constructivist laboratory experiment, for example, or the meticulous abstract exercises of Constantin Brancusi's similar egg-shaped forms.[11] Neither a dystopian symbol of an "egg-as-shelter," like those depicted in Hieronymus Bosch's early 1500s paintings, nor the utopian vision of spherical architecture as systematically developed by Claude-Nicolas Ledoux in the 1780s to 1790s, the Endless Theater appeared to be a loose compilation of affiliated design ideas synthesized into one surprisingly familiar organic (if geometric) form. Its all-inclusive dome-shaped structure performed in remarkably similar fashion to other theater proposals designed around the same time by Bel Geddes, Loos, Walter Gropius, and varied futurist theater designers. Not altogether different from Andreas Weininger's Spherical Theater conceived at the Bauhaus in 1924, Kiesler's Endless Theater was perhaps not so entirely original after all.

Over the following years, compelling doubts arose as to the innovative nature of Kiesler's project. He often retold the design narrative with conflicting dates and information, and his plans, section, and most notably his model did not structurally match or appear similar to any of his known drawing or modeling styles. He could not provide a series of rigorous formal or artistic exercises to substantiate his design process; moreover, he relied predominantly on showmanship and verbal descriptions to explain his ideas. Even the date of its inception became the subject of prolonged debate.

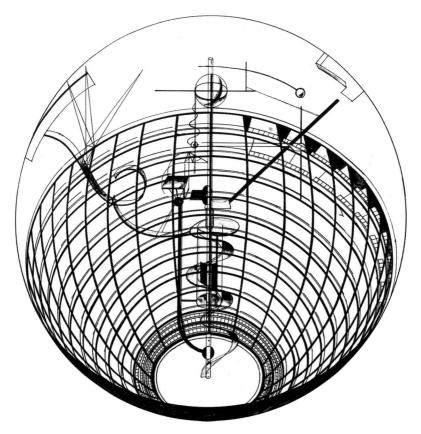

Figure 1.4 Andreas Weininger, Kugeltheater (Spherical Theater), 1924. Drawing. Courtesy of the Bauhaus Archive, Berlin.

Kiesler claimed that he first presented his Endless Theater in Vienna in 1924, but there is no evidence that he drew the plans prior to 1925, or even constructed the model prior to 1926. There are no images available or any mention of an Endless Theater in any known documents, published or otherwise, from 1924. Even the terminology Kiesler used remained arguably inconsistent. He never used the word "Endless" or any German equivalent term (*endlos* or *unendlich*) in any of his known writings or publications prior to 1926. In fact, he first employed the word "Endless" in New York City to title his plans and model for his "Universal" or "Endless Theater without stage" which he then oddly dated 1916 to 1925.[12] 1916, of course, was not a plausible date for Kiesler's Endless Theater, although he repeated it in his writing several times, and after 1932 he referred only to 1924 as the conception date for his design. 1924, however, was the year László Moholy-Nagy published the text "Das Kommende Theater: Theater der Totalität" which notably informed Gropius's design for Erwin Piscator's 1927 Total Theater—a building project that appeared strikingly similar to Kiesler's design, and later became far more renowned. The value of Kiesler's work—its character, originality, and authenticity—proved extremely important to justify, in light of similar projects developed around the same time as the Endless Theater, but any efforts to clarify its originality tended to further compound the confusion.

In 1930, for example, Kiesler attempted to explain away the inconsistencies between his plans and section for the Endless Theater.[13] His unconvincing explanation only fueled further allegations later. In 1996, alongside a major exhibition and publication of Kiesler's work by the Pompidou Center in Paris, Marc Dessauce published a study that attributed Kiesler's Endless Theater to Duchamp and Brancusi, among many others (figure 1.6).[14] Though based on purely visual associations and without evidence, Dessauce's suppositions proved so compelling as to inspire Gunda Luyken's more recent dissertation that attempted to prove Kiesler's theater plans were really Duchamp's original drawings.[15] Kiesler's reputation as a "smart manipulator" of the history of ideas notably gave El Lissitzky pause on whether to include his work in Kiesler's 1926 New York theater exposition, and such opinions of Kiesler continue to shadow the reception of his design efforts even today.

Why such lingering discrepancies, doubts, and controversies surrounding Kiesler's Endless Theater? Why the continuing challenge to the legitimacy of

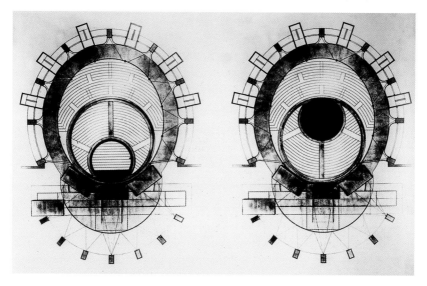

Figure 1.5 Carl Fieger and Walter Gropius, Total Theater for Erwin Piscator, Berlin, 1927. Drawing. Courtesy of the Bauhaus Archive, Berlin. © 2017 Artists Rights Society (ARS), New York / VG Bild-Kunst, Bonn.

Figure 1.6 Friedrich Kiesler, Endless Theater, 1925–1926. Plan drawing. © 2017 Austrian Frederick and Lillian Kiesler Private Foundation, Vienna.

Figure 1.7 Marcel Duchamp, *Anemic Cinema*, 1920–1926. Still images.

Actorless Stages and Endless Theaters

his work? Is there not more to the Endless Theater than its spherical appearance or inconsistencies? Why have so many historians proposed that virtually every egg-shaped or spherical art or building form prior to 1926 was the original precedent for Kiesler's design? In answer to these questions, among others, I believe it is important to trace Kiesler's interests in stage design and theater in the early twentieth century. Identifying the events and figures that inspired the invention of the Endless Theater not only provides the sources of Kiesler's fascination with the "Endless" in architecture but also, as I will argue, legitimizes his innovative engagement with varying disciplines in the pursuit of new architectural ideas. Through interdisciplinary research, Kiesler created one of the most original multimedia design projects in theater architecture relevant to new technology and industry. New industrial technologies had captivated a generation of early twentieth-century intellectuals in art, architecture, theater, science, and philosophy, and Kiesler's invention of the Endless Theater, I argue, proved a very sophisticated critical response to the fears and fantasies of industrialization, automation, and robotics of his time.

R.U.R.

According to his own account, Kiesler began his formative career as a theater designer during the 1920s after casually meeting the actor and director Stahl Nachbauer on a visit to Berlin. Kiesler impressed Nachbauer with his youthful and violent disregard for present-day theater. When Nachbauer acquired what Kiesler later described as "a crazy script," he telegrammed Kiesler to return to Berlin to design the stage sets for Karel Čapek's robot drama *Rossum's Universal Robots, R.U.R.* (*W.U.R.* in German).[16] The *R.U.R.* exploited automatist fears that machines would become ubiquitous, replace humans, and eventually take over the world. Kiesler recalled he had no experience as a stage designer at that time; he "just took it on."[17]

For this production, presented at the Theater am Kurfürstendamm in Berlin from 1922 to 1923, Kiesler incorporated varied optical and mechanical techniques to create dynamic spatial effects. By using mirror devices and motion picture projection techniques, for example, he created a series of illusionary environments. Remarkable in their time, his stage sets for the Čapek play

received critical acclaim. As he later described in a 1947 lecture at Yale School of Architecture:

> When the director of the factory wanted to demonstrate to visitors how modern his factory was, he opened a diaphragm which disclosed a moving picture from the back of the stage to a circular screen and you could see the interior of an enormous factory with people walking busily back and forth. This was an illusion since the camera was walking into the interior of the factory and the audience had the impression that the actors on the stage walked into the perspective of the moving picture, too.[18]

Kiesler's use of a film—perhaps the first silent film *La Sortie des usines Lumière* by Louis Lumière or another similar one—resonated with the social concerns of Čapek's play. Nineteenth- and twentieth-century advances in photography and film had a profound impact on spatial perception, enlivening worldviews. Through cinematographic technology—stop-motion, animation, and close-up techniques—human perception expanded to include new visual and corporeal expression. Kiesler employed film to challenge the spectator's field of vision and to immerse the actors in the mechanical stage and scenery.

The *R.U.R.* questioned the impact of technology on everyday life; it conflated humanity and the machine to challenge the relationship between our bodies and new industrial technologies. Kiesler's use of a tanagra device to project backstage action on stage reinforced Čapek's automatist perception:

> When the director of the human factory in the play pushed a button at his desk, the panel opened and the audience saw two human beings reflected from a mirror arrangement backstage. The actors appeared in this window as a foot-and-a-half tall, casually moving and talking, heard through a hidden loudspeaker. It was quite an illusion, because a minute later you saw the same actors appear on the stage in full size. There was, inevitably, a burst of applause at this moment.[19]

Shifting between live action onstage and moving images in the backdrop through the combination of plane and concave mirror devices, Kiesler's design

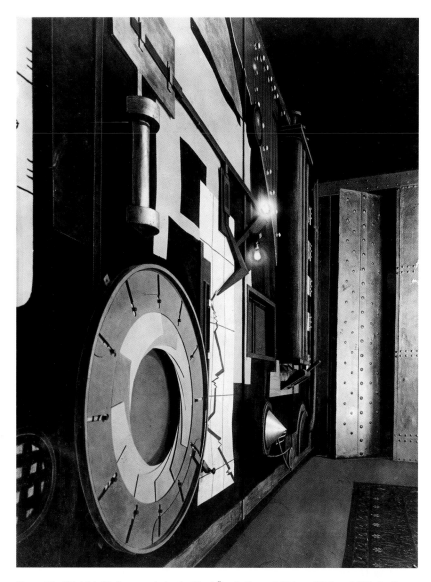

Figure 1.8 Friedrich Kiesler, stage design for Karel Čapek, *Rossum's Universal Robots, R.U.R.*, Berlin, 1922–1923. Photograph. Courtesy of the Harvard Theater Collection, MS Thr 729. Houghton Library, Harvard University, Cambridge, MA.

suggested the impact of automation and new technology on real-world experience. One moment the actors were images projected through mechanized surface; the next, real people engaged in action on stage. Kiesler prompted the question: Are human beings real, images, or machines?

For the final laboratory scene, Kiesler used backstage projection and neon lights to transform the space. As the Berlin Fire Department flooded the screens with water to ensure the projected images would not ignite the backdrops—"making them beautifully translucent"—Kiesler projected images throughout the entire theater, using "a whole abstract forest of neon lights, brilliantly colored, projecting from the ceiling, walls, and floor, flashing off and on. In fact, throughout the entire play, everything was in constant change and movement. Lights shone on the audience, the side walls moved."[20]

Kiesler immersed the audience in lights, images, sounds and movement. His version of *R.U.R.* was one of the first stage designs to use film and neon lights.[21] Quick to engage promising media and technology in theater, Kiesler collapsed the separation between actor and spectator, and immersed the body in technology.

An Avant-garde Career

Kiesler's innovative modern stage design launched his avant-garde career. Dada artist Hans Richter vividly recalled that De Stijl architect Theo van Doesburg insisted, "We must go to the Comedy tonight, the theater on the Kurfürstendamm. There is a play by Čapek, *W.U.R.*, with very modern stage sets."[22] The show delighted van Doesburg, and although the technology left Richter "feeling cold," after the performance he described how he and van Doesburg "waited for the inventive creator. We congratulated a small muscular man who in charming Viennese explained to us very interestingly the importance of technical innovations in the theater."[23] Impressed by Kiesler, they became his lifelong friends and most influential supporters.

Van Doesburg published a collage image of Kiesler's *R.U.R.* set design in *De Stijl* in June 1923.[24] The collage was given ample space; it featured Kiesler's illusory effects and innovative filmic techniques, and van Doesburg inaugurated Kiesler as a member of the De Stijl group alongside Richter, Werner

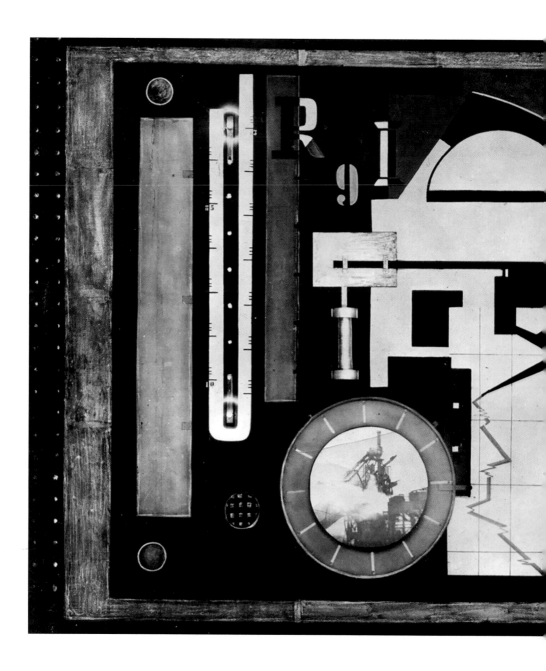

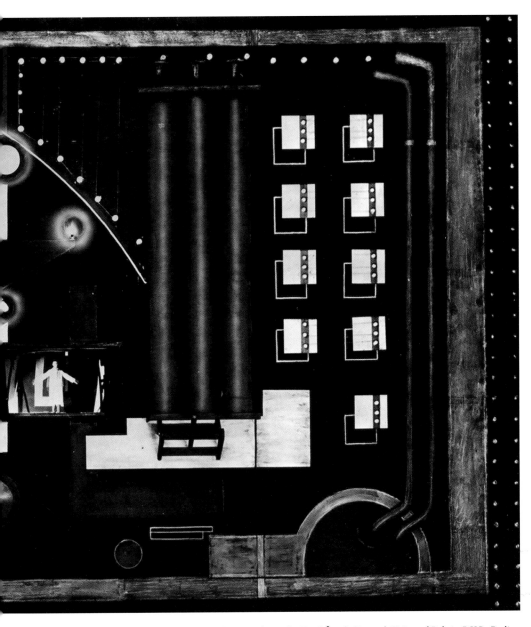

Figure 1.9 Friedrich Kiesler, stage design for Karel Čapek, *Rossum's Universal Robots, R.U.R.*, Berlin, 1923. Collage. © 2017 Austrian Frederick and Lillian Kiesler Private Foundation, Vienna.

Graeff, Piet Mondrian, Aldo Camini, Gerrit Rietveld, Cornelis van Eesteren, I. K. Bonset, and George Antheil; Hans Arp, Hugo Ball, Brancusi, César Domela, and Vordemberge Gildewart would later join the official group in 1925.

Kiesler remained in Berlin for a few more months in 1923, where he designed his next stage set, for the play *Emperor Jones* by Eugene O'Neill, directed by Berghold Viertel and presented in a small theater in the Friedrichstrasse. Richter, interested in Kiesler's work, made it a point to attend the show. The stage sets were imaginative yet simple, more so than any other play in Europe or America at that time, Richter recalled. He remembered "Emperor Jones wandering through the jungle: hanging canvas panels, unpainted, crisscross, in which the wanderer, as in the jungle, has lost his way. Now and then a spotlight on the 'walls,' the man, and the path. A spooky world created out of nothing." For Richter, "Kiesler had created … a masterwork in its simplicity," using what appeared to be very simple stage techniques.[25]

In the sets for *Emperor Jones*, Kiesler angled the ceiling, floor, and walls in the first act to direct attention to the Emperor entering the stage. As the play progressed, the stage transformed. From the slit at the rear, the Emperor arrived on a traditional picture stage. The sets were inclined to focus spectator attention on the static funnel point perspective of the emperor in a desolate room. Accompanied by the increasing beat of the drum, the panicked emperor appeared plagued with dark melancholic visions and repressed memories; he anxiously tried to escape. The red- and black-colored sets began to open up and move back and forth in syncopated rhythm. As the beating sound continued, lighting effects created semitransparent shadows with dreamlike intensity. The motive for the sets was "in the play itself," Kiesler explained, "which [was] … a pursuit of the Emperor by his people until he escape[d] … them. … He r[an] … away, t[ook] … refuge in a forest and [was] … haunted by visions of wrong doings."[26] Fear and guilt were qualities expressed throughout the play, and the story culminated with the stage sets contracting to their original position, as the Emperor shot himself.

Kiesler created the spatial effects for his *Emperor Jones* stage design by adapting constructivist theater techniques from Alexander Vesnin and Meyerhold, among others. Substituting angular plastic forms for painted stage backgrounds, constructivist theater designers in the 1920s created dynamic spatial environments. In Tairov's production of the play *Phèdre* in 1922, Vesnin tilted

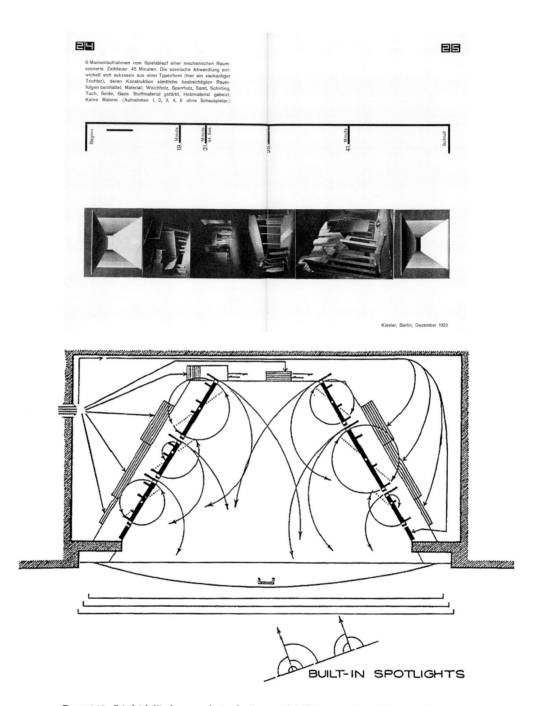

6 Momentaufnahmen vom Spielablauf einer mechanischen Raum-
szenerie. Zeitdauer: 45 Minuten. Die szenische Abwandlung ent-
wickelt sich sukzessiv aus einer Typenform (hier ein vierkantiger
Trichter), deren Konstruktion sämtliche beabsichtigten Raum-
folgen beinhaltet. Material: Weichholz, Sperrholz, Samt, Schirting,
Tuch, Seide, Gaze. Stoffmaterial gefärbt, Holzmaterial gebeizt.
Keine Malerei. (Aufnahmen 1, 2, 3, 4, 6 ohne Schauspieler.)

Kiesler, Berlin, Dezember 1923

BUILT-IN SPOTLIGHTS

Figure 1.10 Friedrich Kiesler, stage design for Eugene O'Neill, *Emperor Jones*, Berlin, 1923. Photo collage. From the catalog of the "Internationale Ausstellung neuer Theatertechnik," Vienna, 1924. Courtesy of the Getty Research Institute, Los Angeles (88-B5731).

Figure 1.11 Friedrich Kiesler, stage design for Eugene O'Neill, *Emperor Jones*, Berlin, 1923. Plan drawing. © 2017 Austrian Frederick and Lillian Kiesler Private Foundation, Vienna.

the stage floor and created angular sidewalls to focus attention on the actors. By 1923, Vesnin like Meyerhold had created stage sets called "devices" that stood and moved independently of the backdrop. "In order to animate the stage," for example, Vesnin "introduced … a moving truck, a moving sidewalk … a system of elevators, a turning crane, spotlights and mobile battens, and a luminous advertising device" in his 1923 production of *The Man Who Was Thursday*.[27] Constructivist sets actively directed spectator interest through sound and movement while providing lively environments for actors to circulate in.

Kiesler orchestrated similar constructivist techniques in his sets for *Emperor Jones*. He inclined the floor 33 degrees in addition to slanting the ceiling and walls, creating a dynamic angular spatial composition. As the play progressed, the stage expanded as Kiesler suggested, "indicating the passage of time."[28] The static aspect of the room opened up through the mobility of its parts set to dynamic motion.

Impressed by Kiesler's engaging kinetic sets, Richter pursued a close friendship. They met in Vienna, and Richter stayed with Kiesler and his first wife Steffi for a week in 1923. As Richter remembered:

> On my way from Rome at six o'clock in the morning, I knocked on the door of the late-rising in Vienna. I was received with so much warmth and friendliness as one does not find in Vienna anymore. I stayed for a week with Steffi and Friedrich, which went by like a day. I met lots of people, was introduced by him to the Café Museum, had to down a dozen dumplings with prunes in order to prove my belief in Viennese cooking, had to climb St. Stephen's Cathedral, ate at the Lindenkeller, and left Vienna elated and exhausted.[29]

Richter enthusiastically invited Kiesler to participate in formative discussions about his new magazine *G* alongside van Doesburg, Graeff, Tristan Tzara, Arp, Man Ray, Walter Benjamin, Naum Gabo, Mies, and Nikolaus Pevsner, among others.[30]

Richter later reflected on Kiesler's involvement in *G* during these formative years. As Richter recalled, he first met Mies in 1921 through newlyweds Theo and Nelly van Doesburg when they stayed with Richter in Berlin. They went to see Mies together because they believed his architectural drawings

resembled a Mondrian painting or even one of Richter's early scrolls. The spacious rooms, lines, and rhythmic surfaces of Mies's houses articulated a visual melody—a new universal visual language—developed from the program the house serves.[31] As Richter remembered:

> We, the artists (young architects and sculptors) were all for Mies and his "living space" as we all were for, what we then called, "Elementare Gestaltung"—"Elementary-creation of form." We that were Mies van der Rohe, my friend and former pupil Werner Graeff, Van Doesburg, Lissitzky, the Dutch architect van Esteren, the Danish architect Lundberg, Holm, Eggeling, Hausmann, Gabo, Pevsener, Arp, Kiesler, etc. And we had to have a magazine, there was not a single modern magazine in Germany yet. We talked a lot about it and when in 1923, by a lucky accident, I got a small amount of unexpected money, we published our magazine "G" (the first letter of the word "Gestaltung"), the lucky solution of the title "G" was found by Lissitzky who therefore was included into the first editorial letterhead![32]

Kiesler was one of the initial members of *G*, according to Richter. Although perhaps not a formative editor, like Lissitzky he was one of the few associates or contributors to be included in the editorial roster.[33] Kiesler contributed one article to *G*, no 4 in 1926, and had an official role as co-worker and editor of *G*, no. 3 from 1923 to 1924. The Austrian representative for the magazine, Kiesler was familiar with its contributors, content, and style effectively from its inception.

Kiesler's youthful involvement in *G* had a significant impact on his career. The magazine's name stood for *Gestaltung* (creation)—in the sense of formation or the process of becoming. It drew contributors from a wide variety of international artistic groups and showcased film, theater, politics, and related contemporary arts and architecture. Published irregularly from 1923 through 1926, *G* generated a central discourse in European avant-garde practices. *G* did not emphasize any particular style or form, but aimed to support a universal or synthetic modern discussion in support of art and architecture.

G, no. 3, the issue Kiesler edited (Graeff, Mies, and Richter are listed with him on the masthead), presented a wide range of contemporary subjects and artistic approaches. The result was seemingly eclectic. Images of laminated

wood lattice construction for the Deutsche Zollbau in Berlin and the glass and steel construction of architect Peter Behrens's work, for example, were presented alongside Tzara's and Benjamin's cultural studies on photography. As Mies argued in *G*, "anyone expecting to reach the industrialization of construction only through the active and contemporary form of organization is wrong."[34] *G* instead attempted to understand industry and design as the consequence of cultural, formal, environmental, material, and structural developments in society; *G* put art and architecture in context within an expanded field.

G primarily featured the work of its editors and contributors in their cultural milieu. It presented Mies's architecture, Lissitzky's Prouns, Graeff's studies of industry, and Kiesler's 1925 exhibition structure. All projects were shown alongside Richter's film studies. Van Doesburg had originally suggested Richter initiate his own magazine to support Richter's and Viking Eggeling's innovative experimental animation studies. Every issue of the magazine included an extensive study of experimental animation relevant to Richter's and Eggeling's early scrolls and films. These animation studies had enormous impact on Kiesler's developing interests.

Experimental Animation

Richter's and Eggeling's experimental animations sought to invoke awareness of the rhythm and continuity of forms transpiring in flux. Richter and Eggeling painted a series of abstract figures on paper scrolls and films depicting the dynamic formation of images becoming in duration. They were directly responding to French philosopher Henri Bergson's provocation to recover poetic experience, the *durée* lost in the interval between the contracted snapshots of our focused conscious perceptions. As Eggeling noted, "becoming and duration are not in any way a diminution of unchanging eternity; they are its expression. Every form occupies not only space but time. … What should be grasped and given form are things in flux."[35] To articulate forms in the process of becoming, Eggeling and Richter derived animation techniques that could achieve "Dehnung in der Zeit Ausdehnung im Raume" (stretching in time and expansion in space).[36]

From Eggeling's interpretation of Bergson's theories on perception in *Creative Evolution*, he and Richter produced scrolls and films to create continuously

moving spatial forms through *contracting* and *expanding* visual effects. Richter and Eggeling lived and worked together on their scrolls and films for three years. By 1919 they elaborated daily formal studies of horizontal-vertical themes that Eggeling termed "instruments." "These everyday exercises were, as I remember," Richter explained, "the real key that opened the way to a 'continuity.'"[37] Eggeling led all these studies, Richter admitted, and it was Eggeling's extensive readings and transcriptions of Bergson's philosophy—his interest in continuity and becoming, among other ideas from *Creative Evolution*—that fueled their designs. Richter recalled, "in his horizontal-vertical series of drawings, … [Eggeling] had one important theme or 'instrument' which he called *Dehnung*—expansion, stretching. He suggested testing this instrument by painting it on a thin rubber foil so that it might expand and contract. *Dehnung* thus became the first 'instrument' to test motion."[38] Expansion and contraction became important themes in Eggeling's and Richter's early scrolls and films.

Intended to serve a social purpose, their experimental animations responded to the tragedy of the First World War as they sought to uncover a universal language to unite different cultures through visual abstraction and spatial continuity. The war had fractured European communities, and modern artists had hoped to create a common ground between different sociopolitical and cultural groups by developing a new abstract language that could be experienced, felt, and communicated universally—devoid of any past tragedies, experiences, or prejudicial biases. Geometric and/or organic forms orchestrated to invoke qualities, intensities, feelings, or affects of modern style and rhythm were believed common sensibilities that could be used to "rebuild men's vision into a spiritual language in which the simplest as well as the most complicated, emotions as well as thought, objects as well as ideas, would find a [new] form."[39] Richter and Eggeling produced spatially ambiguous—continuously evolving—abstract taxonomies based on purportedly common traits in vision and memory to train viewer apperception to a new spatial, visual, and corporeal language that they hoped to produce and distribute en masse through films.

Kiesler visited Eggeling's studio in 1923 to discuss theoretical ideas and learn the details of his and Richter's experimental animation process.[40] Eggeling's animation films impressed Kiesler immensely, and Kiesler was given the original and edited versions of Eggeling's *Symphonie Diagonale* to disseminate

alongside Richter's, Walter Ruttman's, and Fernand Léger's films at Kiesler's theater exhibitions in Paris and New York in 1925 and 1926. In compensation for his years of continued interest and effort to promote and maintain Eggeling's films, by 1937 Kiesler was invited to inscribe a permanent introduction onto *Symphonie Diagonale*.[41]

Exhibiting and lecturing often on Richter's and Eggeling's films, Kiesler emphasized their important investigations into the "contraction and expansion" of space. In Richter's film *Rhythm 21*, the motion of a series of rectangular shapes provided a conceptual diagram that informed Kiesler's research practice.[42] Of Eggeling's work, Kiesler noted: "There is no doubt that the *Symphonie Diagonale* has … an expression of austere beauty that is only inherent to work of nature or art embodying entity of all parts held tenaciously together by its very own power of motion, that makes it *expand and contract, endless in it breath and most concrete in its structure*."[43]

Creating an illusion of spatial depth using a back-and-forth rhythm, these films simulated Bergson's definition of evolving form as an "elastic canalization … in variable and indeterminable directions,"[44] "a perpetual oscillation," "a perpetual flux" "drawn out into an endless chain" which "lets loose the universal becoming. It is an elusive nothing that creeps between the Ideas [Forms] and creates endless agitation, eternal disquiet."[45] As Bergson reminds us, becoming is an indeterminate process, and Kiesler, like Richter and Eggeling, sought to create indeterminate elastic forms that could expand and contract to produce endless articulation.

Inspired by Bergson, Eggeling and Richter developed animation scrolls and films to demonstrate endless spatiotemporal qualities, which Kiesler learned to adapt in part to create his Endless architecture. Like Eggeling and Richter, Kiesler had hoped to formulate the perception in his designs of endless spatial oscillations resonating amidst continuous surfaces. Through the articulation of contracting and expanding spatial elements held together through perceptual rhythms of structural motion, Kiesler was able to express endlessness through the formation of a series of spaces held together in seamless continuity. His Endless Theater was his first attempt to develop the Endless as a speculative proposition and experimental production relevant to contemporary building practice, which he then evolved through his research as an exhibition designer for a series of major international theater expositions from 1924 to 1926.

Figure 1.12 Frederick Kiesler, introduction to Viking Eggeling's 1921 film *Symphonie Diagonale*, 1937. Still image added to film.

Figure 1.13 Hans Richter, studies in the contraction and expansion of space. *Rhythm 21*, 1921. Experimental animation, still images.

Figure 1.14 Viking Eggeling, evolution of the dynamic formation of images in the process of becoming an ensemble in duration. *Symphonie Diagonale*, 1921. Experimental animation, still images.

New Theater Techniques

Influenced in part by the format, participants, and content of *G* and *De Stijl* magazines, Kiesler coordinated the "Internationale Ausstellung neuer Theater-technik" (International Exhibition of New Theater Technique), a part of the International Music and Theater Festival of the city of Vienna in 1924. Kiesler was appointed architect and artistic director for the exhibition, likely due to his international contacts. He developed and presented an extensive study of contemporary stage techniques by avant-garde theater designers in Russia, Austria, France, Germany, and Italy, among others. Designing the catalog, exhibition stands, and a performance stage, in addition to coordinating a series of compelling lecture, theater, and film events, Kiesler demonstrated formative research on contemporary theater as it aimed to challenge static stage traditions with socially defiant intent.[46]

War and the industrialization of society had brought major changes to European theater by the 1920s. Avant-garde artists with revolutionary agendas supported political change through the theater, as it was one of the few mediums that could reach a broad audience. Modern theater varied across Europe, however, and the nations' varied fortunes in the war had created uneven political and economic situations, which supported diverse theatrical interests.

In England and France, for instance, there was little financial support for theater during the war, but afterward theatrical trusts generated substantial profits by exploiting strong nationalist spirit and patriotism. Theater in England and France showed predominantly classics that featured the historical and cultural achievements of the allied nations. Only occasional modern plays were presented in England and France, despite revolutionary changes throughout the rest of Europe. In Russia, on the other hand, innovative constructivist theater developed in response to the Bolshevik revolution and newly forming communist agendas. Constructivists hoped to merge actor, spectator, theater, and stage into one event space that would burst out onto the street in mass festivals. They proposed devices that could move, shift, and evolve in coordination with actors and spectators on stage and off in rhythm with inspiring and liberating action. Meyerhold became the leader of this movement, and his plays simulated the spirit of mass meetings taking place in Russia.

Figure 1.15 Friedrich Kiesler, catalog cover for the "Internationale Ausstellung neuer Theatertechnik," Vienna, 1924. Courtesy of the Harvard Theater Collection, MS Thr 729. Houghton Library, Harvard University, Cambridge, MA.

New forms of theater emerged throughout Europe in response to the dynamism of war, modern industry, and revolution. Besides constructivism in Russia, expressionism developed in Germany around the Berlin Sturm group, as published in *Der Sturm* under the leadership of Herwarth Walden. By 1920, expressionist theater evolved from a group of young insurrectionists into a movement that sought the destruction of the intolerable systems of society. Expressionism, similar to Italian futurism, developed plastic art forms and music with intense dynamism and speed that expressed qualities emerging in modern everyday life. Unlike the futurists, however, expressionists prioritized human body and spirit over industrial progress and its machines, while the futurists under Filippo Tommaso Marinetti embraced humanity as machines. Enrico Prampolini advanced futurist theater with his mechanical ballets and illusory scenic atmospheres, while Kurt Schwitters, August Stramm, Lothar Schreyer, and Walden expanded expressionist theater to incorporate words, sounds, color, and movement to motivate spectators to feel human reactions.

Challenged to incorporate the large array of postwar developments in modern European theater at the "New Theater Technique" exhibition, Kiesler elaborated a rich and unique venue and catalog for the event. The exhibition featured theater designs, films, images, and ideas by expressionists, futurists, constructivists, and Dadaists, though classical and modern music by Beethoven, Mozart, Strauss, Wagner, and Schönberg, among others, were also incorporated into the festival, through live performances daily throughout Vienna from September 22 through October 15.

The texts published in the catalog provided a rich framework of ideas on modern theater in Europe in the 1920s. These texts were juxtaposed with images by the authors and other relevant works. The format of text and image was systematic, and very similar to the characteristic juxtapositions used for *G*. Texts shifted between vertical and horizontal display and incorporated images and marginalia to weave carefully together a vast framework of ideas. A witty introspective play by Schwitters, for example, on the content versus public reception of his *Merzbühne*, crossed boldly through several pages and other texts. Kiesler collaged Schwitters's writing against Marinetti's essay on abstract theater and Josef Trubswasser's discussion and images of violin making (its innovative shape and subsequent mass production). In addition, Kiesler presented Schwitters's text alongside expressionist "speak artist" Rudolf Blumner's essay on "Die

Sprechkunst" and futurist Luigi Russolo's study on spectator acclimatization to modern irritability—"The Art of Noise." These essays conjoined to form a modern cultural discussion on formal production, theater, art, and language.

Several other texts were included in the catalog. Léger wrote on the impact of light, color, and film on theater. Walden analyzed the public's interest in viewing famous actors in the theater rather than greater artistic expression. Architect Hans Fritz wrote on pliant boundless stage interaction achieved through mathematical, systematic cubic arrangements. William Wauer presented the dramatic art of human expression in his article "The Actors." Additionally, Wilhelm Treichlinger and Fritz Rosenbaum included an essay that featured a minimal stage design with actors creating space through their own rhythmic motions. These essays described modern theater and its attempt to choreograph human interaction. Modern theater provided extensive opportunity for artistic expression using color, light, sound, and rhythm, enhancing the visual effects of a series of orchestrated human actions in which actors moved habitually on stage in controlled response to surrounding perceptions of their environment.

In the catalog, Kiesler emphasized texts chosen predominantly by expressionists and futurists that were highly critical in their analysis of theater, which he presented alongside his own stage designs for the *R.U.R.* and a collage image of his *Emperor Jones* stage sets. Kiesler featured his design for *Emperor Jones* as a series of animated still images formatted similarly to Richter's animation films published in *G*, no. 1. Emphasizing his stage designs as a series of rhythmic unfolding constructions contracting and expanding in space and time, the collage was Kiesler's first attempt to describe architectural space using animation techniques. Comparing his stage design to Richter's study, Kiesler suggested that by moving walls, floors, and ceilings to the spatial rhythms of actors on stage one might create endless illusory cinematographic effects similar to those of an animation, scroll, or film. These architectural spaces—not altogether differently than Mies's building plans—might thereby be able to produce a universalizing visual language that constituted a spatiotemporal melody, a spatial film.

Following these still images of his own stage designs and Schwitters's expressionist tale of the *Merzbühne*, the catalog featured an additional cinematographic study by Léger—his *Ballet mécanique*. Léger's animation film (presented first by Kiesler at the 1924 Vienna exhibition) epitomized ideas wrestled with by many modern authors and artists. Providing a series of rhythmic

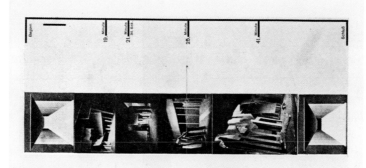

RHYTHM

THE RHYTHM of a work is equal to the idea of the whole. Rhythm is the thing that informs ideas, that which runs through the whole: sense—principle, from which each individual work first gets its meaning. Rhythm is not definite, regular succession in time or space, but the unity binding all parts into a whole.

The emotional world, as well as the intellectual, has laws governing its expression.—It is much more the inner, nature-force which directly forms and animates ideas, through which we are bound up with the elemental nature-forces.

Just as the path of the intellectual formulating-power leads to thought, as a justifying moment of intellectual activity, so the emotional formulating-power leads to rhythm as the essence of emotional expression. Just as thought gives the value to an abstract work so rhythm gives a meaning to forms. Abstract activity for its own sake is the same as formal games for their own sake, they can be ingenious or subtle, but in any case they are futile, so long as they do not follow, to the letter, the whole determining impulse.

Rhythm expresses something different from thought. The meaning of both is incommensurable. Rhythm can not be explained completely by thought nor can thought be put in terms of rhythm, or converted or reproduced. They both find their connection and identity in common and universal human life, the life principle, from which they spring and upon which they build further. The analysis of a rhythm can thus only be undertaken quite generally and comparatively, so long as it does not deal with material construction, with the discipline of building.

HANS RICHTER

Figure 1.16 Friedrich Kiesler, *Emperor Jones* stage set, collage, 1924. From Hans Richter, "Rhythm," in the special issue of the *Little Review* on the International Theater Exposition, Winter 1926. Courtesy of the California Institute of the Arts Library.

images set to three temporal strategies—speeds—the film created flat moving surfaces of varied fragments of bodies and machines devoid of perspective that persisted to intensities too distracting for the spectators' eye and interest. The speed oscillated from slow to fast to slow motion, with tension increasing with speed. Innovative spatial contiguities emerged from the series of fixed still images, subject to incessant rhythmic projection. Automatic arithmetical projection—6 images a second for 30 seconds, 3 images a second for 20 seconds, 10 images a second for 15 seconds—endlessly repeated to generate continuously evolving spatial juxtapositions of innovative imaginative forms.

The Vienna theater exhibition readily explored ideas of the body fused with mechanical rhythm that might be exploited to create a new theatrical performance space. The new industrialized human condition, as the catalog and exhibition repeatedly proposed, implored theaters to have an equally provocative and innovative spatial organization. Revolutionary theater appropriate to the political and industrial challenges of the early twentieth century, Kiesler believed, demanded a new spatial resolve.

The *Raumbühne*

Kiesler's essay "Debacle des Theaters," published in the catalog of the 1924 theater exhibition, defined the laws that he argued could achieve the tension, rhythm, and interplay necessary for the new modern theater. Not limited to perspective views or frontal effects created by the optically rigid proscenium theater, "the new spirit bursts the stage, resolving it into space to meet the demands of the action. It invents the Space Stage [*Raumbühne*], which is not merely a priori space, but also appears as space."[47] Action set before an illusionary backdrop would no longer define theater. Instead, change of position and posture between actors and spectators in correlation with a total environment of speed and motion would create the spatial and plastic tension of modern times. Speech and action would be organic and evolve with the scenery in vital composition with histrionic intensity. For Kiesler, motion was the only space element that could make a composition vital, and he provided the mathematical proof for his scheme.

Here, if perhaps a bit speciously, using calculus Kiesler formatively described the spatial integration of movement in theater: the ideal stage construction

consisted of a sphere, divided by cubic space of three dimensions, plus color divided by animate and inanimate material plus light and sound, multiplied by the differential of motion over time, integrated over the upper and lower limits of color, light, sound, and material. Color, light, sound, and material (both animate and inanimate) could continuously change over time relative to motion within a spherical *Raumbühne* of cubic (volumetric) proportions.[48]

Kiesler proposed two calculable solutions to achieve the *Raumbühne* in 1924. The "*G.-K.-Bühne*" was the modern "Peep Show" stage that was similar to Kiesler's *Emperor Jones* stage design. On the modern Peep Show stage, the ceiling, walls, and floor of the picture stage could be inclined to create what Kiesler described as a "four-sided funnel" perspective that opened toward the audience. The picture stage was no longer a flat background, but a space without decoration or backdrop. The Peep Show stage supported a spherical performance space dependent not on painted scenery but on the play itself, with all its sound, structure, objects, stage mechanisms, and light. The performance would be orchestral and move continuously, if not endlessly, without interruption.

Kiesler constructed another solution to the *Raumbühne*, his full-scale Space Stage, at the Vienna exhibition. Kiesler conceived the *Raumbühne* or Space Stage as a spiral ramp circulating around a central platform that gave structure for dynamic events to unfold. Actors moved up and down the ramp in syncopated rhythm. The Space Stage served to merge actors and spectators on a spiral ramp and circular stage almost automatically in continuous flow. As presented in the exhibition's Concert House and used for several theater and lecture events, the Space Stage constructed of steel and wood provided a platform to engage theater-in-the-round. Kiesler built the Space Stage with seating surrounding three sides, as the existing Concert House stage remained on the fourth side. Ideally, there would be seating all around.

Kiesler's Space Stage structure performed similarly to other constructivist designs. Art and theater historians Lisa Phillips, Barbara Lesák, and R. L. Held have all concurred that Kiesler's Space Stage appeared similar to Vladimir Tatlin's *Monument to the Third International* of 1920.[49] Kiesler's *Raumbühne* and Tatlin's tower incorporated the dynamic movement, mechanization, and mass culture of the times, spiraling out to engage lively atmospheric events. Celebrating constructivism, Kiesler devoted nine pages at the conclusion of his 1924 theater exhibition catalog to Miller's essay on "Die neue russische Bühne." This article

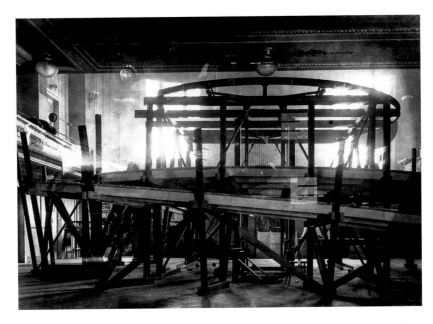

(9) Summing up, one can express the law of construction in the peep-show stage with the formula:

$$C = \text{Stage} \quad + \text{Elements} \quad \times \text{Motion}$$
$$\vee \qquad\qquad \vee$$
$$C = \frac{G}{ZH \times EW \times NS} + \int_{e}^{u}\left(\frac{F}{M_i^a} + L + R\right) \times \frac{dB}{DT}$$

C = construction
G = sphere
ZN = direction: stage zenith—stage nadir
EW = direction: stage east—stage west
NS = direction: stage north—stage south
} u = integral between upper and lower limits (in the strength of
{ e = color, light, sound, material)
F = color
M_i^a = material (animate, inanimate)
L = light
R = sound
dB = differential of motion
dT = differential of time

Figure 1.17 Friedrich Kiesler, Space Stage, Vienna, 1924. © 2017 Austrian Frederick and Lillian Kiesler Private Foundation, Vienna.

Figure 1.18 Friedrich Kiesler, mathematical equation for stage construction, 1924. From Friedrich Kiesler, "Debacle of the Modern Theater," in Friedrich Kiesler and Jane Heap, eds., *Exhibition Catalogue of International Theater Exposition*, 1926. Courtesy of the Getty Research Institute, Los Angeles (88-B11031).

featured images of stage sets by Vesnin and Meyerhold including *The Man Who Was Thursday* and *The Magnanimous Cuckold*. In addition, Kiesler included models of Vesnin and Meyerhold's stage designs in the Vienna exhibition.

Prior to Kiesler's invention of the *Raumbühne*, by 1922 Meyerhold had already created fluid action onstage using complicated freestanding devices. Meyerhold and constructivist artist Liubov Popova had removed the walls onstage and substituted stairs, doors, and landings to provide space for practical performances. Actors continuously circulated in rhythmic succession about lattice frame structures of rotating wheels and moving devices, and stage elements that could move about as needed in response to changing requirements of the play. Actors dialectically engaged mechanical equipment as their bodies tilted, moved, and turned in response to repositionable stage machinery.

Meyerhold trained his actors to move habitually, autonomically, with precision and agility, and his theater of biomechanics featured in *The Magnanimous Cuckold* revealed an art to the sculpting and training of bodily forms that responded to industrialization, mass labor, and political control. Meyerhold appealed to an automatist sensibility of working and living in a daily world of revolutionary machine technology. Automation embodied the contemporary struggle of modern culture, as people had to learn to adapt to an evolving mechanized world. As Karl Marx and Walter Benjamin have suggested, bodies gear their movements with fluid motion to their technological surroundings, and in the face of industry the body naturally becomes an automaton.[50]

Seeking a path to popular theater, Meyerhold engaged the automatisms of everyday life. He popularized Frederick Winslow Taylor's temporal strategies to analyze and control the body in motion, and dramatized Taylorism in an art of efficient rhythm and tempo. Actors moving in continuity of habit with their evolving environment inspired and trained spectators to the new rhythms of modern industry and the promise of collective power.

Kiesler's *Raumbühne* employed similar constructivist devices to incite mass audience participation. The spiral ramp was open on all sides and coiled systematically within the space of the audience, automatically engaging bodily movement in spherical motion. The circular platform opened to all vantage points, and provided flat space for the actors to establish rhythm and free play. Their movements performed the illusion of a spherical space similar to Gert Cadens's design for the "Excentrik Operpoid" featured alongside Kiesler's

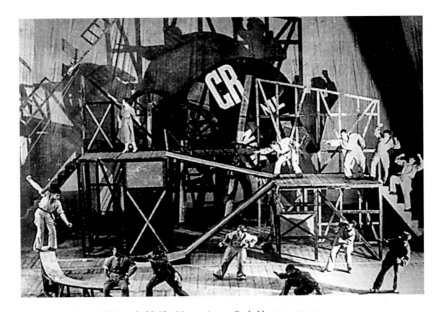

Figure 1.19 Vsevolod Meyerhold, *The Magnanimous Cuckold*, stage set, 1920.

"Debacles des Theaters" essay in the Vienna exhibition catalog. Caden's design incorporated a spherical theatrical performance area in elliptical perspective, with spiral scaffolding central to its structure.

Spiraling movement for constructivist performances suggested a spherical or elliptical field for theatrical action. Used for several exemplary theater productions at the exhibition, the Space Stage arguably demonstrated the first constructivist device set free of the traditional stage within a theatrical context. Surrounded at times with white curtains for projecting images during staged events, the *Raumbühne* engaged innovative modern media. While it provided a rich framework for unique performances and boasted an innovative design, it received dramatically mixed reviews.

Plagiarism

Prior to the opening of the exhibition, a debate had begun in the newspapers over the originality of Kiesler's *Raumbühne*. During opening events at the festival, well-known psychiatrist and theorist Dr. Jacob Levi Moreno accused Kiesler of plagiarism. "I announce, in public, Mr. Friedrich Kiesler is a plagiarist and a scoundrel," Moreno exclaimed.[51] Moreno argued that he had invented the first theater-in-the-round for modern stage performance and that Kiesler had stolen his idea. With Moreno fervently contesting Kiesler's full-scale Space Stage at the festival, the police arrived and arrested Moreno for creating a disturbance. But the incensed psychiatrist continued to confront Kiesler in the newspapers for several weeks. Numerous articles and cartoon characterizations at the time debated the accusations in the press.[52]

The controversy between Kiesler and Moreno focused on a comparison between Dr. Moreno's *Stegreiftheater* and Kiesler's *Raumbühne*. Moreno lectured on the psychology of children's theater in Vienna at the time, as he was interested in the tactics of telling stories to large groups of children, and relished being at the center of many concentric circles of young people. He taught children to join in "spontaneously" and to add to his stories as they developed. Moreno took this didactic storytelling strategy as the basis for his contribution to modern stage design and had architect Rudolf Hönigsfeld illustrate his vision for a *Theater ohne Zuschauer—das Stegreiftheater* in 1923. Hönigsfeld's

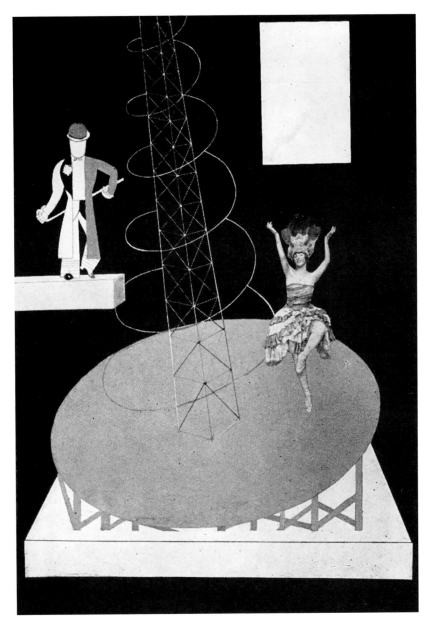

Figure 1.20 Gert Caden, "Excentrik Operpoid." Drawing. From the catalog of the "Internationale Ausstellung neuer Theatertechnik," Vienna, 1924. Courtesy of the Getty Research Institute, Los Angeles (88-B5731).

Actorless Stages and Endless Theaters

oder: A so a Hetz war no net da.

Figure 1.21 Ladislaus Tuszynzky, *Die Raumbühne*, 1924. Cartoon. Courtesy of the Austrian Frederick and Lillian Kiesler Private Foundation Archive, Vienna.

"Theater without Spectators—the Theater of Spontaneity" featured a circular stage circumscribed by concentric rows of seating. The newspapers published the illustration in 1923. In addition, Moreno included the illustration with his studies on the psychology of theater in his book *Das Stegreiftheater* printed in January 1924, with a revised version in 1947.[53]

Kiesler knew Moreno's design well. He had attended Moreno's lectures on the "Theater of Spontaneity" in Vienna, and published Hönigsfeld's illustration of Moreno's theater in his 1924 "New Theater Technique" catalog. Kiesler also exhibited Hönigsfeld's illustration of the *Stegreiftheater* at the festival; but although interested in Moreno's work, Kiesler denied being a plagiarist. To clear his name, Kiesler filed suit against Moreno. Kiesler received strong public support from Josef Hoffmann, Fritz, Léger, Prampolini, Karl Martin, Albrecht Blum, and Oscar Fontana—all of whom confirmed the originality of Kiesler's work at the trial.[54]

Kiesler's *Raumbühne* and Moreno's Theater of Spontaneity, if formally similar, performed radically differently—culturally, politically, and spatially. Kiesler's theater, although centralized, maintained a spiral ramp that extended out into the space of the audience. Movement flowed in multiple directions, and the implied differences among the spaces of the theater—the seating area, the orchestra pit, and stage—were varied. Moreno instead had created a centralized theater with clear hierarchy, where the seated areas radiated out symmetrically under a domed roof. Kiesler's stage created continuity and inclusivity, and attempted to break down hierarchy and social structure between actors and spectators in mass assembly. Moreno's stage, on the other hand, created a controlled pedagogical environment for children to participate within an established hierarchical social system. What the two theaters had in common was a central stage, and the intention to produce spontaneous communication among participants within a spherical spatial condition.

Moreno's claim that he rather than Kiesler designed the first theater-in-the-round for the modern play missed the relevant contributions both he and Kiesler made to theater design at the time. Kiesler and Moreno were among many stage designers, artists, and architects contributing to the meaningful elaboration of spatial ideas relevant to modern theatrical practices (part of a rich history of theater morphology that stretches back to antiquity). Encouraging actor and spectator interaction on and off stage notably developed in the

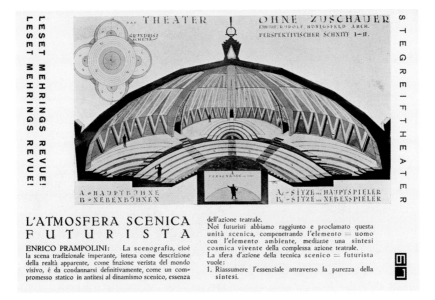

Figure 1.22 Rudolf Hönigsfeld, illustration of J. L. Moreno's *Stegreiftheater*, 1923. From the catalog of the "Internationale Ausstellung neuer Theatertechnik," Vienna, 1924. Courtesy of the Getty Research Institute, Los Angeles (88-B5731).

seventeenth century; more recently, similar spatial ideas had appeared in the work of American theater designer Norman Bel Geddes with his concentric, spiral, and spherical spatial schemes of 1914 and 1923. Bel Geddes in America and Moreno and Kiesler in Vienna were also all equally well informed of the spatial ideas of European theorists Adolphe Appia and Gordon Craig.

Appia and Craig, the fathers of modern theater, were renowned for their dynamic spatial environments. Appia had created stages that relied on platforms, stairs, and simple abstract plastic elements for actors and lighting to actively engage, respond, or resist without relying on painted representational backdrops. To achieve synthesis between time and space without traditional thematic stage scenery, Appia coordinated the rhythms of the living body and dynamic lighting effects to the surrounding scenic atmosphere, while Craig had aimed to do away with actors altogether by allowing costumes if not marionettes to serve, enabling the composer complete control over the entire theatrical event. In his article "L'atmosfera scenica futurista," in Kiesler's 1924 exhibition catalog, Prampolini commended Appia's and Craig's diminishing use of actors: Craig had reduced the actor to a "*spot of color*" an "*object,*" while Appia had established a "hierarchy between *author, actor, and space.*"[55] Appia and Craig had hoped to synthesize the actor, music, and entire stage into one spatial environment that advanced the original intentions of the *Gesamtkunstwerk*, which Prampolini further elaborated to create what he described as polydimensional scenic space.

In accord with Wagner's revolutionary concept of the *Gesamtkunstwerk* for modern opera, Prampolini envisioned unity between vision, sound, time, and space. Wagner had originally conceived the *Gesamtkunstwerk* to unify poetry, art, and music with sonic voice, and similar ambitions were shared by Goethe, Gluck, and Schelling. For Appia and Craig, however, Wagner had failed to incorporate the stage into a *Gesamtkunstwerk* as he maintained the conventional scenographic techniques of the proscenium that marked separation between actor, spectator, stage, image, and intent. Prampolini instead perceived the *Gesamtkunstwerk* in theater with more contemporary and synthetic resolve by elaborating Appia and Craig's interpretation of Wagner's call for "The Art-Work of the Future" to align with the new speed of industry, war, and machines.[56]

Synthetic Theater

Marinetti and Emilio Settinelli were the first Italian futurists to promote a synthetic form of theater, which they proposed in their manifestos "The Variety Theater" in 1913 and "The Futurist Synthetic Theater" in 1915. Incorporating speed, immediacy, and unbroken contact between actors and the crowd, Marinetti and Settinelli argued for a "synthesis of everything that humanity ha[d] … up to now refined in its nerves."[57] Futurist theater would be electric, enriched, and unique—combining technology, arts, and the use of cinema to create incalculable visions and spectacles. Compressed into a few minutes of intensity and action, futurist theater would create indeterminate illusory effects, which Marinetti hoped would produce *"a labyrinth of sensations imprinted on the most exacerbated originality and combined in unpredictable ways."*[58]

Prampolini advanced Marinetti's and Settinelli's call for a futurist theater in his 1915 manifesto "Futurist Scenography." He argued for a "colourless electromechanical architectural structure, enlivened by chromatic emanations from a source of light … in accordance with the spirit of action on stage."[59] Demanding a vibrant environment "letting loose metallic arms and overturning sculptural planes" with diverse quality and exuberant sensations, Prampolini proposed inventing dynamic architectural stages that incorporated modern noises, devices, and colored lighting to heighten the "intensity and vitality of the stage action … in such a way, [that] actors will produce unforeseen dynamic effects."[60] The futurist stage became a modern stage appropriate to the unpredictable dynamism of contemporary life, and as Appia proposed, it used color, light, and rhythm to create intense spatial atmospheres. But unlike Appia, Craig, and Wagner, it conflated man and machine in automatist fantasy. The body was no longer the only living plastic art. The stage became a living organism or machine. Actors and spectators became constructs in a field of new vital technological structures. "Let us create the stage," "Let us reverse the roles," "instead of the illuminated stage," Prampolini suggested, *"let us create the stage that illuminates."*[61]

Prampolini wrote the guidelines for this new stage of illumination in his 1924 essay "The Magnetic Theater and the Futuristic Scenic Atmosphere," of which Kiesler published excerpts in his 1924 Vienna exhibition catalog and a complete English translation in his and Jane Heap's special issue of the *Little*

Review magazine in 1926. Prampolini described a form of theater that incorporated the body within its surrounding environment to create living space:

> [W]e have proclaimed this <u>scenic unity</u> by interpenetrating <u>the human element</u> and the <u>environmental element</u> in a <u>living scenic synthesis</u> of theatrical action. <u>The theater and futuristic art are therefore the consequent projection of the world of the mind, moving rhythmically in scenic space.</u> … [The] "sphere of action in the futuristic scenic technique desires: … SYNTHESIS = PLASTIC = DYNAMIC." … It requires a two-dimensional scenic setting of chromatic elements upon abstract surface, a three-dimensional plastic architecture not of fictitious perspective, but "living plastic reality, a constructive organism.[62]

Prampolini's futurist theories described an organic architectural language in which the body would be coordinated with its environment in spatiotemporal rhythm. This new responsive "panoramic" scenic spatial environment of "centrifugal" action suggested three-dimensional plastic architecture of chromatic surface. Prampolini described a "poly-dimensional and poly-expressive scenic action" that suggested a spherical spatial structure.[63] In a spherical environment theatrical action might be able to engage more fully and freely the living space of everyday life, spiraling out to engage spectators and actors, blurring their distinctions.

Aiming to differ from the constructivist stage, however, Prampolini's futurist theater created innovative "futuristic polydimensional scenic space" through "spheric expansion of plastic planes, moving rhythmically in space."[64] Polydimensional scenic space—unlike modern Russian and German theater that strove to create the perfect technical mechanism using devices that remained on the traditional stage set behind a scenic arc or frame—would be set free of the traditional stage with its flat horizontal and vertical platforms, walls, and frames. Producing simultaneous interpenetration of infinite visual and emotional angles of scenic action, a spherical space of illusory projection surface suggested a multidirectional environment for liberating action.

Within Prampolini's new modern theater, actors now served a new role; they performed as a space-forming component on the stage—as a "dynamic and inter-acting element of expression between the scenic medium and the

public," as Prampolini explained.[65] Synthetic theater connected moving actors, spectators, colored lights, sound, and voice within a continuously dynamic orchestrated performance space. In formal and structural terms, polydimensional futurist scenic space would comprise a new ascending, rotating, and shifting magnetic theater centrally staged that could create spherical expansion using intense projection that fused actor, spectator, scenery, and play within a dynamic illusory atmosphere. It created a four-dimensional setting in which time was introduced as a rhythmic component—a dynamic element necessary to simultaneously unify the environment and the theatrical action. Aiming for an organic architecture that responded to the dynamism of contemporary life, the stage became actorless—a living machine, where architecture reflected the dynamic movements of acting bodies. Architecture came to life as the body became automated, fusing together in dynamic spherical automatist expression.

Rhythm became the fundamental link between people and their environment. In Richter's essay "Rhythm," published in Heap's and Kiesler's 1926 *Little Review* special issue, he described how rhythm can be used to animate plastic form. Rhythm, he proposed, is the life principle of animate form, and "not definite, regular succession in time or space," but rather the "inner nature-force which directly forms and animates ideas."[66] Rhythm implies movement and action typically associated with organic life that synchronizes time with space. Rhythm enlivens the plastic arts—it animates the inanimate body. As animation is an enlivening operation, the art of giving apparent movement to inanimate objects, rhythm constructs space through the *figment* of imagination. Visual effects of pattern and rhythm simulate the appearance of living architecture, what in 1925 Kiesler described as "Vitalbau."[67] For Kiesler, vital building practices incorporated the nature of organic life through the presence of an intrinsic force that motivates action used to shape the growth of outer forms. As a vitalist theater designer, Kiesler believed that live action on stage provided the inner life force to shape his theater designs. His *Emperor Jones* stage set and the Space Stage, for example, coordinated the rhythms of living bodies with dynamic stage scenery to synthesize time with space.

Such ideas dominated European theater in the early 1900s. On the one hand, the stage modulated to bodily action as a living machine; on the other, the body performed to the rhythms of machines effectively as an automaton. Both ideas suggested an extreme form of automatism—one vital, the other mechanical.

∴ ∴ ∴
THE POLYEXPRESSIVE AND MAGNETIC THEATRE
Represents the complete metamorphosis of scenic technique

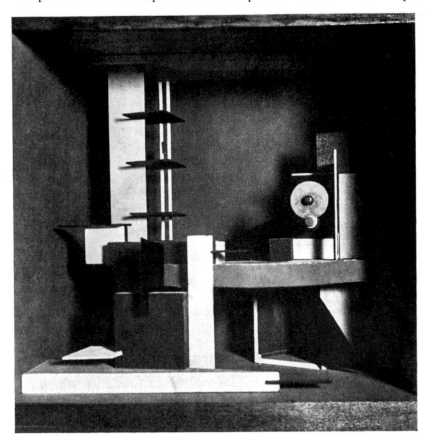

THEATRE MAGNETIQUE
(Scenic-space—polydimensional)

Prampolini, Rome.

Figure 1.23 Enrico Prampolini, *Théâtre magnétique*, Rome/Paris, 1925. From the special issue of the *Little Review* on the International Theater Exposition, Winter 1926. Courtesy of the California Institute of the Arts Library.

"Das Railway-Theater"

Intending to create his own spherical theater similar to Prampolini's vision, Kiesler proposed his initial ideas for what would later become his Endless Theater in his introductory essay "Das Railway-Theater" in the 1924 Vienna exhibition catalog. This short manifesto described the new modern theater as a polydimensional theater of speed where the ground served only as a prop for an open spherical construction. The auditorium would circle in loop shapes with electromotive movements around a spherical stage core. The actor would disappear completely. All scenery would be lost. There would be no proscenium, instead "Milieu-Suggestion schafft die Filmprojecktion. Plastische Formen entstehen aus glasartigem Ballonstoff"; plastic forms created from glassy balloon materials would comprise the space of an atmosphere invoked by film projection—Kiesler's concept for elastic architecture.[68]

The *Raumbühne des Railway-theaters* was thereby a highly theoretical proposition derived through study of a vast network of ideas elaborated by a variety of avant-garde groups presented at the 1924 festival. It synthesized Prampolini's futurist ideas for a Magnetic Theater with Meyerhold's constructivist stage devices, conflating ideas for the Peep Show stage and Kiesler's Space Stage design with the contemporary image of a "Railway." Germans commonly used the English word "Railway" in the 1920s for "rollercoaster," and Kiesler referred to the rollercoaster as the space of a new modern theater—a space that loops around with speed in an endless strip, a Möbius strip.[69] The rollercoaster provided the architectural image for the first Endless proposal, which Kiesler conceived as a series of moving rail cars seamed together along a continuous undulating structure, animated by motion.

Historians such as Held have defined Kiesler's *Raumbühne* as his first Endless design. As Kiesler explained in 1965, the *Raumbühne* was the "Center's double-spiral stage" of his "Endless Theater" project.[70] However, although the German *Bühne* translates as both theater and stage, and *Raum* means both room and space, Kiesler used the term "Endless" specifically to translate *Raumtheater* (as distinguished from *Raumbühne*) into English. When writing about his first job in the United States as an architect working for Harvey Wiley Corbett, Kiesler revealed that he translated *Raumtheater* in English as

"Endless Theater," as distinguished from his *Raumbühne* (the Space Stage)—for he meant there to be a difference.[71]

Kiesler's terminology is very important, because the concepts—*Raumtheater* and *Raumbühne*—were used by Piscator and Gropius in their preliminary studies for the Total Theater in 1927. Defending his original research behind the Endless Theater, notably, Kiesler detailed how he had invited Piscator in 1924 to see the *Raumbühne*, and had made Piscator the plans that the latter purportedly showed to Gropius to inspire the design for the Total Theater. Kiesler additionally claimed to have received a call from the Piscator Theater in 1928 to return to Berlin to sketch an entire *Raumtheater*.[72] Although the accuracy of his account has not been substantiated, we do know from Bauhaus student Franz Ehrlich, who worked with Gropius on the Total Theater, that Piscator did in fact ask Gropius to design a "Raumbühne"—Kiesler's idea—which Gropius then described in 1927 as the "bühnenraums" for his "Raumtheater"—only later referring to it as the Total Theater.[73] The Total Theater of course was originally Moholy-Nagy's vision as published in the Bauhaus Book series in 1924.

Moholy-Nagy's "Theater of Totality" published in *Die Bühne im Bauhaus 4* was extremely significant for Gropius, as for Kiesler and other theater designers in the 1920s. Describing his Endless Theater in 1961, Kiesler inadvertently referred to Moholy-Nagy's influence.[74] Moholy-Nagy had outlined the ideas for a modern theater with its multifarious complexities of light, space, plane, form, motion, sound, and the body, including rotating platforms and bridges of movable construction, and the use of film and nonopaque surfaces to enhance audience participation similar to Kiesler's and Prampolini's proposals. However, unlike Kiesler and Prampolini, Moholoy-Nagy never suggested an innovative spatial form for his theater structure at the time; instead, he referred only to the circus.

The Circus

Working alongside Oskar Schlemmer at the Bauhaus, Moholy-Nagy proposed his Theater of Totality as the human mechanics of the everyday circus, publishing an account in Heap's and Kiesler's 1926 special issue of the *Little Review* as well as in the Bauhaus journals.[75] The circus, as Moholy-Nagy recognized, offered a terrific example—if altogether *Kitsch*—for new theater technique.

The costumes, poses, and makeup used by circus performers and clowns eliminated subjective influences in theater without annihilating the human character needed to invoke mass affection.[76] As Remo Bufano explained in his study on "The Marionette in Theater" in the *Little Review* special issue, Craig's proposal for an actorless theater that hoped to use marionettes or automatons to control theatrical performance was too extreme to influence mass audiences. Audiences simply could not relate to an automaton's complete lack of emotion. Instead, the costume became the device used on stage to best mitigate actor participation and more readily incorporate the human body within the surrounding technological environment. Actors on stage, subdued, dressed as marionettes, could elicit more empathy from an audience than could machines.

Loos presented this same observation in his article on "The Theater," written for Heap's and Kiesler's exhibition catalog and the 1926 *Little Review*. Loos had suggested that the connecting "nerve force" between the participants—"the nervous system of the crowd"—enabled theater to support intellectual creativity resonant with modern times. The modern stage enabled a "succession of nervous impressions as will prepare the ground for the growth of the roots of creative mind." Through light, space, balance, color, and variety in time and sound, similar to architecture, Loos proposed that "the theater [was] … a preparatory school for unborn intellect." The modern stage trained apperception to modern experience and provided interactive engagement. Loos compared the experience of the new mass theater to that of the circus that could affect the crowds "comprising all sorts and conditions of men." "For the circus form," Loos observed, "F. Kiesler has created the 'space-stage' ('*Raumbühne*') which carries in itself the seeds of a revolution in staging methods."[77] Similar to the circus act or athletic event that shocks or astonishes the spectator through extraordinary human feats of prowess, the theatrical stage uses subjective effects—visual and material—to motivate the masses to the new spirit and intellect of modern times.

Kiesler's *Raumbühne*, as Loos argued, revolutionized the space of the stage. Not unlike Loos's *Raumplan*, Kiesler's *Raumbühne* produced an immersive environment in which action could oscillate between varied spatial contiguities. Loos's houses maximized the relationships among space, floor, wall, surface, and opening through a series of integrally compartmentalized spaces. Rooms opened up to rooms that revealed spaces above and below, providing

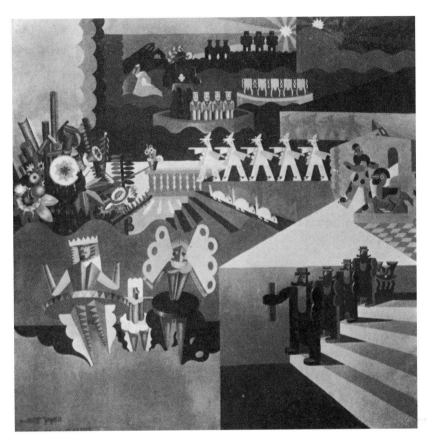

Figure 1.24 Fortunato Depero, *Ballet plastic*, 1918. From the special issue of the *Little Review* on the International Theater Exposition, Winter 1926. Marionettes as automatons replacing actors. Courtesy of the California Institute of the Arts Library.

atmospheres for intimacy and security, movement and free play. Inspired by the "theater box," Loos's *Raumplan* showcased performances of everyday life that might unfold throughout the house.[78] Kiesler's *Raumbühne* served to explode the domestic space of the "theater box" to create diversity, interactivity, and free action on the modern stage. Like the constructivists and futurists, Kiesler aimed to train the masses to this new communal spirit. With elastic synchronicity, and oscillating automatically, Kiesler's theater merged actors and spectators in and about the spiraling action of a new circus theater—the Endless Theater stage.

As Loos, Moholy-Nagy, Kiesler, Meyerhold, and Prampolini all effectively agreed, early twentieth-century theater architecture aimed to train mass audiences through what Moholy-Nagy described as "psychophysical assimilation" to the speed, quality, and intensity of the modern age.[79] They investigated visual and haptic techniques to influence and control their audience's movements, emotions, and perceptions. In the theater, one could study a wide range of modern tactics of mass persuasion and mass manipulation.

These desired effects were studied not only by stage designers but also, very importantly, by architects. Architects sought to expand methods to achieve control over their audiences or users within an orchestrated theatrical event space. Extending those ideas beyond the confines of the stage, they learned to create a *Gesamtkunstwerk*—a total work of art of effects—within the everyday life of the city dweller. Theater served as the locus for artistic and architectural experimentation relevant to real-world experience that initiated a new form of modern environmentalism—the study of humanity and technology correlated to the staged, built, and/or urban environment.

The stage provided the training ground to work out or work through fears and fantasies of automatist conditions, and to invent more provocative spatial solutions to mitigate the very complex sociopolitical forces acting upon everyday human habits and actions among a new world of machines. Theater provided a forum for modern architects to invent new structures geared to a world of modern industry and technological power. The Endless Theater proved one among several similar projects that aimed to enhance new forms of participatory freedom within an environment often characterized by the desire for complete authorial control.

Figure 2.1 Frederick Kiesler, concept of "expansion." Saks Fifth Avenue show window, New York, 1929. Photograph by Karl John Worsinger. From Frederick Kiesler, *Contemporary Art Applied to the Store and Its Display*, 1930.

2 Habits and Tactics: The Automatisms of Display

Your eyes, lit up like shop windows
And trees illuminated for public celebrations,
With insolence make use of borrowed power.
—*Charles Baudelaire*

Walter Benjamin and Siegfried Kracauer did not view distraction as a limitation to social awareness. For both men, it held great promise for training, illuminating, and mobilizing the masses. As indicated in their writings of the 1920s and 1930s, film was understood as the newest medium of distraction; Benjamin would suggest utilizing a "*physical shock effect*" produced through constant moving images to "induce heightened attention" (*Geistesgegenwart*).[1] Distraction, however, was not unique to film—the Dadaists and Surrealists also implemented physical shock effects to induce a heightened presence of mind to promote social awareness through the fine and graphic arts. Moreover, as Benjamin provocatively argued, "architecture has always offered the prototype of an artwork that is received in a state of distraction," for a building is "received in a twofold manner: by use and by perception. Or better, tactilely and optically"; it is experienced for the most part "spontaneously" through "casual noticing" in a state of *habitual* activity that does not require concentrated attention.[2] In a state of distraction, habits of action in response to the built environment become *autonomic*, supporting for Benjamin the promise of a "covert"

"training ground" for "profound changes in apperception."[3] Architecture, film, and other arts, theoretically, can be formulated to create *unconscious* habitual affects that motivate the masses through distractive *conscious* stimulation in the visual and tactile realm. This formulation would provide humanity, in Benjamin's words, not only "an adaptation to the dangers threatening it"—"the increased threat to life that faces people today"—but the potential for collective revolutionary transformation.[4]

Exploring distractive techniques, perhaps similarly to Benjamin and Kracauer, during the 1920s and 1930s in his urban architecture, Kiesler arguably designed covert training grounds for adaptation by promoting autonomic states of habitual action. Most specifically, credited with bringing the applied arts (*Kunstgewerbe*) to American shop window displays, Kiesler made a curious effort to develop the synesthetic potential of the optical and the tactile realms for mass consumer manipulation. Using design techniques developed from the modern arts and theater, Kiesler sought to promote enigmatic *physical shock effects*—material effects—through the optical techniques of distraction in an effort to lure consumers toward the *intérieur* of a store. He developed these techniques of mass manipulation to enhance the art of persuasive storefront architecture, notably in contradistinction to Baudelaire's surrealist fantasy of inciting collective revolutionary action. Unlike members of the avant-garde, Kiesler did not aspire to disrupt the flow of capitalist expansion and overthrow the dominance of the bourgeoisie. Kiesler's work instead marked an astute utilization of the changes in perception and technology that were responding to a shift in the auratic power structures in the everyday life of the twentieth-century city dweller. His urban designs disclose the complicity of modern art in consumerism surrounding the politics of authority in mass culture.

Shopping

Before immigrating to the United States in 1926, Kiesler had a promising career that positioned him among the leaders of De Stijl and constructivism as a theater designer and visionary young architect. Working with the members of *De Stijl* and *G* magazines, he published an urban manifesto, the "Manifesto of Tensionism," in which he gave an interpretation of the modern city accompanied

Figure 2.2 Frederick Kiesler, spiral department store
design, Paris, 1925. © 2017 Austrian Frederick and Lillian
Kiesler Private Foundation, Vienna.

by a section for a spiral department store tower that proposed the programmatic promise of shopping. Developed from ideas already presented in his Space Stage and Endless Theater projects, Kiesler's department store presented continuity in tension "in free space" with the "abolition of the static axis."[5] Where the Endless Theater situated the audience and actors together in continual movement on a double spiral stage, the department store tower promoted the "free equal distribution of traffic" which Kiesler believed would combine product and consumer, in a spiral environment in which "shoppers will often walk down several floors without realizing it because of the slightness of the incline."[6] Moving through the department store unencumbered by structure and mechanical systems from floor to floor, shoppers casually—almost automatically—would be able to lose their sense of time and place among commodities as "the store becomes practically one continuous main floor," connected to other buildings and incorporated into the urban fabric in endless continuity.[7]

As Kiesler proclaimed in his manifesto, the department store tower, like our future cities, "will have NO MORE WALLS," as "glass encases the entire structure."[8] The building would be open to the surrounding city and joined to other buildings at every third floor. Kiesler was promoting what he described at the time as an organic building typology: "we must have organic building … functional architecture; ELASTICITY OF BUILDING ADEQUATE TO THE ELASTICITY OF LIVING. … The new city will bring with it the solution of the problems of traffic and hygiene; make possible the diversity of private life and freedom of the masses."[9] The spiral plan encased in a glass tower Kiesler saw as, similar to Erich Mendelsohn's 1926 Schocken department store's entry circulation stair, advancing dynamic continuity through the promise of a new tectonic. Kiesler believed uninterrupted elastic architecture expressing dynamic spiral motion could "carry … out the tenets of 'tensionism' in city planning," able to create "new kinds of living, and through them, the demands which will remould society."[10] Shopping in the modern tower he believed could reconstitute urban life.

His proposed retail building would contain the open structure of the Eiffel Tower and the dynamism and communal intent of the Tatlin tower.[11] Similarly to the Russian constructivists, Kiesler aimed for a festive dynamic atmosphere of unity through street theater for the masses. Benjamin equally referred to this popular intent of constructivism in his 1925 essay on exploring the streets

Figure 2.3 Erich Mendelsohn, Schocken Department Store, Suttgart, 1926.

Figure 2.4 Vladimir Tatlin, Russian constructivist Monument to the Third International tower, 1919–1920.

of Naples. Kiesler was among a group of theorists and architects promoting what Benjamin described as buildings "used as a popular stage" where "shops … are the reference points" and "everything joyful is mobile" and "circulate[s] through the street."[12] Benjamin fantasized that as "building and action interpenetrate in the courtyards, arcades and stairways, in everything they preserve the scope to become a theater of new, unforeseen constellations."[13] For Benjamin, through architectural porosity transparency would be achieved in people's everyday lives, with "the stamp of the definitive" being avoided: "No situation appear[ing] intended forever … [;] no figure assert[ing] it 'thus or not otherwise.' This is how architecture, the most binding part of the communal rhythm, comes into being."[14] Permanence and authority were theoretically undermined by the everyday theater, which Benjamin described as "porous" open architecture.[15] The popular stage symbolized a new "communal rhythm" that could be achieved through habitual action, as promised by Tatlin in Russia, Benjamin in Naples, and Kiesler in Paris with his monument to shopping.

Display

Upon moving to America, Kiesler struggled to establish his career in the arts and architecture—his avant-garde interests in theater were not readily accepted, nor were most of his remarkable architectural projects.[16] After designing an experimental theater stage for the Brooklyn Chamber of Commerce, which did not get built, Kiesler fortunately secured the commission to design the storefront displays for Saks Fifth Avenue in New York City from 1928 to 1929. While his show windows aimed to bring art to the masses, Kiesler did not use avant-garde aesthetics in the cause of social revolution. He had been heavily criticized in 1926 at the International Theater Exposition for endorsing popular theater. Instead, he tried to adapt to American life by accepting the demands of its capitalist culture and sought to use avant-garde practices for mass consumer appeal.

As many of his visionary ideas were conceptual as well as practical, he wrote a book, *Contemporary Art Applied to the Store and Its Display*, in 1930, establishing the history and theory of his interests in show window design. In the idealization of mass production through the use of machines, similar to Bauhaus ideology, Kiesler saw an opportunity not only to better his finances by

glamorizing his role as avant-garde designer, but also to suggest a new means to reach mass culture—the art of window design and store front architecture.[17] As he argued, "the department store … was the true introducer of modernism to the public at large. It revealed contemporary art to American commerce," and as "the new art is for the masses … if ever a country has had the chance to create an art for its people, through its people, not through individuals and handicraft, but through machine mass production, that is America today."[18] Kiesler strongly emphasized the potential for a creative use of machine production that could be brought to the public through the everyday commerce of shopping. As he suggested, "unprecedented though it may be in the annals of art, a main channel through which the new style [machine aesthetics] will approach popularization is the store. Here is where a new art can come into closest contact with the stream of the mass, by employing the quickest working faculty: the eye."[19] The store created an opportunity to reach "the stream of the mass" in the streets, and this could most readily be achieved through a conscious effort to rethink window display architecture with the speed and immediacy possible through the mechanics of optical perception and the new art of abstract machine aesthetics.

Unlike practices in Germany, France, and Holland, prior to the late 1920s American shop window displays were usually designed to represent library and parlor rooms, with wood paneling and wax mannequins simulating narrative postures of everyday life; abstract machine aesthetics were only slowly introduced to the mass culture of the time. Although there had certainly been festive "eye-catching" holiday windows, as Leonard S. Marcus discusses in *The American Store Window*, clutter was the main effort of American window display, and lighting tended to be diffused with little attempt to keep pace with modernity. In 1919, Raymond Loewy, who had emigrated from France, was one of the first to attempt to challenge American shop window tradition in his Macy's show windows, using what Marcus described as a display whose "contrast meant to shock."[20] Leaving the window in semidarkness with three spotlights focused on only one mannequin in a black evening gown, Loewy hoped to strike the attention of passersby; but the simplicity and intensity of gesture were too strong for the time, upsetting his boss and forcing his resignation.

Kiesler and Bel Geddes by the late 1920s took on a similar challenge, both claiming to be the first to bring abstract art to the store window display. In fact,

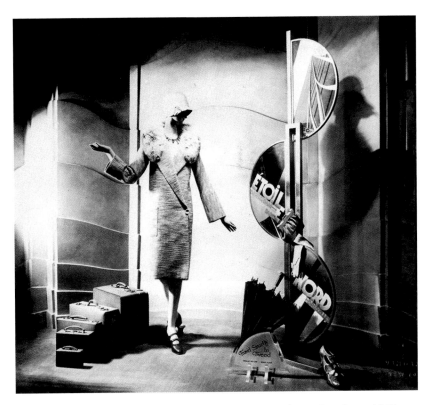

Figure 2.5 Norman Bel Geddes, display for Franklin-Simon, New York, 1929. From Leonard S. Marcus, *The American Store Window*, 1978. © The Edith Luytens and Norman Bel Geddes Foundation, Inc.

Display World, the preeminent American trade magazine, had after 1926 consistently featured photographs of European *moderne* store displays inspired by window designs featured at the 1925 Paris Exposition des Arts Décoratifs that toured the United States.[21] Art Deco became the leading fashion in Europe and America by the late 1920s, with its streamlined machine aesthetic that attempted to seam together various artistic and architectural display productions. Bel Geddes proved to be a leader in America for his Art Deco and streamlined machine aesthetic in both window display and industrial design, while Kiesler developed a more hybridized avant-garde modern aesthetic incorporating the influences of Dada, De Stijl, constructivism, and Surrealism in his work.

Kiesler developed a series of techniques for Saks Fifth Avenue in an effort to draw attention to the merchandise and lure passersby into the store with greater ease. He designed the entire series of windows comprising the corner and 49th Street side of the store—fourteen windows in total—utilizing his experience in theater stage design to promote sales. As he suggested, "the revolution in the theatrical arts … developed into 'Constructivism' in Russia and Austria [and] it is in its manifestation that we must seek the models for show window decoration today. Looking through the glass into the show window is really like looking at the stage with this difference: the actors in art terms, are speaking plastics in motion, whereas the merchandise is a silent static object."[22] In claiming that innovation in theater developed into constructivism, Kiesler made the clear observation that window display was similar to stage design except that silent inanimate objects separated from the viewer through glass have been substituted for the animate actors. Unlike the traditional open market halls where "commerce was free, more intimate … one could touch and handle what one proposed to buy," merchandise had now been "sealed off" in stores, needing the voice of "show windows, institutional propaganda and advertising. What was perfectly natural in the market halls must now be built up artificially by means of … media."[23] As Kiesler understood, show windows are multidimensional stage sets situated on the street; their effect on consumers is generated through the decisive gesture instituted by "a plate of glass between the merchandise and the passer by" that separates inanimate commodities from animate consumers.[24]

The use of large expanses of plate glass for storefronts was well established in the United States by the 1880s. It marked a provocative relationship between interior and exterior, and established a shift from the tactile and aural immediacy available at the open market to the persuasive optical tactics utilized in storefront architecture. As Kiesler argued, "contact between the street and store, between passerby and merchandise, this is the function of show windows," and "after the passerby has halted, the silent window has a duty: to talk. To demonstrate. To explain. In short: to sell."[25] The window marks a threshold between the street and the merchandise and becomes the medium through which one must pass in order to engage objects of desire.

"What makes people purchase?" asks Kiesler. "Real and artificially stimulated needs," he responds, as "usually artificial needs become genuine needs. *Habit* asserts itself and makes them *vital*."[26] Show windows employed to manufacture needs through visual sensations elicit a habitual—tactile—response in the consumer, who enters the store to indulge the comforts and pleasures experienced synesthetically before the store window. Enticed without the immediate means to satiate the appetite—the glass not allowing the body to experience the quality of what it believes it sees—the viewer's desire to know the value and character of the merchandise is intensified. Empathizing with the commodity, desiring its value, struck by its aura—manufactured through distance—one is enticed to enter the store to purchase the product, or more precisely its reproduction. Similarly to possessing a photograph—as Benjamin suggested, where the "technique of diminution … helps people to achieve control over works of art"—obtaining a material reproduction which can be readily held, comprehended, framed, or inscribed with personal meaning establishes a sense of identity and empowerment for the consumer.[27]

The show window marks the newest and most vital of means to establish a semblance of identity—one's surface character. As one peers into the shop window through the projection of shadow superimposed on the glass surface, the displayed objects reflect back on the viewer's eyes with narcissistic splendor. The means to effect subjectivity is afforded by the promise of what lies inside—prompted by desire to belong (whether inclusive or exclusive). Identity is presented and sold by the store—an identity, critical theorist Theodor W. Adorno would remark, that is directed toward an average of interchangeability, as everyone is "a copy"—a semblance. Identity is designed for mass appeal, and

the window display becomes the "surface-level expressions," as Kracauer might have suggested, of a "body culture" built to support the ever-changing tastes of an elusive "modern" or "contemporary" culture.[28] They are a pragmatic *ornament* built into the architectural facade, able to adapt to changing needs of capitalist society. Unlike the permanent aged, handcrafted architectural ornament that appealed to Ruskin in his *Seven Lamps of Architecture*, this new dynamic architecture provided a means to articulate an aesthetic of continuous transformation and invention requisite to support consumerism.[29] Capital exchange value generated through the constant flow of new and improved goods underlies the need for flexible shop window designs that can keep pace with competition and the continuous sale of an ever-evolving semblance of "good taste" and "high fashion." Shop windows become a temporal zone situated between desire and consumption that can transform as needed in response to changes in consumer interest. Any attempts to counter existing trends can be readily met through the design of a new window display. As Kiesler well recognized, display managers could quickly absorb radical aesthetic practices into their designs to provide the newest trend for consumer sales.

Show Windows

Accepting the premise that show windows sell merchandise, with a silent voice that suggests, as Kiesler stated, "this way gentleman, Here, only here can you see," he designed his shop windows as a series, in articulate distractive rhythm.[30] The Saks Fifth Avenue windows as originally built were lined up one after the other, surrounding the department store at street level on three sides with a set of doors centered in each facade (effectively a square building with one facade hidden against the adjacent building). The plate glass display openings were set right up against the street—shallow in depth to afford as much interior store space as possible. As Kiesler pointed out, "custom has taught us that show windows lined side by side like the cards of a fortune-teller's pack are the best method of announcing: 'Here is a store, it sells this and this, come in, buy, call again.'"[31] The Saks Fifth Avenue windows, rhythmically lined up, shaped the experience of the passerby, with each display typically taking a suggestive role

in the overall narrative of the display. Suggestibility was no longer provided by the voice of the salesperson or the tactile sensation of the actual material object in an open market; the storefront had developed instead as a response to changes in the urban environment.

As Kiesler suggested, "the evolution of the show window is due to one fact: Speed. For this reason the show window is a modern method of communication."[32] As nineteenth-century industrialization brought changes through mechanization, and urbanity increased its speed of operation and action—the hustle and bustle of the city street—a new means was required to elicit the attention of the crowds of passersby. Rhythmic storefront displays afforded, as Kiesler argued, "the most direct method of contact … we want to be informed about things quickly. Our age is forgetting how to hear and how to listen. We live mainly by the eye. The eye observes, calculates, advises: it is quicker than the ear, more precise and impartial."[33] Although perhaps overly enthusiastic about the impartiality of sight, Kiesler realized that speed was fundamental to the societal and cultural transformations of modern urban life, leading to the need to reevaluate the use and articulation of the urban facade.

Attempting to increase the efficacy of the Saks Fifth Avenue windows in response to changes in urban life, Kiesler made a series of sketch designs that attempted to reconfigure the storefront facade, which he published in his 1930 book on applied art. His most dramatic option was an "experiment in a rhythmic storefront" that used a "series of setbacks at intervals from the building line … exerting a suction-like effect upon the passerby."[34] Effectively he claimed that, through a montage of juxtaposed windows of varying sizes and shapes asymmetrically arranged both in height and depth, moving rhythmically forward into the street and back toward the store, he could pull the passerby toward the storefront entry. At the entry he suggested using a "funnel effect" which sought to merge the entry door into the display window, moving the crowd gradually through the doorway while also providing enough shelter to the interior to keep the door as open as possible to the life of the city.[35] Similarly to the department store designs of Erich Mendelsohn and the display windows of Paul Mahlberg in Germany of the same period, Kiesler wanted the door to effectively disappear, to provide a continuous flow from the street toward the interior of the store.[36] However, he was unable to realize any exterior transformation to the

facade of Saks Fifth Avenue, and sought to develop other persuasive tactics by emphasizing continuity of "flux" and "flow" through theatrical and artistic transformations of the entire bank of existing show windows.

Contraction and Expansion

Utilizing techniques of "contraction," Kiesler sought to alter perception by controlling the eye in front of each individual window. As he suggested, "contraction gives you different depth and different backgrounds in one display," affording the ability to emphasize any particular object by moving or angling the sides, ceiling, or floor levels of the staging to concentrate attention and focus the eye.[37] Using flats, partitions, and platforms of various sizes and dimensions, Kiesler created the illusion of perspective by directing the eye to various points within the window. Although the center might be the typical point on which the eye may be focused in a shop window, Kiesler was adamant about the benefits of using asymmetric designs. As he argued, "because of the asymmetry which characterizes practically every modern creation in the arts, focusing the gaze of the spectator on the mathematical center of the window is wrong. It does not matter which part of the window the merchandise is shown provided that the whole scheme of the display has been consciously integrated. … Asymmetry is dynamic."[38] Conscious articulation of the gaze through asymmetry supports dynamic action, while "a symmetric scheme is static."[39] For, as he put it, "the rhythm which results from asymmetry is mobile and kinetic. Therefore, if rightly composed, it directs the eye straight to the point to which you wish it directed. In this case it would be to your merchandise."[40] Contraction was the means to focus conscious perception upon different objects within the display, and through the addition of an asymmetrical composition Kiesler directed the eye from one image to the next—moving the eye—within each window frame.

With the eye set in motion through techniques of contraction, Kiesler then sought to use expansion to establish rhythm and continuity of action between successive window frames. As he suggested, "in the Saks Fifth Avenue windows I simply took out all the side walls which separated the fourteen windows and created a free rhythmic background throughout the entire window space.

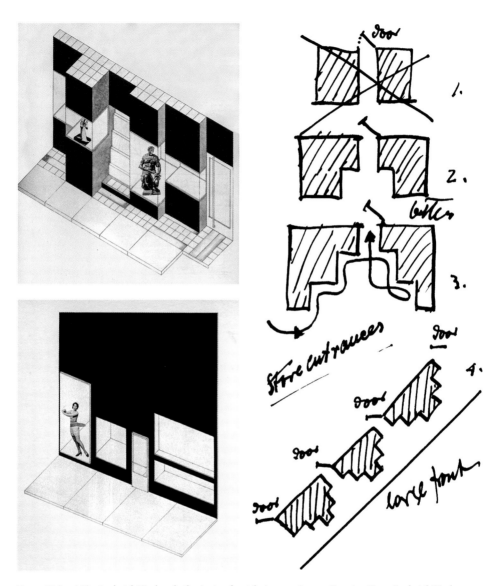

Figure 2.6 (top left) Frederick Kiesler, rhythmic storefront designs, 1928–1929. Drawing. From Frederick Kiesler, *Contemporary Art Applied to the Store and Its Display*, 1930.

Figure 2.7 (bottom left) Frederick Kiesler, asymmetric show window design, 1928–1929. Drawing. From Frederick Kiesler, *Contemporary Art Applied to the Store and Its Display*, 1930.

Figure 2.8 (right) Frederick Kiesler, funnel effect, 1928–1929. Sketch. From Frederick Kiesler, *Contemporary Art Applied to the Store and Its Display*, 1930.

Habits and Tactics: The Automatisms of Display

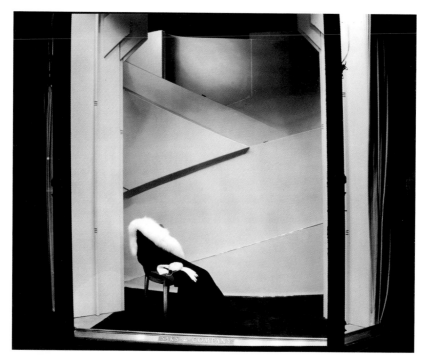

Figure 2.9 Frederick Kiesler, concept of "contraction": Saks Fifth Avenue show windows, New York, 1929. Photograph by Karl John Worsinger. From Frederick Kiesler, *Contemporary Art Applied to the Store and Its Display*, 1930. Courtesy of the Austrian Frederick and Lillian Kiesler Private Foundation, Vienna.

Each window seemed to continue into the next. Expansion was the basis of the rhythmic effect and continuity."[41] Seamed together in continuous progression from one window to the next, the effect created through contraction and expansion—within and between window frames—produced a spatial rhythm similar to Richter and Eggeling's early scrolls and animation films. As in the scroll, a continuous design of images was situated in a dynamic asymmetrical pattern where tension was produced *unconsciously* in the continuous back-and-forth movement of the eye, with the "accumulated energy" being released, as Richter might describe it, "into actual movement."[42] The continuous background undulating dynamically provided unification and rhythm by use of memory from one window to the next, which enticed the eye and in effect the body to move automatically along the street facade. Haptic sensation produced at intervals from the effect of the moving eye between striking images gave one the tactile impression of the dynamic action of the display in the process of becoming an ensemble in duration (*dureé*). As a series of contracted frames, each window focused *conscious* attention with dynamic expression of asymmetrical action, directing the eye among the merchandise within the display by creating a constant state of distraction. In effect, this perception was similar to a series of photographs spliced together in continuous articulation, immobilizing time with "fixed" moments of consciousness, as Bergson might have described it, while our memory "solidifies into sensible qualities the continuous flow of things."[43] Effectively the Saks Fifth Avenue designs performed as a series of picture frames—movie frames—seamed together in continuous articulation set to motion by the speed of the passersby.

Kiesler also paid specific attention to what Richter described in his own work as the "contrast and analogy" between materials and colors. Kiesler's visual effects created a cohesive illusory filmic quality. As one journalist at the time described,

> accordingly, lines and angles, wood and metal and glass are conspicuous in the reconstructed Saks display stages. Shallowness is a characteristic common to all the rebuilt windows. Similarly, a grayish-white wood has been employed for the background of each. This wood, cut into angles and curves, has been so set up that it creates the illusion, despite the actual physical shallowness, of a considerable depth to the

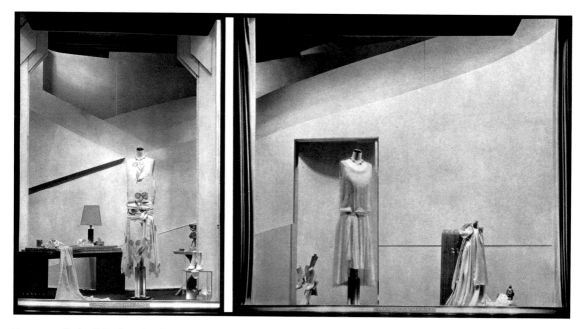

Figure 2.10 Frederick Kiesler, Saks Fifth Avenue show windows, New York, 1928–1929. Photograph by Karl John Worsinger. From *Architectural Record*, September 1930.

windows. ... Here a suggestion of a cylinder, there a glint of brass or the sparkle of a mirror, and again the dull reflection of iron are expressive of the industrial age. The novelty of the background, however, instead of detracting from the merchandise, actually throws it into greater relief, the very shallowness of the window seeming to push it further forward.[44]

The background of gray undulating wood (actually Vehisote) with angles that accent varying objects in the display provided not only movement and continuity between windows, but helped provide an illusion of spatial depth. The store display effectively moved perception of figure-ground relationships back and forth in relief. Kiesler referred specifically to Léger's textiles and paintings as the inspiration for these visual effects: Léger used "shaded modeling of individual parts" in contrast with other "flat" parts in order to stimulate "dynamic" character; "the vigorous juxtaposition of highly modeled forms and purely flat surfaces creates such a basic contrast that by it alone the picture produces a dynamic effect."[45] The undulation of Kiesler's expanded background set against diversely focused individual elements created a rhythm of dynamic action in motion that stimulated the eye to perceive an illusion of greater spatial depth. Also contributing to this effect were the strong color, sparkle, and material juxtapositions used to accentuate each object—catching the eye and sparking attention. As Kiesler described, "one sees only a chair, over which a coat and a pair of gloves have been thrown, displayed against a vast background. The background is of a neutral uniform gray, the coat is black velvet with a white fur collar, the gloves are also white, the cushion of the chair red, the wood of the chair gray."[46] Material and color analogy and contrast became part of the composition of a series of objects that worked in a coordinated effort to manipulate attention and perception. The background did not distract from the objects on display—it moved the eye haptically and the viewer subconsciously among the sparkling objects in continuous articulation.

Kiesler's use of lighting played a significant role in sparking attention and moving the eye from object to object—the body from window to window. As a theater designer he had always promoted the creative use of lighting, claiming to be the first set designer to use projective techniques for his *R.U.R.* sets in 1922. Lighting his window frames made them, in his words, "aura-frames."[47]

Figure 2.11 Fernand Léger, *Nature morte*, Paris, c. 1927. Flat and dynamic contrast. From Frederick Kiesler, *Contemporary Art Applied to the Store and Its Display*, 1930. Courtesy of the Austrian Frederick and Lillian Kiesler Private Foundation, Vienna. © 2017 Artists Rights Society (ARS), New York / ADAGP, Paris.

They could be lit from hidden valances around the perimeter of each individual glazed unit "to create an aura around the entire window"; "aura-frames used in a series of show windows, can result in attractive rhythms of light along the whole building front—the whole psychological value of color can here be utilized."[48] He even noted the potential to "connect an electric clock to the lighting system of the window frame"; "light would flash on and off at determined intervals," turning the window display into an "advertising medium," demanding the attention of the audience and moving them along set to the timed action of flickering images.[49]

Kiesler brought concepts developed in film and theater to the three-dimensional bodily space of the street through his window designs, to stimulate the passerby to approach the store through striking lighting, materials, patterns, and colors. The body synesthetically experienced the space of the windows expanding out into the street and contracting back into the store. Kiesler's window designs dissolved the boundaries of spatial perception and incorporated the viewer into one continuous environment. Like those watching a film on a screen, the audience became absorbed in the window's illusory spatial effects. The surface boundary of the screen as an articulated street facade was designed to dissolve in motion, so passersby would lose sense of time and place. Kiesler moved them in a state of constant distraction toward the interior of the store, coordinating their movements to the shock of haptic sensations induced by flickering images within an expanding spatial field.

Shock Effects

To increase these spatial and lighting effects, Kiesler suggested inducing heightened attention through *shock* as inspired by the Dadaists, within an exhibition of disparate objects juxtaposed in *tension* as explored by the Surrealists. In what Kiesler called a "composite background," he suggested,

> if a still more striking effect is desired, introduce a variety of other materials in combination … metals, sandpaper in brown, black or ochre, corkpaper, enlarged photographs, enlarged typefaces, etc. A further variation … would be to introduce light as a contributing element to

the rhythm or pattern … by cutting openings in your background. … [T]he origin of this type of decoration … comes to us from the most destructive and radical artistic movement in Europe: Dadaism.[50]

Dada techniques—material juxtapositions, lighting, signage, and photomontage—provided a way to intensify the window display's effect on the viewer. In one of his children's window and junior apparel displays for Saks, Kiesler used leather of different colors in abstract patterns, molded aluminum, opaque glass, and a variety of different-shaped display frames with lighting to establish rhythm and definition that focused attention on varied objects. Most curious are the hats displayed as lampshades, the consistent use of headless mannequins, an oddly placed goose, and the subtly enigmatic draping of various fabrics, clothes, and jewelry. Kiesler used these devices, as he wrote, for "Surrealism" with its "naturalism again magical and magnified," exemplified in the "natural illogical way … [it] brings together all kinds of objects" and "orders these things into a logical pictorial harmony. … This is the task of the display manager … to create an atmosphere of tension between several pieces of merchandise exposed within the frame of the show window."[51] Kiesler held up for observation each distinct, oddly placed object by providing space—distance. He used enigmatic juxtapositions of curiously positioned and illogical objects to stimulate a pause—an interval of hesitation—that opened the mind to wonder. Stimulated to attention at a moment of hesitation, the intellect is held open, questioning the lack of resolution. Parrying the initial shock, the conscious mind draws attention to the various shapes, colors, materials, and glimmers of *Schein*. The enigmatic then opens a moment within the state of shock, allowing for the possibility of poetic experience in a state of distracted awareness. Open to suggestion at a moment of unresolved tension, one is enticed to search *critically* among the display windows for further direction and understanding. Enigma opens the mind, eye, and in effect the body to wander among the inanimate objects on display, removed from the hustle and bustle of everyday city life. Lured into a state of semiautonomic *awakening*, the passerby's curiosity is piqued and at the same time guided subconsciously.

Investigations to access the *unconscious* while *conscious* were the effort of the Surrealists, as they developed the tactics of the Dadaists into a discourse of automatism as a state of awakening. The tactics of distraction were intimately

Figure 2.12 Frederick Kiesler, Saks Fifth Avenue junior apparel display, New York, 1929. From Frederick Kiesler, *Contemporary Art Applied to the Store and Its Display*, 1930. Courtesy of the Austrian Frederick and Lillian Kiesler Private Foundation, Vienna.

Figure 2.13 Frederick Kiesler, Saks Fifth Avenue children's window display, New York, 1929. From Frederick Kiesler, *Contemporary Art Applied to the Store and Its Display*, 1930. Courtesy of the Austrian Frederick and Lillian Kiesler Private Foundation, Vienna.

Figure 2.14 André Breton and Marcel Duchamp, *Lazy Hardware*. Window display with painting by Matta, New York, 1945. Photograph by Maya Deren.

linked to that effort, as critically investigated by Benjamin in many of his writings; however, these tactics were not limited to their "revolutionary potential" but instead were available for multiple uses. Of particular concern to Marxist critique is the ease with which people are manipulated to participate in the manufacture, production, and consumption of marketable goods, which promise comfort through the provocative complexities of automatist practices as they mediate the animate and the inanimate (between subject and object). The mass culture of commodity fetishism with its translation of use value into exchange value within a market of exhibition was intimately implicated in the magical diction of an art of distraction. For Benjamin, this required "profane illumination" to demystify aura in an effort to open the "image space" for "bodily collective innervation."[52] As the Surrealists sought to induce in the animate a state of semiautonomic awakening through habitual action (i.e., as if becoming automatons), they sought to covertly mobilize the masses to revolutionary action using the "borrowed power," as Baudelaire suggested, developed by capitalism.[53] Kiesler, however, in his storefront window designs was more an opportunist than an activist, seeking to absorb Surrealist and Dada techniques to further the power of consumerism.

Kiesler employed a full range of artistic, photographic, cinematic, and theatrical techniques to design his window displays as three-dimensional illusionist space. His shop windows were architectural—they engaged the body in motion through perception and habit—optically and tactilely—using applied artistic practices to build form. His technique of contraction served to heighten attention, while expansion sought to join disparate moments of conscious attention into a unified spatial experience. Through montage, Kiesler juxtaposed and superimposed images, objects, and materials with dynamic asymmetrical affect to spark attention and wonder, leading the mind and body to wander— open to suggestion. By creating an image space he was able to manipulate the body space. Kiesler's work points to the remarkable promise to closely examine the practices of art, theater, and film and their relation to architecture not solely in terms of content (what is displayed in the window) but of dynamic haptic technique (how the window creates optic and tactile affects).

Although the content of the display remained important to Kiesler's designs, particularly in terms of material selection, content was certainly less important to him than it was to other show windows of the time. His environments were

descriptive, not entirely informative; they did not define a specific place, but were more interested in dynamic gestures to manipulate perception. His windows didn't present many products that actually could be purchased. Instead, they served as dynamic advertising events that sought to draw attention and engage the curiosity of passersby to move them emotionally and physically. Nor were they necessarily gender-specific. Dynamic and lavish, insistent and yet seemingly casual in appearance, Kiesler's window designs were artistic events that created a sensual auratic atmosphere that promoted casual, almost automatic desire to purchase commodities.

Aura Effects

Kiesler realized there had been a shift in the power structures in the everyday life of the twentieth-century city dweller, and he attempted to theorize a new typology of architecture that could utilize the aura of display within an evolving flow of capital markets. Kiesler was a visionary. His window designs were conceived to move well beyond the limits of nineteenth-century storefronts, eventually incorporating all the technology and mechanics of the electric and electronic world in their design. Seeking to expand the "aura-frames" potential, he argued for the complete removal of all window frames in commercial buildings. He wanted to unify the entire building facade into one continuous unit, believing that if one "omits the window frame completely, the front itself becomes in fact the frame."[54] He envisioned this effect in a series of unbuilt department store projects in the late 1920s and early 1930s, proposing buildings that would be in their entirety "aura-frames"—lit up as if billboards. He envisioned these buildings as the future of urban architecture. Inspired, as he suggested, by J. W. Buijs's use of white opaque and transparent glass for the Cooperatie De Volharding in Holland, Kiesler designed two schemes both featuring a double exterior wall with glass on the exterior and a windowless interior to provide a shallow display case over the entire building surface. Building on Buijs's use of white opaque glass for night-lit signage, Kiesler suggested "transforming the whole space into a single electric sign."[55] He saw the potential to design a building entirely of glass to exhibit a frameless aura through a series of projective and illusory techniques.

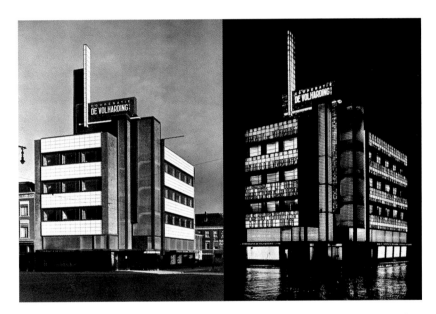

Figure 2.15 J. W. Buijs, De Volharding building, Holland. "A use of opaque glass and transparent glass, letting in a maximum of light from outside the city. By night giving the opposite effect: projecting artificial light into the street. Especially happy is the use of opaque glass for publicity. The lettering attached to the back of the glass appears only at night, transforming the whole space into a single electric sign." From Frederick Kiesler, *Contemporary Art Applied to the Store and Its Display*, 1930.

Figure 2.16 Frederick Kiesler, department store, 1928. Drawing. From Frederick Kiesler, *Contemporary Art Applied to the Store and Its Display*, 1930.

Figure 2.17 Frederick Kiesler, "Project for a department store on Fifth Avenue, 1928. Floors of sheet glass. All walls of the building, both inside and out, are of colored plate glass. Second and third floors are of opaque glass. Floor levels are marked by duraluminum channels. The building has no windows. By means of double walls, which house between them heating, cooling, and ventilating systems, the store remains independent of outside weather conditions and literally manufactures its own climate. The entire front space is used for display purposes. […] The floors are cantilevered. The central verticals indicate the elevators." From Kiesler's *Contemporary Art Applied to the Store and Its Display*, 1930.

Although using a frame traditionally creates an aura, as seen in the static art of painting, Kiesler was well aware of the potential of a frameless building that utilized the entire facade as a billboard for advertising display, alongside a whole series of projective techniques. In particular, he advocated using "sensitized panels which will act as receiving-surfaces for broadcasted pictures." He predicted the use of television as well as movies, "especially talkies, used to work together with them [lightbulbs and floodlights] in the promotion of sales, by advertising and publicity." Kiesler foresaw the use of television "screen-curtains" in store windows "which will suddenly sweep down close to the plate glass ... telling its story to the passerby." He envisioned the electronic space of the store window to be interactive and "retain the view" of a passerby, unlike the mechanized store windows of his time whose moving mannequins could not return one's gaze. To that effect, he suggested inventing a "pushbutton system for the convenience of the passerby, one which would open and close windows at will."[56] Kiesler ultimately hoped to create an electronic image space of projected illusionary atmosphere as a casing around the entire department store that implemented technology to its fullest potential. He even suggested using *virtual* techniques within the interior of the store.

Kiesler sought to match and even intensify the expectations stimulated outside the store when consumers moved inside. Here they would encounter "Fashion news. Daily events. A talking newspaper. Scientific productions. ... Films which show desired merchandise to customers and explain its qualities and merits" as "*sales robots.*"[57] Kiesler was not limited by nostalgia for the *flânerie* of nineteenth-century street life. Nor was he concerned that modern technology would, as Benjamin described, promote the decay of the *intérieur*—the end of *flânerie*—whose last bastion may have been the department store where external pedestrian street life was internalized as a "labyrinth of commodities" in which one could still roam.[58] Kiesler saw the department store not as an internalization of the street but instead as an opportunity to immerse the spectator in the virtual promise of technology. The interior climate was to be completely controlled through internal devices, while the exterior display would contain no support columns or structural systems so as to provide a free-flowing zone for unrestricted advertisement. One of his schemes used glass elevators with exterior show windows as columns to lift the building off the street and provide open circulation; another made use of opaque glass for

signage, colored glass for spectacle, and glass floors. Glass became the prominent theme in these buildings as it had in his Paris department store tower of 1925 and his "Endless Theater" project of 1926. Kiesler's projects would realize the potential to supplant the boundary surface of architecture with a glass shell, to separate exterior and interior public display with a surface that would negate a sense of place with an auratic zone of projected exhibition.

Unlike his contemporaries, Kiesler understood that glass had the potential to be auratic—in profound contradiction to International Style modernists, from whom he inevitably became estranged. For them, glass had become the prominent material of an ideology that promoted transparent, open, and temporal community value. In his essay "Experience and Poverty," Benjamin thought that "objects made of glass have no aura" as "glass is in general the enemy of secrets. It is the enemy of possession."[59] In strong support of modern materials as promoted by Scheerbart, Giedion, Mendelsohn, and Taut, Benjamin believed modern architects were "converting human habitations" into "the transitional spaces of every imaginable force and wave of light and air" through the "moral exhibitionism" of glass with its resistance to leaving traces.[60] Like hard cold steel, glass bears the potential, as Benjamin suggested, to end the "cult of dwelling."[61] While the *flâneur*'s role was to "read off" the everyday bourgeois objects and buildings throughout the city as if a "master detective," searching urbanity for images "wherever they lodge," building in glass and steel was supposed to minimize any further effort to reinscribe the city with bourgeois narrative gestures.[62]

Kiesler's plans for the American Bauhaus—the proposed "American Institute for Industrial Design," published in the *American Magazine of Art* in 1934—clearly demonstrated through its surface application of glass and steel his interest in using these modern materials. He proposed an exterior of "interlocked and insulated monel metal" for the middle floors, a three-story glass exhibition hall and museum display that "can be clearly seen by passers-by" for the entry floor, and "stamped steel, wall-framing sheet glass" for the upper floors.[63] However, Kiesler's use of glass for display, as demonstrated in his storefront and exhibition architecture, exemplifies a critical shift in the way aura is generated; it effectively undermines any effort to establish porosity (physically, visually, socially, or politically). Aura, as Kiesler realized, is no longer specifically established through the tactile marking of time and memory on the

Figure 2.18 Frederick Kiesler, American Institute for Industrial Design, New York, 1934. From Frederick Kiesler, "American Institute for Industrial Design," *American Magazine of Art*, 1934. © American Federation of the Arts.

surface of an aged material that could be "read off" through imaginative inter-pretation ("profane illumination"), as Benjamin had it. It is now made manifest through *anticipation* generated by the returning gaze of inanimate objects held back at distance and encased behind a glass display window open to the street.[64] In effect, this use of glass works against the twentieth-century notion that this material would ensure transparency and clarity, or as Benjamin had quoted Bertolt Brecht, that it would "erase the traces!"[65] Porosity provided by a glass win-dow—whether limited to the shallow spatial illusion of the display or extended to the entire store on exhibition to the street—creates distance of aura that can be covertly manipulated for mass consumer appeal. In Kiesler's glass depart-ment stores of the late 1920s as well as his American Bauhaus scheme, display and exhibition tactics compromised any effects of porosity and transparency.[66]

Clarity is no more guaranteed to the naked eye behind a glass window than veiled behind a curtain. As Harry Francis Mallgrave argued in his introduction to Gottfried Semper's *The Four Elements of Architecture and Other Writings*, a veil can perform almost as a "ruse," to provoke the meaning of a form, while the promise of the "naked" truth may only support pretension without apparent clues to detect meaning.[67] The idea that one cannot leave traces upon a material that is hard and cold, such as glass or steel, misinterprets what Benjamin him-self realized about aura, as clearly defined in his hashish writings and later con-firmed in "On Some Motifs in Baudelaire": that aura is comprised of imagined ornamental images that are embodied or projected on surfaces as halos that surround all objects and beings—the "characteristic feature of genuine aura is ornament."[68] Aura is not limited to the traces embodied on a material surface recorded in time, for it is also effectually the ornament *projected* onto a surface as understood and manufactured through imaginative interpretation. Mate-rials are used rhetorically and always embody images and produce material effects whether carved stone, soft wood, machine-smooth steel, or transparent glass; materials always embody ideas whether or not these ideas are under-stood, intended, or desired. At times, Benjamin sought to limit the possibility of inscribing traces on a material that affords the intimate relics of bourgeois security and livelihood. At other times he realized that it is not the material that embodies images and ideas, but the projection of the human imagination in response to memory—the promise of the hermetic (magical) tradition—that marks meaning as a breathy halo upon objects of desire. A mark or inscription

is merely a scratch on a surface without a projected meaning made in response to that action. It is the imagined interpretation of a sensation of memory associated with an object that defines history and meaning—that gives formed matter its sonic voice.

As glass with its phantasmagoric properties of reflection and refraction proves to be an excellent material on which to project an illusory casing of inexplicable wonder, the role of the *flâneur* may not be entirely obsolete in a modern or contemporary world of glass and steel. As Benjamin discussed in the "Return of the *Flâneur*," the "perfected art of the *flâneur* included a knowledge of 'dwelling,'" and as "the primal image of dwelling … is the matrix of shell—that is, the thing which enables us to read off the exact figure of whatever lives inside it," so it is still necessary to read off the "atmosphere" surrounding bourgeois life in the casings of modern or contemporary objects, homes, and everyday city life if we are to understand this world and promote the promise of a new political life.[69] What a casing is, however, has evolved throughout the twentieth century—dwelling is no longer only apparent in the physical markings on an architectural surface (like a worn marble doorstep) but instead is found as a projection on or associated with the architectural body through multimedia. Benjamin was not wrong to want to explode the "atmosphere concerned in these things," to release objects and architecture from their encasement of imagined history and memory as a means to politicization that can be maintained with continued "organization," "pessimism," and "mistrust."[70] However, unlike Adorno and Kracauer, he was perhaps all too enamored by the promise of new media experienced in a state of distraction to realize how easily society might adapt its new technologies to further advance covert mechanisms of control.

Adorno and Kracauer realized to some extent the potential shortcomings of new media technology used in capitalist markets. Adorno was critical of the shifts in the music industry, as Kracauer was concerned for cinema. Adorno believed that aesthetic politics which utilized distractive techniques "generally have no real consequences, smoothly insinuating themselves into the episodic action."[71] Political life was only slightly altered by "revolutionary [aesthetic] tactics" which were all too easily employed by the mass advertising market, similar to what Kiesler had accomplished with his shop window designs. The market learns to adapt to every new tactic and absorb every artistic gesture for its own

benefit, merged in the "endless" flux and flow of an evolving ever more exciting contemporary capitalist culture. Adorno's lament, in response to this effect on music, applies equally well to mass media in general:

> But what are emancipated from formal law are no longer the productive impulses which rebelled against conventions. Impulse, subjectivity and profanation, the old adversaries of materialistic alienation, now succumb to it. ... The representatives of the opposition to the authoritarian schema become witnesses to the authority of commercial success ... the listener is converted, along his line of least resistance, into the acquiescent purchaser. No longer do the partial moments serve as a critique to the whole; instead, they suspend the critique which the successful aesthetic totality exerts against the flawed one of society.[72]

Whether naive or blindly optimistic, modern artists who sought to promote freedom and revolution through aesthetics were ultimately challenged by the "authority of commercial success" that sought to use their own skillfully idealized techniques for profit, gain, and control. Criticality was smoothed over to facilitate the acquiescence of the purchaser through techniques of modern art and covert means of mass media. We have become unconsciously driven through autonomic habits induced through what Kracauer describes as "American distraction factories," not only to avoid the dangers of everyday modern life but to habitually consume in a constant state of distraction.[73] We have been trained to respond to the intensifying demands of an ever-evolving consumerist society with less and less critical attention and more and more physical action. "Shock effects" were never really successful in the effort to achieve mass revolution, but instead became the everyday tactics of mass consumer manipulation that have significantly benefited capitalist society.

The Movie House

Kiesler used the applied arts and new projective technology to instigate covert mechanisms of control through synesthetic tactics in his shop window and

department store projects. In another built work, he brought his storefront cinematic tactics to bear on the actual presentation of film. In the same years as he was designing his department store schemes and window display designs, he also received a significant commission to design the new Film Arts Guild Theater for 52 West 8th Street in New York City. In this project he was able to develop his interests in moving people to engage modern technology through artistic tactics from the street facade to an interior illusionary atmosphere. As in the glass department store designs where the exterior used material effects to create new electric and potentially electronic spaces, for the Film Arts Guild Theater Kiesler designed a new form of movie house that rethought how film would be accessed and presented to the masses.

To lure the viewer from the street into the movie house, Kiesler used similar techniques to those of his shop window designs. The movie house facade featured an asymmetric rhythm of windows, doors, signage, display, and vertical and horizontal ornament using Dada and De Stijl tactics to draw the attention of the modern city dweller toward a demarcated entry. Inspired as he suggests by the Café De Unie of J. J. P. Oud in Holland, Kiesler implemented what he termed the "psycho-function" of architecture through lines, planes, and forms as well as juxtapositions of different colors and materials. For as he suggested,

> glass has a different psychological effect from leather, wood, and from metal. The same applies, of course, to color schemes. Function and efficiency alone cannot create art works. "Psycho-function" is that "surplus" above efficiency which may turn a functional solution into art. The front of this motion picture house is conceived of black and white opaque glass. The design as it spreads from the inside of the building into the front moves in an asymmetric rhythm, emphasizing the purpose of the building as a home of moving pictures.[74]

Fittingly for a house of film, the exterior was designed to move the eye intensively back and forth. As is clear from images of the lobby, linear patterns of the ceilings, floors, and walls moved the spectator's eye in a constant state of distraction. The body automatically follows the rhythm down the hall and into the theater or back out into the street. Through the image space, the body space can be controlled and manipulated. What we politely call "way-finding"

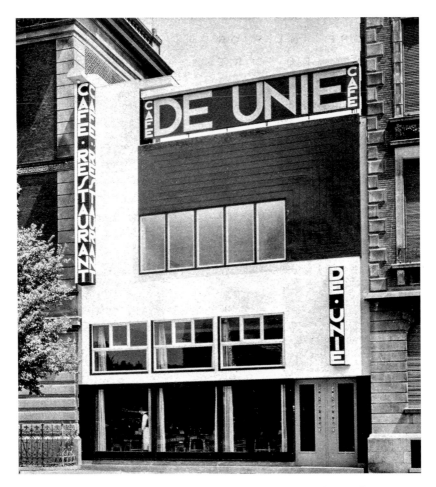

Figure 2.19 J. J. P. Oud, Café De Unie, Holland. "The asymmetric balance in relation to the inscriptions on the whole front is perfectly solved." From Frederick Kiesler, *Contemporary Art Applied to the Store and Its Display*, 1930.

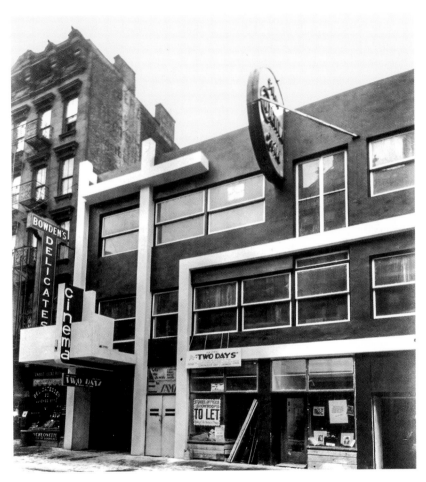

Figure 2.20 Frederick Kiesler, Film Arts Guild Theater, New York, 1929, exterior facade and entry. © 2017 Austrian Frederick and Lillian Kiesler Private Foundation, Vienna.

signage—the tactics of advertising and display—Kiesler employed to move the audience, through "tactile quality" of "habit," to assume the position in front of the screen where focused attention set to the rhythm of distraction with illusory affect serves to expand the limits of the architectural body. Cinema and life effectively lost their distinction in one continuous spatial atmosphere.

The Film Arts Guild Theater was designed to concentrate the audience's attention on the screen for the duration of the film, and not to distract them with the surrounding architecture during the event, a problem that had concerned Kracauer in his essay on "The Mass Ornament." Kiesler writing in 1929, likely influenced by Kracauer, realized the need to rethink the movie house as opposed to the theater house, for as he suggested, "architecturally, there is an enormous difference between the theater and the cinema. The cinema has all interests concentrated on a single point of two dimensions, while theatre must have the interest dispersed in three dimensions."[75] Kiesler disapproved of traditional movie houses that replaced the proscenium stage with a movie screen while still maintaining the look of a theater house. His argument focused on the replacement of the three-dimensional "real" space of the theater by a two-dimensional screen for film:

> While in the theatre each spectator must lose his individuality in order to be fused into complete unity with the actors. In the cinema which I have designed for the Film Arts Guild is this most important quality of the auditorium its power to suggest concentrated attention and at the same time to destroy the sensation of confinement that may occur easily when the spectator concentrates on the screen.[76]

To obtain "unity" within the theater is to create continuity with the actors and the theatrical stage; the audience is lured inside the action of the event as the actors on stage permit them to approach and become absorbed into their art. Film, however, had by this time "grown mature enough to create its own form of architecture which must signify 100 per cent cinema. Our age is an optical one. The rapidity of events and their brief duration require a recording apparatus that can register as speedily as possible. It is the eye. The speed of light waves exceeds that of all other waves. The film is the optical flying machine of the camera."[77] As the individual's eye is concentrated on the rapid

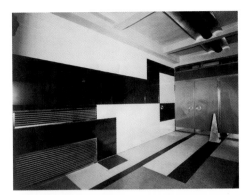

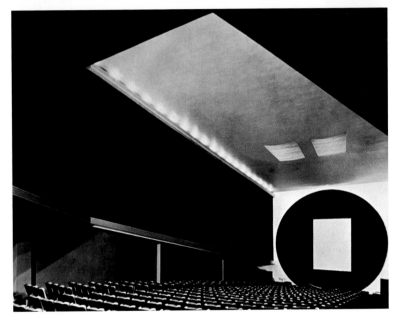

Figure 2.21 (top left)　Frederick Kiesler, Film Arts Guild Theater, New York, 1929, lobby. Photograph by Karl John Worsinger. Courtesy of the Austrian Frederick and Lillian Kiesler Private Foundation, Vienna.

Figure 2.22 (top right)　Frederick Kiesler, Film Arts Guild Theater, New York, 1929, lobby ceiling. Photograph by Karl John Worsinger. Courtesy of the Austrian Frederick and Lillian Kiesler Private Foundation, Vienna.

Figure 2.23 (bottom)　Frederick Kiesler, Film Arts Guild Theater, New York, 1929. Photograph by Ruth Bernhard. Courtesy of the Austrian Frederick and Lillian Kiesler Private Foundation, Vienna. Reproduced with permission of the Ruth Bernhard Archive, Princeton University Art Museum. © Trustees of Princeton University.

Figure 2.24 Frederick Kiesler, Film Arts Guild Theater, New York, 1929, "Screen-O-Scope." © 2017 Austrian Frederick and Lillian Kiesler Private Foundation, Vienna.

movement of the images on the screen, a new environment is needed that can "concentrate attention" (contraction) and at the same time "destroy the sensation of confinement" (expansion).[78] This effect Kiesler argued could occur in his Film Arts Guild Theater, as the action of the film makes its way toward the individual who takes the critical position of the camera.

Seated before the film manufactured and designed for reproducibility, the viewer can assume the intimate position of the camera, informed by the new vision of the optical unconscious with techniques, as Benjamin suggested, of "tenth of a second" "closely-expanded space" and "slow motion-extended movement."[79] Enveloped, according to Benjamin, in "the most intensive interpenetration of reality with equipment," in the movie house one intimately experiences the events situated on film from the safe, empowered critical position of one's seat without intimidation from the aura of an authoritative presence.[80] From this contrived position of intimacy without intimidation, perception is theoretically enhanced by the nonhuman perspective of the detailed, mechanically reproduced media experience of artistic reality, which might lead to a more critically engaged mass. Film as envisioned by Benjamin and perhaps Kiesler aimed to put "the public in the position of critic" as "an examiner, but a distracted one," inciting the viewer to a conscious "presence of mind."[81]

In Kiesler's cinema, the spectator would now "be able to lose himself in an imaginary, endless space even though the screen implies the opposite."[82] Kiesler attempted to eliminate any reference to the proscenium stage, its curtain or platform, by offering a new "Screen-O-Scope" in its place. This stage curtain resembled the aperture of a camera, although not entirely circular—more split in two, like the lids of an eye that opened and closed to allow more or less screen to become visible as needed. In addition, instead of using only one screen, Kiesler hoped to be able to use the ceiling and walls as projection areas to enhance the illusory atmosphere. Surrounding the screen with lighting effects that directed the eye toward the filmic action, "interior lines of the theater … focalize to the screen compelling unbroken attention on the spectator" in a completely blackened room.[83] The intention here was different than the all-encompassing "unity" intended by his earlier stage projects. Now Kiesler provided for an immobile, secure, yet unconfined and quiet spectator to be enveloped within the image screen in a state of distraction—individually yet among others, in the ideal cinema, as "the ideal cinema is the house of silence."[84]

Contraction and expansion of the field of vision provided the illusion of a flexible spatial environment that could extend beyond the architectural limits set by inherent physical barriers. Kiesler's 1920s designs exploded the limits of traditional architecture to achieve continuity between the street life and interior life of modern dwelling. His storefront projects sought to extend to the entire exterior surface of his buildings with dynamic illusory effect, while his cinema and theater projects sought to expand the entire interior atmosphere. All these projects had the same intention, to organize spaces of control. The interior and exterior surfaces effectively met at the limit of the architectural body as if a skin *modulating* interior life separate from city life, which could then expand through the illusory promise of a new porous architecture to erase the memory and history of bourgeois life through the hope of modern glass and steel materials. However, this surface, becoming ever more "elastic," "porous," and "atmospheric," seems only to further employ tactics of display, advertising, and mass media that manipulate the habits of everyday life, until we become increasingly comfortable assuming our position before the cinema screen. We are ever more convinced that we are individuals making our own conscious choices, and yet in this media-induced *virtual* state of distraction in which attention has become so well entertained we may have lost sight of the habits of our actions.

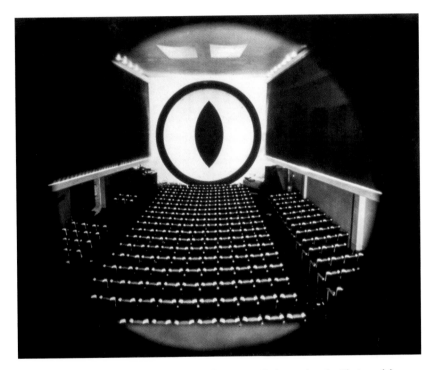

Figure 2.25 Frederick Kiesler, Film Arts Guild Theater, New York, 1929, interior. Photograph by Ruth Bernhard. Courtesy of the Austrian Frederick and Lillian Kiesler Private Foundation, Vienna. Reproduced with permission of the Ruth Bernhard Archive, Princeton University Art Museum. © Trustees of Princeton University.

Figure 3.1 Frederick Kiesler, Mobile Home Library, 1938. Photograph by Ezra Stoller. © Ezra Stoller/Esto.

3 Design Correlation: Laboratory Experiments

Habit diminishes the conscious attention with which our acts are performed.
—*William James*

"Architectural education's primary purpose is to teach students to think for themselves," Kiesler declared at the Conference on Coordination in Design held at the University of Michigan, March 8, 1940.[1] Kiesler's pedagogical statement was met with stunned silence in the room. He suggested a radical departure from the opinions held by his colleagues at the conference Gropius, Moholy-Nagy, and Eero Saarinen, who strongly favored teaching manual training, material knowledge, and universal principles of design. Kiesler instead supported educating students with a broad scientific approach to problems through innovative laboratory research that might generate new modes of independent and creative thinking. Not interested in teaching students acritical design methodologies that merely supported static standards and accepted ideals, he even had the temerity to suggest that architecture students avoid copying modern European architecture as fervently as modernists had insisted that they avoid copying historical styles. Mesmerized by Kiesler's proposition, the conference committee—which comprised Wells Bennett, dean of the College of Architecture and Design at the University of Michigan; Joseph Hudnut, dean

of Harvard's Graduate School of Design; and Walter Baermann, director of the California Graduate School of Design at the California Institute of Technology (Caltech)—unanimously adopted his vision as a promising new direction for architectural and industrial design education.

The conference committee organized the meeting in Ann Arbor as a serious attempt to establish a fundamental educational background for architects and industrial designers in the United States. Prior to the 1930s, American architects typically received formal education through Beaux-Arts training in universities, a combination of theory and practice in polytechnic institutions, or through the fine arts in academies. With the influx of European émigrés to America during the Second World War, architectural education evolved to incorporate broad curriculums that coordinated technology and theory, fine and applied arts, and building crafts into complex fields of knowledge. Modern European approaches to architectural education, most notably those formed under Gropius at the Bauhaus, took hold at the most prestigious institutions in the United States. The Ann Arbor conference served as a sounding board for the most prominent proponents of modern design pedagogy.

Although Kiesler was a marginal figure in education at the time, his emphasis on architectural intelligence, process, and research methods over the training of rote skills, techniques, and autonomic procedures carried enormous value. Leopold Arnaud, dean of the Columbia University School of Architecture, invited Kiesler to participate at the Ann Arbor conference in light of Kiesler's innovative teaching methods. As a visiting professor at Columbia since 1936, Kiesler had avoided the meaningless production of repetitive simulacra typically generated in architecture schools by adapting the studio environment to make an intensive research laboratory.

Employing a multidisciplinary approach in what he titled his Laboratory of Design Correlation, Kiesler expanded the role of architectural education to include diverse fields of knowledge. He and his students engaged historic, theoretic, and technical investigations to formulate design variation. They researched and examined case studies, read philosophic and scientific texts, analyzed planning relationships, and built working prototypes. Through diverse and intensive explorations, Kiesler challenged his students to develop innovative organizational strategies and research procedures to invent and test new modularized systems for mass production.

In his laboratory, Kiesler organized assignments and lectures to examine how architecture could affect spatial perception and coordinate everyday habits through vision and touch. Students studied late nineteenth- and early twentieth-century uses of the time-motion study and applied their research to formulate design methodologies that incorporated varied psychological and physiological parameters. The laboratory invented new ways to modulate the built environment in response to multiple spatial habits of perceiving bodies in motion as situated and evolving through time. Their forms were designed to be "elastic"—mobile and flexible, able to expand and contract to perform multiple dwelling tasks. Kiesler's laboratory was at the forefront of a design research culture interested in harnessing human perception and behavior in order to facilitate new and evolving systems of capital production, and it proves an important precedent to educational models interested in the study of mass behavior, objectification, visual and corporeal affect, resilient and responsive systems, and relational organic structures.

Theater Laboratory

Kiesler's teaching experience began in New York City in 1926 as a stage design instructor. Upon traveling to the United States to present new European avant-garde theater to an American audience at the International Theater Exposition in New York City, Kiesler formed the Brooklyn International Theatre Arts Institute with associates Princess Norina Matchabelli (aka Maria Carmi) and Dr. Bess Mensendieck. Together they built "a laboratory of the modern stage" by organizing the school into three departments—one psychological, one scientific, and the other artistic.[2] Although Kiesler was affiliated with the institute for only a short time, it proved to have an enormous impact on his developing pedagogy.

To teach students to control their outward expressions, Matchabelli contributed theories on psychoanalysis and autosuggestion to the institute's acting program. She believed acting to be an art of *"co-relation"* between the brain, soul, and body modeled through an art of training where "inborn unconscious talent" can be studied and enacted "consciously."[3] The body's ability to express affections was a common theme explored in her courses. As they worked together, Matchabelli provided Kiesler with extensive reading material in the

fields of psychology and perception, in addition to texts on electricity, magnetism, cyclical theory, space-time, and continuity by Walter Russell, Einstein, and others.[4] Contracting and expanding universal principles of degenerative and regenerative energy forces—balancing in dramatic states of comfort and discomfort—became powerful themes Kiesler would develop along the lines of similar work by Mensendieck.

As an American who had studied sculpture in Paris and medicine in Zurich to become "a sculptor of human flesh," Mensendieck was a leading authority on scientific physical culture related to human anatomy, biology, rhythm, motion, and dance.[5] Her research, which she taught daily at the institute, aimed to revitalize the human body by combating faulty habits and retraining body structure to perform intelligent gestures and graceful movements. "In order to express the innate unconscious talent consciously," she explained, students were taught to analyze the moving body in order to determine how to best express themselves autonomically.[6] In observing that "Control of the Delineation and Extent of Movement in Space" created "beauty of contour" and "economy of energy" in everyday gestures, Mensendieck showed her students through training and exercise how to optimize their body actions.[7] Her work focused on the "elastic" capacity of joints and muscles to flow in what she called "physiologic rhythm."[8]

The twentieth century marked an obsessive curiosity about the habits of human performance, which the Brooklyn Theater Institute was interested to investigate. From the study of quantifiable actions to the analysis of qualitative conditions, they were guided by scientific inquiry into human perceptions, thoughts, feelings, and actions. No longer characterized by a form of classical stasis, human bodies were studied for their capacity to coexist as organisms within an evolving field. The Brooklyn institute researched the mind and body's elastic capacities to adapt to changing environmental conditions. Kiesler later translated the results of this research to stage design.

Kiesler taught artistic stage practices at the institute from 1926 to 1927 and continued to lecture at other arts and theater institutions in New York over the next few years, until he accepted a permanent position as director of scenic design at the Juilliard School of Music, where he worked from 1934 to 1957.[9] At Juilliard, Kiesler produced one of his first biomorphic designs, the opera sets for *Helen Retires* by George Antheil and John Erskine in 1934. Kiesler's design consisted of a series of plywood shields in forms shaped to the body movements

ALL DIRECTION IS CURVED–ALL MOTION IS SPIRAL

THE LAW
GENERATING
MATTER SEEKS
HIGHER PRES-
SURE ZONES

EXPANDING, CENTRIFUGAL ORBIT OF RADIATION
MAGNETIC, EXOTHERMAL ORBIT
CONTRACTING, CENTRIPETAL ORBIT OF GENERATION
ELECTRIC, ENDOTHERMAL ORBIT

DISCHARGING +

CHARGING +

CHARGING +

CONTRACTING, CENTRIPETAL ORBIT
ELECTRIC ORBIT
EXPANDING, CENTRIFUGAL ORBIT OF GENERATION
MAGNETIC ORBIT, EXOTHERMAL, OR HEAT LIBERATING
ENDOTHERMAL OR HEAT ABSORBING

DISCHARGING +

THE LAW
RADIATING
MATTER SEEKS
LOWER PRES-
SURE ZONES

STRUCTURE OF THE ATOM

Motion begins its expression by an infinitesimally slight over balance electrically, and an under balance magnetically, of particles of the One substance. This creates the appearance of two forces, which move away from each other at 180°, each force spirally seeking its own pressure zones. Electricity seeks itself alone against magnetic resistance. The contest between the two forces develops pressure zones of positive force which increase in gravitative power toward the nucleal centers of disturbed areas. As centrifugal and centripetal forces increase in their opposition the plane of spiral expansion decreases. Imagine these lines drawn on the surface of a cone into which you are looking and you will know the lines of force of the hydrogene atom, 1+. Shorten the cone gradually until these lines are as flat as a watch spring and you then have the carbon atom, 4+. The axis of the cone is the dimension of the ecliptic expansion.

CHART No. 1. EVOLUTION OF FORCE INTO SEVEN TONES,
FOUR UNITS AND ONE UNIVERSAL CONSTANT WHICH
CHANGES ITS DIMENSION IN ALL EFFECTS OF
MOTION, BUT NEVER CHANGES ITS ENERGY CONSTANT

NATURE'S METHOD OF STORING ENERGY IN MASS

178

Figure 3.2 "All Direction Is Curved—All Motion Is Spiral." Figure from Walter Russell, *The Universal One*; reprinted in *The Russell Genero-Radiative Concept or the Cyclic Theory of Continuous Motion*. © University of Science and Philosophy, Virginia.

Figure 3.3 "Nature's Method of Storing Energy in Mass." Figure from Walter Russell, *The Universal One*; reprinted in *The Russell Genero-Radiative Concept or the Cyclic Theory of Continuous Motion*. © University of Science and Philosophy, Virginia.

Ill. 26.—The elasticity made available through a correct stooping position (Ill. 25) entered advantageously into the rhythmical rising motion which resulted in this perfect distribution of the masses in space. If movements in sport are based upon automatisms that conform with those laws of mechanics which govern muscle function, the architectural structure of the body will not be impaired.

Ill. 25.—The right technique in stooping results in a position which is the mechanically correct one from which to start the rising movement. When the foot-forward position is used for stooping, the greatest possible amount of elasticity for the upward movement will be secured. A right automatism ensures unbroken Physiological Rhythm in the act itself, as well as readiness for continued movement.

Figures 3.4, 3.5 Nickolas Muray, figures demonstrating physiological rhythm. From Bess M. Mensendieck, *It's Up to You*. Photographs by Nickolas Muray. © Nickolas Muray Archives.

Figure 3.6 Frederick Kiesler, stage and costume designs for *Helen Retires*, 1934, photograph. Courtesy of the Austrian Frederick and Lillian Kiesler Private Foundation, Vienna.

of actors playing the ghosts of dead war heroes. Helen moved about the heroes dressed in black, with reflective lines and points on her arms, joints, and legs similar to those used by Étienne-Jules Marey in his chronophotographic studies. Kiesler explored the artistic potential of Marey's experiments; through time-motion study of human movement, gesture, and rhythm, he began to stylize his stage designs using shapes characterized by human forms.

For Kiesler, correlating costumes and stage scenery to the organic rhythms of bodies in motion supported the study of architecture, as it had earlier for Oskar Schlemmer and Moholy-Nagy at the Bauhaus. As Kiesler would later suggest in *Architectural Forum*, stage design responds to performative criteria that evolve throughout the drama of the play.[10] Theater is not a static proposal, and theater architecture as Kiesler imagined it did not aim to be permanent or fixed. For him, a stage was designed according to the rhythms and movements of actors and spectators. In his 1935 design at the Metropolitan Opera for *In the Pasha's Garden* by John Seymour and Henry Tracy, for instance, he created a spiral platform similar to his 1924 Space Stage to stimulate actors to encircle space fluidly, almost automatically, along a spiral incline. Kiesler's ambition to create environments that motivate human actions informed his theater constructions, and throughout his career he sought opportunities to experiment with architecture that would respond to performative events.

Valued highly in educational circles in New York at the time, Kiesler was invited by Leopold Arnaud to collaborate on a new course in scenic design that was instituted in the fall of 1936 at Columbia's School of Architecture. Kiesler directed his students to plan and construct the sets and costumes used for two of the operatic performances produced at Juilliard that year. His course was well received, and he not only continued to teach stage design at Columbia but was also invited to launch his Laboratory of Design Correlation.

The Laboratory of Design Correlation

The Laboratory of Design Correlation was created for the systematic study of pure form and its application to architecture and industry. The laboratory was part of a larger programmatic experiment at Columbia initiated to investigate a scientific approach to architecture, design, and urban planning. Devised for

experimentation in practical systems of construction technique, the laboratory served as an alternative course of study to the core graduate architecture studio design curriculum—leading to a degree of master of science in architecture.[11]

The course was multidisciplinary in nature and open to candidates throughout the university. In the first year of the laboratory, Kiesler selected one student from the School of Architecture and enlisted three other students outside the department: one from industrial design, one from art, and the other from sociology. He divided the laboratory into theory lectures, research techniques, graphic presentation methods, model planning, and shop work. Alongside his lectures, he presented films from physics, anthropology, and biology and taught a supplemental weekly two-hour graduate elective architecture seminar, "Morphology of Design," on the interrelationship of form, function, and structure in nature and in shelter construction. Studies presented on the evolution of form and function both in nature and technology were then structured around a practical laboratory experiment.[12]

In his "First Report on the Laboratory for Design Correlation" to Arnaud, Kiesler explained that he had introduced the practical problem of storing books in the home: "I chose … [this] theme because everyone is familiar with it, and by that have probably lost perspective of it. One of the chief aims of our Laboratory is to learn to see everyday happenings with a fresh keen eye and to develop by that a more and more critical sense for our environment."[13] Critical study of everyday life was important; by challenging perceptions of daily habits, Kiesler hoped to gain new insights into designs for familiar activities. He proposed to study "Biotechnique," the dialectical relationship between a human being and the environment, or, as he described it, "the interrelation of a body to its environment: spiritual, physical, social [and] mechanical."[14]

Biotechnique/Biotechnic

Although Kiesler used the term *biotechnic* in his preliminary proposal for "A Laboratory for Social Architecture" while lecturing in Chicago on industrial design in 1933, by 1934 he switched to using the term *biotechnique*.[15] "*Biotechnics*, a term which Sir Patric[k] Geddes ha[d] … employed," Kiesler argued, "can be used only in speaking of *nature's* method of building, not of *man's*."

Biotechnique, he emphasized, "*is the special skill of man which he has developed to influence life in a desired direction.*"[16] Among his contemporaries, architecture historian Lewis Mumford had begun using the term *biotechnic* in his 1934 *Technics and Civilization*, in which he defined the "biotechnic" as a period of architecture when machines would completely integrate with human needs and desires. For Mumford, the biotechnic described a future period of unity between society, morality, and the machine, where, through close observation, analysis, and abstraction of nature, architects and planners would study the environment to assimilate bodies and machines in the hope of creating "a new conception of the organic" as an economic "collective."[17] The biotechnic period, according to Mumford, aspired to a complex state of automatism that he believed would best support a communist lifestyle by eliminating social distinctions and providing more leisure time for the masses. Although Kiesler's and Mumford's overall strategies in creating an ecologically informed architecture were similar, Kiesler's interest in "biotechnique"—as a systematic environmental design methodology—more closely resonated with Hungarian plant biologist Raoul H. Francé's 1920s "biotechnic" proposal.

As described in Francé's *Die Pflanze als Erfinder*, a biotechnic design approach examined the technical arrangements of unicellular organisms and other artistic forms in nature in order to manufacture economic constructions. To design a new medicinal and household shaker, for example, Francé observed and proposed to emulate how the elastic holes of a ripe poppy plant expanded or contracted in the presence of humidity or dry air to release spores.[18] These natural material processes among others inspired his writings on design, which proved to have enormous impact on the circle around *G* magazine, especially Moholy-Nagy, Mies, and, at least indirectly, Kiesler.[19] Francé's biotechnic (*biotechnischen*) approach to growth and structure in plants provided members of *G* an environmentally sensitive model for synthetic design practices. In 1928, Moholy-Nagy, referring to Francé's writings, coined the term *biotechnique* to describe a formal methodology that specifically applied seven basic elements—the crystal, sphere, cone, plate, strip, rod, and spiral—to shape all forms of industrial and building design.[20] Kiesler later developed biotechnique instead as a complex environmental design practice, one that he elaborated for housing design and first published in *Hound and Horn* magazine in March 1934 to annotate his Space House building project.

Figure 3.7 Frederick Kiesler, Space House, 1933, photograph of prototype by F. S. Lincoln. Courtesy of the Austrian Frederick and Lillian Kiesler Private Foundation, Vienna.

The Space House

Kiesler's Space House was one of his few architecture projects ever constructed and the only house he built; it incorporated his biotechnical strategies by creatively correlating moving bodies with performative building systems. He designed the Space House—which was constructed in 1933 as a way of attracting visitors to the Modernage Furniture Company's headquarters on East Thirty-third Street in New York City—to respond to changing habits and user needs.[21] With push-button roll-down doorways, flexible sponge rubber carpets, rollaway curtains, and sliding partitions, the Space House created a variety of mobile and flexible environments. As described by Kiesler in a series of unpublished sketches and notes, the Space House "contracted" to provide seclusion for a single individual and "expanded" to support group interactions. The house was not intended to be fixed in time, but to be keyed to the changing and evolving requirements of its habitants. Kiesler's design for the Space House sought to envelop dwelling within architecture geared to the changing interactions of work, rest, or play. Its form was intended to take shape in correlation with everyday use: the house would move with seamless organic expression in response to the body. "Stream-lining becomes here an organic force," he asserted, "as it relates the dynamic equilibrium of body-motion within encompassed space."[22] The "proprio-spatial dynamic" function of the house, he argued, was its ability to seam complex components into one continuous "elastic" construction. The house provided a variety of spaces that correlated multiple shifting human actions within a unified structure. Correlation of bodies and their surroundings became the central principle of Kiesler's design, which in turn formed the basis of his innovative doctrine of "correalism."

Correalism/Correlation

Kiesler most likely derived his use of the term *correlation* from theories of plant and animal morphology described by Geddes in his 1911 book *Evolution*. Geddes's chapter on "Variation and Heredity" examined the history and theory of correlation, which R. S. Russell then substantially developed in his work *Form and Function*.[23] Kiesler kept a copy of *Evolution* in his library and later had

Figure 3.8 Frederick Kiesler, "Time-Space-Architecture," 1933–1934. Space House sketch diagram. © 2017 Austrian Frederick and Lillian Kiesler Private Foundation, Vienna.

Design Correlation: Laboratory Experiments

his students transcribe *Form and Function* in the Design Correlation Laboratory. Similarly to Russell, Kiesler used *correlation* to describe the practical application of structural form to bodily function where the aggregate whole is constructed in relation to its parts. Correlation became a significant topic in architecture in the 1930s after Buckminster Fuller titled his introduction to the second issue of *Shelter* magazine "Correlation" in 1932.[24] For Fuller, the idea of correlation best described the interconnection, continuity, and interrelationship among the varying interests, working practices, and general discourses taken up by the Structural Studies Associates, of which Kiesler was a member. Kiesler elaborated the study of correlation to apply more specifically to architecture in its relation to human bodies and the environment.

Correalism was Kiesler's own neologism for *correlation*.[25] According to him, correalism provided a scientific basis on which to construct viable technological environments and applied to all possible design products, from "shirts to shelter," that could become the "constituent parts of … [our] total environment."[26] Correlation between nature, bodies, and the built environment, he believed, could be modeled on the laws of molecular relationships among natural and manufactured organisms and systems, where reality and forms were merely "visible trading posts" of continuously mutating "anabolic and catabolic," "*nuclear-multiple-force*[s]," "integrating and disintegrating … at low rates of speed."[27] Any distinctions between subjects and objects were understood to be diffuse products of the constant exchange of molecular forces acting in time. Time thus was essential to correalist practice, because "time," Kiesler declared, is "the only resistance to continuity … that keeps matter (the world) together."[28] Movement in time resists static form; it creates continuous dynamic relationships between bodies and the environment. In time, Kiesler believed everything eventually becomes networked, relational, and continuous. Correalism as the science and biotechnique as the method, he argued, would facilitate the production of a total environment, a *Gesamtkunstwerk* of effects providing a "unified architectural principle" for design, one that could achieve "Time-Space-Continuity."[29] Believing his theory innovative, Kiesler trademarked the word *Correalism* in 1939 while completing his manuscript "On Correalism and Biotechnique." An edited version of the manuscript was published in *Architectural Record* in September 1939, alongside images by Ezra Stoller of the Mobile Home Library built during the second year of Kiesler's laboratory.[30]

Laboratory Research

The first year of the laboratory introduced students to the concepts of correal-ism and biotechnique and included general research on the study of variation and heredity in biology. In addition, Dr. Alexander Lesser, Dr. Gene Weltfish, and Dr. Robert S. Lynd of Columbia University spoke on anthropology and sociology. Hoping to teach students to think for themselves, Kiesler challenged architectural interests with broad intellectual research on evolutionary prac-tices relevant to design.

By the second year of the program, Kiesler had initiated several research investigations with his students addressing the problem of book storage in the home that produced pragmatic results. His student David Tukey began by charting and sketching new ideas for space economy, materials, light condi-tioning, and dust protection. He also consulted catalogs on stack manufactur-ing from Snead and Company and Shaw-Walker, as well as catalogs on metal office equipment from GF. Kiesler had Tukey, Alden Thompson, and Ronald Kaufmann complete a survey of problems for storing books in the home.[31] Stu-dents discussed several "elastic" spatial configurations with continuous built-in furnishings designed by Richard Neutra and others.[32] Kiesler then asked the students to make a report from an illustrated study he found in J. W. Clark's *The Care of Books* of Vittorio Carpaccio's *St. Jerome in His Study* (which was actually Carpaccio's *Vision of St. Augustine*) in order to examine the "psycho-physiological succession" from "optical tactilism to manual tactilism" needed to establish contact with a book.[33] This included studies of revolving storage devices, in addition to examinations of the progression from vision to touch (i.e., from eye to grasping to movement of the foot and so forth) involved in the process of securing a book.

Kiesler's assignments analyzed relevant historical, technical, and manufac-turer research and began to elaborate contemporary scientific studies to explore the body's relationship to the natural and built environment. To study the spatial effects of apperception on the visual and tactile habits of the user, he initiated a series of experiments described as "contact cycle studies."[34] Students imagined and recorded the experience of seeing and obtaining a book from studying the image they had of St. Jerome's library, for example. They envisioned moving about the room in various scenarios as they invented time-motion diagrams

Figure 3.9 Vittorio Carpaccio, *Vision of St. Augustine*, ca. 1502. Scuola di San Giorgio degli Schiavoni, Venice.

and charts of the virtual and habitual experiences of occupying space. Similar to diagrams originally generated by Christine Frederick in her studies of time management for the home in 1912, the temporal charts created by Kiesler's students recorded human actions. These investigations prescribed positivist agendas for examining the body and its habits. Students scientifically observed, dissected, codified, and recorded bodies in motion to imagine and test the limits of spatial designs and their organization.

Adding to these contact cycle studies, Thompson began a series of scientific explorations into the "present day method of measuring fatigue"; he charted bioelectric systems for observing sensory, central, and motor nerve impulses.[35] The intention of these biotechnical studies was to disclose tenseness in the muscles between "contracting and relaxing phases." By the use, for example, of delicate electrical instruments developed at the University of Chicago, Kiesler proposed to measure muscle tension. Fine wires leading directly from body muscles to a recording instrument were to be used to measure intensity of movement. Through this research, Kiesler endeavored to determine how bodies coordinated and became tired when obtaining a book from a shelf. He then coupled these investigations of lassitude measurement with information garnered from studies of Francis Gano Benedict's 1905 respiration calorimeter in an attempt to quantify the molecular processes involved in energy balance, expenditure, and heat transfer. Students measured fatigue and the regeneration of bodies from their contact cycle studies of St. Jerome's library and produced calculations of labor performance in foot-pounds. From these investigations, Kiesler intended to derive a home library prototype of energy- and time-saving efficiency. To ensure this result, students examined successful case studies, including a circular desk used at Harvard Law Library and several examples of mobile, flexible, and modular furniture published in Herbert Hoffmann's treatise *Gute Möbel* and Adolf G. Schneck's *Das Möbel als Gegrauchsgegenstand*.[36]

In all of these investigations, Kiesler and his students gave special attention to the study of moving bodies and systems in order to create readily accessible "elastic" constructions. Many of the furniture designs that the students studied had varied mechanisms to fold and unfold a series of surfaces into multiple and extended parts. Joinery and hinging systems became extremely important, as did the interactive study of direct access to storage devices. Kiesler and his students drew several charts and diagrams to accompany their study of bodies

reaching, extending, standing, and bending to use books at different times for different purposes.

The correlation between furniture and the moving body was vital to Kiesler's project. Any "maladjustment between the body and some parts of its environment, external or internal," he argued, would "impair the efficiency of the body," leading to increased "physical resistance," unbalanced health, and, in the extreme if not simply absurd case, "a progression from fatigue to death."[37] "*Architecture*," he explained, is "*a tool for the control of man's* [physical and mental] *health, its de-generation and re-generation*."[38] He believed aligning architecture with bodies in motion would guarantee a harmonious and balanced interaction between humanity and its technological environment. Coordination between the body and its surroundings would create a healthy exchange of forces that "mitigates physical and psychological maladjustments" by providing "*protection against fatigue* (preventive) and … *relief of fatigue* (curative)."[39] Architecture would thus function as a generator for the individual by protecting and replenishing the dweller's energy forces; it would serve to energize both *physis* and *psyche* as it coordinated the habits of everyday actions on a molecular level. "If I use the chair," Kiesler maintained, "I accumulate its energy, I add it to mine"; "when we use a chair we <u>absorb</u> its energy."[40] Pseudoscientific theories of energy transfer between technology and the body situated in an ever-changing, adapting field suggested a state of pure automatism, in which the technological surface of elastic construction modulated in response to the body to control equilibrium and maintain good health.

Health has concerned architects at least since Vitruvius emphasized building in healthy climates. For Kiesler, science with its new technologies could be used to ensure healthier, more productive lives. Like Mensendieck and Mumford, Kiesler had hoped that bodies correlated to their environment would form lasting symbiotic relationships. Where Mensendieck had systematically taught bodies to move with natural elasticity in response to different situations— ensuring perpetual "beauty and health"—Kiesler scientifically studied bodies to design and test furniture that would move in correlation with the elasticity of bodily actions.[41] Where Mumford believed coordination between human needs, bodily desires, and machines would guarantee an organic society of collective economy and leisure—without social distinctions—Kiesler anticipated that architecture designed to dissolve subject-object relations between bodies

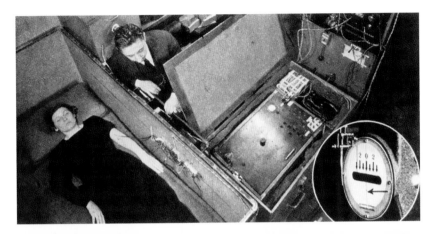

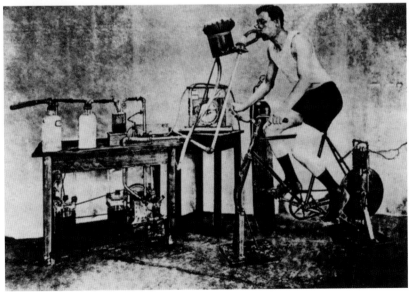

Figure 3.10 Bioelectric research experiment at the University of Chicago, 1928. Image from the Design Correlation Laboratory Files, 1938. Courtesy of the Austrian Frederick and Lillian Kiesler Private Foundation, Vienna.

Figure 3.11 Francis Gano Benedict's respiration calorimeter, 1905. Image from the Design Correlation Laboratory Files, 1938. Courtesy of the Austrian Frederick and Lillian Kiesler Private Foundation, Vienna.

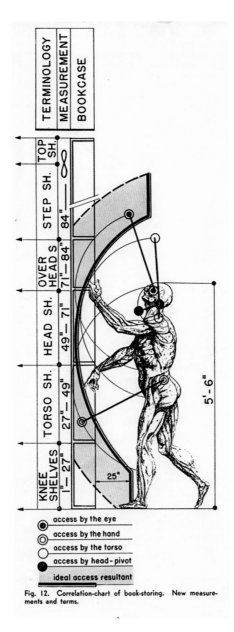

Fig. 12. Correlation-chart of book-storing. New measurements and terms.

Figure 3.12 Frederick Kiesler, biotechnical motion study. Collaged drawing, 1938. © 2017 Austrian Frederick and Lillian Kiesler Private Foundation, Vienna.

Figure 3.13 Frederick Kiesler, "From Deficiency to Efficiency," time scale chart. Drawing collage, 1938. © 2017 Austrian Frederick and Lillian Kiesler Private Foundation, Vienna.

and their surroundings on a molecular level would reenergize habitants and ease daily tensions and stress. For Kiesler, Mensendieck, and Mumford, fluid continuity of the body-machine complex within its environment would assure bodily control in the service of good forms of productive health.

To ensure the construction of healthy and productive biotechnological environments, Kiesler employed time-motion studies similar to those invented by Marey and Eadweard Muybridge, and later advanced by Frederick Winslow Taylor and Henry Ford. Unlike Fordist practice, however, which attempted to mold the body to the specialized demands of an efficient technological, mechanized workforce, Kiesler sought to develop "variation in technology" that might adapt to the needs of an evolutionary process of socioeconomic changes. "From deficiency to efficiency," he charted how "actual needs are not the direct incentive to technological and socio-economic changes"; instead, he remarked, *needs are not static: they evolve.*[42] He proposed an organic architecture of the living machine (and not a machine for living) that might modulate to one's motion in time as a consequence of one's societal and bodily habits. Kiesler was not interested in a functional static architecture where bodies strain to move in a fixed environment, but believed in a biotechnological architecture that shifts the strain from human beings to their tools. He wanted technology to engage bodies in action in order to create a balanced environment of comfort and discomfort—relaxation and extension—contracting and expanding in a correlative time-space continuum. The Mobile Home Library was his attempt to achieve this goal.

The Mobile Home Library

The Mobile Home Library, constructed by professional manufacturers in coordination with Kiesler's students Tukey, Kaufman, Thompson, and Armand Bartos, appeared flexible and adaptable to different users. With angular shelf-unit sizes increasing to 15 inches deep at their center, the library could accommodate more types of books with varied arrangements. Each unit could rotate 360 degrees and be easily adjusted and transported between locations. The home library was designed to physically engage bodies in motion. Three types of joints were custom-designed to achieve varied action. A tubular system of

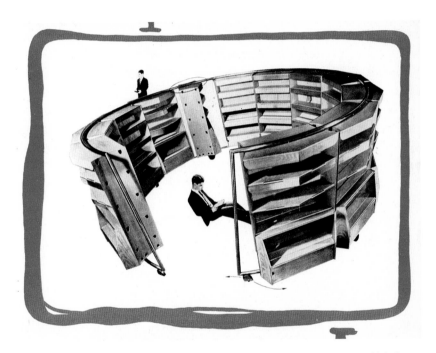

Figure 3.14 Frederick Kiesler, Mobile Home Library, 1938–1939. Photomontage, 1947, as published in the "Manifeste du Corréalisme," *L'Architecture d'Aujourd'hui*, 1949. Courtesy of the Austrian Frederick and Lillian Kiesler Private Foundation, Vienna. Original photograph by Ezra Stoller. © Ezra Stoller/Esto.

Design Correlation: Laboratory Experiments

chromium-plated steel construction telescopically extended to create more space for additional units. Units could be compiled in aggregates—stacked beside one another flat against a wall or floating in space on a circular wheeled track. Additionally, as Kiesler noted, "by designing each unit of the library—as well as the total assembly—according to the physical limitations of man," the storage system would reduce strain on the user to a minimum.[43] To optimize manufacture for future mass-customizable production, students tabulated and charted use frequencies and accessibility requirements alongside contact cycle studies.[44] Motion in time was designed into the physical construction of the tectonic body as a temporal structure manufactured to house books—or, in the future, microfilm, television, optophonics, or other kinds of new media.[45] Multiplicity and temporality were built into the system.

As a built work, however, the Mobile Home Library was designed to ideally support multiple research forms and reading practices. The library did not have a centralized modular design that stored individual books to control easy access, but instead allowed contact from a variety of standing and sitting locations as potentially needed by any number of information systems. The design exemplified a shift away from the formation of confined individualized spaces toward more flexible and resilient modulating open control systems. Kiesler's research laboratory thus engaged in experiments that supported an evolution in human behavior or training during the mid-twentieth century, as philosopher Gilles Deleuze has more recently identified—from the study and construction of static-fixed functional typologies toward the invention of machinic structures tailored to the needs of a constantly changing advanced capitalist *control society*.[46]

As a built work, however, the Mobile Home Library had its limitations. Its chestnut wood construction, chromium-plated steel, aluminum sheathing, and metal joints were only as flexible as the original design prescribed; it could grow only to a certain extent; it could accommodate only an identifiable typology of books and information systems; it could not be designed for unforeseen changes in lifestyle or technology; and it could expand only in a linear direction against a wall or in a curvilinear manner upon a floor. Unable to adjust to changes in style, color, or material fetish, it was an object limited and characterized by its time and one that could not fully adapt to changes in environmental conditions.

Kiesler did realize both the promise and limitation of actual construction, however, and incorporated a theory he described as "time-zoning" into his design correlation project. Time-zoning initiated during the design process recognizes the temporal limitations built into any technological production; it considers the life span "according to the stresses and strains of usage," as well as the decay of its parts, on a sliding scale from durability to disposability.[47] Life cycles and maintenance schedules are thereby a part of the design. "A time-zoned process of assimilation within the present domains of industries" is essential, Kiesler remarked; it replaces "the principle of static change … [with] the principle of continuous adaptation."[48] Despite its actuality, the Mobile Home Library was considered a standard type that would evolve variations based on observation, habituation, education, and invention. "Life-zoning of Building Materials" creates products, Kiesler suggested, that are designed to achieve an endless state of perpetual becoming.[49]

Kiesler's time-zoning process attempted to design products appropriate to the limits and extents of their use, while at the same time being cognizant of, and adaptable to, the ever-changing needs of varied situations. He hoped to produce designs that would not simply assimilate the body to repetitive known standards that he believed wasted human resources and impeded "technological progress," and he fundamentally opposed habituating the public to simulated standards by selling the same mass-produced products over and over—a practice that, he argued, only perpetuated a cultural lag in favor of pure consumerist profit. Instead, he aimed to properly coordinate manufacturing processes in "biotechnical research laboratories" as "the group expression" of the "consumer, the designer, the manufacturer, the distributor, [and] the salesman."[50] In other words, he wanted to optimize the production capacity of the masses to endlessly create new evolving standards that supported innovative forms of future progress.

Kiesler believed technological progress aiming at seamless continuity between bodies and machines would achieve ultimate human fulfillment. He did not lament the loss of human experience that might occur in this automatist process (as did Bergson, for example).[51] Instead he put his hope in an idea of continuous infinite progress, even though technology might expropriate humanity from its human dimension to evolve more effectively with machines. In the 1930s and 1940s, he readily supported conflating bodies and machines in the service of

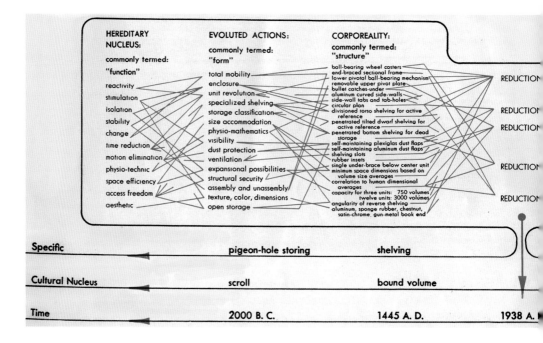

HEREDITARY NUCLEUS: commonly termed: "function"	EVOLUTED ACTIONS: commonly termed: "form"	CORPOREALITY: commonly termed: "structure"	
reactivity	total mobility	ball-bearing wheel casters	
stimulation	enclosure	end-braced sectional frame	REDUCTION
isolation	unit revolution	lower pivotal ball-bearing mechanism	
stability	specialized shelving	removable upper pivot plate	
change	storage classification	bullet catches-under	
time reduction	size accommodation	aluminum curved side-walls	
motion elimination	physio-mathematics	side-wall tabs and tab-holes	
physio-technic	visibility	circular plan	REDUCTION
space efficiency	dust protection	divisioned torso shelving for active reference	
access freedom	ventilation	penetrated tilted dwarf shelving for active reference	REDUCTION
aesthetic	expansional possibilities	penetrated bottom shelving for dead storage	
	structural security	self-maintaining plexiglas dust flaps	
	assembly and unassembly	self-maintaining aluminum dust flaps	
	texture, color, dimensions	shelving slots	
	open storage	rubber insets	REDUCTION
		single under-brace below center unit	
		minimum space dimensions based on volume size averages	
		correlation to human dimensional averages	
		capacity for three units: 750 volumes twelve units: 3000 volumes	REDUCTION
		angularity of reverse shelving	
		aluminum, sponge rubber, chestnut, satin-chrome, gun-metal book end	

Specific	pigeon-hole storing	shelving	
Cultural Nucleus	scroll	bound volume	
Time	2000 B. C.	1445 A. D.	1938 A.

technological materialist ideology, perhaps in contradistinction to any guiding moral or humanist values he may have cherished or hoped to believe.

Kiesler's biotechnological model for architecture aimed to maximize what he called "capital power" through new forms of production. He thus embraced capitalism in service of "MASS PRODUCTION" (the masses producing) but "NOT" as he argued "PRODUCTION FOR THE MASSES."[52] Promoting a biotechnic lifestyle expressly different from Mumford's communist fantasy of mass leisure, Kiesler sought a healthy coordination between the body and its environment that would improve mass productivity by continuously fine-tuning the body-machine complex to work to its greatest capacity. He promoted, in effect, a society of perpetual work in the service of mass markets for the "ultimate purpose" of enabling man to construct higher levels of continuous productivity. In Kiesler's biotechnic system, leisure was no longer a reward for work

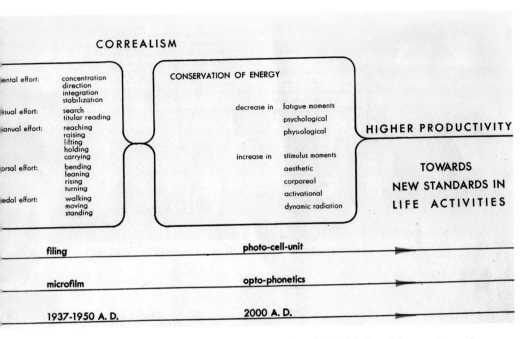

Figure 3.15 Frederick Kiesler, metabolism chart of the Mobile Home Library, 1938–1939. © 2017 Austrian Frederick and Lillian Kiesler Private Foundation, Vienna.

but an integral component of continuous satisfaction where liberatory actions and feelings were incorporated into productive daily routines. His laboratory carefully and systematically developed research into adaptable responsive mechanisms to harness life forces that increase work power. His goal (whether desirable or not) was to form for every member of society a "BIOTECHNICAL MINIMUM STANDARD" that resulted in the construction of *satisfyingly productive lives*.[53]

Social Design

Perhaps with this goal in mind, during the third and fourth year of the laboratory, Kiesler's research projects incorporated more-intensive time-motion

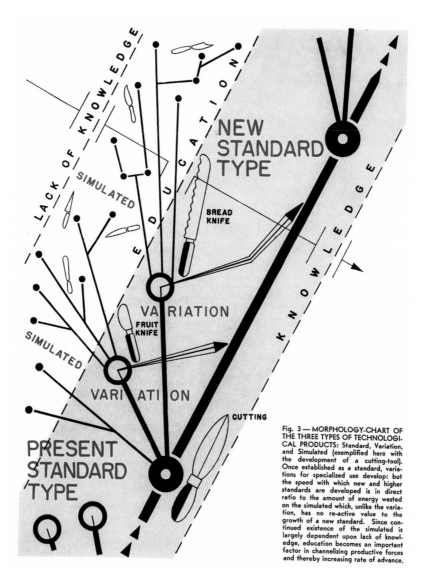

Fig. 3 — MORPHOLOGY-CHART OF THE THREE TYPES OF TECHNOLOGICAL PRODUCTS: Standard, Variation, and Simulated (exemplified here with the development of a cutting-tool). Once established as a standard, variations for specialized use develop: but the speed with which new and higher standards are developed is in direct ratio to the amount of energy wasted on the simulated which, unlike the variation, has no re-active value to the growth of a new standard. Since continued existence of the simulated is largely dependent upon lack of knowledge, education becomes an important factor in channelizing productive forces and thereby increasing rate of advance.

Figure 3.16 Frederick Kiesler, Correalism Chart showing the evolution of the knife. Lack of education leads to simulated versions, while education leads to variations of new standards. From "On Correalism and Biotechnique," *Architectural Record*, 1939.

investigations, as well as biological and evolutionary approaches to social design.[54] He discussed writings by Walter Rautenstrauch on "The Role of Organization in Attaining Optimum Productivity," which included studies of pattern organization, labor, and kinematics.[55] Mario Salvadori provided several lectures on the origins of motion study, movement analysis, and Taylorism in the workplace and in housing.[56] Additionally, Kiesler covered the evolutionary theories of Jean-Baptiste Lamarck, Charles Darwin, and Thomas Hunt Morgan, as well as studies on nervous systems, polyelectrophysiography, and radioactive rays.[57]

The laboratory explored the human autonomic nervous system and its relationship to social conditioning. In lectures on time and motion, students observed how architecture and industrial design not only facilitate human action but also train the habits of everyday life. Salvadori taught students charting methods to quantify time spent on habitual actions such as smoking a pipe or packing luggage. They studied how the body learns to adjust to its environment, becomes "a slave to habit," and how to problematize varied situations by asking "What is to be done?," "Who is to do it?," and "Why," "Where," and "When should [an] operation be performed?"[58] The laboratory then applied the students' analytical strategies to study real-world conditions—for example, the social politics between a factory worker, foreman, and his management in the construction of a San Francisco housing project was compared to work relations at a prefabrication housing plant in Seattle.[59] Students examined the structure of work in correlation with political and social engagement on the job through both "Macromotion" and "Micromotion" investigations.[60] From these studies of how bodies move habitually in response to their physical, social, and political environments, students proposed ways to improve productivity and profitability. By lending conscious attention to areas of discontinuity, they assessed better elastic methods to ensure the plastic habits of bodily actions as they rethought factory setups or invented new design or production tools.

By enabling more-fluid plastic states of action, Kiesler and his students hoped to generate greater human production power, an idea he derived in part from philosopher William James. Kiesler had been an avid reader of James's theories on brain activity, habits, nerves, education, and the environment. He held James's *The Energies of Man* and both volumes of the first edition of *Principles of Psychology* in his library.[61] In James's formative studies at the turn of the twentieth century, he had observed that bodily habits are effectively "plastic":

they are "weak enough to yield to an influence, but strong enough not to yield all at once."[62] In habit, pure sensation drives us in the effortless custody of the automatisms to which we have become accustomed. Our daily actions are guided through a series of successive nervous events as if moving in a "continuous stream" unencumbered by conscious perception, until we encounter disruption in our everyday patterns or workflow.[63] Unaccustomed situations force us to stop or slow down until we learn to develop "change[s] of habit."[64] To streamline everyday actions, James advised educating human nature to the habits of multiple activities through "*continuity* of training" that might encourage new motor effects and free habits of will.[65] James hoped "*to make our nervous system our ally*" by training people to develop multiple behavioral patterns early in life, as well as the flexibility of will to evolve new habits more readily, continuously, and frequently.[66] Kiesler attempted in his laboratory to extend James's theories to the plastic arts by developing flexible systems that more continuously supported and encouraged multiple changing habits. Kiesler's laboratory developed strategies to construct at an ever-increasing capacity architecture that would operate more smoothly and more seamlessly (i.e., that would be in sync) with evolving behavioral needs, wills, and desires.

In its effort to generate structures and systems most readily adaptable to constantly evolving forms of organic life, the laboratory became more and more interested in the adaptive potential of the sensory nervous system. Kiesler, like Rautenstrauch, believed that human beings both physically and psychically correlate in balance with their environment through nerves. The human nervous system senses its surroundings and coordinates necessary regulation. Because every social organism is a living system functioning in an ever-changing environment, its very existence depends on its resilience and capacity to adapt. As Rautenstrauch argued, "social progress … will depend upon our ability to evolve a pattern of organized life which is an evolving pattern of organization of new functional equipments and expanding nervous systems to meet the needs of a constantly changing society."[67] Arguing against static exogenous organizations that rupture under the pressure of expanding civilizations, Kiesler and Rautenstrauch instead believed organizational strategies must be developed that utilize endogenous social and economic processes to survive.[68] For Kiesler, architecture was fundamentally an extension of the human nervous system, a prosthesis designed to innervate physical, social, and political environments.

Vision Machine

In order to better understand the extensive capacity of the human nervous system relative to the plastic arts, Kiesler made sensory perception, in particular vision, an important focus of the laboratory. In their research on St. Jerome's library, for example, Kiesler and his students had observed that aesthetic and visual perceptions were integral to the fluid processes of seeing and securing books from shelves. To understand the decisive human mechanisms of choice and selection in aesthetic practices, Kiesler began to pursue conversations with Columbia biophysics professor Selig Hecht on the precise nature of human vision. Hecht visited the lab in 1938 to lecture on the eye, gave Kiesler's students a short illustrated summary of its varied nerve functions, and had them study living retinas in the biophysics department. This technical research informed the design of the laboratory's well-known "Vision Machine."

By 1938, preliminary designs for the Vision Machine were clearly outlined and the laboratory was working to develop the techniques of its mechanism and manufacture. Engineers from Biolite, Bausch and Lomb, and Master Optical were consulted alongside lectures provided by educational experts in the field of ocular mechanics.[69] In 1940, Kiesler convened an advisory board to support the project, which included leaders from New York and Boston in the fields of chemistry, biology, anatomy, education, anthropology, natural history, psychology, and brain studies.[70] He intended to build his Vision Machine to simulate the physical and aesthetic mechanisms of the sensorial body, and hoped to publish his findings widely.

The Vision Machine designed by Kiesler and his students aimed to show how networks of nerves correlate visual and tactile information between the mind, eye, body, and the environment. The machine was modeled on the study of cathode tubes and X-ray machines and would be operated through a rotary switch that generated a spark, which set the machine into motion. Gyrating continuously, the Vision Machine was intended to demonstrate the complete creative cycle of the imagination. To be constructed using an electrostatic generator, brass balls, blown glass tubes, colored gases, and electric wires, the Vision Machine appeared not altogether different from a push-button exhibit at a local science fair. It purportedly worked by reflecting light off an object, for example an apple. The reflected light was then drawn into focus by an ocular aperture

and projected onto an apparatus where it stimulated the flow of bubbles and gases through a network of tubes representing nerves and bodily systems. By using film animation technology, an excess of images—including artworks created by the blind, the insane, and small children—theoretically would stream forth from the machine. These images provided a visual depository of allied mental processes that simulated recognition, subconscious conflicts and associated prejudice, and previous experiences. From among the array of dreamlike images recollected and presented in accord with bodily affect and environmental conditions, a unified image would be created from a selection and then reflected back onto the initial object—the apple.[71]

Designed to show how perception is subjective—that is, temporal and personal—the Vision Machine purportedly would be able to project choice selections from various users onto a screen for further study and analysis. Kiesler argued that his Vision Machine could replace the couch, chair, pencil, and pad commonly used in psychoanalysis, because the Vision Machine would be able to take a "direct imprint of dreams" without interference from the dreamer or the therapist.[72] The Vision Machine was a Dream Machine designed to take snapshots of unconscious perception—what Kiesler called the "*after-image* of a memory flash."[73]

Although an avid reader of Sigmund Freud's basic writings, Kiesler (like James) dismissed interpretive methods of dream therapy in favor of popular scientific research on the inner workings of the mind and vision. Kiesler had hoped to use an electroencephalogram or cathode ray tubes, electrodes, and an oscillograph to record on either light-sensitive materials or continuous rolls of automatically flowing paper—latent energies, excitations, and phosphorescence from deep inside the unconscious brain. He hoped successive visual recordings would produce more accurate images from a person's memory and would thereby bypass study of the unconscious mind by therapists, who are subject to their own or their patients' biases. In his unpublished "Manuscript: Dream-Recorded," Kiesler detailed his experimental research to observe direct dream images without the intermediary action of conscious perception.[74]

In an attempt to understand human discernment that guides bodily actions, Kiesler probed the mechanisms and influences of the conscious and unconscious in his laboratory by, for instance, designing the Vision Machine to demonstrate the art of memory. The lab examined the process of memory

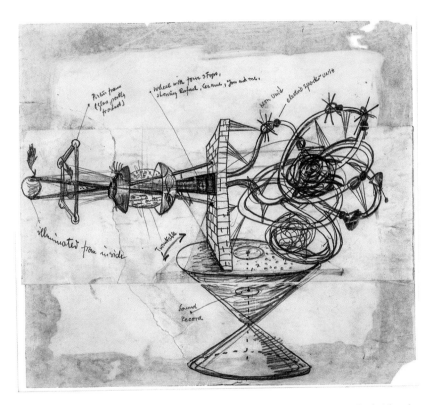

Figure 3.17 Frederick Kiesler, Vision Machine, 1937–1941. Drawing. © 2017 Austrian Frederick and Lillian Kiesler Private Foundation, Vienna.

instantiated in the art of automatic writing, hypnosis, and dream theory and generated a history of imagery, from early cave drawings to Marcel Duchamp's paintings, to clarify the interrelationships and physiopsychological sources at the origins of art. These studies enlivened their work and served to elaborate a series of diagrammatic sketches on environmental, hereditary, and intuitive forces acting on the mind and body in the art of plastic creation.

From their research, Kiesler and his students derived their own map of the mind and invented a model of sensory perception wherein the *physis* and *psyche* coexist within a continuous field of environmental and technological forces. They considered experience osmotic, habitual, and sensual, where qualities and intensities passed through semipermeable surfaces of networked internal and external nervous systems. They determined that manufactured technology coexists with the body—bound in continuum—whereby the visual apparatus makes cuts from the surrounding immanent field of matter, only to reconstitute unique spatial perception through memory. Space, Kiesler observed, is really a construct of recognition, because "what appears to be space is [simply] an illusion of it, merely a succession" of transpiring sensorial images coordinated in time.[75] Because succession is so rapid, conscious perceptions seem retrospective. Events are not known in the moment but choreographed in the body—like a quality, intensity, or feeling. Spatial perception is habitual.

Designed to investigate the processes of choice, feeling, and action associated with aesthetic perceptions, the Vision Machine potentially demonstrated the intimate processes of spatial imagination by simulating human memory, perception, and bodily affect. Like Bergson in *Matter and Memory*, Kiesler studied the body as a zone of indetermination, as a screen that makes cuts in a field of excess images through choice selections that define subjectivity and personality based on individual needs.[76] Where Bergson ideally hoped to return life to an immanent state of being by restoring plastic continuity between perceptions and needs (not limited by conscious attention), Kiesler proposed to construct prosthetic devices that would enable human beings to live in greater continuity—habitually and autonomically—with their surroundings. Kiesler aimed in this regard to design architectural machines that could heal what he called the split between "fact" and "vision" (matter and memory) by facilitating processes of human discernment, and streamlining perceptions and actions.[77] His research points toward what Paul Virilio would later describe as a "new

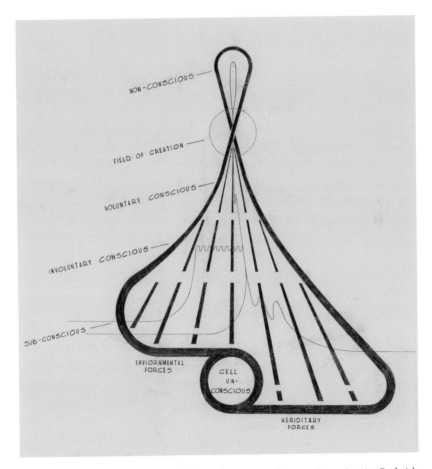

Figure 3.18 Frederick Kiesler, Vision Machine study, 1937–1941. Diagram. © 2017 Austrian Frederick and Lillian Kiesler Private Foundation, Vienna.

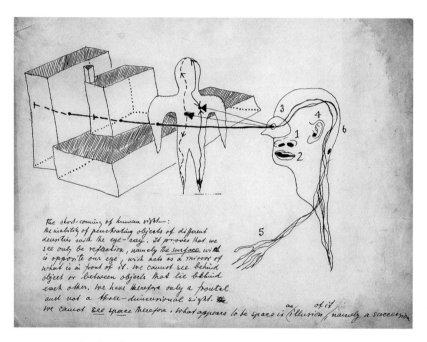

The short-coming of human sight—:
the inability of penetrating objects of different
densities with the eye-ray. It proves that we
see only be refraction, namely the surface with
is opposite our eye, with acts as a mirror of
what is in front of it. we cannot see behind
object or between objects that lie behind
each other. we have therefore only a frontal
and not a three-dimensional sight. ✳
we cannot _see_ space therefore, what appears to be space is (illusion/namely a succession
 an of it)

Figure 3.19 Frederick Kiesler, Vision Machine study, 1937–1941. Diagram. © 2017 Austrian Frederick and Lillian Kiesler Private Foundation, Vienna.

industrialisation of vision."[78] Kiesler's Vision Machine aimed to harness the central nervous system and externalize the imagination and creative cycle in order to instrumentalize it for the use of the design industry. He wanted his research to provide artists and architects effective understanding of creative and optical sensibilities in order to support the design of more continuous forms of productivity. By all accounts, however, his efforts failed miserably.

The Vision Machine was never built. In the words of Fuller, the laboratory "assumed far too pretentious a plant and budget, … their approach to design … [was] self-deceptive, … [and] they start[ed] with scientifically outmoded limitations." He berated Kiesler's "esthetically emotional exclamations of 'apperception,'" calling them "fatuous." "In short," Fuller argued, the laboratory "looks like an innocuous and unconscious racket."[79] Others would agree. Eugene Raskin of *Pencil Points* publicly denounced Kiesler's theories of correalism and biotechnique as being nothing more than mere "Cerebrationism & Vacuotechnique."[80] Kiesler faced significant opposition to his research agenda, and in 1941 the Design Correlation Laboratory was permanently shut down at Columbia. Although Kiesler attempted to remain on campus with support from external research funding, in June 1942 he was asked to vacate his office, arguably because of a shift in priorities during the Second World War.

Research as Method

Despite his sometimes nonlinear, esoteric, and often misunderstood popular scientific approach to design research, Kiesler's innovative ideas and methods at Columbia proved highly productive. His laboratory research in the construction of the Mobile Home Library and design of the Vision Machine supported his innovative practice in exhibition, housing, and theater design from the 1940s through the 1960s. The Vision Machine, for example, inspired several of his optical displays for Peggy Guggenheim's Art of This Century galleries in New York City in 1942. Additionally, his biotechnical studies into the correlation between bodies, technology, and the environment culminated in a unique organic architecture by the late 1950s and early 1960s, exemplified by his Endless House and Universal Theater projects.

Kiesler's laboratory research also had an immediate impact on major educational institutions across the United States. Wells Bennett at the University of Michigan was convinced that Kiesler's innovative model for design research held great promise and consulted with him to establish similar scientific methods to design problems at Michigan. Cooper Union debated opening a laboratory of design correlation in the 1940s. Walter Gropius at Harvard University in the 1940s promoted scientific study of vision and perception that was similar to Kiesler's work. In addition, Moholy-Nagy invited Kiesler to lecture on design correlation in Chicago several times, and Kiesler received similar invitations from several major architecture schools throughout the United States over the following years.

The most significant interest in Kiesler's laboratory was by George Howe, the chairman of the Yale University School of Architecture, who in the 1940s discussed Kiesler's innovative approach to design education with him and then invited him to develop his research at Yale in 1951 and 1952. Committed to introducing design research to the Yale School of Architecture, Howe provided the opportunity for Kiesler to revive his laboratory agenda with specific focus on biotechnical analysis. At Yale, Kiesler asked his students in the second-year curriculum to study the design and construction of a chair using research methods similar to those developed for the Mobile Home Library. His student Benjamin B. DuPont maintained a complete notebook on the Yale assignments. He included sketches of "Fixed & Variable" chair dimensions and a chart of "Feelings observed from sitting in [a] test rig" with the back "adjusted to best position." He also made a study of feet and legs extended with knees up and crossed for best back comfort and included a "Progressive Contact Support Study" showing steps from minimum contact to a fully relaxed position that included the body reclining with all fatigue points supported. For the final assignment, DuPont designed a seat with an expandable, soft cushion back to support multiple positions of the body "superimpose[d with] additional areas for shifting, manufacture, and tradition."[81] The Yale research assignment was based on Kiesler's design for his own remarkable chair for the Art of This Century galleries, which could be repositioned for a variety of purposes; it could be lifted and moved about different rooms as needed to interact with the body in multiple positions, standing or sitting, and could be modulated and shaped to shifting motions.

Kiesler's pedagogical aim was not necessarily to teach students to think for themselves by inventing the program and design of their own creative ideas, but to teach them to learn how to think critically and independently in response to their professor's original design research. In the final years of his Columbia laboratory, for example, students devised several independent projects that developed Kiesler's ideas: Kaufmann designed a flexible reading lamp; Bartos started a sociological study of the family; Florence Doe prepared an outline for an investigation of primitive dwellings for emergency shelters and early housing in China; Paula Mann prepared a bibliography on color; and Stark designed an inexpensive linear-wall library.[82] Kiesler's pedagogical plan was similar to the laboratory sciences' model, which sets out to teach students research as a method so that they might learn to generate original experiments. Although this form of education teaches students to begin their research in response to a particular school of thought, it creates an ongoing dialogue between generations interested in evolving new design trends.

Kiesler's innovative laboratory research challenged the normative practices of his time. His teaching methods, although similar to those of Charles and Ray Eames, George Nelson, and others, were still surprisingly controversial even in the early 1950s. Howe had hoped to establish a permanent position for Kiesler to teach a design research seminar at Yale, but the university determined that Kiesler's research philosophy and methods were not appropriate to the larger educational goals of the institution, and he was not invited to return. The postwar climate required far more direct and practical training of young architects in order to address the need for more housing and institutional building, and speculative methodological research that encouraged critical thinking and challenged functional modern prototypes was deemed inappropriate. Architecture schools were not, it seemed, interested in teaching design students the research skills needed to generate innovative and visionary ideas, but instead intended to train them with the practical design and construction skills necessary to reproduce accepted conventions for mass distribution. "How much money is wasted to teach pseudo-modernism" was Kiesler's retort to this ultimate rejection.[83]

Kiesler, however, equally fell short in his own ambitions to educate students to think about the work they were producing. His work marks a prescient moment in the history of modern design. His laboratory research engaged

artistic and scientific study of dynamic bodily habits and sensorial affects to support shifting biopolitical structures aimed at advancing capitalist markets and evolving control societies.[84] Although his body of work would later suggest alternative and more resistant liberatory applications, his efforts to produce responsive systems designed to modulate to the qualities and intensities of dynamic bodies in motion facilitated a society of unconsciously motivated actions. Kiesler's challenges and failures as an educator remain quite poignant. For, regardless of one's own values or institutional biases, to teach students to unwittingly speculate, experiment, and produce in accordance with their faculty's lead is simply not enough.

Figure 3.20 Frederick Kiesler, Correalist Chair, 1942. Drawing. © 2017 Austrian Frederick and Lillian Kiesler Private Foundation, Vienna.

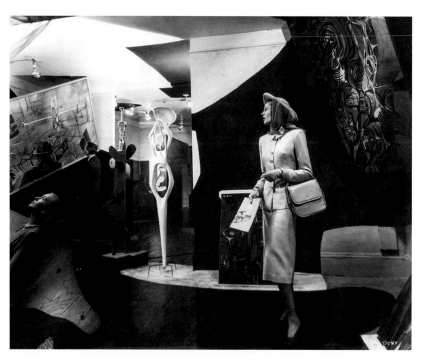

Figure 4.1 Frederick Kiesler, "Bloodflames" exhibition, New York, 1947. Photograph by Constantin Joffé / Vogue. Courtesy of the Austrian Frederick and Lillian Kiesler Private Foundation, Vienna. © Condé Nast.

4 Autonomic Vision: The Galleries

Form does not follow function.
Function follows vision.
Vision follows reality.
—*Frederick Kiesler*

"An end must be brought to the divorce between architecture and painting," exclaimed Nicolas Calas and Kiesler in their 1947 catalog for the Surrealist exhibition "Bloodflames." Attacking Le Corbusier's "pure architecture" of austere white walls, which "ostracize" painting, and Frank Lloyd Wright's views out to natural landscapes that substitute for pictures, Calas and Kiesler proposed a new integration between art and architecture for their exhibition designs. We must challenge the typical gallery, they argued, with its "tame groves of polished objects" and "trimmed plants" that look like "any other expensive object produced for conspicuous consumption." Instead, they proposed "organizing the field of vision" with interrelationships broad enough "to include in one continuum the feeling of painting, sculpture, walls, ceiling, floor and spectators." Unimpressed with Le Corbusier's long-time effort, as Kieser reminds us, to introduce "painting into the … white bleakness of functional design by tinting walls with paint hues of colors and hanging paintings by Fernand Léger," Kiesler presented in "Bloodflames" an oppositional approach to functional design.[1]

The "Bloodflames" exhibition opened at the Hugo Gallery on East 55th Street in New York City on March 3, 1947. It featured paintings by Roberto Matta, Arshile Gorky, Wilfredo Lam, and Gerald Kamrowski; sculptures by Isamu Noguchi, Helen Phillips, and David Hare; and mosaics by Jeanne Reynal. Calas, the curator for the show and a writer for the magazine *View*, was its instigator.[2] He chose the sculptures, paintings, and mosaics while Kiesler designed and painted the architectural layout for the space. Kiesler spent only two and a half days painting and installing the actual exhibit.[3] Yet despite this speed, "Bloodflames" marked a moment of clarity within the scope of his larger lifelong project—his endless research project. The "Bloodflames" gallery realized Kiesler's vision of correlating a seamless organization of disconnected parts into one continuous elastic space, healing the split he believed stood between vision and fact (dreams and reality).

Magic Architecture

So regardless of "whatever the truth may be," Kiesler mused in his incomplete and unpublished manuscript "Magic Architecture: The Story of Human Housing," "with the erection of the first hut" there was a "Split in the Unity of Vision and Fact."[4] While completing his 1942 and 1947 gallery exhibitions, Kiesler wrote "Magic Architecture" to mythologize his intentions to synthesize art, architecture, and humanity with the environment. Writers have often invoked the notion of a primitive hut, cave, or tomb to validate an architect's ideology and/or a building practice (one thinks of Gottfried Semper, Karl Bötticher, Karl Schinkel, Antoine Chrysostome Quatremère de Quincy, Eugène-Emmanuel Viollet-le-Duc, Sir Banister Fletcher, Adolf Loos, and Le Corbusier, to name only a few), and Kiesler proved to be no different.[5] Through his studies of objects from nests, caves, huts, and pyramids to skyscrapers, he realized that in building a world of artificial environments, humanity constructed shelters that distinguished humans from each other and from their natural surroundings. "Nature is Architecture," he imagined, until humanity became "individualized" and began to link "cause and effect in time and space."[6] As humanity learned to discern differences in their world, people became more and more "detached" from their family or group, until they broke apart from any "natural adherence."

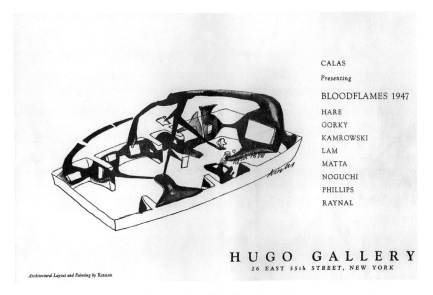

Figure 4.2 Frederick Kiesler and Nicolas Calas, "Bloodflames" exhibition, catalog cover. © 2017 Austrian Frederick and Lillian Kiesler Private Foundation, Vienna.

"Architecture," he argued, will have to "wait" for humanity to again become unified with their environment, if people are ever to bring their dreams together with the facts of reality.[7]

For Kiesler, humanity had once lived autonomically without the ability for abstraction—where sensations, qualities, feelings, and affects guided amorphous relations and "instinct, intuition, imagery and thought," as he argued, were "unified within the nucleus of experience."[8] An "energy of a common origin" bound intelligence and feeling, and "the play of that flow" created an ideal universe of "magnetic fields of great exuberance."[9] For Kiesler "everything [was] ever-present"—nothing was completely dead—"time [was] ... feeling space, and space the objectification of emotion."[10] "There [was] ... only one Reality, and it [was] ... the result of a constant interchange of the visible and the invisible, the dead and the alive. They inter-penetrate[d]. They depend[ed] upon each other. All objects, all configurations [were] ... felt transparently."[11]

In this prehistory as Kiesler described it, Nature provided the enclosure— "trees, rocks, mountains, rivers, the ocean and the sky [were] ... all a part of man's 'shelter.'" "They [were] ... the archi-tectonics of the great structure of the seen and felt universe." Nature's all-nurturing atmosphere guided humanity in the space of pure feelings and emotions. "Soft and elastic," he claimed, the natural environment "yield[ed] to pressure" and "envelop[ed] one's body continuously."[12] Being enveloped and enfolded within a continuous environment proved the basis of Kiesler's primordial myth.

As it was important to Kiesler to reintegrate society in its environment, he proposed to coordinate art and science into a unified building practice. For primitive cultures, he deduced, the "Imagery of Art ...[had] heal[ed] ... the breach in the Unity of man and nature"; so for contemporary society, devoted to the rules of positivism, a synthesis between art and science would be the best way to align humanity within their surroundings.[13] Thus to "eliminate the barriers between art and technology," one must correlate building—"structure, equipment, furnishings, sculpture, and painting"—into an "organic fusion between the physiological and psychological demands" of human existence.[14] "The Hygiene of Functional Architecture," where modern architects "cleaned building[s] inside and outside of ornamental growths ... (Loos)," or where the "human house was nothing but a machine (Corbusier)," for Kiesler could not reconstitute unity.[15] As an outgrowth of his research on

design correlation in the 1930s, he proposed instead to combine "Science that resurrected fact" with "Surrealism that resurrected vision" to design continuous worlds of immanent feelings.[16]

Kiesler aimed to heal the split between what he called dreams and reality, vision and fact, by adapting his prior research on human habits and perceptions to stimulate the perceiving body into a state of pure automatism within a totalizing atmosphere of mediated effects. As art, he observed, elicited viewer perceptions that could affect human actions, he chose to instrumentalize art to create interactive and immersive spatial environments, using optic and haptic techniques to draw viewers into an instinctive relation within their surroundings. His automatist research interests, not surprisingly, appealed to the Surrealist group at the time, and he was commissioned to design a number of gallery exhibitions in addition to "Bloodflames," where he attempted to create continuity between art, the viewer, and the architectural setting. Kiesler's engagement with the Surrealists during the 1940s proved to have an enormous impact on his design opportunities, as he elaborated his research and writing on "Magic Architecture" and his subsequent investigations into shelter design.

Surrealist Relationships

Prior to designing his Surrealist gallery exhibitions, Kiesler had had very limited involvement with the Surrealist group. He was a close friend to Dadaists and future Surrealists Hans Arp and Tristan Tzara in Europe during the 1920s, but when Kiesler moved to New York, those relationships became distant. Save for a series of brief reunion meetings while the Kieslers traveled to Paris in the fall of 1930, Kiesler's relationships to Surrealists was not decisive until he began associating with Duchamp in the late 1930s.

Kiesler had been generally acquainted with Duchamp prior to the 1940s; however, their relationship could hardly be construed as close.[17] Steffi Kiesler worked for Katherine Dreier at the Anderson Gallery managing an exhibition of modern art in 1927, and during that time Kiesler volunteered to design a museum of modern art for Dreier and the Société Anonyme that was never completed. It has been inferred that Kiesler and Duchamp worked together during the planning stages of this museum design, and it is known that Duchamp

and Kiesler actually did attend the same dinner party once in 1933, and another time in 1936.[18] However, it was not until the success of Kiesler's article on Duchamp's *Large Glass*, published in *Architectural Record* in 1937, that Duchamp took much notice of Kiesler.[19]

Kiesler's contact with Duchamp was predominantly through Dreier. Kiesler had visited Dreier's house to make photographs of Duchamp's *Large Glass* on January 28, 1937.[20] Kiesler had also contacted Man Ray around this time, who had worked with Dreier alongside Duchamp at the Société Anonyme, to discuss a portrait of Duchamp Kiesler had seen in Man Ray's hotel room while at the Barbizon Plaza in New York.[21] Kiesler hoped to use these images and other works by Duchamp for his upcoming "Design-Correlation" article. After the article was published, Dreier invited the Kieslers to her home in West Redding, Connecticut, to discuss Duchamp's response.[22] Dreier received a letter from Duchamp, who had seen, as she said, "the wonderful article (*Architectural Record*) on the Glass."[23] Dreier was extremely excited for Kiesler, as she had "never heard him [Duchamp] use such praise."[24]

Kiesler's interpretation of the *Large Glass* was unexpected. It did not focus on the meaning of symbols presented in Duchamp's painted sculpture but more creatively on the technique of its manufacture and subsequent fracture. In contradistinction to glass as a transparent surface that physically separated and visually linked space, Duchamp's "painting" of an "opaque picture" suspended in midair negated, as Kiesler argued, "the actual transparency of the glass."[25] The painting "floated in a state of eternal readiness for action, motion and radiation."[26] The image suspended in "tension" produced what Kiesler had been striving for in much of his own work since his relationship with members of De Stijl in the 1920s. As he wrote,

> nature distinguishes between framework and tensional fillings, both elastic and interdependent, while we build rigidly, inflexibly, lifelessly. The manner of joining parts of similar or of different densities in this interdependence is tantamount to nature and to artifice. Contour design is nothing else but joint. A contour is the illusion of a spatial joint of forms. Joints are dangerous links; they tend to dis-joint (everything in nature is joined and a group of joints is form). Hence, all design and construction in the arts and architecture are specific calculations

for rejoining into unity, artificially assembled material, and the *control* of its decay.[27]

As all architecture is effectively constructed through assembly, "building design must, therefore, aim at the reduction of joints."[28] Kiesler believed Duchamp's work supported a new elastic "contouring"—which built more closely to nature—"with the aim of continuity."[29] Duchamp's joints in the *Large Glass* held the composition together despite the fracturing of the glass plane, and Kiesler argued that Duchamp's work suggested new ways to manufacture buildings more similarly to nature's way of "cell division."[30] Duchamp's method of "precise form articulation" created "ligaments of steel-or-what-not" that "divide[d] all shapes and at the same time link[ed] them!"[31] Duchamp's technique Kiesler compared to the structure of an "x-ray-graph" of a leaf where "the veins … are merely the extensions into the leaf of the chief elements of the stem," which "help to create *turgor*."[32] The veins on each leaf grow to support the skin, networked together in cellular tension. Like Goethe and Francé in their studies on plant morphology, Kiesler looked to the relationship between art and science in nature to discover new ways to construct continuous forms that might control inevitable fracture.

Duchamp and Kiesler met for dinner while Duchamp was visiting New York in February 1938; with Duchamp's support, Kiesler thereafter gained access to the intimate Surrealist circle surrounding André Breton.[33] With the ensuing emigration of European Surrealists to New York during the Second World War, Kiesler reaped the full benefits of his association with the group. He became the only architect recognized as an official member of the group, and his penthouse apartment quickly became a central hub for Surrealist meetings, intimate dinners, and late night gatherings.

Matta was one of the first Surrealists to meet Kiesler in New York, visiting Kiesler's apartment on June 9, 1940.[34] Kiesler and Matta most likely met through their mutual friend, the English painter Gordon Onslow Ford, who had been a frequent visitor to the Kieslers' penthouse in Manhattan. Onslow Ford, Matta, and Kiesler met often together, and when Richter came to New York, he started meeting weekly with the group after May 1941. Nicolas Calas began stopping by at that time, and Breton notably visited the Kieslers with Onslow Ford on August 4, 1941. When Duchamp returned to New York in 1942

from Marseille, the Kieslers attended his welcoming party at Breton's apartment. Duchamp moved into the Kieslers' home in October of the same year. Although Duchamp was not there often, he stayed with Kiesler until October 14, 1943, and they worked intensively together alongside Breton, Matta, and Richter on ideas, exhibitions, and several essays and projects throughout the 1940s.

Murals without Walls

The artists Arshile Gorky and Isamu Noguchi, whom the Surrealists especially influenced during their stay in New York, joined Kiesler and his friends for dinner on several occasions during that exciting time. They had already been visiting the Kieslers' home for several years; Gorky and Noguchi had been dinner companions of the Kieslers certainly since 1933 and 1931 respectively, and Noguchi likely met Kiesler through their mutual association with Fuller and Eugene Schoen.[35]

In defense of his friend, Kiesler wrote an article praising Gorky's mural for the Newark Airport in 1938.[36] Kiesler supported the way Gorky painted the mural on a canvas that floated free of existing walls, arguing that an artist must design a mural in "heterogeneous unity" with surrounding architecture.[37] While an easel painter "has control of the unity" of his work—and even chooses or designs the frame—for Kiesler the mural painter must instead consider the building his frame, designing and situating the painting in response to its environment.[38] Recalling Gottfried Semper's principle of wall dressing (*Bekleidung*), Gorky suspended his mural to form a new architectural space that covered the existing wall.[39] For Semper wall coverings reveal forms of meaning, and Gorky painted his mural, Kiesler argued, to appear two-dimensional, "outflattened," as if the room enclosure.[40] Its two-dimensional surface focused viewer attention on the quality of paint while at the same time forming the illusion of an expansive three-dimensional atmosphere. The painting used abstract images of airplane parts overlapping and gesturing in flight to create illusory space. The mural—not the wall—provided the qualitative spatial enclosure that now defined the surrounding atmosphere.

Kiesler's article spoke to a very important aspect of his own research project. As in constructivist theater designs by Vesnin and Meyerhold, Kiesler had

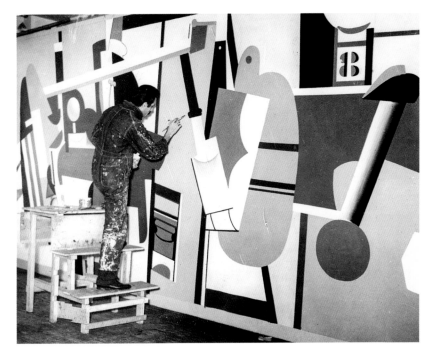

Figure 4.3 Arshile Gorky, *Activities on the Field, Aviation*, 1936. Newark Airport. Courtesy of the Austrian Frederick and Lillian Kiesler Private Foundation, Vienna. © Art Service Project W.P.A.

hoped to eliminate the wall as a spatially defining element, not only in stage and exhibition designs but also in architecture. Buildings should have "NO MORE WALLS," Kiesler had argued; like Semper, he favored temporal solutions that formed elastic spatial expressions.[41] Gorky's floating mural created space in heterogeneous unity with the surrounding environment by using the functional flexibility of paintings as wall coverings. Kiesler applied a similar strategy, using artworks to form spatial environments in all his 1940s exhibition designs.

Art of This Century

With respect and understanding from the Surrealist circle, Kiesler received an invitation from Peggy Guggenheim to design the four new gallery exhibits for her Art of This Century gallery in New York in 1942.[42] Kiesler designed the galleries to display an array of European artwork smuggled from France during its occupation by Germany in the Second World War. The gallery featured a cubist exhibit (Abstract Gallery), a temporary exhibit (Daylight Gallery), and a Surrealist exhibit (Surrealist Gallery), alongside an interactive show of works by Paul Klee and Duchamp (Kinetic Gallery). Kiesler found inspiration for his exhibition from previous Surrealist gallery designs. Most particularly he was informed by Duchamp's design for the "First Papers of Surrealism" exhibition that opened one week earlier in New York for the benefit of French prisoners of war, which featured miles of string threaded through various dolls, idols, ceremonial masks and work by René Magritte, Marc Chagall, and Guggenheim's then-husband Max Ernst, among others.[43] In Duchamp's exhibition, he arguably created continuous interrelationships through the introduction of a framework of string that synthesized space in heterogeneous unity like a wall covering.[44] The intentions of Duchamp's work clearly resonated with Kiesler's writing on Gorky's murals, though the full extent of their working relationship at the time remains unclear.

Kiesler's Surrealist Gallery received perhaps the most attention of his four Art of This Century exhibition spaces. It took advantage of newly developing plywood materials used in furniture and the aerospace industry to achieve a continuous topological surface.[45] The Surrealist Gallery featured a dark tunnel with two curved plywood walls, with paintings suspended on wooden

armatures with flexible metal joints. Presenting a series of images in asymmetrical rhythm that appeared to float in space before the curved spatial background, the layout resembled Herbert Bayer's 1930 "diagram of the field of vision" that biotechnologically studied the limits of perception.[46] Kiesler's spatial atmosphere also promoted visual linkages between images by eliminating frames from all paintings.

Interested in how images interact with the viewer in space, Kiesler constructed several shadow box devices based on his studies of the Vision Machine from his design correlation research in the 1930s. The shadow boxes isolated art through openings in a wall or screen to force the spectator to "focus completely and unnaturally on the object itself."[47] Similarly to Duchamp's rotating disks, *Anemic Cinema*, and precision optic devices, Kiesler's shadow boxes focused conscious perception on a series of successive images—set to motion—to create a sense of illusionary space. One optical machine in the Kinetic Gallery at Art of This Century used a rotary device like a magic lantern to animate a series of images of Duchamp's partially opened *Boîte-en-valise* (1935–1941).[48] Another shadow box device set up between the Abstract and Daylight galleries used an ocular diaphragm surrounded by a series of fisheye mirrors. Opening the lens, one saw Klee's *Magic Garden*, superimposed against the mirror image of the spectator and the Abstract Gallery behind. Closing the diaphragm, one looked up to see Kurt Schwitters's *Relief* suspended within a glass picture frame that revealed part of the Daylight Gallery beyond. When one moved through the door into this distant room, the image space expanded to complete the picture of the Daylight Gallery held in the mind's eye. Then looking back toward the shadow box, the viewer visualized the Abstract Gallery contracted within this same glass picture frame (from this side Arp's *Untitled* (1940) is suspended in the window frame). This last framed image then became superimposed against the series of afterimages in memory reflected within the shadow box device. Perception fluctuated between these successive images unfolding through time, creating the sense of an elastic spatial continuum between the rooms.[49]

The Vision Machine and the subsequent shadow box devices were designed, Kiesler wrote, as "instrument[s] to facilitate the co-reality of fact and vision."[50] They "specifically ... demonstrate the transformation of images into eidetic visions," he claimed, in that they stimulated a zone of optical perception between *objective* bodily sensations and *subjective* pictorial images.[51] Within

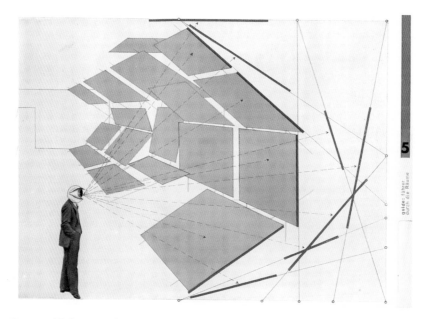

Figure 4.4 Herbert Bayer, "Diagram of Field of Vision," Bauhaus Typography Collection, ca. 1930. Courtesy Getty Research Institute, Los Angeles (850513). © 2017 Artists Rights Society (ARS), New York / VG Bild-Kunst, Bonn.

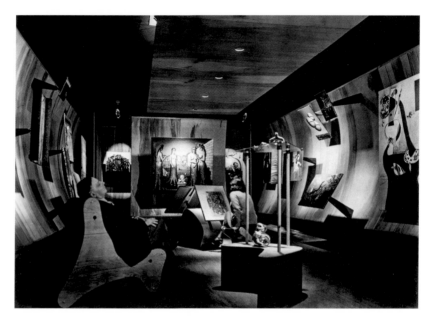

Figure 4.5 Frederick Kiesler, Surrealist Gallery, Art of This Century, 1942. Photograph by Berenice Abbott. Courtesy of the Austrian Frederick and Lillian Kiesler Private Foundation, Vienna. © Getty Images.

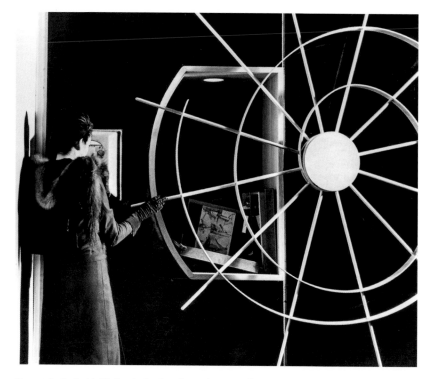

Figure 4.6 Frederick Kiesler, shadow box device, Kinetic Gallery, Art of This Century, 1942. Viewing mechanism for Marcel Duchamp's *Boîte-en-valise* (1935–1941). Photograph by K. W. Herrmann. Courtesy of the Austrian Frederick and Lillian Kiesler Private Foundation, Vienna.

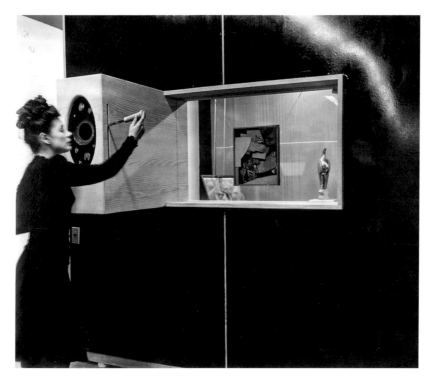

Figure 4.7 Frederick Kiesler, shadow box device, Abstract Gallery, Art of This Century, 1942. Kurt Schwitters, *Relief* (1923) suspended on this side of the window frame. Photograph by Berenice Abbott. Courtesy of the Austrian Frederick and Lillian Kiesler Private Foundation, Vienna. © Getty Images.

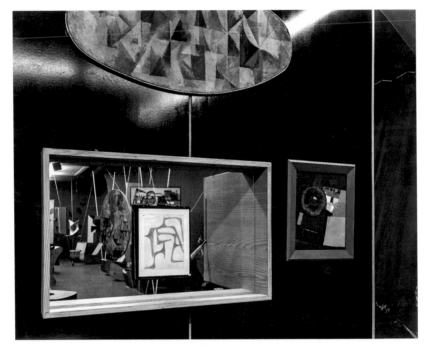

Figure 4.8 Frederick Kiesler, shadow box device, Daylight Gallery, Art of This Century, 1942. Views Robert Delaunay's *Windows Open Simultaneously*, with Abstract Gallery seen beyond with Hans Arp's *Untitled* 1940) suspended on this side of the window frame, creating a succession of images and their afterimages. Photograph by Berenice Abbott. Courtesy of the Austrian Frederick and Lillian Kiesler Private Foundation, Vienna. © Getty Images.

this *zone of indeterminacy*, neither subjective nor objective, eidetic images constitute a virtual depository of endless images in the process of becoming.[52] They stream forth in memory between two poles of the imagination, as ideas and afterimages. Surrounded within a world of virtual images, the Vision Machine and shadow box devices simulated not only conscious perception by taking snapshots of passing reality, but the imagination correlating together images through memory to create new ideas/forms.

The shadow box devices and the Vision Machine functioned similarly to his Saks Fifth Avenue show window displays. In all of them, perception worked similarly to a series of photographs that fragment and immobilize time, as Bergson might describe, into "fixed" moments of consciousness, while our memory "solidifies into sensible qualities the continuous flow of things."[53] Perceptions were seamed together into continuous articulations. The first shadow box device created a spatial continuum limited to the imagination, while the second device actually began to activate the body to move about among a series of continuous spaces.

Richter's *Stalingrad* scroll, featured in the Daylight Gallery of the Art of This Century, demonstrated the effects of these optical techniques. In Richter's scroll, images situated in dynamic patterns produced tension *unconsciously* in the continuous movement of the eye with the "accumulated energy" released, as Richter described, "into actual movement."[54] "Sensation lay in the stimulus which the remembering eye received by carrying its attention from one detail, phase or sequence, to another that could be continued indefinitely. … [I]n this way, the eye [is] … stimulated to an especially active participation, through the *necessity of memorizing*."[55] As the eye is directed between a series of images and their afterimages in memory, haptic stimulation is impressed upon the viewer—and then released through movement of the body in motion.

Surreal Impressions

Kiesler employed these visual and spatial tactics in all his 1940s exhibition designs to stimulate the imagination and invite the unconscious mind and body to wander. The Abstract Gallery featured a series of images suspended off the wall, wrapped within the scroll-like enclosure of a sinuously curved spatial

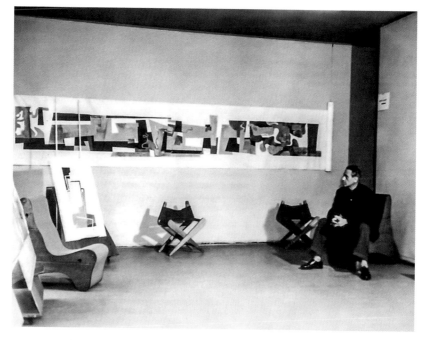

Figure 4.9 Frederick Kiesler, Daylight Gallery, Art of This Century, 1942. Hans Richter seated next to his scroll *Stalingrad, Victory in the East (1943–1944)*, 1946. Courtesy Virginia Dorazio Dortch.

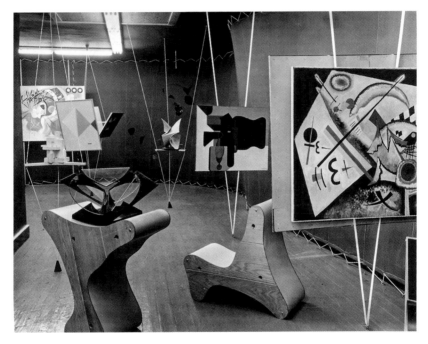

Figure 4.10 Frederick Kiesler, Abstract Gallery, Art of This Century, 1942. Photograph by Berenice Abbott. Courtesy of the Austrian Frederick and Lillian Kiesler Private Foundation, Vienna. © Getty Images.

backdrop.[56] "Geometrically severe" art was often displayed in Kiesler's postimpressionist exhibition designs with a "distracting jumble of effects," as Edgar Kaufmann Jr. remarked in his review of the galleries at Art of This Century.[57] With the eye set to distracting images of wonder, the body moved habitually—autonomically—about the galleries. The "viewer … [was] led around the room by the eye, and shown objects singly, but in no special sequence," Kaufmann commented.[58] Passing into the Surrealist Gallery space between two curved plywood walls and a looming plywood ceiling and sinuous linoleum floor, one found pulsating lights moving in rhythmic distracting succession that focused concentrated attention upon the individual images, while a roaring sound like an approaching train was heard in the background. "It's dynamic, it pulsates like your blood," as Kiesler described it.[59] The flickering movement imposed by "the lights going on and off automatically" in the Surrealist Gallery, Kaufman suggested, created an equally complicated effect.[60] Too shocking, the automatic feature had to be permanently switched off.

Kiesler's 1947 "Bloodflames" exhibition at the Hugo Gallery streamlined these multimedia spatial effects. The visitor to this exhibition was immediately pulled into a vortex of distracting images upon entering the room. "My eyes have never bulged farther from their sockets," abstract expressionist painter and newspaper critic Ad Reinhardt exclaimed, attempting to "resist … being ushered into the anguished, amorphous world of some of the pictures."[61] "Matta's dental equipment, Kamrowski's digestive tracts, and Lam's sexual jungle" grabbed one's focused attention, wrote another critic. Matta's pictures even "appear able to move about and to pinch you with metal fingers and crush you with metal arms."[62] Angled on the ground, twisted on the wall, or hanging from above, the arrangement of works forced the eye and in turn the body to shift back and forth continuously.

Lured toward the central image of Lam's *Eternal Presence*, the viewer entered a peep show chamber, as one critic abashedly remarked, to stand "bride-like under the white-veiled canopy as long as my neck could take the strain of staring at the ceiling."[63] Induced to sit in one of Kiesler's modular chairs to view the painting hung from the ceiling, the body cranked and twisted to one side while looking up at the image. A path delineated like a Möbius strip—an endless strip—through the gallery spaces invited the eye, and in turn the body, to move unconsciously about the room within a labyrinthine maze. From image

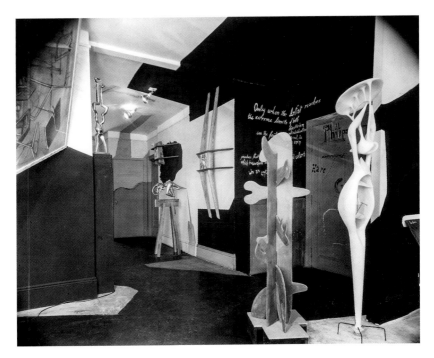

Figure 4.11 Frederick Kiesler, "Bloodflames" exhibition, New York, 1947. Photograph by Bernice Kaufmann. Courtesy of the Austrian Frederick and Lillian Kiesler Private Foundation, Vienna.

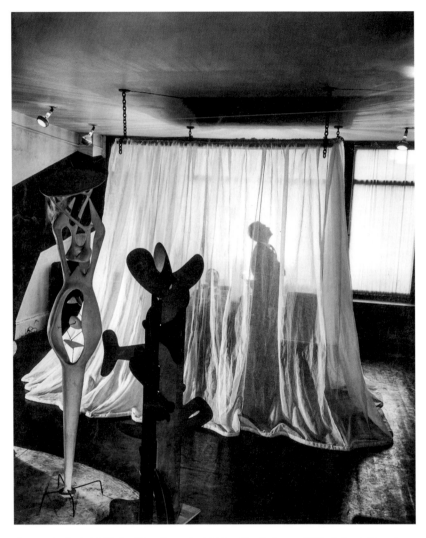

Figure 4.12 Frederick Kiesler, "Bloodflames" exhibition, New York, 1947. Wilfredo Lam's *Eternal Presence* viewed hanging from the ceiling. Courtesy of the Austrian Frederick and Lillian Kiesler Private Foundation, Vienna.

to image—from moment to moment—time merged into an expansive space. As in his Saks Fifth Avenue show window displays, Kiesler created environments of contraction through focused image and of expansion through undulating surface. Individual works of art were seamed together by the autonomic motion of the viewer along the path of exhibition. Contents of fantastic imagery alongside the surging darkness of the room served to support a dreamlike state of Surrealist awakening, where the dreaming self became a relaxed self—open to suggestion—among a flow of internal remembrances.

All of Kiesler's exhibition designs used cinematographic techniques that he discovered in the early experimental animations made by Richter and Eggeling to diffuse the boundaries between subjects and objects. The galleries in effect enacted a spatial sequence of events that simultaneously controlled bodily action while liberating the imagination, as they incorporated the viewer unconsciously into the dynamic space of the artworks on display. The optical and tactile spatial effects moved participants about the room in a nonsequential and distracted manner, providing opportunity for accidental correspondences and affinities to develop between varied images and ideas in accordance with past personal experiences. Utilizing exhibition tactics notably employed by Bayer and Duchamp among other modern designers, Kiesler began to construct a spatial environment that enveloped the viewer, synthesizing the objects on display with the subject of the event to form a cohesive spatial environment that began to blur the distinctions between art objects and exhibition architecture. A theater designer with allegiances to totalizing design practices from Wagner, Appia, and Craig to Meyerhold, Vesnin, and Prampolini, Kiesler emphasized synthesizing actors and spectators—artworks and moving participants—to imaginatively participate within the creative world proposed in the exhibition.

Kiesler was attempting, as Bergson described in his less-known work *The World of Dreams,* to understand how memories "spring forth" as afterimages incited by sensation and stimulation that can produce dreams.[64] For Bergson, dreams are the products of afterimages immanent to matter that spring forth when the conscious mind has become relaxed and we "stop willing." In autonomic—aconscious—states "disinterested" and surrounded by bodily sensations, visual, aural, and tactile, Bergson understood that a dreamer is caught in *suspended animation*, open to a flow of suggestion from both *external* and *internal* stimulus. As Bergson argued, "a dreaming self is a relaxed self. It

Figure 4.13 Frederick Kiesler, "Bloodflames" exhibition, New York, 1947. Wilfredo Lam's *Eternal Presence* viewed hanging from the ceiling. Courtesy of the Austrian Frederick and Lillian Kiesler Private Foundation, Vienna.

welcomes most readily incidental, *distracting*, remembrances not characterized by effort."[65] As the conscious mind relaxes to some extent and attention begins to wander, afterimages of memory start to flow forward. These remembrances enter into consciousness in response to visceral, aural, and visual stimulation. As Bergson had observed, conscious perception contracts to make select cuts from an immanent field of images (matter), while in *afterimage* memory reconstitutes spatial experience—cinematographically.

For Bergson, however, the cinematographic effects of spatial perception present us with "a series of pictorial, but discontinuous, views of the universe," which concerned him immensely.[66] Selected images choreographed in memory create a *false sense of spirit and reality*, he believed.[67] Instead he imagined an ideal state of being not limited to the false experience of cinematographic perception, where "subject and object would unite in an extended perception, the subjective side of perception being the contraction effected by memory, and

the objective reality of matter fusing with the multitudinous and successive vibrations into which this perception can be internally broken up."[68] Bergson believed "we [could] touch … reality … in an immediate intuition" and thereby "grasp them [instantaneous visions of the real] in one relatively simple intuition, an endless number of moments of endlessly divisible time."[69] He hoped humanity could "eliminate all memory" and live immanently in an autonomic state of pure perception and pure memory in pure duration.[70] No longer subject to quantified spatial dimensions of false perceptions and measure, Bergson imagined humanity would again "arrest and retain that which is virtual" outside "cause" and "effect" and exist within an "extended *continuum*" in immediate "action" and "correlation" of mind, body, and soul.[71]

Like Kiesler, Bergson believed a split had occurred between reality and vision. According to Benjamin, however, Bergson's invocation of a pure state of automatism only proved to form a theory of "fictitious characters who have

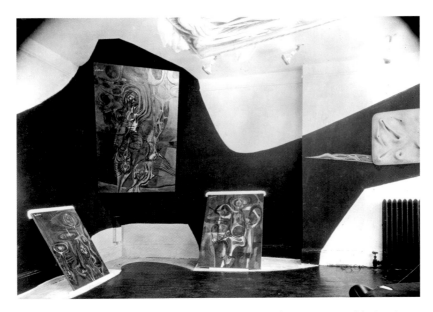

Figure 4.14 Frederick Kiesler, "Bloodflames" exhibition, New York, 1947. Courtesy of the Austrian Frederick and Lillian Kiesler Private Foundation, Vienna.

… completely liquidated their memories," as if in a horror story by Edgar Allan Poe, to live "their lives as automatons."[72] Bergson's philosophy, even if desirable, according to Benjamin was realistically unattainable; it would require us to become effectively robots.

Kiesler's gallery designs ultimately did not function as Bergson would have imagined. Instead they performed more like Benjamin's interpretation of Proust, who had at one time endeavored "to produce experience, as Bergson imagines it, in a synthetic way under today's social conditions."[73] In Kiesler's galleries, viewers were distracted and motivated into semiautonomic states of awakening in which images presented through shock effects might pass through to the psyche. "Parried by consciousness," in a state both conscious and unconscious, these incidents as Benjamin argued would not sterilize poetic experience (*Erfahrung*) but instead associate with the unconscious in memory.[74] Viewers would experience qualities, feelings, and affects in correlation with experience through surreal recollection. According to Paul Valéry, as Benjamin had argued, "recollection is … an elemental phenomenon which aims at giving us the time for organizing 'the reception of stimuli' which we initially lacked."[75] In Kiesler's Surrealist galleries, a series of distracting if not shocking images juxtaposed in *heterogeneous unity* hoped to invoke surreal recollection in viewers that initiated the psychic benefits of dreaming.[76]

Kiesler had long been interested in satisfying the *physis* and the *psyche* of the dweller, which was the hallmark of his theories on shelter design in which he adamantly spoke against modern functionalism in favor of an architecture that might produce more favorable psychic conditions.[77] In his research practice, he hoped to heal the split between reality (matter) and dreams (memory) by inducing intensive, qualitative, spatial atmospheres through cinematographic techniques for curative effect. There is a cathartic effect to dreams which is not so different from the experience in watching television or certain films which "trigger a therapeutic release of unconscious energies," as Benjamin put it.[78] As the body rejuvenates at rest, the psyche works out unresolved tension and stress.

Kiesler used shock effects to stimulate autonomic experience, which aligned with Breton's longtime interest in deriving a state of automatism in Surrealist practice. Breton's Surrealist manifesto of 1924 defined Surrealism as "pure psychic automatism" in spontaneous creative production, without conscious moral or aesthetic self-censorship.[79] Breton and Philippe Soupault had

written the first automatist study, *Les Champs magnétiques*, in 1919, and Breton elaborated their proposal in "The Automatic Message," published in *Minotaure* in 1933.[80] In their practice, the Surrealists studied "autonomic, involuntary habit[s]" to derive ways to evade the "control of the thinking man" to produce more creative art, which informed their research into automatic writing and its machines.[81] In inducing autonomic states, Breton hoped to access "*eidetic* (aesthetic) image[s]" that would transform the study of everyday objects into "infinitely changeable" art forms.[82] Breton had a "direct interest" in overriding "the distinctions between [the] subjective and objective"—in activating the unconscious through habits of the autonomic nervous system.[83] Breton's and Kiesler's similar interests in autonomic states of sensation and action supported their strong mutual affiliation.[84]

Kiesler developed his study of eidetic images in his Laboratory of Design Correlation from his reading of E. R. Jaensch's *Eidetic Imagery*.[85] Kiesler and his students had transcribed extensive passages of this book while compiling a seven-page study of automatism, habits, and eidetic imagery.[86] As his relationship with the Surrealists developed in the 1940s, Kiesler incorporated a wider range of psychoanalytical studies into his research and writing, including works by Freud. Although Kiesler had taken an early interest in Freud, most of the relevant books in his library, including *The Basic Writings of Sigmund Freud*, as well as *The Interpretation of Dreams*, *Totem and Taboo*, and *Three Contributions to the Theory of Sex*, were obtained after 1938.[87] Working with the Surrealists, Kiesler read Freud's *Leonardo da Vinci, a Study in Psychosexuality* and José Corti's *Surreálisme et psychologie*, and began to refer to Freud more often in his writings.[88]

Although Kiesler was enamored of the science of "pragmatic naturalism," the mythological aspects of his theories of art and life derived not only from the natural sciences but from psychoanalysis. As he explained in "Magic Architecture," "pragmatic naturalism … leaves us, as it often does, with the feeling that we have made art too resolutely functional, too outward looking, too optimistic," and although "psychoanalysis may be misleading as psychology … the 'pleasure principle' and the desperate 'instincts' of sex and death give myth a dramatic richness unknown to contemporary pragmatism."[89] Effectively Kiesler found the scientific research that had dominated his interests in the 1930s too limiting. On the complex emotional and physical needs and desires latent in

the study and practice of architecture, he turned in his later work to the study and application of Freudian psychoanalysis and its theory of the drives.

Freud originally introduced his theory of the sex and death drives in *Beyond the Pleasure Principle* as a response to the trauma of the First World War.[90] In *Beyond the Pleasure Principle* he evolved his study of dreams beyond pure wish fulfillment, as he had left it in his *Interpretation of Dreams*, to include the study of shock (which notably informed Benjamin's theories on memory and perception). With *The Ego and the Id*, Freud completed his revisions to his theory of the sex and death drives, which Kiesler began to incorporate into his automatist ideas while working with the Surrealists and writing "Magic Architecture" in the 1940s.

For Kiesler and the Surrealists, the automaton was "associated with each of the two classes of instincts" as understood by Freud: the death instinct— "the task of which is to lead organic life back into the inanimate state"—and Eros, which "aims at complicating life and at the same time preserving it."[91] The Surrealists, as Marcel Jean had explained, originally borrowed the word automatism "from psychiatry [as it] … designates involuntary, unconscious psychic-poetic happenings."[92] Automatism "contained the passion mixed with anguish of human beings in their relationship with machines that seem always to be on the point of liberating themselves from their creators and leading an autonomous existence."[93] Although fear of the machine and its inevitable autonomy is latent in the passion for automatism, it provided the ultimate fantasy of humanity's liberation from its own mortality.

Like Mumford's dream of a biotechnic period when humanity would one day merge completely with technology, or the fear and exuberance of robots expressed in Čapek's play *R.U.R.*, automatism aimed to produce doubles, inanimate automatons, which both Freud and Otto Rank posed as symbols of repetition behind fantasies of immortality.[94] Conflating the inanimate double with animate being, automatism for Breton, Mumford, Bergson, and Kiesler— even if each conceived it differently—hoped to achieve a state of "nirvana" or paradise lost.[95] Automatism relied on the magical promises of technological progress to create a posthuman fantasy of primordial unity. Breton's "vow … *to return to a habitable world*," he declared in exile from Europe in *VVV* magazine in 1942, corresponded well to these hopes.[96] Having left Europe during the war, the Surrealists now seemed homeless, conjuring nostalgic images of the

uncanny in their repressed fantasies of returning to an ideal home.[97] Perhaps Kiesler and the Surrealists shared an interest in working together, in New York during the war and on their return to Paris immediately thereafter, because of a shared hope of recreating a lost paradise.

Hall of Superstitions

Following the great success of both Art of This Century and the "Bloodflames" exhibition, Kiesler traveled to Paris to help finish Duchamp's design for the first international Surrealist show since 1938, held at the Galerie Maeght in Paris in 1947. With the end of the war, Kiesler went to Europe with great enthusiasm to produce a remarkable collaborative work. The "main purpose," of the exhibition, Kiesler recalled, "was to have artists and sculptors make new works to be integrated with new architecture, lined and bound together by a poet's vision."[98] The Hall of Superstitions, however, would be his last Surrealist exhibition design.

The "International Exposition of Surrealism" proved an enormous undertaking that combined over 125 paintings, photographs, and sculptures by artists from over 19 nations.[99] Breton had replaced Marxist and Communist ideals with his fascination with dreams, and the exposition hoped to reunite the Surrealists upon their return to Europe.[100] Arriving in Paris, however, Kiesler found the collaborative spirit after the war completely lacking. "When I followed the call from New York to France to transform the two floors of the Maeght gallery in Paris into a world of surrealism," he recalled, "I encountered with the exception of A. Breton, who headed the idea, and Monsieur Maeght, who lent his place for it, nothing but resistance after resistance from the participating painters, sculptors and workmen to the work to be done."[101] Paris, Kiesler explained was filled with "perpetual melancholia." The city withheld cooperation and failed to deliver materials and labor. "What a call to adventure in the plastic arts," Kiesler remembered, and yet "no one cared to participate. Agony, despair, resentments all around." The political and economic life of Europe seemed hopeless at that time to Kiesler, and the biggest obstacle he felt to the collaborative spirit proved the subjective "personal jealousies" and "idiosyncratic personalities" of the artists who refused to work together.[102]

Placed in charge of the design for the Hall of Superstitions, a key part of the exposition, Kiesler began to coordinate works by Joan Miró, Duchamp, Matta, Yves Tanguy, Max Ernst, Hare, and Maria Martins. Kiesler's solution to the discord was to allow the artists to work together as "free coordinates," as he explained. He gave them enough leeway to produce their own individual works, yet enough of a framework to maintain a successful result. Kiesler and Breton provided the conceptual framework—a vague notion of superstition—and Kiesler collected all the works within an endless ribbon of space. As he remembered,

> they all followed the composition of the so-called paintings (they were actually free coordinates) without obvious resistance. They were given enough leeway within the framework of the original concept *not to feel dictated*, but most important: the poet's idea of expressing together the impact of "superstition" was powerful enough to mouthshut any stubbornness to collaborate. Once they were involved in their individual craft they became more and more linked to the idea, and to the complex intricacies of the whole complex.[103]

In his gallery design, Kiesler gave the artists enough freedom not to feel overly controlled as they conformed to Breton's ideas. Kiesler created a loose framework that linked the disparate artists together within an "enveloping architecture."[104] "The seduction by a poet" and the blindfolded enthusiasm of a belief in chance "converted sordid resistance into *blinding* correlation," Kiesler explained.[105] Despite the recent fascist politics of war, he remained hopeful that individual spirit might flourish under a unified organization.

Similar to Richter and Eggeling who had hoped to establish a universal language through abstract art that might reconstitute world relationships fractured catastrophically during the First World War, Kiesler hoped to satisfy the physiological and psychological needs of a war-torn society by healing the split between vision and fact. Yet in light of the horrific consequences of extreme nationalism, fascism, and ethnic cleansing during the Second World War, any attempt to reconstruct totalizing unity at that time proved suspect. War had been traumatically destructive, as had attempts to reconstruct world structures under unifying nationalist dogma that became fascist. Kiesler's attempt to fuse vision and reality in a state of automatism suggested a frightening proposal—a

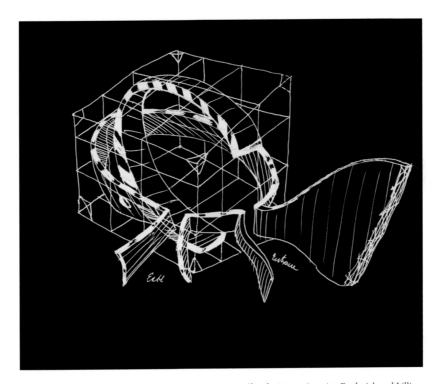

Figure 4.15 Frederick Kiesler, Hall of Superstitions, 1947. Sketch. © 2017 Austrian Frederick and Lillian Kiesler Private Foundation, Vienna.

return to primordial instincts devoid of intellectual debate, criticism, personality, diversity, subjectivity, and choice.

Art historian T. J. Demos has most recently criticized Kiesler for his attempt to recreate an affective atmosphere of primordial unity in his Surrealist Gallery at Art of This Century.[106] Kiesler, according to Demos, created an environment that enabled Surrealist homesick fantasies approaching nationalist if not fascist dogma. Although Kiesler was hardly a fascist and had little power, money, or control, he did perhaps too ideally believe in the promise of the *Gesamtkunstwerk* to synthesize humanity and its surrounding environment into a perfect work of art. Extrapolating ideas from theater for his exhibition designs, and ultimately his architecture, he wanted desperately to coordinate people and their surroundings within a semblance of order and control. "We, the inheritors of chaos, must be the architects of a new unity," he insisted; and his passion to incorporate multiplicity in spatial continuity dominated his ideas regardless of historical, cultural, or political context—the actual environment—in which he worked.[107] Inclusivity, multiplicity, heterogeneity, and diversity are all twentieth-century liberal ambitions, which historically face governing principals of order, control, organization, and normalization. Kiesler's exhibition designs posed strategies for blurring these distinctions within innovatively engaging elastic spatial conditions that arguably produced an exemplary space of Surrealist awakening that incited a new sense of familiarity and ease.

The Hall of Superstitions Kiesler believed proved his most complete work of art, and over 1,500 curious Parisians climbed the twenty-one gallery stairs to enter the Hall on opening day.[108] Breton had hoped the exhibit would evoke "a primordial concern to retrace successive stages of an initiation."[109] Each visitor had to enter Kiesler' Hall of Superstitions before seeing the larger exposition. "To cure man of his anguish," as Arp suggested, Kiesler led visitors into the Hall past Kiesler's *Anti-Taboo Figure* of a large plaster arm and hand with pointed thumb.[110] There Kiesler confronted the visitor with his *Totem for All Religions*. As he described in "Magic Architecture," these figures represented life as a continuity of cycles, where

> death as we understand it does not exist. Death is rather a punishment, a damnation. It is an act of being ordered into Exile; from there you watch your family; from there you participate in their lives. You

become part of their Totem, or you impose Taboos. You either take revenge or help them. Particularly through dreams you take an active hand in their <u>everyday</u> affairs.[111]

Referring to Freud's *Totem and Taboo*, Kiesler's *Anti-Taboo Figure* announced Surrealism's afterlife—its return from exile to participate in everyday Parisian affairs—through both dreams and totems. In light of recent tragedy, Kiesler's totem spoke to all religions dispersed throughout the world from Babylon to Tibet, including Buddhism, Hinduism, and Orthodox beliefs.[112] Kiesler built his totem ideally to protect freedom of religion while shunning taboo and the superstitions that form prejudice and enable fear.

In the Hall of Superstitions, endlessness served as the organizational strategy to seam the ceiling, floors, and walls together with the artwork into one continuous free-flowing spatial form. Intertwining curvilinear ribbons in crocus-yellow broke turquoise cloth walls that surrounded and supported the various works.[113] Ernst painted *Black Lake*, the "Feeding-Source of Fear," along the ground, while a scantily clothed woman lounged in the spotlight as she "nourishe[d] … anguish."[114] *Waterfall* by Miró "congealed by superstitions," cascaded along the ribbon.[115] Hare suspended his *Anguished Man Sculpture* beneath the color bow, while Matta composed *Whist* with the "luck of the owl, crow, bat, woman" open to view from a hole in the wall.[116] Surrealist fantasies of sex and fear—desire, consumption, and anguish—were *correlated* into a total work of art. The Hall of Superstitions performed as a unified environmental sculpture, but unlike in Kiesler's past exhibitions, the series of artworks also composed a narrative theme. Despite conflict among them, the artists represented there had a common aim—to relieve passersby of their fear and suffering by evoking their dreams and superstitions and allowing them an opportunity to imaginatively work through them, as Freud might have imagined.

In the postwar context, however, the Hall of Superstitions didn't work as intended and proved a complete failure; as the critics agreed, the "observers discounted the big talk."[117] If Surrealists had hoped to shock society, their effort appeared delusional and inept. "After the gas chambers, [with] those heaps of bones and teeth and shoes and eyeglasses, what is there left for the poor Surrealists to shock us with?" reacted one critic.[118] The Surrealist exposition of 1947 was "a most depressing spectacle," wrote John Devoluy in the *Art News*: "In

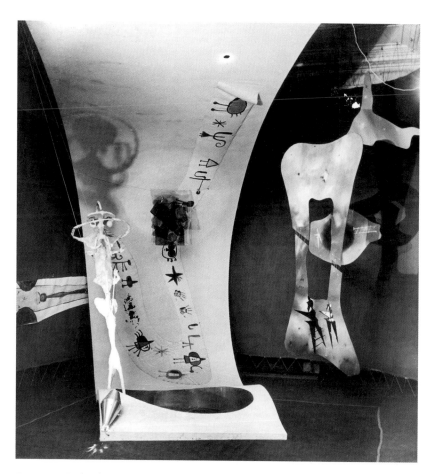

Figure 4.16 Frederick Kiesler, Hall of Superstitions at the "International Exposition of Surrealism," Gallery Maeght, Paris, 1947. Photograph by Willy Maywald. Composition of Miró's *Waterfall*, Hare's *Anguished Man Sculpture*, and Ernst's *Black Lake*. Courtesy of the Austrian Frederick and Lillian Kiesler Private Foundation, Vienna. © 2017 Association Willy Maywald / Artists Rights Society (ARS), New York / ADAGP, Paris.

Figure 4.17 Frederick Kiesler, Hall of Superstitions, 1947. Photograph by Willy Maywald of woman posing near Ernst's *Black Lake*. Courtesy of the Austrian Frederick and Lillian Kiesler Private Foundation, Vienna. © 2017 Association Willy Maywald / Artists Rights Society (ARS), New York / ADAGP, Paris.

Figure 4.18 Frederick Kiesler, Hall of Superstitions, 1947.
Composition of Miró's *Waterfall*, Hare's *Anguished Man Sculpture*, and
Ernst's *Black Lake*. Photograph by Willy Maywald. Courtesy of the
Lillian and Frederick Kiesler Papers, Archives of American Art,
Smithsonian Institution, Washington, DC. © 2017 Association Willy
Maywald / Artists Rights Society (ARS), New York / ADAGP, Paris.

Figure 4.19 Frederick Kiesler, Hall of Superstitions, 1947. Undressed
woman posing near Ernst's *Black Lake*, 1947. Photograph by Willy
Maywald. Courtesy of the Lillian and Frederick Kiesler Papers,
Archives of American Art, Smithsonian Institution, Washington, DC.
© 2017 Association Willy Maywald / Artists Rights Society (ARS),
New York / ADAGP, Paris.

spite of its fantastic presentation, its elaborate catalogue, and its literary hoop-la, it misses fire entirely."[119] For Europeans who had survived the war, the Sur-realist antics hardly proved revolutionary. Paris had become accustomed to shock, and any nostalgic fantasy of uncanny recollection that hoped to repeat repressed fantasies of paradise lost no longer sufficed.

Despite these perceived failures, the Hall of Superstitions, like Kiesler's other exhibition designs, had a positive impact on his own art and architecture research practice in the years to follow. Psychoanalytical studies continued to prove important to his work, as did his interest in optic and haptic techniques that motivate human actions through perception, as inspired by early experi-mental animation. Still hoping to generate immersive environments that would heal the split between vision and fact, Kiesler's designs continued to suggest alternatives to the normalizing modern practices of his time.

One architectural example in particular by Kiesler poses the question of whether it is possible to take these all-encompassing optic and haptic exhibi-tion design techniques too far. Near the end of his career, Kiesler and his former Columbia University student and later business partner Armand Bartos faced a daunting ethical dilemma—whether to apply Kiesler's psychoanalytic and natural scientific research to a building project bearing on real-world politics. The inno-vative display tactics and techniques he had developed in a lifetime of research came to fruition in his greatest exhibition design near the end of his life, for the Shrine of the Book in Jerusalem, with surprising and challenging implications.

Endless Politics or Perverted Ethics

In his final years, while completing speculative research on his now famous Endless House and Universal Theater designs, Kiesler faced a most daunting ethical question—whether to apply his research interests in the design for the Shrine of the Book. "The Dead Sea Scrolls unfold a new life for me, architec-turally speaking—demanding a blunt reality, not a theory," recalled Kiesler in his diary May 19, 1958.[120] Kiesler and Bartos were hired to design a hallway display for the Dead Sea Scrolls in the new Hebrew University Library at Jeru-salem in 1957. With his years of experience in gallery display design, however, Kiesler disagreed with the university's original functionalist plan and suggested

a more innovative proposition. As he first explained to the building committee, "there is much more involved here than the display of rare manuscripts." If they wanted a mere modern display, Kiesler contended, the university already had a group of architects "talented in the tradition of Mies and Corbusier," who could readily handle such an assignment. "It would just be a matter of getting enough donations," he proposed, "to put in a marble floor and walls, bronze showcases, heavy rubber plants in corners, Mies van der Rhoe chairs and couches throughout, and air-condition the atmosphere—that would be the 'modern' way, in the great tradition of the Bauhaus."[121] But he believed there was a greater ethical responsibility at stake. A project of such sacred scale and value required a more insightful proposition. He had committed his career to opposing modernist solutions to contemporary building problems, and for him a standard solution was not an option for such historically significant discoveries. The scrolls being displayed were mere tattered strips of parchment—"only decorative ciphers"—effectively illegible "to a wide world which cannot read Hebrew," Kiesler observed. "Yet these signs," he noted, "have shaken with their content the somnolent religious world of the cathedrals."[122] As Bartos agreed, "it was up to us to say something about them."[123] The Shrine had to speak to the history of the Dead Sea scrolls and their awe-inspiring significance to the Jewish people.

In November of 1946, a Bedouin goat herder by the name of Mohammed Ahmed el-Hamed (nicknamed edh-Dhib, "the Wolf") found seven scrolls and documents hidden in caves near the Dead Sea, the first of nearly a thousand that were eventually discovered.[124] Fragments were taken to Israeli archaeology professor Eleazar Sukenik, who deciphered and purchased three of the scrolls.[125] Some of the scrolls were found to contain parts of the Jewish Bible in its original language while others preserved writings of a Roman-era Jewish sect, providing remarkable documentation of human history. The scrolls were thought to have been hidden in the caves at the time of the Jewish revolt against the Roman Empire in the first century C.E., when an independent Jewish existence in Palestine (the last for nineteen centuries) was violently ended. Their authenticity had enormous value, providing evidence of the heritage and religious traditions of the Jewish people in that region. Their fortuitous return symbolized the promise of Jewish independence after years of suffering, persecution, and unfathomable extermination during the Second World War.

Four of the other more complete scrolls surprisingly surfaced years later through an advertisement in the *Wall Street Journal*, June 1, 1954.[126] Yigael Yadin, son of Professor Sukenik, was able to purchase the scrolls for $250,000 with funds from Israeli Finance Minister Levi Eshkol and New York philanthropist David Samuel Gottesman.[127] On February 13, 1955, Israel announced that the Gottesman Foundation would fund a shrine to display the seven scrolls now in Israeli possession.

Gottesman's son-in-law Bartos, and the latter's former professor and now design partner Kiesler, were given the commission.[128] Both architects were Jewish, and they had worked most recently together on a remarkable display space for the World House Gallery, completed in New York in 1957, that exhibited many of Kiesler's earlier design interests. In keeping with Kiesler's display strategies from the Art of This Century gallery and the "Bloodflames" Surrealist exhibition, the World House Gallery provided continuous curvilinear surfaces to display paintings and sculptures in endless correlation.

Seeing a once-in-a-lifetime opportunity to build his endless research project on an incredibly symbolic scale for the Shrine of the Book, Kiesler invoked his concept in his first meeting with the client:

> I wonder if one could find a plastic expression for the idea of "rebirth"—that is, an architectural concept that would make visitors feel the necessity for each person to renew himself while yet on this earth. *To give birth to oneself*—not to be satisfied with the birth by a mother, but to re-create one's own being in the image of his own life experience. This is not, of course, rebirth after death, but rebirth during one's very own lifetime. Perhaps, a Sanctuary of Silence, with the flow and return of water suggesting to everyone the Second Coming of himself.[129]

The Shrine of the Book, according to Kiesler, would be a distinct architecture, "a plastic expression of rebirth" inspired by a remarkable story of a Wolf man who, Kiesler emphasized in his writings, had followed a goat into a cave to discover hidden treasures of biblical dimension brought forth to redeem mankind—a return, a second coming, a rebirth (as he explains) outside the mother's womb. Although riddled with phantasmagorical innuendo, Kiesler's proposal appeared altogether intoxicating to the clients.

Figure 4.20 Frederick Kiesler and Armand Bartos, World House Gallery, New York, 1957. Photograph by Sam Falk. Courtesy of the Austrian Frederick and Lillian Kiesler Private Foundation, Vienna.

With approval from Hebrew University President Dr. Benjamin Mazar, Kiesler quickly sketched his vision. "The sanctuary proper would be a vessel," Kiesler described, a "double-parabolic, old time wine vessel. The lower parabola, bulging outward from cave of the earth. ... The upper parabola ... the mouth exhaling and inhaling space."[130] The container would pierce the floors of the newly planned university library to emerge from the roof to allow in light.

After initial approval, the project had three extensive revisions. The local architects responsible for the library first objected to the location of the building because of its expressive form. "It seemed that the parabolas of the shrine were considered to be guerillas invading the cubicles of the Bauhaus," Kiesler surmised. The Shrine was "Exiled," as he lamented, to a new site in front of the library.[131] In the second scheme a partially submerged dome and patio were linked to the new library with an underground corridor alongside a stair that led to the nearby famed Monastery of the Cross. This second scheme elaborated several new elements—including processional character and a free-form Shrine—and again the novel design challenged the aesthetics of the local architects.[132] The dome exceeded the functional requirements of the project and undermined the modern architecture of the university.[133]

To prove their point, the university architects tested the design. In October 1959, they constructed a model dome without Kiesler's consent, using two black rods at right angles spanned by chicken wire mesh and muslin, tattered and dangling.[134] No other elements were included—just a sham dome hanging in midair, as Kiesler saw it. "Totally missing were the architectural ritual of the one area following the other," he bemoaned.[135] The dome was displayed without poetry; "it was a cloak-and-dagger murder ... a monster building ... the project was dead, they had buried it alive."[136]

The Shrine was then moved again, this time to its final location on the nearby hilltop development called Nave Shaabab (Peaceful Habitation) among three new museums designed by Al Mansfeld of Haifa and Dora Gad of Tel Aviv, and a sculpture garden by Noguchi, where it opened in April 1965.[137] The final design for the Shrine of the Book notably relied on a series of architectural elements joined along a path of travel, each element carefully orchestrated to suggest a unique abstract form that would give its meaning in correlation with other elements in the composition. Similar to Kiesler's extensive adaptation of the scroll in his film theater projects and art galleries, the architects

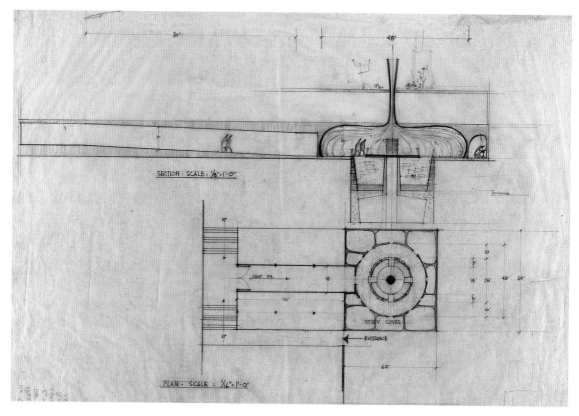

Figure 4.21　Frederick Kiesler, Shrine of the Book, 1957–1958. Preliminarily plan and section. The Israel Museum, Jerusalem Archive. © 2017 Austrian Frederick and Lillian Kiesler Private Foundation, Vienna.

imagined their work as a series of symbolic gestures that combined to form a mythological narrative that unfolded in ritual passage through the Shrine. "Our task was to create a series of architectural events," Bartos explained, not one or two but sixteen different constituents that worked together to create value and meaning.[138] The building itself performed like a scroll, unfolding its history and power to the viewer.

Visitors approached the site along a slowly ascending marble promenade flanked by pines and olive trees—symbols of life, endurance, and light. The promenade opened onto a broad square plaza where the partly submerged circular dome appeared to float above the pool of water. Although occasionally referred to as a large breast, the dome appeared to most as an onion shape, with its rings of hand-carved hard-fired ceramic tiles of decreasing corrugation set over a continuous concrete parabola shell.[139] The top of the dome was cut off to allow light to penetrate the interior, and fountains surrounded the dome to keep the underground Shrine naturally cool. A black basalt wall blocked the natural elements on the exposed hilltop, and stood as a contrast to the white dome. Whether intended or not, the oversized sculptural forms set apart in tension provided a wealth of opportunity for poetic imagination. To some, the subterranean sanctuary represented the rebirth of the Israeli people, and the wall—with fire blazing atop—recalled the heavy burden of the past; while to others they represented symbols of life and death.[140]

From the plaza, visitors descended alongside a pink stone wall and marble staircase to the plaza below to enter a set of bronze doors into a long cavernous tunnel, past a series of curved openings that undulated along a set of equidistant displays. At the end of the cave, visitors began their ascent into the light of the dome structure where the Torah of Isaiah was presented in a circular glass display case. The scroll surrounded an oversized handle, and was surrounded in turn by stone stairs that spiraled down into a seminal crypt. To protect the scrolls, the handle could retract up and down. As a climax, Kiesler had hoped the handle would shoot water out the central oculus onto the exterior dome. Too erotic, suggestive, and not altogether practical—Kiesler and Bartos were forced to abandon the idea.

The architecture with its series of symbolic gestures and exhibition spaces—derived in part from the history of the scrolls themselves alongside the theoretic research interests of the architect—provided a legible story that served as

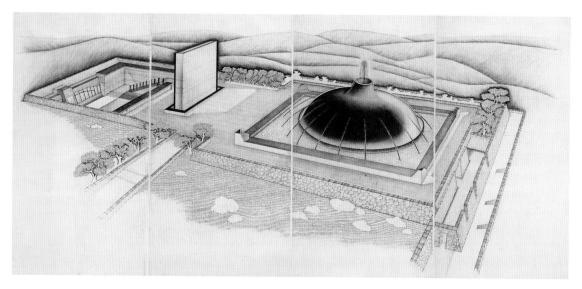

Figure 4.22 Frederick Kiesler, Shrine of the Book, 1957–1959. Elevated perspective drawing. © 2017 Austrian Frederick and Lillian Kiesler Private Foundation, Vienna.

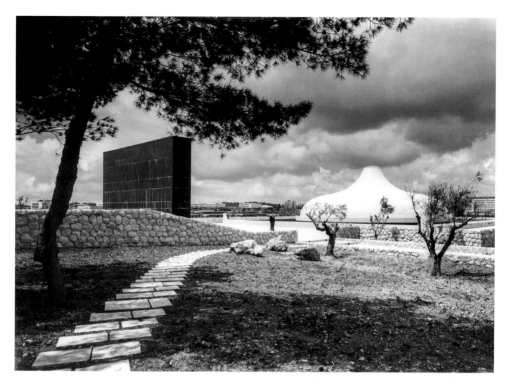

Figure 4.23 Frederick Kiesler and Armand Bartos, Shrine of the Book, 1965. Photograph of ascent to the shrine. Courtesy of the Austrian Frederick and Lillian Kiesler Private Foundation, Vienna.

Figure 4.24 Frederick Kiesler and Armand Bartos, Shrine of the Book, 1965. Photograph of descent toward the gated entry. Courtesy of the Austrian Frederick and Lillian Kiesler Private Foundation, Vienna.

Figure 4.25 Frederick Kiesler and Armand Bartos, Shrine of the Book, 1965. Photograph of underground passage beside a series of display cases. Courtesy of the Austrian Frederick and Lillian Kiesler Private Foundation, Vienna.

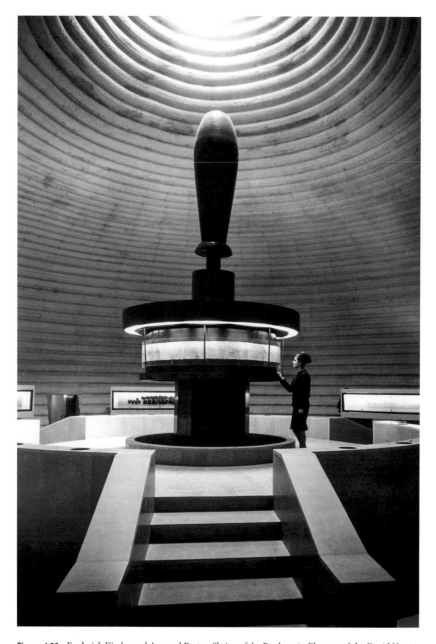

Figure 4.26 Frederick Kiesler and Armand Bartos, Shrine of the Book, 1965. Photograph by David Harris. Courtesy of the Austrian Frederick and Lillian Kiesler Private Foundation, Vienna.

a supplement to the effectively illegible scrolls presented inside the museum. The building performed the work of the display—it offered tourists visiting the Shrine an opportunity to gain a semblance of understanding of the scrolls and their religious value. By doing so, the building became a visual representation that marked a return to symbol, myth, and metaphor—in part prefiguring an end to modern functionalism and a turn, for better or worse, toward an overtly legible postmodern architecture that aimed to recover lost forms of language, syntax, and meaning.

The Shrine of the Book was built as a memorial and symbol of great power. It was a "Symbol of State" and "Gesture of Great Confidence," as newspapers reported at the time.[141] Yet though it won a national AIA Merit Award in 1966, critics attacked the Shrine specifically for its nonfunctional aesthetic. They saw it as quite "fey," "off-beat," and "flamboyant," with very disturbing and undeniably surreal psychoanalytic characteristics.[142]

With his interest in psychoanalytic theory, Kiesler perhaps more than any other architect consciously acted against the psychological repressions of the modern period. For him the story of the Dead Sea Scrolls carried a number of references to Freud's famous story of the "Wolf Man."[143] "This account seemed to me beyond belief," Kiesler recalled, "but as I learned later, was factual indeed. The earth had given forth seeds of truth" that inspired his design.[144] In retelling the story of the Scrolls, Kiesler oddly emphasized the warm mud caves, the goat, the vessels, and the curious nickname of the boy—"the Wolf." But in light of his final design for the Shrine of the Book and the history of his psychoanalytical interests, his reference to Freud's writing and his intentions behind the symbolic gestures of the Shrine seem quite telling.

For Freud's famous case study of the Wolf Man was that of a young man whose childhood had been riddled with trauma that had led to anxiety, frustration, and guilt. The Wolf Man exhibited these tendencies through obsessional neuroses demonstrated through appetite, piety, and sadomasochistic tendency. His experiences of incest and abuse from his sister, amidst unrequited love for his nursemaid and his father, fused into an erotic desire laden with deep-rooted anxieties and fears. Through dream work, the Wolf Man's anxiety was revealed in the form of seven wolves that represented a story of "The Wolf and the Seven Little Goats" perched in a tree—an image not at all unlike the formidable origin stories Kiesler writes of his own childhood that took place under a foreboding

chestnut tree in his back yard that led to his becoming an architect.[145] Freud's Wolf boy had sadistically carved into a walnut tree only to fear cutting off his finger (having his digit removed). In the end, Freud treated the Wolf Man with periodic enemas that resolved his intestinal problems, along with his obsessional neuroses. The enema, Freud observed, was as a symbol of rebirth that ripped or tore through the bowels of the Wolf Man's infantile veil, his caul or lucky hood.[146]

The Wolf Man gave birth to feces, Freud's symbol for all gifts, all disjunction, and all fragmentation offered to the loved one (including that of the penis, money, art, architecture, and the baby). Freud believed intrauterine fantasy—the desire to return to the womb—stemmed from unresolved sexual desire in the libidinal world. For the Wolf Man, according to Freud, desired to copulate both with his mother and with his father. He had a wish-fantasy to be back in the womb. But from the womb he hoped to take his mother's place and be the sexualized object of his father, with the ultimate goal to be reborn from his mother as a baby, free of all previous traumatic life experience. In his extreme architectural vision, Kiesler hoped to perform this same ultimate cleansing—to regenerate and liberate humanity to start all over, free again.

Clearly, Kiesler had not been satisfied with the modern functional architecture of his time—the white painted box—and instead spent much of his life constructing an alternative style, strategy, and mythology through a wide range of intellectual and artistic media. Prefiguring postmodernism, the Shrine of the Book posed a challenging example of what might happen when the architecture itself becomes an object put on display. Beyond the performative aspects of its construction, the building notably becomes a representation—an image of an idea—subject to delimiting narratives and pejorative critiques. Yet at the same time the Shrine of the Book, with all its psychoanalytic nuance and eroticism, performed Kiesler's greatest therapeutic act—to rip through modernism's tectonic veil and release architecture from all its pseudo-functional repression.

Figure 4.27 Frederick Kiesler and Armand Bartos, Shrine of the Book, c. 1965. Page from a French magazine, found on Frederick Kiesler's desk. Unidentified creator. Held in 1959 Desk Notes, Clippings, Miscellaneous, Lillian and Frederick Kiesler Papers. Courtesy Lillian and Frederick Kiesler Papers. Archives of American Art, Smithsonian Institution, Washington, DC.

Figure 5.1 Frederick Kiesler, *Bucephalus*, 1965. Photograph by Adelaide de Menil of Kiesler inside his horse sculpture. Courtesy of the Austrian Frederick and Lillian Kiesler Private Foundation, Vienna. © Adelaide de Menil.

5 Introjection and Projection: Endless Houses and Dream Machines

The difficulty in reflecting on dwelling: on the one hand, there is something age-old—perhaps eternal—to be investigated here, the image of the abode of the human being in the maternal womb. ... [O]n the other hand ... we must understand dwelling in its most extreme form. ... The original form of all dwelling is existence not in the house but in the shell. The shell bears the impression of its occupant. In the most extreme instance, the dwelling becomes a shell.
—*Walter Benjamin*

The Surrealists positioned themselves in opposition to modern architecture, as reflected in well-known public disagreements between Breton and Le Corbusier. Surrealists argued against the sterile overrationalized technological realism of modern building in favor of more habitable architecture. Tzara and Matta described Surrealist architecture best in the eclectic journal *Minotaure* during the 1930s.[1] Tzara wrote against modern aesthetics that deny human dwelling in favor of architecture with intrauterine appeal.[2] He called for a new serenity of "prenatal comfort" ushered in by the qualities of "soft tactile depths" experienced inside "circular, spherical, and irregular houses."[3] From a "cave" or "tomb" in the "hollows of the earth," Tzara believed "health" could be restored in the realm of "luxury, calm and voluptuousness."[4] Matta argued for a folded body-wrapping architecture of "wet walls" and "appetizing" furniture that fit our "infinite motions," "like plastic psychoanalytic mirrors."[5] He envisioned architecture that could "get out of shape" to "fit our psychological fears," and relieve "the body of all the weight of ... [its] right-angle past."[6] Matta was describing a provocative Surrealist project which sought to create *alloplastic* architecture

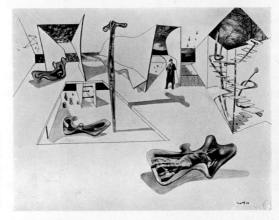

Projet - maquette d'appartement : Espace propre à rendre consciente la verticale humaine. Plans différents, escalier sans barre d'appui, pour maîtriser le vide. Colonne ionique

psychologique. Fauteuils souples, pneumatiques. Matériaux employés : caoutchouc gonflé, liège, papiers divers ; béton, plâtre ; armature d'architecture rationnelle.

Mathématique sensible - Architecture du temps

par MATTA ECHAURREN
(Adaptation de Georges Hugnet).

I. s'agit de découvrir la manière de passer entre les rages qui se déplacent dans de tendres parallèles, des angles mous et épais ou sous des ondulations velues à travers lesquelles se retiennent bien des frayeurs. L'homme regrette les obscures poussées de son origine qui l'enveloppaient de parois humides où le sang battait tout près de l'œil avec le bruit de la mère.

Que l'homme s'accroche, s'incruste jusqu'à la possession d'une géométrie où les rythmes du papier marbré, froissé, de la mie de pain, la désolation de la fumée lui soient comme une pupille entre les lèvres.

Laissons de côté la technique qui consiste à mettre debout les matériaux toujours employés et poussons brutalement celui qui les habite, au milieu d'un théâtre final où il est tout, l'argument et l'acteur, la scène et ce silo à l'intérieur duquel il peut vivre en silence parmi ses chiffons. Renversons tous les étalages de l'histoire avec leurs styles et leurs élégantes gaufrettes afin qu'en fuient des rais de poussière dont la pyrotechnie doit créer l'espace. Et restons immobiles parmi les murs qui circulent, pour nous débarrasser avec les ongles de la croûte rapportée de la rue et du travail.

Il nous faut des murs comme des draps mouillés qui se déforment et épousent nos peurs psychologiques ; des bras pendant parmi les interrupteurs qui jettent une lumière aboyant aux formes et à leurs ombres de couleur susceptibles d'éveiller les gencives elles-mêmes comme des sculptures pour lèvres.

Appuyé sur ses coudes, notre personnage se sent déformé jusqu'au spasme dans le couloir, titubant et pris entre le vertige des côtés égaux et la panique de la succion, étourdi lorsqu'il réalise enfin les efforts de l'horloge qui s'ingénie à imposer une heure à l'infini de temps de ces objets décrivant en bois ou en verre leur existence dont il a conscience qu'elle est perpétuellement menacée. Et il souhaite d'avoir à sa disposition des surfaces qu'il pourrait appliquer exactement contre lui et qui, en portant nos organes, par le bien-être ou la douleur, à leur suprême degré de conscience, éveilleraient sur commande l'esprit. Pour cela, on insinue le corps comme un moulage, comme en une matrice fondue sur nos mouvements, où il trouvera une libération telle que ne le touchera pas la bousculade liquide de la vie qui cède ici ou résiste là, sans toutefois que cela ait un intérêt pour nous.

Des objets pour les dents dont la pointe osseuse est un para-

tonnerre, devront aspirer notre fatigue, nous délivrer des angles dans un air qui ne sera plus bleu-ange, mais avec lequel il nous sera loisible de lutter.

Et encore, d'autres objets entr'ouverts, comportant des sexes à conformation inouïe dont la découverte provoque des désirs plus agissants que d'homme à femme, jusqu'à l'extase. Jusqu'à la connaissance de flottements très nerveux qui puissent compenser l'ouverture pleine d'arbres et de nuages de cette fenêtre au jour toujours identique, plaqué du dehors.

Dans un coin où cacher nos plis acides et pleurer notre timidité lorsqu'une dentelle, une brosse ou tout autre objet nous situe en face de notre incompréhension. Et dès lors, en réaction, consciemment, d'une main plusieurs fois gantée, se frotter les intestins avec des hosties. Ceci parviendra à créer en soi le charme, la douceur.

Très apéritifs et profils moulés, avancent les meubles qui déroulent d'inattendus espaces, cédant, se pliant, s'arrondissant comme une marche dans l'eau, jusqu'à un livre qui, se mirant en miroir, reflète ses images en un parcours informulable qui dessine un espace nouveau, architectural, habitable.

Ce serait un mobilier qui déchargerait le corps de tout son passé à angle droit de fauteuil, qui délaissant l'origine du style de ses prédécesseurs, s'ouvrirait au coude, à la nuque, épousant des mouvements infinis selon l'organe à rendre conscient et l'intensité de vie.

Trouver pour chacun ces cordons ombilicaux qui nous mettent en communication avec d'autres soleils, des objets à liberté totale qui seraient comme des miroirs plastiques psychanalytiques et certaines heures de repos comme si, entre autres choses, les pompiers vêtus de masques, s'accroupissant pour ne briser aucune ombre, apportaient à madame une carte pleine de pigeons et un paquet de tirelires. Il faudrait un cri contre les digestions à angle droit au milieu desquelles on se laisse abrutir en contemplant des nombres des étiquettes de prix et en ne considérant les choses que sous l'aspect d'une seule fois parmi tant d'autres.

Par des mêlées de doigts semblables aux mains jointes d'une femme dont les seins déchiquetés, on sentirait les indurations et les mollesses de l'espace.

Et nous commencerons à le gaspiller, ce temps sale et troué que nous offre le soleil. Et nous demanderons à nos mères d'accoucher d'un meuble aux lèvres tièdes.

43

Figure 5.2 Matta, architectural sketch, 1938. From "Mathématique sensible—architecture du temps," 1938, *Minotaure*. Courtesy of Getty Research Institute, Los Angeles (84-S173 v. 11) © Artists Rights Society (ARS), New York / VG Bild-Kunst, Bonn.

modulating to the infinite transformations of the body in motion.[7] Uncon-
scious sensual desires could be forever satiated with flexible architectural skins
moving in response to our every need. For Tzara and Matta, nonrectilinear
houses embodied Surrealist architecture—one that Kiesler had been well on
the way to developing.[8] Since its inception in 1924, Kiesler's Endless project had
served to nurture the dweller inside an embryonic casing of eggshell construc-
tion, and eventually, as the design developed, inside a cavelike intrauterine
space. As the Surrealist artist Hans Arp reportedly described, "in [Kiesler's] egg,
in these spheroid egg-shaped structures, a human being can now take shelter
and live as in his mother's womb."[9]

The First House

Kiesler began studying architecture in the 1920s while living in Vienna and
Paris. He had attended the Technical University and the Academy of Fine Arts
in Vienna under Otto Wagner and Josef Hoffmann and purportedly interned
under Loos in 1920 on a workers' housing project constructed at Heuberg, for
the City of Vienna, in 1921.[10] Kiesler never finished his formal training in archi-
tecture and instead began his career as a stage designer—traveling to Berlin
in 1922 to build his *R.U.R.* and *Emperor Jones* stage designs. Upon his success
in Berlin, his former instructor Hoffmann provided Kiesler with a significant
commission to organize and stage the Austrian Exhibition of International
Theater at the 1925 world's fair in Paris.

Moving to Paris in 1925, Kiesler and his wife Steffi developed close relation-
ships with their friends from Berlin—the van Doesburgs, Tzara, and Arp and
his wife Sophie Taeuber-Arp. In addition, they met with Mies, Le Corbusier,
Loos, and Richter.[11] Kiesler notably made site visits to Tzara's house designed
by Loos while it was in construction.[12] Kiesler and Tzara shared an affinity for
Loos's work. Tzara had met Loos in Zurich, and was instrumental in his move
to Paris in 1923.[13] Tzara began working together with Loos on the design and
construction of his house in 1925.[14] In March 1925, Kiesler wrote to Tzara asking
"Wie geht es Loos? Und [e]urem Haus?";[15] the Kieslers also met with Tzara and
Loos at "Lavique [possibly the Grand Hotel Leveque] Montparnasse" that same
year for a meal and to discuss the project.[16] Kiesler visited the construction site

in October and proposed on his next visit to send Tzara construction pictures of Loos, the supervisor, and his workers on site.[17] The Tzara House proved a significant building project for Loos, and perhaps an important impetus for Tzara's Surrealist housing ideas in addition to Kiesler's first shelter designs.

Is it possible that living in a modern house by Loos prompted Tzara's reaction against modern architecture in favor of the warm palpable spherical constructions soon to be developed by his friend Kiesler? Kiesler notably designed his spheroid-matrix-shaped Endless Theater while living in Paris between 1925 and 1926, but it's unclear that his work was oppositional to Loos. Neither Kiesler nor Tzara indicated anything but admiration for Loos's house designs in their letters to each other. And although in the 1940s Kiesler would attack Loos for his sterile housing concepts, Loos's housing designs arguably resist such criticism.

For although he was strongly opposed to ornament in favor of plain quality production, Loos like Semper believed in the "principle of cladding."[18] For Loos the architect's first task was "to provide a warm livable space," and the "second task" was to build structure that supported, similarly to what Semper wrote about, varied surface materials that both veiled and revealed meaning.[19] Loos designed interior spaces with overt *character* using different cladding materials that expressed sensual qualities.[20] On the exterior, however, he believed the design had to respond to the needs of a wider audience; there, ornament was a crime, and he stripped the walls to bare expression.[21] Loos believed society should suppress individual artistic tastes behind a mask.[22] Art instead would serve a cathartic role for the aristocrat on the interior. "We have art, which has taken the place of ornament," Loos said, for we go home "after the toils and troubles of the day … to Beethoven or to Tristan."[23] Relegated to the interior for curative effect, art for Loos sustained public life in the face of modern *Kultur*. In 1930, Tzara admired Loos's fortitude in attaining "a human possibility of clarity, within the hub of social activity."[24] Tzara more likely realized his Surrealist vision in light of Loos's concept of dwelling rather than in spite of it. Loos created houses as if they were masks or protective shells while comforting the human psyche within warm, palpable interiors—and so would Kiesler.

For his part, Kiesler translated Loos's essay "Ornament and Crime" into English, and later lectured on the subject in 1932.[25] Kiesler studied the text; in his later "On Correalism and Biotechnique" he reproached ornamental crafts

in terms similar to Loos's in favor of streamlining laboring processes, reducing costs to consumers, and avoiding wasted materials. While Loos had prescribed a "plain shoe modernism" in "Ornament and Crime" to form a "completely smooth" modern aesthetic, Kiesler anticipated the coming of a new form of architecture that maintained the fewest possible joints, connections, and parts.[26] However, very differently from Loos, Kiesler did not intend to clad a building's frame structure. Kiesler hoped to merge art into the walls of construction to create a unified design—a total work of art. Kiesler's egg-shaped shell for his Endless Theater that had projected multimedia imagery on its continuous structural tension-shell surfaces might both veil and reveal the building's design and its structure; it was his initial proposal to fuse art with architecture. Although he did not intend his Endless Theater to be a house, as he wrote in "On Correalism and Biotechnique," it was his "first directed effort at a method of Continuous Construction"—an innovative structural system he conceived in the 1920s.[27]

As early as 1925, Kiesler advanced a new structural principle in contrast to the frame construction of traditional building. He envisioned tension-shell structures like an eggshell to reduce joints by unifying walls, ceilings, and floors into one continuous environment, though he lacked the engineering skill and technical wherewithal to develop this idea. In his 1930s show window design publication, Kiesler noted that advances in steel and concrete design were leading toward this new method of construction—similarly to what Viollet-le-Duc had realized in the historic shift from stone to iron.[28] From the heavy and static construction of steel posts and beams, to advances in steel trusses by several bridge designers, to the sprayed-concrete-encased steel skeletal dome at the 1926 Zeiss Planetarium, Kiesler foretold the "coming tensionism" in building practice.[29] Le Corbusier had already stated the significance of bridge design for modern architecture in his *Vers une architecture*, published in 1923. And Giedion would later explain a similar historical progression, identifying Swiss bridge builder Robert Maillart and Parisian architect Eugène Freyssinet as the builders of the first eggshell-concrete constructions.[30] For Giedion the "lithe, elastic resilience with which" Maillart's bridges leap their chasms approached pure plastic expression through structure like none other.[31] Maillart had the technical skill and capacity to form the first continuous tension-shell elastic structures in steel-reinforced concrete, showing the viability of Kiesler's

structural form for his Endless Theater as exhibited in New York in 1926. *Architectural Record* recognized Kiesler's contribution to history as an innovative structural theorist of this new technology in their publication of his Endless Theater in 1930.[32]

Modern Housing

Kiesler, however, did not employ this new structural idea for his first single-family housing design in 1931. Like Le Corbusier in the Citrohan House (1922), Kiesler designed his speculative Nucleus House in cellular fashion to fit the scale and approach of modern cars alongside an expandable rooftop terrace supported on *pilotis*. Despite his later attack on Le Corbusier and Loos, Kiesler derived his understanding of modern housing from learned study of their work. Kiesler used frame construction similarly to Le Corbusier (and Mies) for his Nucleus House. He provided a drive-through entryway adjacent to a curved stair tower that led to a rooftop or second-floor living space, mimicking Le Corbusier's Villa Savoye (1931). As with the Citrohan House, floor area could be added on the ground floor or on the roof plan to increase the size and shape of Kiesler's two-story scheme. Kiesler proposed four versions of a standard unit reminiscent of Le Corbusier's Quartiers Frugès housing project in Pessac (1924). Kiesler intended to mass-produce the Nucleus House in linear fashion to create one larger International Style housing block, as had been demonstrated by Mies, Le Corbusier, J. J. P. Oud, Peter Behrens, Gropius, and others at the Weissenhofsiedlung housing estate built for exhibition in Stuttgart, Germany, 1925–1927. Although Kiesler's contemporaries, Austrian-American architects Richard Neutra and Rudolph Schindler, had also built notable modern houses—the Schindler House in Los Angeles, 1922; the Lovell Beach House in Newport Beach, 1926; and the Lovell (Health) House, in Los Angeles, 1929, among others—these were relatively little known at the time.

It wasn't until 1933 that Kiesler became recognized for his housing designs. And it really wasn't until he departed from International Style modernism that he received serious attention. Afforded an opportunity to travel to Chicago in 1933, he presented his Nucleus House scheme to Sears, Roebuck & Company with the hope that they would mass-produce it.[33] Although the company did

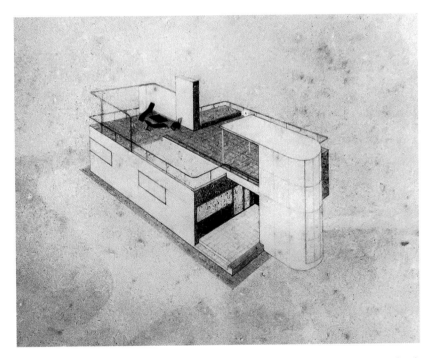

Figure 5.3 Frederick Kiesler, Nucleus House, 1931. Perspective drawing. Courtesy Austrian Frederick and Lillian Kiesler Private Foundation, Vienna.

not pursue Kiesler's prototype design, he was inspired to push beyond such standardized modern prototypes to invent a new form of architecture—his "Space House" project constructed that same year in New York. While in Chicago, Kiesler had visited the World's Fair with gallery owner and friend Sidney Janis.[34] The Space House would surpass anything he had seen at the fair. "The world is moving at a fast pace these days," wrote one critic from the *New York Sun*, in response to Kiesler's new Space House design. "Chicago's Century of Progress Exposition has still two weeks to run, but the modernistic model houses that were knocking 'em cold there all summer have already been outmoded. The 'Space House' is the latest thing."[35]

The Space House

Kiesler exhibited his full-scale prototype of the Space House for the Modernage Furniture Company in New York City in 1933. The Space House was a decisive building project for him as it would prove a rare opportunity to construct his visionary ideas. Kiesler "was never eager to build"—"no building at the moment can satisfy," he admitted, because "*no organic result in Buildings can [yet] be achieved.*"[36] In his view, the technology to construct continuous tension-shell building forms did not exist; the Space House proved only "a proportionate substitute with actual possibilities to the original plan."[37] Because it was a temporary installation and prototype structure built to challenge modern ideas, it could present his innovative structural principle without having to answer to the demands of durability.

Originally intended as a display for advertisement, the Space House attracted visitors to the 33 furnished showrooms at the Modernage Furniture Company headquarters on East 33rd Street. Although Kiesler had little practical experience in housing, his knowledge of show window, exhibition, theater, and furniture design was well suited to the commission. As a member of the American Union of Decorative Artists and Craftsmen, Kiesler had recently garnered a reputation for several creative furniture pieces for private clients and showroom displays that included a Flying Desk. In the 1930s, he held exhibitions with modern furniture designers Donald Deskey, Wolfgang and Pola Hoffmann, Willis Harrison, and Alexander Kachinsky.[38] The Modernage

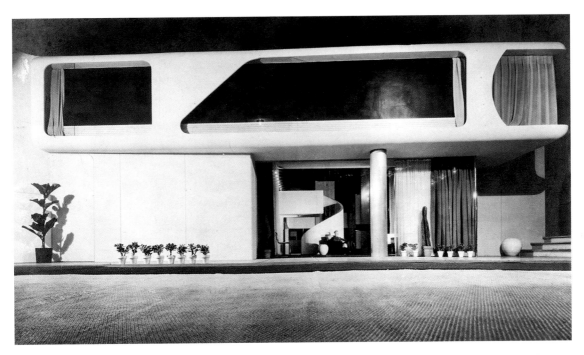

Figure 5.4 Frederick Kiesler, Space House, 1933. Photograph by F. S. Lincoln. Full-scale prototype at Modernage Furniture Company. Courtesy of the Austrian Frederick and Lillian Kiesler Private Foundation, Vienna.

Furniture Company hired Kiesler for his potential to rejuvenate their style and image, and lure customers into showrooms that had most recently displayed outmoded French-style Art Deco motifs.[39]

Kiesler published an extensive description of the Space House in *Hound and Horn* magazine in March 1934. He divided his article into three parts: the social requirements of the house, the tectonic solutions to achieve those requirements, and the structural technology used for building the exterior shell. In the social realm, he insisted, housing should support family and group relationships but must also provide for "complete seclusion," "physical separation," and "privacy."[40] The Space House ideally provided introverted living for every member of the household; as Kiesler remarked, "the house must act as a generator for the individual. His generated forces are to be discharged to the outer world. The outer world: his own family or any outer group. The house is built on this two-way principle: charging and discharging through a flexibility that is contracting and expanding."[41]

As Kiesler represented in a series of unpublished notes and sketches on the Space House, his concept of contraction was to provide a sense of security through individual space enclosures that could then expand to provide for group interactions and ultimately outer-world experiences. He anticipated that time could be a factor in the use of the house, with the building transforming in accord with varied needs.[42]

The house, Kiesler argued, functioned through an organic machination of metabolic processes where the "individual passing through time" was "subjected to two forces; Anabolism: building up; Catabolism: breaking down."[43] He believed that within all objects, whether animate or inanimate, there was a constant exchange of these two mutating forces.[44] As the individual passes horizontally to the world outside, vertically into the inner world, parabolically to work, and spherically for play, the house interacted and exchanged forces with the dweller. This was achieved, he said, through the "*the mobile space enclosure, and the individual as qualified by it.*"[45] "This expansion and contraction is a propensity of the house," and it was to be achieved tectonically through a series of push-button roll-down doorways, flexible sponge rubber carpets, roll-away curtains, and sliding partitions.[46] Despite its delimited form, the Space House created a variety of mobile-flexible environments suited to varied temporal needs.[47] Kiesler intended the "whole house to be one living room" of

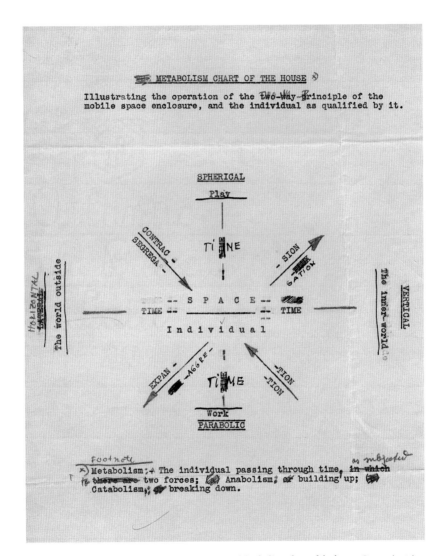

Figure 5.5 Frederick Kiesler, Space House, 1933–1934. Metabolism chart of the house. © 2017 Austrian Frederick and Lillian Kiesler Private Foundation, Vienna.

226

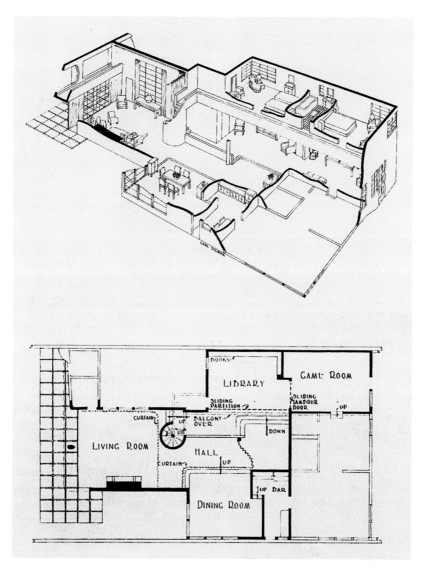

Figure 5.6 Frederick Kiesler, Space House, 1933–1934. Axonometric and plan drawings. © 2017 Austrian Frederick and Lillian Kiesler Private Foundation, Vienna.

"static-flexibility" that could adjust as needed.[48] The house was not to be fixed in time but was intended to transform to changes in human dwelling keyed to the evolving necessities of the inhabitant.

Kiesler's design for the Space House elaborated the former design strategies of his show window, film, and theater projects to create a contracting and expanding interior space. The Space House also introduced ideas on construction technology that he later advanced in his Design Correlation laboratories. Kiesler's design for his Space House sought to envelop dwelling within a mobile-flexible architecture that served to cultivate the body in coordination with daily habits. It could charge and discharge one's energy forces geared to interactions of everyday life. The house engaged the body tactilely, and its form took shape in correlation with use.

Touch and vision were essential to the dynamic function of the house. In a series of images relating to the Space House in *Architectural Record*, Kiesler presented a shoe subtly applying pressure to an elastic sponge rubber carpet or a scissor tearing through the veil of a net fabric ceiling,[49] as well as cropped images of materials in provocative juxtaposition to each other and objects of everyday use that elicited feelings of "something beyond," "something else," "something imagined," "something endless." In the Space House, Kiesler used materials to envelop the habitant in tactile protective layers, whose varied functions included facilitating "sound proofing," "isolation," and "vision."[50] Achieving flexibility and security, the house provided comfort through tactile pleasures, temporal and sensual. Its materials served as screens that could be drawn to veil or be pulled back to reveal the outside world.

Kiesler recognized that materials have "psycho-functions" that can be utilized to stimulate the psyche.[51] As Colomina argues, the erotic "sensuality of Kiesler's house extends from touch into the visual freedom the design affords and beyond into the psyche."[52] In a sketch of this concept, Kiesler showed the sensing terrestrial body surrounded by a world of objects, with arrows and lines reaching out toward a perceptual boundary he described as the "stellar spectra." His architecture attempted to entice perception to pass through the tactile senses, through the psyche, and beyond to outer space.

Curiously, the Space House functioned quite similarly to Freud's 1923 idealization of the bodily ego.[53] In a diagram of the ego and the id, Freud constructed the ego as a spatial body generated from the nucleus of conscious perception.[54]

Figure 5.7 Frederick Kiesler, Space House, 1933–1934. Sketch of psychic projection. © 2017 Austrian Frederick and Lillian Kiesler Private Foundation, Vienna.

The ego he mapped as a surface that separated interior and exterior relationships. It housed unconscious psychical systems within a hard semipermeable membrane that formed in response to external and internal stimulation. As Freud described in *Beyond the Pleasure Principle*, the ego formed a shell—an inorganic shield—that protected unconscious energies by becoming resistant to external stimuli, while in turn controlling the relative discharge of mobile cathectic excitations of the internal drives—the instincts—back into the external world.

These instincts influencing the id, and in turn the ego, Freud articulated as the drives of sex or Eros and death or Thanatos. They underlay all basic life functions and commingled in Freud's theory on a molecular level, where both kinds of instincts were active and fused in every living particle to varying degrees in time.[55] Freud described their interaction as an "organic elasticity" of special physiological "catabolic" and "anabolic" processes that fused, blended, and alloyed themselves together in tension.[56] Under stress from too much tension, the shell of the ego became susceptible to fracture. The ego then either discharged protective cathexes to strengthen its shell, discharged energy to relieve pressure, or when faced with excessive real danger relied on the flight reflex to seek alternative protection—a wish fantasy Freud allied with the desire to return to the womb.[57] As a response to the trauma of the First World War, in his study of shock, Freud deduced his structural theory of the mind, with an analogy to the therapeutic effects of housing and protecting the sensorial and motor functions of the bodily ego within the shell of cerebral anatomy.[58]

Kiesler's architecture by 1933—prior to his entrenching himself in the ideas of the Surrealist group—had developed a therapeutic intent similar to Freud's theories of the mind—one aimed at protecting the psyche through shelter design.[59] "Houses are defense mechanisms," Kiesler would later explain in the draft of his book "Magic Architecture," that "give physical expression to the sheltering of [the human] … psyche."[60] For Kiesler the house served a psychoanalytic purpose, to heal mind, body, and soul from the traumatic events of everyday life. The Space House was his first attempt at that goal.

Kiesler designed his Space House as a perceptual boundary or semipermeable shell similar to Freud's diagram of the ego and the id that could respond to inner needs while at the same time resisting external pressures. The structural "outer shell" of the house facilitated the flow of physical and psychical force.[61]

Figure 5.8 Sigmund Freud, diagram of the ego and the id. From Sigmund Freud, *The Ego and the Id*, 1923.

It acted like a cellular membrane that provided, as Kiesler said, "*flexible* division between outdoor and indoor."[62] It was "not a wall" but instead provided glass panels for optical contact, movable glass for physical contact, and terraces for extensity.[63] Its overall structure was modeled on the concept of an eggshell, which Kiesler argued was the most "exquisite example we know of utmost resistance to *outer* and *inner* stress with a minimum of strength."[64] Kiesler designed his Space House as one viable protective skin that could provide shelter, enclosure, and floor without conflict between parts. Continuous tension-shell structures do not have joints that are subject to disjoint. Instead, their elastic nature and cellular structure resist fracture and decay.

Kiesler was well aware, however, that the technology to construct his shell was still not available. "There is no question: a new construction method has not yet been reached. We are in transition from conglomeration to simplification."[65] He aimed to construct architecture organically, unlike the techniques used to build the modernist box. Thus he rejected machine-fastened panel and frame construction, as best represented by the work of Mies and Le Corbusier, and he departed wildly from the International Style with the invention of his spheroid eggshell structures and palpable-tactile interiors that stimulated psychical experiences. In light of recent advances in building technology in the 1920s and 1930s, he proposed to build the Space House out of poured monolithic concrete with steel reinforcement.[66] Ideally held together in tension, the Space House would not require structural columns or joints, but would instead support endless spatial continuity within a unified building structure that modulated to the fluid bodily parameters of alloplastic systems.

Through architecture, Kiesler hoped to eliminate all joints. Joints, as he argued in his 1936 writings on design correlation in support of Duchamp's *Large Glass*, are dangerous due to their susceptibility to decay and disjoint. Understood in this light, all architecture, if not all manufactured forms, produced from an idea framed in the mind's eye that manifests the patterns, the drafts, the cuts needed to construct them out of materials, is shaped alongside the ultimate fear of decomposition—the wearing down, fatiguing, or breaking apart of the whole. The Space House with its aim of continuity was formed in reaction to this ultimate fear—fear of the loss of a part or a digit.

The first digit removed, as Freud had suggested, is the feces that a child either offers or denies, as a gift to his love, which Freud proposed as the basis

of all art and architecture through drawing, inscribing, and joining matter. In Kiesler's ideal universe, where animate and inanimate subjects and objects fuse together in continuity without division, there would be no more need for joints. This ideal world of the *informe* would ensure prenatal hygiene and mental stability as Tzara and Matta had hoped for all humanity, as there would no longer be a repetitive need for doubling forms to stave off mortality. There would be no joints, no feces, no separation anxiety, no need for cleanliness—no death— and certainly no Freudian castration fears.

Raumseele (Space Soul)

To derive continuous connections that would best protect against human fears—fear of separation, fear of losing a loved one, fear of death, or even the projected fear of one's birth—Kiesler looked to Nature for answers. In the hope of reconstituting primordial unity and relieving human anxiety, he responded as he suggested every architect does—by creating mental and physical health through the art of construction.

When asked by *Time* magazine why he became an architect, Kiesler invoked his favorite story of his beloved chestnut tree (as retold by his second wife Lillian):

> When Kiesler was eighteen months old there was a nursemaid-housekeeper and one day each week she would knead dough to make bread. One warm spring day, she took the dough into the garden and kneaded it under his beloved chestnut tree. He said she wore full skirts and he didn't know why, but he went under her skirt and took some matches which he lit to look up, and that's how he started being an architect.[67]

Whether the tale is remotely true, Kiesler and Lillian elicited human sexuality to describe his formative desire to be an architect. As his nursemaid prepared nourishment in the shadow of his beloved tree, Kiesler fantasized that he went under the skirt of a woman—who was a substitute for his mother— with all the eroticism associated with a fertile flame taken to light his passage

to becoming an architect. Architecture here substitutes for the libidinal act of social engagement.

Kiesler's 1930 story titled "Chestnut" was a fragmented memory that Freud might suggest reenacted the primal scene marking Kiesler for life, similarly to the Wolf Man's story of a walnut tree as published in "From the History of an Infantile Neurosis" that inspired Kiesler's design for the Shrine of the Book. Kiesler's fantasy sets up a prehistory which anticipates and perhaps justifies his fascination with primordial unity, automatism, environmentalism, and even his studies on plant and animal morphology. As Kiesler recalls,

> From my earliest childhood on, one picture pursued me constantly. And I can still see it today very clearly, before my eyes. This vision was an obsession with me. ... Perhaps it had something to do with the big chestnut trees that stood in our backyard and under those shadows I played all summer long. I was very much attached to them, and often I would pick up the big fallen leaves, sit down quietly and take their structural affiliations apart and be delighted by the mystery of their intricacies.[68]

The big trees in the back yard under whose shadow Kiesler played gave him, as he explains, a sense of security and interest. Like many children, he was attracted to playing and sitting beside trees, while also curiously ripping apart their leaves. In this story, he expressed his fascination with veined structures and skinlike organic forms relevant to his later study on Duchamp's *Large Glass*. What was to strike Kiesler most in telling this story, however, was that one day the gardener came over to speak with his nursemaid, who was kneading dough on the rear porch while watching over young Kiesler. The gardener

> drove a nail into the big trunk of the chestnut tree, because it was very convenient for him to hang his straw hat there. When he went away, I lifted the straw hat off and looked at the spot where the nail was driven in the trunk. I saw that the body of the tree was hurt, that light fluid gathered around the hole, but that that clash of forces was not considered as something abnormal or prohibited, but rather as a matter of routine. If, so I said to myself, such a thing happened to the

body of a human being, there would be violent reactions taking place, both audible and visible; but no one paid any attention to the clash of dead wood and dead steel. It was commonplace.[69]

Concerned with the wound inflicted by a nail driven into the big trunk of his chestnut tree, Kiesler understood the magnitude of routine loss caused by aggressive violence. He was angry that the gardener showed no empathy for the silent tree's pain. As Kiesler declared, "constantly after this event I wanted to design pictures where I had brought my beloved chestnut tree to life and had enlarged the very minute particles of the wood of its trunk to rebel against the intrusion of that steel bar."[70] As with Freud's diagram of the ego and id, where *repression* is marked as if a nail had punctured the shell of the mind, Kiesler proposed to design images that could "rebel against the intrusion" and bring his tree back to life.

For Kiesler, art and architecture arguably alleviate the repression that forms through such acts of aggression. He felt the tree was alive with feeling and that the steel was an intruder, which he should engage in battle. It was the "inanimate chunk of form, the very villain in that drama. ... Again and again that vision appeared in my dreams";[71] "it constantly crowded itself during my days behavior into my consciousness. ... The relationship between *animate and inanimate matter* absorbed me."[72] In response, he made a woodcut named *Raumseele* (Space Soul), as he explains in his chestnut tree story that featured

a man seated with closed eyes, his hands and feet immovable, as though in a state of petrification. From him into the background of this picture extended a landscape and the extension continued into the sky, and the sky bent above his head, then backwards into the foreground, into the earth again, and forward toward his seat. It was evident from this picture and from the title given to it, that the man was conscious of his interrelationship with his environment, although not seeing it or actually touching it.[73]

From this calm, silent state, with his eyes closed and immobile, almost in a meditative state of nirvana (similar to stories of the Buddha), asleep or (as here described) as if turned to stone, *Raumseele* as a work of art came to life as a

psyche-real state through the act of artistic sublimation. It was born from fear of aggression against a loved object, and took the form of an image of a man accessing soul space through projected connection otherwise unseen or felt.

Kiesler believed man was "conscious of his interrelationship with his environment" through a *space* which was the *soul* that extended out into the landscape and sky and then back to his place on earth.[74] The space of the soul related all things, inanimate and animate; it expanded out to the cosmos and contracted back to earth. Environmentalism, as Kiesler understood with psychoanalytic perspective, hoped to heal the divide between "Man and Nature"—to perform a necessary unity.[75] As an environmentalist hoping to protect "Mother Earth" from the impact of thoughtless human acts of aggression, Kiesler proposed an ecological theory of the universe that might relieve modern society of its repressed anxiety. Through the defining act of *architecture*—a form of therapy in the libidinal world—he hoped to bring the mind, body, and soul back into balance in continuity with surrounding nature.

Kiesler presents an animist concept of soul space that hoped to heal the split between the animate and inanimate, subjects and objects, people and their environment, humans and their machines. He envisioned space—whether best represented by the natural sciences as nuclear, magnetic, or electrical forces, or through psychical entities of cathexis, affects, or spirits to connect all things conscious, unconscious, alive, or dead—as an architectural construct that resolved subject and object relations while at the same time warding off humanity's greatest fear, that of death.

Raumseele is the space created by "architecture [that] seems to be the plastic (spatial) link between the here and the beyond, between the tangible and intangible," Kiesler explains in "Magic Architecture."[76] He understood that "the beginnings of architecture are strangely enough not connected with life necessities, but with death."[77] "Architecture [connects] with death," and "the anxiety of explaining to himself the process of death leads [one] … even today to believe in immortality."[78] For the architect of the twentieth century, not only did architecture follow from a fear of death (Loos's theory of the *tomb*); so did the desire to modulate space (Kiesler's idea of *soul space*).[79]

Freud's disciple Otto Rank understood the idea of the soul in the 1930s as the manifestation of a desire for immortality, whether it was represented as spirit, the unconscious, or as a reality in itself. For Rank, the very concept of a

soul was a connection that guaranteed from within all states of being, including death, that humanity existed and related in collective space somehow—somewhere—outside or beyond conscious sense, time, and mortality. In historicocentric myth and religion, Rank argued in *Psychology and the Soul*, the totem is the embodiment of the immortal collective ancestor soul preserved through procreation, while dreams are the "proof" that there is an individual soul beyond the body that locates subjectivity externally and eternally.[80] For Rank, the work of Freud first associated the soul with the unconscious as the expression of our "inner life" for psychoanalytic purposes of self-knowledge and knowledge of the "other."[81] Through psychoanalysis, we heal our soul. Ultimately, the "Psyche," Rank explained, became associated with the maternal as "woman represented the soul." "This is the meaning of Psyche, the later conscious representation of the feminine soul, and patron saint of our science, which was named for her," he concludes. For woman represented and guaranteed the immortal soul by "animating children while keeping her own soul"; women were understood to be the "Soul Bearer."[82] The maternal body represented the very potential for birth of the next generation, effectively seen as a *soul space* in these logocentric myths.[83]

Not surprisingly, for Kiesler *Raumseele* would be associated with the maternal for generation and regeneration of mind, body, and soul through the inhabitation of a house designed to recreate the *aura* of the maternal body. As he recognized in the 1940s when writing the chapter "Enigma of Birth" in his "Magic Architecture," "man … finds a strange attraction for the locality of birth," and "this locality may be called the psychological shelter of man."[84] Like Rank and Freud, Kiesler associated psychological shelter with the maternal body:

> The place of birth carries with it the memory of the sheltering love of the mother, and the matriarchate is then the first form of social contract. Whatever evolution man has gone through, the attraction to the place of birth and to the actual house and home remains the same. Exactly like the animals, he is drawn to return home no matter how far away the search for the necessities of existence may have carried him. It is well established that animals, which have been carried away from their place of birth will find their way back with an *uncanny* sureness.[85]

For someone like Kiesler whose mother died when he was a baby, it is perhaps easy to suggest that he hoped to reconstitute this distant love through architecture.

Kiesler's intrauterine fetish was not naive, however: he was well aware of the Freudian and Rankian implications of his architectural research. Not altogether unlike the Surrealists, Kiesler studied Freud and similar psychoanalytic resources to problematize, enact, and potentially work through historic and contemporary enigmas of modern society.[86] If it is true, as Demos suggested, that Kiesler had an uncanny desire to achieve prelinguistic unity by invoking fusion between vision and reality in his 1940s Surrealist gallery spaces, we have to account for his instrumentalization of psychoanalysis in his architectural practice. If he simulated the aura of the primal maternal relationship in his Surrealist galleries, he did so to work through modern trauma and repressed wish fantasies in hope of arriving at what he believed could be a more critically engaging and ethically conscious building practice. Kiesler's architecture enacted modern myths in his attempt to reconstitute auratic relationships associated with the maternal soul space.

For Benjamin in his writings on Surrealism, as discussed in chapter 2, aura comprises a breathy ornamental halo that encases an inanimate object whose exact figure can be "read off" through the art of imaginative interpretation.[87] This halo that encases an object physically and psychically embodies traces of memory inscribed through acts of dwelling that gives an object sonic voice. Benjamin's Surrealist project endeavored to liberate the *physis* and *psyche*—the body and image space surrounding all things for political revolution. To this purpose, he idealistically sought to end "the cult of dwelling" by "reading off" auratic traces.[88] Kiesler's Surrealist project, on the other hand, wanted to dwell in the most primal of all auratic spaces—the image of the abode of the maternal being.

Kiesler's 1940s galleries were all idealizations of his continuous embryonic eggshell structures designed to recreate the sensual environment of continuity with the mother. As his sketches of them show, he intended these galleries to be the interior of his egg-shaped spaces that encased surreal habitation within a spheroid-matrix shell. Kiesler had been obsessed with spherical spaces since the formation of his 1924 Endless Theater project, and he would spend a lifetime struggling to build spherical eggshell forms. When he could not build the 1933 Space House as a continuous eggshell structure, for example, he drew it

Figure 5.9 Frederick Kiesler, Space House, 1933–1939. Collage. © 2017 Austrian Frederick and Lillian Kiesler Private Foundation, Vienna.

Figure 5.10 Frederick Kiesler, Surrealist Gallery, Art of This Century, c. 1942. Sketch. © 2017 Austrian Frederick and Lillian Kiesler Private Foundation, Vienna.

to appear as if an egg anyway. He also drew the interior of his 1942 Surrealist Gallery as if an egg, and he painted his egg as the culminating figure of his 1947 "Bloodflames" Surrealist exhibition. In his 1947 Hall of Superstitions, he perhaps most innovatively wrapped the entire gallery within a Möbius strip—an endless strip—to structure the space of an egg-shaped form. Kiesler's creative project grew from the struggle to build spherical and egg-shaped forms that arguably led to the design of his more complex endless spaces.

The Endless House

Kiesler began his design for the Endless House while completing his Hall of Superstitions for the 1947 Surrealist exhibition in Paris. He produced a series of sketches, now referred to as the "Paris Endless," that formed sinuous enclosures and cavernous spaces of varied houselike conditions. Only one drawing proved an actual egg; most of the schemes appeared to advance as a series of angular solids in which he carved out interior spaces and applied shadows to emphasize material presence and a ground plane. Kiesler designed his Paris Endless from a solid—a germ cell of a rock or an egg—and then stretched out areas to constitute spaces from the original mass. In these carved and stretched-out forms, he created orifices and protrusions that constituted potential skylights, doors, and windows. In addition, he cut sections from loosely sketched axonometric drawings that revealed confining interior spaces with potential stair configurations. Kiesler's Paris Endless incorporated bodily growths and unnerving appendages with estranged primitive structures.

Not altogether different from Le Corbusier's Ubu sculptures and poetic rock formations which he associated with the very essential acts of place making in his *New World of Space*, Kiesler began evoking primitivist fantasies in his architecture to inform his housing designs.[89] Kiesler looked primarily to prehistoric cultures and the structures of animal shelters to renaturalize modern building practices. His uncanny regression into primitivism highly influenced his study of "magic architecture" and subsequently his Endless House designs.

Throughout his research Kiesler maintained that *protection* was the primary concern of all shelter design, as it was for all animal dwellings. "Man's

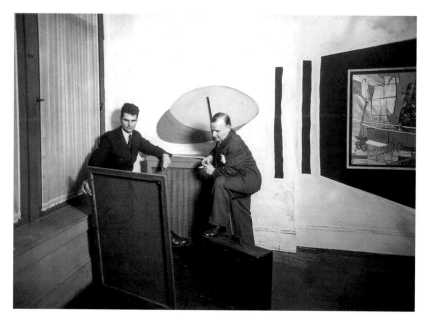

Figure 5.11 Frederick Kiesler, "Bloodflames" exhibition, 1947. Photograph of Kiesler and Calas alongside wall painting of Kiesler's egg. Courtesy of the Austrian Frederick and Lillian Kiesler Private Foundation, Vienna.

house-building is nothing else but Animal-Architecture," he explained in "Magic Architecture"; "its function is physical protection" through "nest-building."[90] For Kiesler, "the talent for building is … nothing else but the extended gesture of defense of the animal-psyche: protection against attack and death; preservation of food, shielding the weakened sick," and so on.[91] The house existed fundamentally for the safety it provided; for Kiesler, "no better illustration of the house as a shield for physical protection can be found [than] the homes of the termites."[92] He looked very carefully at the way termites constructed arches and shelters from grains of sand with grass reinforcement.[93] Termites, he observed, instinctively build in continuous mounds primarily through cellular chambers that envelop the queen and her nursery.[94] Kieser proposed that humanity likewise must build instinctively:

> It is now clear that the instinctive ability of … man in general to build and to wear clothing has a dual root: a physiological as well as a psychological one: Physiologically arbitrary reflex motions of the body are in time, mechanized and standardized through our nervous system. Psychologically all animals, and especially man, living collectively, invariably learn by imitating.[95]

To design as nature does, Kiesler proposed, humanity should build autonomically—trained through imitation of reflex action built up in our nervous system habitually over time. Recalling James's automatist theories, Kiesler studied the instinctive construction and cellular building patterns of animals; by imitating more innate building practices, he hoped to construct more environmentally sensitive modern shelters.

Caves, nests, and stones were the basic elements he concluded that architects should mimic. Caves, not surprisingly for Kiesler, represented the innermost cell and first natural shelter for all humanity, while the nest proved the first artificial building. In piling stones, humans could imitate the space of sheltering caves as a continuous arch of rocks.[96] Studying nests like those of the orangutan, Kiesler observed how shelters could "retain elasticity" so that their structure more "easily accommodates the movement of the body which they protect."[97] From his research, Kiesler asserted that cellular mounds, rock formations, and flexible structures were the fundamental building blocks that

Figure 5.12 Frederick Kiesler, Paris Endless, 1947. Gouache drawing. © 2017 Austrian Frederick and Lillian Kiesler Private Foundation, Vienna.

Figure 5.13 Frederick Kiesler, Paris Endless, 1947. Drawing. © 2017 Austrian Frederick and Lillian Kiesler Private Foundation, Vienna.

Figure 5.14 Frederick Kiesler, Paris Endless, 1947. Drawing. © 2017 Austrian Frederick and Lillian Kiesler Private Foundation, Vienna.

Figure 5.15 Frederick Kiesler, Paris Endless, 1947. Drawing. © 2017 Austrian Frederick and Lillian Kiesler Private Foundation, Vienna.

(15). Page 105

Termites building an Arch. (Arch considered to be invention of man.
(left): Erecting two columns out of sand grains.
(right): Laying a grass-stalk across the two columns as a reinforce-
ment of the arch.

16 (a): Schematic section through a Termitary, showing tower of super-
imposed arches. Cell of the queen at base, center.
16 (b): The Colosseum in Rome, also a circular structure of superimposed
arches.

Figure 5.16 Images of termite structures. From Frederick Kiesler, "Magic Architecture,"
unpublished, c. 1940s. Courtesy of the Austrian Frederick and Lillian Kiesler Private
Foundation, Vienna.

Figure 5.17 Image of termite structures, "Schematic section through a Termitary." From
Frederick Kiesler, "Magic Architecture," unpublished, c. 1940s. Courtesy of the Austrian Frederick
and Lillian Kiesler Private Foundation, Vienna.

Figure 5.18 Dolmen, Carnac, Brittany, France, 4500–1500 BCE. Photograph from Frederick Kiesler, "Magic Architecture," unpublished, c. 1940s. Courtesy of the Lillian and Frederick Kiesler Papers, Archives of American Art, Smithsonian Institution, Washington, DC.

create natural shelter designs. "Magic Architecture" was his historic proof that both justified and informed his interest in elastic architecture.

Kiesler's 1947 Paris Endless was his first response to these natural history studies. The final version of the Paris Endless emerged from a series of rock-like formations, with cellular spaces that served to create a cohesive structure within an elastic skin. The Endless House supposed a mass that Kiesler stretched, pulled, and modulated about a delineated circulatory path to form one organic system. Derived through the cavernous shaping of rocks and piling of stones, Kiesler lifted the Endless House off the ground at different locations. In the final version, it had punctures through its skin on appendages and on top of the main body of the house. These openings showed lines exuding dynamic forces between interior and exterior spaces. The whole body of the Endless House undulated to the contracting and expanding rhythms in release of what appear in Kiesler's lexicon to be dynamic energy forces. Besides its primitive qualities, Kiesler's 1947 Paris Endless had an especially erotic disposition.

Notably, both the visual and verbal descriptions of Kiesler's houses ultimately resonated with Wilhelm Reich's writings on orgasm theory. Kiesler had seen Reich's lectures in New York at the New School for Social Research between 1939 and 1941 and he held several of Reich's books in his library, including *Die Bione*, 1938, *Listen, Little Man*, 1948, *An Introduction to Orgonomy*, 1960 and *Wilhelm Reich, Selected Writings*, 1961.[98] Reich's work sustained Kiesler's interest throughout his entire study of the Endless House from the 1940s through the 1960s. Kiesler eventually became close to Reich, conversing with him and staying at his home.[99]

Like Kiesler, Reich researched human physiology and psychology to propose a *"functional unity"* of the *"balance of forces"*—between the tension and relaxation, contraction and expansion, of the psychic and the somatic systems of the body.[100] Reich's theories of course all pertained to sexuality. He proposed an analogy between the physical and psychical structures of the body, in particular the sexual organs and the urinary system. Similar to the bladder, the sex organs build up forces between internal pressure and surface tension, expanding and contracting, in search of release.[101] Referencing Freud's theory of the drives, Reich associated sex with the psychical entities of pleasure and pain. Expansion of the physical body represented for Reich pleasure and joy "outside the self—toward the world," and contraction represented sorrow and pain

Figure 5.19 Frederick Kiesler, Paris Endless, 1947. Drawing. "Charging and Discharging with a force that is both Expanding and Contracting." © 2017 Austrian Frederick and Lillian Kiesler Private Foundation, Vienna.

"away from the world—back into the self."[102] Not unlike Kiesler's theories on shelter design for his Space House, Reich deduced that "Life process" takes "place in the constant alternation of expansion and contraction."[103] "Sexuality" was nothing other than "*the biological function of expansion* ('out of the self') ... [and] *anxiety* ... (back into the self)."[104] On an instinctual level, "expansion and contraction function as sexual excitation and anxiety, respectively."[105]

Reich not surprisingly deduced that the process of reaching orgasm was instinctual, and had natural benefits for both the human *physis* and *psyche*. During the act of sex, he observed, a balanced organism reaches a convulsive state of "autonomic innervation" not altogether different from the act of breathing. "Life process," he observed, "in especial respiration, can thus be understood as a constant state of pulsation in which the organism continues to alternate, pendulum-like, between parasympathetic expansion (expiration) and sympathetic contraction (inspiration)."[106] Like the "rhythmic behavior of an ameba, a medusa, or heart," the body releases pressures autonomically through sexual orgasm. For Reich, sex had nothing to do with love but with *pelvic anxiety* that built up toward release. "*The elimination of sexual stasis through orgastic discharge eliminate[ed] ... every neurotic manifestation*," he believed.[107] In the compulsive act of sex, associated with a natural release of aggression, the body achieved momentary therapeutic benefit from achieving orgastic fusion with another human being.[108] Through the orgasm, one gives oneself over fully, autonomically, to be fused momentarily with internal and external atmospheric energy—what Reich described as the aura of "Comic Orgone Energy."[109]

Not altogether differently from Reich, Kiesler hoped to instrumentalize the automatisms of everyday life, to simulate a state of auratic communication, of deep release with the cosmos. If Kiesler's house posed a relationship to Reich's theories on the benefits of sexual orgasms, the Endless House enacted one of its most primal expressions. It performed as a bodily supplement—a prophylactic sex toy—to release pent-up anxiety and frustration. If Loos's modern house hoped to build up bodily armor on the exterior by repressing sensual pleasure on the interior, Kiesler hoped to release modernism's repression through the invention of architecture as sexual liberation. Within the contracting and expanding apertures of surreal dwelling, the Endless House conformed to the body to enact modern pleasure in the hope of releasing repressed pain.

1950 Endless

On his return to New York from Paris after staging the Hall of Superstitions, Kiesler had few design projects immediately waiting for him. But as the following years saw an enormous modern housing boom across the country, he believed his research on housing had become ever more urgent and necessary. In 1946, he had written a proposal to reopen his Design Correlation Laboratory, which he sent in 1948 to the University of Michigan. He asserted there was an unmet "URGENT NEED" after the war, "when all those interested either by profession or speculation plunge into housing-design, with studies of necessarily limited scope."[110] To counteract "this rush with investigations independent of immediate application and sales," Kiesler proposed his newest housing studies as a more appropriate response; but this line of research found no immediate interest.[111]

Kiesler's first break in the postwar era was publishing his "Manifeste du corréalisme" in *L'Architecture d'Aujourd'hui* in 1949, which received significant international attention. Here he presented his most significant housing and design projects and new ideas he was developing in his manuscript for "Magic Architecture," alongside familiar ideas from "On Correalism and Biotechnique."[112] Upon recommendation by Lewis Mumford, Kiesler showed a more complete version of the article to McGraw-Hill, hoping to publish it under the title *Toward a Union of Art and Architecture*.[113] The manuscript also included his recent article "Pseudo-Functionalism in Modern Architecture" published in *Parisian Review*.[114] Interest in Kiesler's work gained momentum that year, as he presented lectures at Harvard University, the University of Michigan, Columbia University, and the Institute of Design in Chicago.[115] By June 1949, he had met for the first time with Alfred Barr, then Director of the Museum Collections at MoMA.[116] Upon recommendation from Philip Johnson, who had begun to prove a "staunch supporter and ally" for Kiesler, he was invited to hold a Design Seminar group, "a sort of School for Designers," at MoMA, planned for some time in the following year.[117]

In June 1950, Kiesler's friend David Hare invited him to participate in a collaborative group show, "The Muralists and Modern Architecture," at the Kootz Gallery, New York. Kiesler felt he had been "put amusingly on the spot" in

light of the "type of architect" participating—namely Johnson, Gropius, and Marcel Breuer, who were all directly invited to participate in the show.[118] Kiesler felt he was an outsider to this group, as he was reminded by the indirect invitation he received to participate.

For the exhibition, Kiesler designed a 9-inch-diameter scale model in clay of a new version of his Endless House. Perhaps too insecure to expose the overt sexuality of his 1947 Paris Endless, Kiesler proposed instead to present an ideal solid egg-shaped structure for this design. Hare and Kiesler collaborated as they had for the 1947 Hall of Superstitions. Hare produced an interior sculpture to be surrounded by Kiesler's curved shell. To fit his sculpture, Hare produced a large egg-shaped structure based on Kiesler's smaller model, but as it proved too strange, they exhibited only Kiesler's small clay model and a fragment of the larger shell.

Presented in October, Kiesler's design was remarkably well received. In many ways, the exhibition proved a breakthrough that launched him as a significant figure in the history of modern architecture. Arthur Drexler, Director of the Department of Architecture and Design at MoMA, published Kiesler's project in *Interiors* magazine in 1950 alongside an elaborate description of the work.[119] Johnson acquired the Endless House model and many of the drawings for MoMA in 1951 and showed it again at Drexler's exhibition "Two Houses: New Ways to Build" alongside Fuller's geodesic dome in 1952. *Life* and *Time* magazines featured Kiesler's Endless House in May and October of 1952, and soon after he became somewhat of a celebrity to a wider audience of educators, architects, and critics.

This speculative clay model of the Endless House successfully incorporated years of Kiesler's design interests. As he had with the Space House, he generated its form in response to varied social dynamics, proposing the Endless House as a form for extended family living; it brought two or three generations together under one roof. Different room sizes were correlated with varied activity levels. Where "generous spaces preferable for group living demand double or even triple heights in such areas as the living room," Kiesler explained, "minimal 8-foot heights are best in bedrooms and other private areas."[120] The plan revealed three "individual recreation and sleeping areas," with minimal windows for daylight, a soundproof study, and a children's playground and workshop. All rooms were located off a central group living-eating area and separated by thick *poché* space

with doors as flexible screens.[121] Unlike the Space House, however, the Endless House did not advance overt mechanized systems and mobile furnishings to create spatial variation, but relied heavily on multimedia lighting effects similar to those of his 1924 Endless Theater.

In the Endless House, Kiesler's stage effects became psychological lighting effects, which dominated the interior atmosphere. He delineated psychic projection through a series of colored lines that enveloped and generated from within the house, similarly to his *Raumseele* woodcut. Lighting "push[ed] back the physical boundaries" of the architecture, he argued, at the same time surrounding the inhabitant with distracting "color and brilliance" to inspire expansive rumination secure in remote havens of rest.[122]

Featured during the daytime in the "Endless House" was a large crystal that filtered the sun into a prismatic kaleidoscope. It used "convex mirror reflex devices" to translate light—"to diffuse it"—into rays that transformed into a series of three colors from dawn until dusk, marking the passage of daily habits in "continuity of time" and "dynamic integration with natural forces."[123] Kiesler introduced time into his architecture to demarcate habitation—to codify the body's actions in relation to spatial conditions. As time passed, the room systematically changed color, diffused on surfaces and inscribed in personal memory.

Nighttime lighting provided similar effect, with "exhilarating" "double-direct-indirect" lighting that reflected off woolen white carpeting and then bounced back onto the walls and ceiling—"diffused" endlessly. Night lighting, being theatrical and motion-sensitive, moved with the inhabitant and provided a variety of experiences marked by "vast succession of shadows beyond shadows."[124] Spotlights focused on objects and habitants. Diffuse light radiated on curvilinear walls. Kiesler transformed the habits of everyday life into the *auratic* traces of surface memory dispersed as colorful illusory affects timed to the movement of the body and rhythms of sun and moon.

Dwelling no longer left traces in the physical markings on material surfaces of the architectural body. Instead, dwelling was dispersed as sensational images marked through time as phantasmatic illusory colors and shadows recorded in memory. Kiesler believed twentieth-century beings could dwell in multimedia, and he designed his architecture to envelop habitation within a casing of illusory projection. The house formed a virtual environment that became an effervescent halo surrounding the habitant—constructed as a seemingly

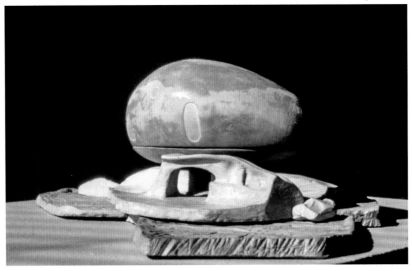

Figure 5.20 Frederick Kiesler, Endless House, 1950. Lighting diagram. From "Frederick Kiesler's Endless House and Its Psychological Lighting," *Contract Interiors*, November 1950. © 2017 Austrian Frederick and Lillian Kiesler Private Foundation, Vienna.

Figure 5.21 Frederick Kiesler, Endless House, 1950. Model. © 2017 Austrian Frederick and Lillian Kiesler Private Foundation, Vienna.

elusive surface of "continuous tension" eggshell construction, a complex matrix or shell that encased, prefigured, adapted, and controlled the parameters of dwelling inside its virtual elastic skin.

Like the Space House, Kiesler conceived his Endless House as "a shock-proof shelter."[125] Its image and form were almost identical to the rock-shaped formations of his studies for "Magic Architecture" based on prehistoric mono-lith constructions.[126] The Endless House was rooted in a primitivist regression, but unlike the 1947 Paris Endless it did not exhibit hypersexualized elastic expression. Rather than autonomic sexual release, it embodied the palpable luxury of warm soft glowing atmospheres of multimedia affections. In his End-less House, Kiesler exploded space—"Die Kulisse explodiert"—creating end-lessness through *illusions* that "sweep past the boundaries" while at the same time integrating dwelling in a solid protective shell.[127]

Despite its innovation and celebrated reception, Kiesler's eggshell con-struction nevertheless remained purely a provocation. Although he never stopped searching for a client to build his Endless House, no materials, struc-tural knowledge, or fabrication techniques were available to construct his con-tinuous eggshell forms cost-effectively. Throughout the 1950s, however, this technology started to gain traction with other architects and engineers.

The 1950s saw several continuous tension-shell constructions similar to Kiesler's vision. John M. Johansen produced eggshell structures for his Sprayform House in 1954, and constructed a small version in Zagreb in 1956.[128] Eero Saarinen constructed the TWA terminal in steel-reinforced concrete in New York between 1956 and 1962, proving it was possible to build innovative organic structures at least on an institutional scale. Sanford Hohauser published his egg-shaped Beach House in 1956, while MIT architects produced the first continuous tension-shell plastic structure, the Monsanto House of the Future, in 1957.[129]

Interest in continuous tension-shell technology advanced rapidly during the postwar years, especially in the plastics industry. Douglas Haskell, edito-rial chairman of *Architectural Forum*, argued in 1954 that these plastics would generate a "second 'modern' order ... to which today's 'modern' will be just an antecedent."[130] In favor of structures similar to Kiesler, Haskell remarked:

Today's typical "order," as Mies van der Rohe says, is the skeleton frame. ... Tomorrow's structure may be typically all "skin." Its skin

may be formed to become its shell *and* its interior columns of cellular structure. … A single continuous envelope of a thin sandwich material may yield structure and enclosure; resistance to destructive forces from outside; solidity or porosity; control of light and view; insulation for heat and sound, color and finish—all characteristics we now impose separately. … Future buildings may be as thin as eggshells.[131]

Continuous eggshell construction hoped to promote a building typology alternative to the traditionally accepted modern practice of "skin and bone" architecture. Kiesler had known Haskell a long time, since their involvement at the American Union of Decorative Artists and Craftsmen; in 1949 Kiesler sent Haskell his "Manifeste du corréalisme" that featured his Space House. "To Doug Haskell with 20 years of fighting Memories (in the U.S.A.)," Kiesler signed his article, hoping that his vision for the Endless House might one day be taken seriously. Finally, in the 1950s his ambition was starting to be realized.[132]

Endless Sculpture

Finally breaking through the shell of his egg-shaped structures, Kiesler created architecture far more provocative through a series of Endless Sculpture projects he produced around 1954. The sculpture titled *The Vessel of Fire* began from a series of three hollow clay shells that nested together "like broken eggshells." Originally designed for his 1950 Endless House, the shells had cracked due to faulty craftsmanship and were then cast in bronze to retain their form. "The mutation into sculpture," took place by accident, as Kiesler observed. He had received a Graham Foundation grant to pursue creative artistic work, and with the time this allowed him, he began serendipitously standing one of the broken cast shells upright for amusement. The "form became more prominent than its function," he remembered, and the Endless House instead became a sculpture that needed a base for support.[133] Using wood planks ripped to appear "utterly muscular" from "a tree trunk," he made a support for the shell; he then added two more shells to the sides as "wings," to create "breath" for the sculpture.[134] To support its growing weight he needed a "widespread base," and found a series of burned, charred wood planks in a foundry which he fastened together.[135] Realizing

Figure 5.22 Frederick Kiesler, *Endless Sculpture (Vessel of Fire)*, c. 1954. © 2017 Austrian Frederick and Lillian Kiesler Private Foundation, Vienna.

the sculpture was still incomplete, he added a vessel of fire to bring light beneath the shells between the widespread base of its muscular tree trunk legs.

As he made more sketches, adding more shells—more units—to achieve "continuity," Kiesler believed his Endless Sculpture proved "indigenous to its environment"; it "constitutes a global organism," he proposed, "in itself growing constantly from fixation to discontinuity within the will of an unlimited continuum."[136] He saw the sculpture as a series of part objects brought together in continuum and able to breathe life:

> [For as] you see, the sculptor's wings are really made of clay and his work is earthbound. It is the breathing of the intervals between details that makes his materials live and expand visually. Isn't the dimensioning of space-distances, the exactitude of intervals, the physical nothingness which links the solid parts together so powerfully—isn't this the major device for translating nature's time-space continuity into man-made objects?[137]

Kiesler fantasized one could translate nature's life principles of time-space continuity and make the inanimate animate, by marking space through relative distance in time. He envisioned joining different objects, even those broken apart, via endless spatial connections—through a fantasy of soul space that he imagined existed virtually within the intervals between segments.

Throughout his practice, Kiesler was obsessed with resolving subject-object relations by evoking relative spatial distance to connect all things. He commingled this obsession with theories by Einstein and Minkowski on space and time with those of Lorentz on dilation and contraction. By the 1950s, his pseudo-scientific fantasies resonated with events of contemporary culture. As modern developments in "nuclear science, fission, fusion, and satellites unexpectedly rocketed everybody's imagination into outer space," Kiesler realized, popular culture "suddenly made the Endless a natural."[138] Science and technology had motivated him since the 1920s, long before "the new terminology ha[d] … entered our vocabulary," as he observed.[139] He hoped to negate separation and difference between things through elaboration of *space science*. In his 1959 essay on "How Things Hold Together," Kiesler proposed a similar theory of spatial connectivity for his "galaxial" sculpture projects.[140] Not surprisingly, he

ultimately determined to set his sculptures to motion—to create an "indoor cosmos," which he described as his "mobiloids" that appeared to breathe through parallax perception or the addition of electromechanical devices.[141]

Animated by the miracles of motion—human or machine—his sculptures received names. His expanded wall sculpture he called *Heliose*, and his ceiling sculpture *Embryo*. *Heliose* was the daughter of the *Vessel of Fire*, "slender compared to the mother."[142] She was the regression from the mother, he explained; "she stands now in my house, threefold puberty: shyness, anguish, longing. She is wrapped in snow-white cloud tissues, a heavy body of bronze inside. … We shall undress her as soon as Alice arrives to view her … the kettle is whistling. I must go and prepare my brunch."[143] As Kiesler prepared to undress his pubescent child for her unveiling to his friends, he returned to the subject of food (as often in his writing), as apparently he was always hungry, plagued by unresolved needs and drives.[144] In the 1930s, Steffi began a diary to record major events in Kiesler's life that almost always revolved around food. By the 1950s Kiesler elaborated his own story in a diary, which has since been published as a book titled *Inside the Endless House*.

Inside the Endless

Kiesler realized his final version of the Endless House when Johnson and Drexler presented him with an opportunity to construct the Endless House inside MoMA's garden courtyard in the late 1950s. Kiesler had received a $12,000 grant from the R. H. Gottesmann Foundation in February 1958 to build the model and develop the plans. Drexler invited Kiesler to present his plans and model at the "Visionary Architecture" show planned for MoMA in September 1960.[145] Convinced he should make a large-scale mock-up, he began to construct a new version of the Endless out of hammered bronze metal sheets. Friends had criticized him for his former 1950s version of the Endless House—a small uninhabitable egg, considered a "castrated scrap" of Kiesler's original intention.[146] Instead, he chose to build a "super-galaxy" in shells to give the space-time feeling of the Endless House.[147] To dwell inside its raw materiality became one of his ultimate obsessions.

The version built of hammered bronze sheets was too amorphous, so rather than presenting it at MoMA he invented a smaller version with new techniques.[148] Kiesler began cutting, hammering, and twisting together metal wire mesh to produce loosely defined hollow forms to be held up in tension. He doodled the size and shape of the house by forming programmatic bubble diagrams that enveloped various intertwined spaces—some small, some large—that modulated to a series of intuitively defined intrinsic parameters. Kiesler worked as a sculptor—feeling his way through the form to shape his ideas. Like a Surrealist artist working on automatic writings or making chance-choice operations, he designed more instinctively—doodling with the nonlinear complexity of aconscious habitual experience, evading the limited prescriptions of overrationalized thinking. From his lifelong study of housing, bodily measure, and spatial relationships, he was able to instinctively design the size, shape, and quality of forms he was interested in producing—at least on the schematic level. He allowed what Bergson might describe as "intuition as method" to form his ideas, as opposed to developing a priori an *esquisse* or sketch as one might do in Beaux-Arts training to determine the exact plan of form prior to working with specific modeling materials.[149] Working directly with materiality, smearing concrete over both the inside and outside of the mesh he had suspended, he created a series of undulating shell-like strips forming continuous spaces that he imagined fitting himself inside. Endlessness embodied virtual poetic spaces that resonated indefinitely between a series of contiguous material forms of somewhat undefined areas. To achieve endlessness, Kiesler formed a design strategy to create multiple spatial possibilities wrapped loosely together within a series of continuous temporal forms. He made an endless array of spatial intervals—a series of soul spaces—intertwined together intuitively (psychically) and held together by spatial tension between enfolding planes reminiscent of the railway or rollercoaster design for his first 1924 Endless.

"The Endless House is called 'Endless' because all ends meet, and meet continuously," Kiesler said.[150] The final form of the house undulated with shapes and volumes that he demanded were not "amorphous, not a free-for-all form. On the contrary, its construction has strict boundaries according to the scale of your living. Its shape and form are determined by inherent life processes."[151] Daily events of the family and guests shaped the form of the house—and not only guests of the conscious world, but those from the unconscious realm as

Figure 5.23 Frederick Kiesler, Endless House, 1959. Wire-mesh armature for model. Courtesy of the Austrian Frederick and Lillian Kiesler Private Foundation, Vienna.

well. For as Kiesler contended, "the 'Endless' cannot be only a home for the family, but must definitely make room and comfort for those 'visitors' from your own inner world. Communion with yourself. The ritual of meditation inspired."[152] The home was "no longer a single block with either flat, curved, or zigzag walls," Kiesler argued, for it had become a softer, gentler space of seclusion;[153] it was "rather sensuous, more like the female body in contrast to sharp-angled male architecture." Inside the Endless House, "you could womb yourself into happy solitude."[154] For Kiesler, the house was a body that one desired to inhabit; it was organic and nonrectilinear and provided for mental hygiene through an obsessive neurotic return to the womb.

Rank understood that an obsessive neurotic need to return to the womb stemmed from anxiety. But for Rank, anxiety came from the very nature of being born—exiting the maternal body—symbolized by the first fecal excretion, breath, or cry. An idealistic premise in his theory in the *Trauma of Birth* is the notion that the womb was a warm, protective, nurturing environment in which a child developed in continuity with its mother and perhaps didn't want to leave. Rudely awakened to the cold harsh external environment, an infant supposedly desires to return to that original humble dwelling. Separation anxiety, Rank argued, leads to a neurotic need to return to the paradise of an ideal home. He understood that intrauterine fantasy was an *idealization* developed during extrauterine existence, and did not propose that a return to the womb was healthy. In fact, dwelling—the obsessive desire to regress to auratic unity surrounded by soft palpable warmths—can be an indication of an unstable and unhealthy life. For Rank and Freud it proved the infantile neurotic behavior pattern of a maladjusted person who had not yet developed the facility to accept distinct subject-object relationships or reify "love" through external libidinal engagements. It was a narcissistic state of regression—as is all architecture that attempts to sublimate fear of action through internalized caves of the *unheimlich*.

Exposing the myth of this *uncanny aura*, the Greeks told the tale of the Minotaur, a hybrid monster, a man with the head of a bull, that lived inside a labyrinth until he was slain by the hero Theseus.[155] As Rank suggests in the *Trauma of Birth*, the Minotaur can be understood as the human monster that lived inside the "complicated dark passages" of the labyrinth that "are a representation of the human intestines (the 'Palace of Intestines')." For Rank, the

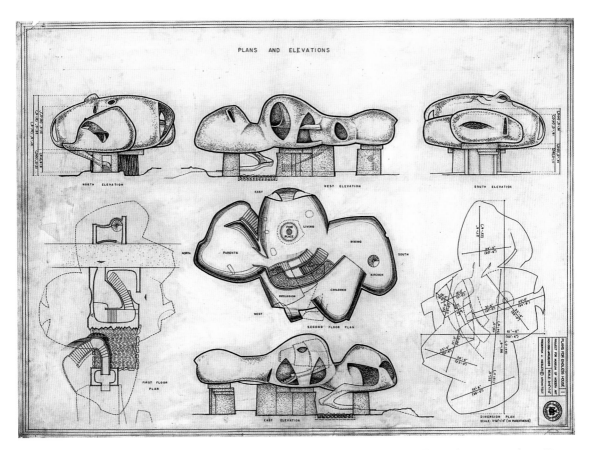

Figure 5.24 Frederick Kiesler, Endless House, 1959. Plans and elevations. © 2017 Austrian Frederick and Lillian Kiesler Private Foundation, Vienna.

Figure 5.25 Josep Sert with Frederick Kiesler as the Minotaur in Hans Richter's film *Poem 8x8*, 1957. Courtesy of the Austrian Frederick and Lillian Kiesler Private Foundation, Vienna.

Figure 5.26 Frederick Kiesler as Minotaur in Hans Richter's film *Poem 8x8*, 1957. Courtesy of the Austrian Frederick and Lillian Kiesler Private Foundation, Vienna.

analytic concept of the labyrinth "as the prison" for "a mis-shaped form ([or] embryo [i.e., the Minotaur]) unable to find the exit, is clear in the sense of [an] unconscious wish fulfillment." Inspired by Freud's work on the uncanny and the Wolf Man, Rank described this unconscious wish fulfillment as a neurotic infantile fantasy of return to the "underground labyrinth of the womb situation."[156] The endless environment of the labyrinth suggested a prenatal or digestive condition where there were only continuous spatial configurations riddled with enigmatic interior and exterior relationships.[157] On the one hand the space of the labyrinth can be argued to be paradisiacal, while on the other it can be said to lead one to wander about anxious, excited, and somewhat paranoid about what is yet to come.

Not surprisingly, Kiesler was given the role of Minotaur in Richter's Surrealist "film-poem" *8x8* in 1957. Kiesler's architecture bore a striking similarity to Rank's interpretation of the labyrinthine palace. It did not, however, create a simplistic fantasy of intrauterine return, vaginal or similarly intestinal/anal, to avoid existence in the external world. For within the Endless House, at the darkest moment of solitude, sheltered in the warm palpable depths, Kiesler hoped to provide a phantasmatic dream world that could reach out to the cosmos and expand. He attempted to rely on the technology of magic illusion—theatrical projection, cinema, and even television as "Broadcasted Decoration"—to achieve expansive space.[158] He recognized that "we *want* to live in a confined space, we want to be protected, so to say, from the outer world. What is important is the necessity of *temporary* confinement."[159] *Temporality* for Kiesler, however, could not happen within the shape of a box; it had to be formed biotechnologically in the shape of a shell:

> When the moment comes when we want to move a wall way out, to breathe more fully—yes, when we want the ceiling to be higher, or the whole area to change into another shape—that is where the Endless House comes in. Because it has a twofold expression: first, it has the reality of the walls and the ceiling and the floor as they are … but also a lighting system … so that by changing the lights … one can expand or contract the interior in an illusionary way. You can't do that with boxes.[160]

At the heart of Kiesler's interest in the Endless was the promise of the "illusionary way." The Endless House provided no sense of boundary, but was still able to shelter. Kiesler created a machine for dreaming, a sort of living organism that could be inhabited and engaged by the body. He designed his dream machine for curative effect—to strengthen the body and psyche to discharge individuals back into the sensual world of men, digested, regenerated, and redeemed.

To strengthen the ego is a complex project, and as Melanie Klein argues in her pre-Oedipal theory of childhood development, phantasy and hallucination are primary to ego (and superego) formation.[161] Born in a world without any self-distinction, a child, Klein believed, is bound to the mother's body without being as yet a separate object.[162] Challenged by experiences of both pleasure and pain indiscriminately introjecting everything, through phantasy and hallucination the child instinctively learns to project the negative and idealize the positive.[163] It splits the continuum into bits. In bits, this feeling amounts to a state of disintegration, which is normally transitory.[164] This disintegrated body in bits, the ego in bits, is reconfigured through a curative-reparative stage ushered in by guilt feelings of the developing superego.[165] The ego resolves identity and spatial configurations from among the flux of partial objects in continuum. Whether intended or not, Kiesler had searched for an architecture to create a similar zone. As the editors of *L'Architecture d'Aujourd'hui* once said, "but does it not seem that Kiesler pursues one goal only: to reach Man, to destroy him in some fashion to re-create him, and to let him eject a new 'elan' of imagination and liberty?"[166]

Kiesler's Endless House aimed to stimulate an idealized paradisiacal life inside an ergonomically designed illusionary cinematic spatial experience that could expand and contract to engage one's every motion and desire. It was geared to rebuild both the physis and the psyche of the dweller—tailored to mediate the flux and flow of the evolving demands of daily existence. Designed to adapt to constantly changing parameters, the house was built of materials that on a molecular level could absorb and resist shock. Fluctuating between reparation (building up) and destruction (breaking down), the house was ideally porous and protective; it enveloped the body in a phantasmatic elastic skin not unlike the maternal womb. This architecture of eternal contraction and expansion (*détente*) assimilated the perceiving body within "the total artwork

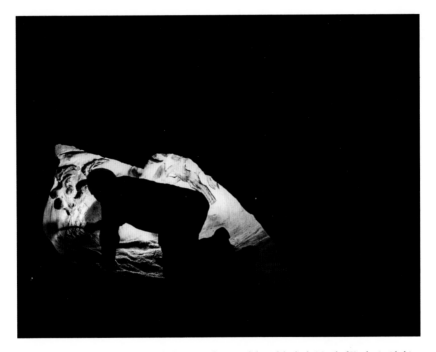

Figure 5.27 Frederick Kiesler, *Bucephalus*, 1965. Photograph by Adelaide de Menil of Kiesler inside his horse sculpture. Courtesy of the Austrian Frederick and Lillian Kiesler Private Foundation, Vienna. © Adelaide de Menil.

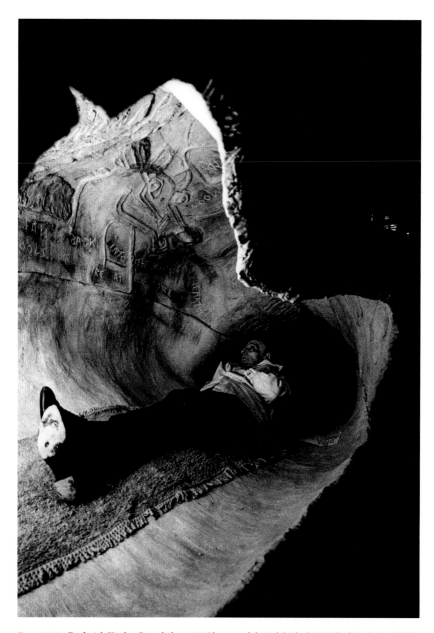

Figure 5.28 Frederick Kiesler, *Bucephalus*, 1965. Photograph by Adelaide de Menil of Kiesler inside his horse sculpture. Courtesy of the Austrian Frederick and Lillian Kiesler Private Foundation, Vienna. © Adelaide de Menil.

[*Gesamtkunstwerk*] of effects." Surface boundaries became diffuse and elusive—yet were immanently maintained through "organic creation." Its transmutable shape characterized the disposition of its inhabitants stretched between introjected perceptions and projected actions. Dwelling found its home between illusion and reality, continuity and individuality, vision and fact.

Figure 5.29 Frederick Kiesler, Endless House, 1959. Frederick Kiesler with model. Photograph by Hans Namuth, circa 1960. Courtesy Center for Creative Photography, University of Arizona. © 1991 Hans Namuth Estate.

Figure 6.1 Frederick Kiesler, Universal Theater, 1959–1960. Schematic design sketch on back of Russian Tea Room menu. Courtesy of the Harvard Theater Collection, MS Thr 729. Houghton Library, Harvard University, Cambridge, MA.

6 Elastic Architecture: From Control to Liberation

So the form determines the manner of life of the animal, and the manner
of life in its turn reacts powerfully upon all forms.
—*Goethe*

"Just hold onto your hat and be ready to orbit," declared newspaper critic Hubert
Houssel of the *Houston Post*, April 8, 1962. The exhibition "The Ideal Theater:
Eight Concepts," he wrote, is an "Adventure ... in Space"—"the most bizarre
and arresting this country has seen on the theatre subject."[1] Setting out on a
national tour on January 27, 1962, with its first stop the Museum of Contempo-
rary Crafts, 29 West 58th Street in New York City, the "Ideal Theater" exhibition
presented eight visionary designs that proposed various pragmatic and utopian
solutions for creating innovative theatrical forms. Organized by the American
Federation of Arts through a grant program initiated by the Ford Foundation,
the exhibition aimed to challenge the limits of Broadway theater.[2] "Broadway
theaters ... had not changed ... since 1905," playwright Arthur Miller explained
during initial programming meetings at the Ford Foundation offices.[3] He and
other playwrights felt limited by the encumbrances of New York theater spaces.
"I think a new form is going to burst out because the world is now impossible
to reflect in such a cubic fashion," Miller argued.[4] Playwrights wanted more

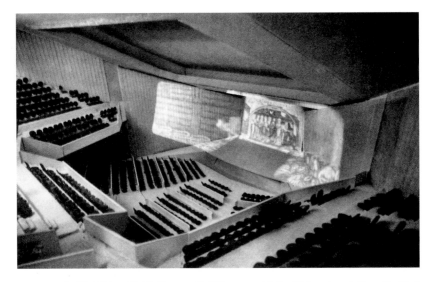

Figure 6.2 Paul Rudolph and Ralph Alswang, Ideal Theater, model, New York, 1960–1961. From *The Ideal Theater: Eight Concepts*, 1962.

flexible performance arenas, and the Ideal Theater competition planned to revolutionize the modern stage.

Selected from a list of nominees, eight teams of prominent architects and designers received grants to complete projects for the exhibition.[5] Nominated by Thomas Creighton of *Progressive Architecture*, Kiesler was selected to participate due to his unique expertise as both a stage designer and architect. The various proposals in the exhibition boasted an array of means and methods to liberate space for new theatrical events. The eight theater designs were arguably "violently diverse," yet all advanced flexible auditoriums and theatrical arrangements that exploited the latest electronic and computer technologies.[6] Lighting techniques could affect the mood of the audience; stage performances could transform from indoor to outdoor, three-quarter or in the round. "Projected pictures could dissolve directly and smoothly into actual stage settings"—all, as one critic declared, at the miraculous "touch of a button."[7]

Despite their technological similarities, Kiesler's plan and stage had a unique shape categorically different from the seven others schemes.[8] Where most of the designs developed along the functionalist trope "form follows function," Kiesler's planning strategies exceeded any obvious correlation with their rational requirements. Architect Paul Rudolph's scheme, for example, compiled quadratic shapes that conformed to specific known, measurable components of his theater. Kiesler's design, instead, had additional spaces in varied locations, multiple redundant forms, expansive circulation zones, and a distributed cellular construction.[9] Kiesler had combined what critics described as a "molded, free-form auditorium and skyscraper," which they compared to the shape of a "vast potato" or "unborn moose."[10] The Universal Theater had a vegetative quality with an embryonic structure. It was much larger than any other scheme and went beyond the given program to incorporate a thirty-story tower, which could house theater, film, offices, and sporting events all simultaneously within one elastic spatial configuration.

Kiesler's *"elastic spatial planning"* strategy, as he called it, offered *"the possibility of creating … [an] environment best suited to each species of the performing arts."*[11] With the organizational scheme of his Universal Theater designed to house *"the most diverse types of productions,"* Kiesler suggested that theater would no longer *"have to be squeezed into the strait jacket of a fixed architectural*

Figure 6.3 Plans for the exhibition "The Ideal Theater: Eight Concepts," 1960–1961. Left to right, top to bottom: George Izenour and Paul Schweikher; Paul Rudolph and Ralph Alswang; David Hayes and Peter Blake; Eldon Elder and Edward Durell Stone; Barrie Greenbie and Elizabeth Harris; Donald Oenslager and Ben Schlanger. From *The Ideal Theater: Eight Concepts*, 1962.

Figure 6.4 Paul Rudolph and Ralph Alswang, Ideal Theater, 1960–1961. Plan and section. From *The Ideal Theater: Eight Concepts*, 1962.

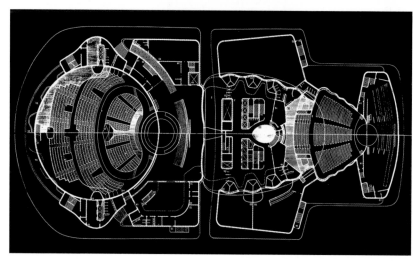

Figure 6.5 Frederick Kiesler, Universal Theater, 1960–1961. Cast aluminum model of main auditorium and entry. Photography by Alex Langley. Courtesy of the Lillian and Frederick Kiesler Papers, Archive of American Art, Smithsonian Institution, Washington, DC.

Figure 6.6 Frederick Kiesler, Universal Theater, 1960–1961. Floor plan. © 2017 Austrian Frederick and Lillian Kiesler Private Foundation, Vienna.

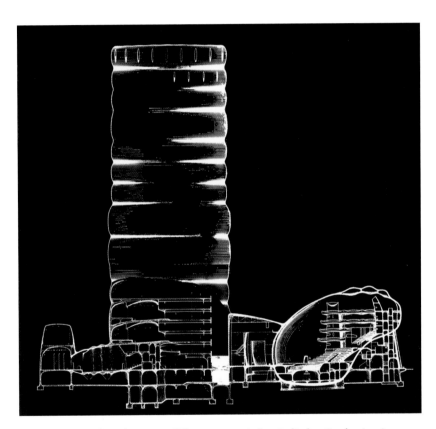

Figure 6.7 Frederick Kiesler, Universal Theater, 1960–1961. Longitudinal section drawing. © 2017 Austrian Frederick and Lillian Kiesler Private Foundation, Vienna.

scheme."[12] Instead, the Universal would accommodate a series of programmatic spaces tailored to varying activities and needs.

Relying heavily on his knowledge of stage, theater, exhibition, and building design, Kiesler proposed to incorporate simultaneity and multiplicity within a unique organic building structure. The Universal Theater was a visionary exploration aimed at his greatest architectural ambition—to create elastic architecture modulated to an evolving set of parameters that could expand and contract with changing user needs. Guided by the metaphor of elasticity, derived in part from the European De Stijl movement, Kiesler's seemingly disparate lifelong interests—from his City-in-Space structure (1925) to his Universal Theater project (1961)—came together in a distinct building concept. He invented a comprehensive programmatic, planning, and urban design strategy that structured the invention of a complex and excessive organic form designed to revolutionize the social, psychological, and biopolitical practices—from control to liberation—of modern life.

Organic Design

Long before he received his architect's license in New York City in 1930, Kiesler's training and interest in organic architecture had begun with his studies under Otto Wagner and Josef Hoffmann in Vienna. Wagner and Hoffmann were significant figures in the history of modern architecture, engaging with the Belgian- and French-derived Art Nouveau that challenged the relationship between structure and ornament. Intended in part to preserve artistic values under the conditions of a new industrial capitalism, Art Nouveau—with its flowering plantlike forms that conflated continuous organic surfaces with ornate building structures—created shapes that demonstrated the qualitative capacities of new industrial materials. Particularly interested in the elastic strength of wrought iron, alongside an organicism derived in part from the romantic movement, Art Nouveau architects attempted to construct buildings with dynamic fluid appearances. In Austria, however, there was soon a shift toward separating (if not completely eliminating) naturalized decoration in favor of more rational building designs. Works from Wagner's ornate tattooing of the Karlsplatz Pavilion and the Majolikahaus (1899) to Loos's stoic treatment

of the Michaelerplatz (1911) inspired a new generation of modern design and construction around the time of Kiesler's student days.

Such struggles to find an appropriate union between ornament and structure proved central to Kiesler's work, as he experimented with new multimedia projection technologies in theater, stage, and film relevant to the social and political debates occurring in Vienna at the time. Beginning his career during the postwar reconstruction when strong cooperative values advanced markedly liberal social programs, Kiesler identified himself with the humanitarian concerns of his great modern mentors—Hoffmann, Wagner, and Loos. Interning in Loos's office on a workers' housing project, for example, Kiesler found himself focusing on designs that aimed to ameliorate problems associated with the collapse of the Habsburg empire and the shortage of adequate housing in and around a war-weary Vienna.[13] Kiesler learned to consider the inherent cultural problems associated with the complexities of modern living. Specifically relevant were Loos's advanced housing ideas, which produced simple buildings molded to individual needs and purposes that supported cultural independence, economic productivity, and social unity among workers. Loos's Heuberg project with its flexible planning arrangements and neo-agrarian worker gardens proved significant, not only for the inclusive socialist lifestyle it promoted but for its innovative building structure that suspended housing units from beams hung along a linear foundation wall system. The "House with one wall: System Loos," as it was called, created a structurally and spatially integrated and economic building arrangement, which Kiesler learned to adapt to his own architectural practice.[14]

Kiesler received his first architectural commission from his former instructor Hoffmann, who was the commissioner in charge of the Austrian Pavilion for the 1925 Art Deco exposition in Paris. Hoffmann hired architect Peter Behrens, who had been teaching at the Academy of Fine Arts, Vienna, to design the main pavilion; Kiesler was commissioned to design the smaller theater exhibit for the Grand Palais. As a stage designer, Kiesler hoped to build an Optophon theater, similar to ideas described by Raoul Hausmann in his article "Optophonics" published in G, no. 1.[15] For his Optophon stage, Kiesler planned to incorporate sound and film with theatrical events, as suggested by Craig and Prampolini (see chapter 1). The Optophon Theater was intended to provide an actorless stage for automated performances, including a series of platforms

and stairs similar to Appia's stage designs. As it proved too difficult and costly to construct, however, Kiesler abandoned the idea and quickly constructed his "Die Stadt in der Luft"—or as he called it, his "City-in-Space" project.[16]

De Stijl Intent

Kiesler's City-in-Space was a sculptural installation used to display theater drawings and models at the Paris exhibition. A significant elementarist design, it successfully incorporated Richard Wagner's concept of the *Gesamtkunstwerk* into an innovative modern De Stijl building language. The City-in-Space project "realized what we dream ... one day could be done," as Kiesler recalled van Doesburg remarking: "This is the union of the arts and not—the Pavilion of *L'Esprit Nouveau* ([by] Le Corbusier). ... I had, without knowing it, transformed Mondrian's and van Doesburg's paintings into three dimensions," creating an "insoluble fusion of painting, sculpture and architecture."[17] Suspended in tension, the City-in-Space project created open, flexible, continuous space; it created no more barriers, "NO MORE WALLS," Kiesler declared. "We must have organic building, ELASTICITY OF BUILDING ADEQUATE TO THE ELASTICITY OF LIVING."[18]

Elaborating on his *Leger und Trager* (L+T) exhibition system invented for the 1924 Vienna theater exhibition, his City-in-Space structure used theatrical lighting and staging techniques to produce a vast free-floating open structure that implied a new inclusive urban housing condition.[19] The L+T system had consisted of a series of movable armatures that provided low platforms for models and higher backboards for images to be presented between polychrome surfaces, with dynamic asymmetrical spatial pattern and rhythm. Unencumbered by gravity or defined limits, the City-in-Space structure created a networked spatial field without boundaries or walls in pure extension. Using systematic rectilinear lattice structures that eroded distinctions between space and place, Kiesler created multidirectional points, lines, and planes to suggest an open and expanding field condition. An indeterminate spatial contiguity staged in a darkened atmosphere, the installation used contrasting primary colors along with vertical, horizontal, and diagonal spatial elements to generate dynamic movement and rhythm.

Figure 6.8 Frederick Kiesler, City in Space, 1925. Courtesy of the Austrian Frederick and Lillian Kiesler Private Foundation, Vienna.

Kiesler's City-in-Space project, although De Stijl in composition, functioned quite similarly to a constructivist stage device, except that, not unlike his show window designs of the late 1920s, it substituted inanimate theater projects in the typical place of animate performers. In the City-in-Space, spectators moved about theater exhibits independent of any gallery wall or backdrop. Doubling as an urban design for a "decentralized and entirely suspended [city] in space," according to Kiesler, "it formed a constellation without boundaries, floating dwellings, the habitat for the man of the future, where he can feel at home in anyone's place, and is welcomed."[20] As both an exhibition framework and experimental urban topography, Kiesler's City-in-Space fused art and architecture to create powerful event spaces that aimed to facilitate a liberal modern society and world culture.

Using articulated joinery, with doubled posts and beams that appeared purposefully incomplete, he created a dramatic architectural environment that did not completely envelop space, but instead created tension through directed motion of suspended elements. Movement and gesture from strong parallel and perpendicular elements created energetic extension, while large polychrome panels created a virtual sense of partially enclosing walls, floors, and ceilings. Space created between panels provided partial boundaries that suggested infinite habitations. As Reyner Banham famously argued, Kiesler's City-in-Space project represented "the ultimate condition of the ideas of *de Stijl* and Elementarism."[21] It elaborated spatial strategies articulated by Gerrit Rietveld in his furniture and housing designs and an elementary means of plastic expression outlined by van Doesburg in his writings and lectures.[22]

Elementarism, the late strategy of the De Stijl movement, evolved from van Doesburg's theories on plastic architecture. Already in 1916, van Doesburg had sought "*the separation of the various realms of plastic expression*" into their elementary components in a way that would not negate the respective contribution of each element within a total work of art. Similarly to De Stijl painting, through contrast of void and mass, contraction and expansion, transparent and opaque, and plan and elevation, discordant, complementary, and contrasting energies achieved continuous relations.[23] De Stijl created unity by juxtaposing oppositions through the binary logic of comparisons to produce a sense of elasticity and continuity—a virtual space—between contrasting elements held in *relative* tension.[24]

For van Doesburg, Einstein's theory of relativity suggested a radical departure from traditional methods for expanding three-dimensional mass. The concept of matter, as van Doesburg argued, had radically changed due to new advances in physics, where solids (like liquids and gases) were now understood as units of molecular energy—shifting and changing over time.[25] To investigate these new scientific principles, van Doesburg constructed a series of designs which he exhibited in Paris in 1923 after leaving the Bauhaus, with multi-sided interpenetrating squares that promoted the flow of space between and within boxlike forms that created multidirectional and unresolved open volumetric spatial conditions.[26]

Kiesler began working with van Doesburg on his space-time theories after their meeting in 1922 or 1923, and invited him to lecture on the subject at the 1924 Vienna theater exhibition.[27] Van Doesburg published a similar version of his lecture as the manifesto "Towards Plastic Architecture" in *De Stijl* in 1924, where he articulated his ambition to develop forms not a priori in *concept* but experientially through *percept*.[28] Economical, functional, and "shapeless"—"*formless*"—"the new architecture is not built … from a mold into which functional spaces are poured," he explained, but is generated over time through balanced composition of "rectangular planes; that … can extend to infinity on every side."[29] Spatial cells developing from the center toward the periphery gave "the impression of being suspended or of hovering in the air, contrary to natural gravitation," avoiding monotonous repetition or normalized symmetry.[30] Instead, a "balanced relationship of unequal parts … through their functional character" would contribute to the whole plastic composition of a building structure as it evolved, floated, and shifted in space.[31] Movable partitions and screens suppressed the "duality between interior and exterior," and the new architecture would be liberating as boundaries and limits became diffuse through open and elastic spatial compositional elements.[32] Non-Euclidean calculations suggested to the modern architects a new plastic aspect of four-dimensional space-time that met the progressive sociopolitical interests of the postwar era.

Adapting van Doesburg's theory of neoplasticism—opposites held in tension—Kiesler's City-in-Space project generated perpetually dynamic spatial conditions that formed a balanced synthesis between indeterminate heterogeneous volumes floating in space and time. It formed volumetric and directional

Figure 6.9 Theo van Doesburg and Cornelis van Eesteren, Maison Particulière, 1923. Collage of model. Courtesy of the RKD Netherlands Institute for Art History.

spatial qualities seemingly without literal—physical—connections through point, line, and plane relations that appeared held up in "tension." The combined elements relied on the viewer's intuitive psychical responses to strong linear direction and multiple planar surface relations. Tension (or the illusion of tension) emerged from the viewer's intuitive sense of different parts of the sculpture connecting in the psyche. Suspended off the ground, literally hung in tension, the project represented gravity through this perceived sense of tension—the *anticipation* that there had to be a connection to counter the natural forces of gravity, and the *anxiety* generated from the perception that without a literal connection the sculpture would in fact fall. The observer experienced the installation through a psychic feeling that was not simply a projection of space between the parts of the sculpture, but the viewer's relationship to the project itself. This psychic relation to the work was as such *auratic*; it was effectually *felt* and projected onto the inanimate installation sensually, intuitively.[33] Tension in modern art and architecture has both a structural basis and a psychological affect; it mimics material stability, energy, and form understood by modern physics, while at the same time enacting the anxieties of an unstable modern sensibility.

Tension thus proved a central trope in Kiesler's work, as it had for van Doesburg in his study of the oblique for painting and architecture.[34] "Elementarism," van Doesburg explained, "postulate[d] ... a *heterogeneous*, contrasting, unstable manner of plastic expression based on planes oblique in relation to the static, perpendicular axis of gravitation."[35] Similar to Richter and Eggeling's descriptions of balance, counterbalance, contrast, and analogy that generated dynamic spatial rhythm, van Doesburg postulated an "*unbalanced counter-composition*, which [produced] ... a phenomenon of temporal-spatial tension."[36]

Tension in art and architecture was not, of course, Kiesler's or van Doesburg's invention; in the abstract arts, it commonly refers to a sense of space—an interval—held *open* between two or more elements that establishes a relationship, whether physical (hidden force) or imaginary (psychical stress), between objects and their environment.[37] Mondrian, in his first essays on neoplasticism published in *De Stijl* in 1917, considered *tension* fundamental to the universal platonic principles of his paintings.[38] Visual connections between separate lines, planes, and colors perceived on the canvas can create an unnatural plastic space—the illusion of space—on a flat surface. For the elementarist, it was

neither the walled surface nor the occupied place that generated a sense of space, but the psychical tension created from an elastic condition perceived by the viewer.

Elasticity thus became a fundamental and dynamic condition of the modern plastic arts. As understood by van Doesburg, Mondrian, and Kiesler, it formed a comprehensive engagement between sensual psychic bodies and their physical environments. There did not need to be an actual connection for this condition to occur. De Stijl artists and architects did not presume compositional structures to be bound solely to their surroundings physically; instead, unseen projected energies could be formulated to correlate varying elements contextually within an all-inclusive spatial condition. Extending a De Stijl understanding of elastic space to inform his overall research into the Endless, Kiesler developed ideas for correlating the naturally elastic body to the environment through an auratic sense of perceived tension, which he applied to his housing and theater designs from the 1920s to the 1960s. Modern theories of space and time were paramount to his theoretical interests as they supported his developing sociopolitical concerns on everyday human conditions. Open and indeterminate spatial strategies that might liberate daily actions while providing intimacy, privacy, and shelter proved fundamental to his design creativity, motivating a lifetime of innovative research.

Experimenting with these elastic spatial strategies on the urban scale, Kiesler proposed a megastructure complex—"a horizontal skyscraper"— intended to span the intersection of Place de la Concorde in Paris, 1925.[39] As recalled by Richter, this project was "the breakthrough of the real Kiesler … the man with 'total' plans," who "like a man possessed" transformed the "anyhow useless" square of Place de la Concorde into a "skyscraper-junction from which huge highways were supposed to lead out of Paris in all 4 directions."[40] Within the square, Kiesler inserted four blocks on each corner of the highway intersection to provide parking alongside "wide-stretching wings" of housing that could expand and contract from a central core.[41] Suspending living quarters off the ground above the street adjacent to an open park space—in contrast to Le Corbusier's linear city concepts for Algiers and Rio de Janeiro of the 1930s— Kiesler staggered housing blocks that were open above and below for air and light. He did not pile the blocks on top of each other "like boxes," as Richter explained, and "anybody who has ever tried to drive out of Paris or rather limp,

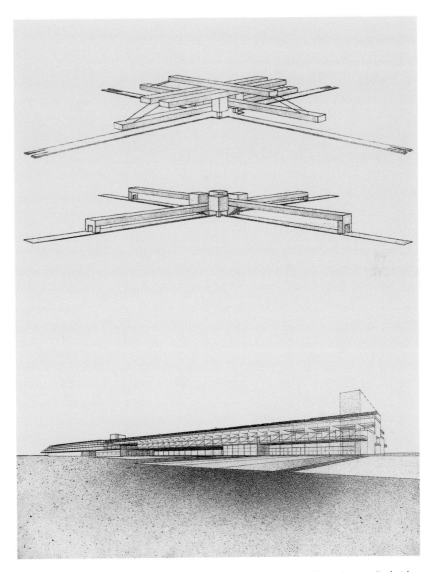

Figure 6.10 Frederick Kiesler, Horizontal Skyscraper, Paris, 1925. Drawing. © 2017 Austrian Frederick and Lillian Kiesler Private Foundation, Vienna.

should appreciate such a plan."[42] Kiesler's Horizontal Skyscraper like his City-in-Space defined new organizational strategies by inventing forms of architecture that might lead to more spatially indeterminate and thus likely more socially open living environments. Parisians, however, had little interest in his visionary concepts at the time, and his first urban proposals were not taken very seriously, in line with Le Corbusier's disparaging retort to the City-in-Space project—"But how does he keep the houses up? Does he hang them from zeppelins?"[43]

Theater Practice

Kiesler's Endless Theater of 1925 to 1926 was his following attempt to encourage more inclusive and open social interactions through his building practice, and it proved his most comprehensive urban design prior to his 1960s Universal Theater. For his Endless Theater he envisioned synthesizing a vast program into one spatial atmosphere correlated to the networked movements of a dynamic mass of more freely moving people. The design promoted liberal sociopolitical agendas similar to those of De Stijl and the constructivist artists. The Endless Theater aimed to generate expansive indeterminate spaces within long-span tensile-shell structural technologies alongside new multimedia projection techniques. Although the Endless Theater was not feasible in the 1920s, Kiesler designed and built a number of pragmatic theater projects from the 1920s to the 1950s that advanced the organizational strategies and building technologies proposed for his utopian design.

Commissioned by President Ralph Jonas of the Brooklyn Chamber of Commerce in 1926, Kiesler's Brooklyn Heights Performing Arts Center notably used traditional theatrical forms in innovative ways. Kiesler had met Jonas while working with Princess Matchabelli on the new International Theatre Arts Institute in Brooklyn. Jonas donated the use of a brownstone for Matchabelli, Mensendieck, and Kiesler's new theater school on 102 Remsen Street in Brooklyn. For Jonas's proposed Performing Arts Center, Kiesler developed ideas he had explored previously for his *Emperor Jones* stage sets. Incorporating funnel-shaped walls, ceilings, and floors, he aimed to dramatically focus audience attention on stage while providing expansive variety and flexibility through the invention of a central vertical open flyway that served either as one

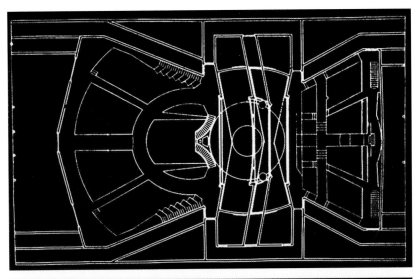

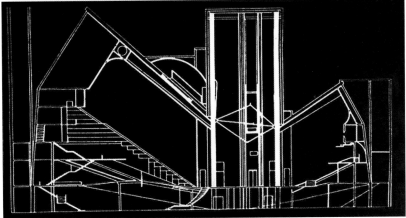

Figure 6.11 Frederick Kiesler, Brooklyn Heights Performing Arts Center, 1926. Plan and section drawings. © 2017 Austrian Frederick and Lillian Kiesler Private Foundation, Vienna.

large stage or two simultaneous smaller theaters. Making time coextensive with space, Kiesler's Brooklyn Heights theater expanded audience participation by producing multiple theatrical event spaces that might adjust to evolving action on stage. Creating two theaters in one proved an important concept for him, as it provided a practical form for creating multiple staged environments. Unfortunately, as the theater school closed, Kiesler's working relationship with Jonas soon ended and their plans for the Brooklyn Heights Performing Arts Center were abandoned.

Kiesler's Film Arts Guild Theater, built at 52 West 8th Street in New York City from 1928 to 1929, did however employ these ideas to create an auditorium space that could be used to generate multiple scenographic experiences within one spatial atmosphere. Relying on the capacity of film to be projected on multiple surfaces simultaneously, the Film Arts Guild Theater created a provocative series of coterminous event spaces. Although proving a highly controlled environment that relied on optic and haptic techniques to motivate viewer participation within a total work of art of organic creation—a *Gesamtkunstwerk* of effects—it did not, as perhaps Kracauer would have feared, diminish one's experience of watching new films. Kracauer believed integrating the film screen within the architectural environment diminished an audience's ability to separate themselves critically from screen action. Instead, as Kiesler showed, concentrating viewer attention on an expansive screen generated a fully immersive filmic experience in which the audience could still lose themselves within the imaginary world of film while at the same time maintaining, as Benjamin had suggested, a safe critical position. If the spatial experience within the Film Arts Guild Theater was highly controlled, it was not without a progressive (if not liberatory) intention.

Winning the Woodstock Theater Design Competition of 1932, Kiesler soon advanced a very complex and innovative organizational scheme to similarly incorporate conterminous event spaces into one complex spatial building form. At Woodstock he was able to integrate several open and inclusive theatrical programs within one very flexible festival complex. Woodstock was a rural resort town where theatergoers arrived by car at different times and rates, with maximum attendance occurring during the summer festival season. As Kiesler quickly realized, "the public is not to be received as a unit mass [at any given point in time], but as a changing flux of independent groups."[44] Actors, artists,

sporting enthusiasts, and spectators arrived on varying days for multiple events and stayed for inexact durations. Crowds generally accumulated during June and July, with peak performances in August; Kiesler looked closely at this evolving criterion shaping the event space and applied his research to advance a very flexible design.

To formalize these temporal parameters in a cohesive manner, he charted the types and sizes of multiple stages, arenas, and halls in coordination with the number of people attending the performances throughout the year. Quantities ranged from 84 to 535 people, with as many as 2,000 being possible.[45] He determined the maximum and minimum limits of the audience based on failures of existing local theaters, and analyzed the range of stage and auditorium sizes that might fit an evolving performance schedule. From these criteria he proposed a multi-space theater that could accommodate a number of different situations.

Unlike Gropius's Total Theater conceived for Piscator, Kiesler hoped to be able to change the staging arrangements without always having to remove built-in seats or create discontinuity on stage between events. He wanted smoother transitions between multiple activities that could occur simultaneously with complete control. The Woodstock theater design thus proposed two stages on either side of a central flyway, similarly to his Brooklyn theater. The smaller stage provided for intimate performances that could occur at the same time as larger events in the main auditorium. The auditorium could extend to include a mezzanine, and the entire stage could spread out from the center to create one large arena. The larger auditorium could function with or without the mezzanine, and a stage opened from the center by separating and shifting the seating to create a full-size arena. Seating in the smaller theater could then slide onto the flyway to create one enormous theatrical performance area. In addition, the flyway served as a series of workshops and dressing areas without a large overhead space above the stage. Cars could drive right onto the stage for car shows, and multiple screens, some even two-sided, could extend throughout the space as in his Film Arts Guild Theater to create large cinematic events. Space became flexible and adaptable to accommodate shifting action on stage throughout the summer months, producing multiple audience-spectator relations. To study these possible staging performance patterns, Kiesler diagrammed a series of evolving scenarios using analytical drawings and dynamic 3D models with shifting pieces and rolling marbles showing actors, chorus, and

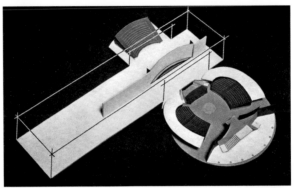

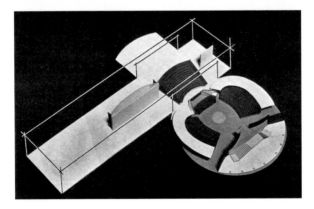

Figure 6.12 Frederick Kiesler, Space Theater for Woodstock, New York, 1932. Theater scheme organized for only one mid-sized event in main auditorium. From "The Universal," *Architectural Forum*, December 1932.

Figure 6.13 Frederick Kiesler, Space Theater for Woodstock, New York, 1932. Theater scheme organized for one small event in theater at top, and one larger event in theater main auditorium at the bottom with expanded mezzanine. From "The Universal," *Architectural Forum*, December 1932.

Figure 6.14 Frederick Kiesler, Space Theater for Woodstock, New York, 1932. Theater scheme organized for one large arena event in main auditorium with expanded mezzanine. From "The Universal," *Architectural Forum*, December 1932.

crowds moving about freely on stage and off. He evolved a theatrical form tailored to varied performances not only by employing a series of mechanical devices, but by generating and organizing multiuse spaces.

For its construction, Kiesler's Woodstock theater took the form of a temporary structure—an elastic ephemeral construction held together in tension with lightweight, easily fabricated tubular supports of metal and weatherproofed fabric web coverings, prefabricated and assembled with flexible joinery out of steel tubing, steel cables, steel grating, fireproof canvas, and a wooden stage on top of a concrete block foundation. According to Kiesler, the city could erect and demount the theater at a reasonable cost in only two weeks.[46] The theater notably impressed many with its researched system. "'Lithesome' seems to describe it," wrote Buckminster Fuller; "many designs will be inspired by his intention. Respect and honor to him."[47] Although never built, whether because of the depression or the complexity of its overly mechanized system, as an unrealized research experiment in advanced elastic spatial planning strategies and structural systems, the Festival Theater (Space Theater for Woodstock), besides directly inspiring the construction of his Empire State Theater tent structure in Ellenville, New York (1955), helped Kiesler to think well beyond modern expectations for his later Universal Theater project.

While other stage designers and architects in the "Ideal Theater" exhibition relied solely on mechanical systems (similar to some of Kiesler's earlier designs) for creating their adaptable moving stage devices that might achieve flexibility alongside varied atmospheric effects, for the Universal he proposed a more complex and advanced solution. Here he generated a manifold theater to create elastic space, using a more organic and viable organizational strategy aimed at generating a complex programmatic environment.

Kiesler's Universal Theater was perhaps his greatest theatrical production. It created an inclusive spatial atmosphere that diffused the physical and social boundaries of architecture. It melded actors, spectators, cinema, and theater in immersive continuity within their surrounding environment. The Universal posed a complex labyrinth of sinuously expandable surfaces that formed the space of a vast program of shared activities. Yet it had a unified appearance, with surfaces folding one into the next. Relying on multimedia projection techniques he had investigated for so many years, Kiesler created an illusory atmosphere that exploded the limits of the architecture. Space flowed

Figure 6.15 Frederick Kiesler, Empire State Theater, Ellenville, New York, 1955. Courtesy of the Harvard Theater Collection, MS Thr 729. Houghton Library, Harvard University, Cambridge, MA.

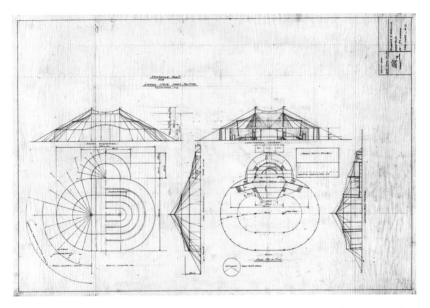

Figure 6.16 Frederick Kiesler, Empire State Theater, Ellenville, New York, 1955. Plan, section, and elevation drawings. Courtesy of the Harvard Theater Collection, MS Thr 729. Houghton Library, Harvard University, Cambridge, MA.

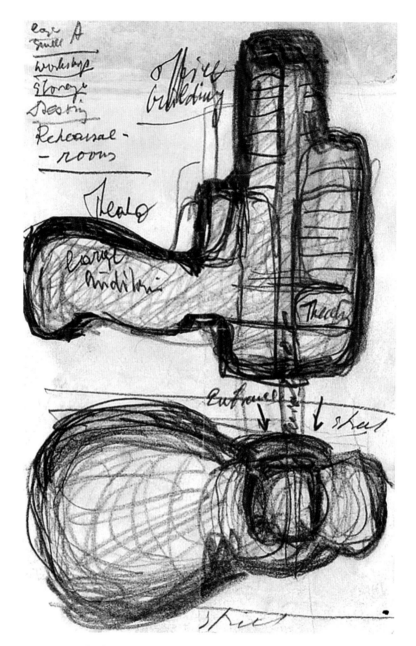

Figure 6.17 Frederick Kiesler, Universal Theater, 1959–1961. Schematic plan and section drawings.
© 2017 Austrian Frederick and Lillian Kiesler Private Foundation, Vienna.

universally—*endlessly*—about the theater as actors and spectators moved about with elastic continuity alongside changes in their environment.

Most significantly, for the Universal Theater the traditional central flyway became an elaborate thirty-story professional office tower that served the business relations of the performing arts. It housed large and small television studios and radio stations, along with workspaces for publishers and record and movie producers, and had additional floors for public and private exhibition spaces. All tenants shared common dining, storage, and workshop facilities. Business, entertainment, and art were thereby combined socially, economically, and culturally through innovative programmatic integration.

Audience and spectators were free to flow in and around fixed and revolving seating arrangements on multiple tiers. Balcony seating surrounded a decentralized oval auditorium that incorporated projection, communication, and satellite towers to generate multiple, vast, changing ambient effects that expanded spatial boundaries through distracting cinematic illusions. Seats, guardrails, and interior surfaces *modulated* to support multiple bodies in motion correlated with shifting actions. Large permanent and mobile cycloramas provided backdrops for both experimental and traditional theatrical events.

The Universal provided for a great variety of spectacles: operas, revues, large-scale dramas, small-scale dramas, symphonies, choral works, intimate quartets, solo concerts, conventions, and large public meeting halls. Moving crowds or swarms of people could appear along various walks and runways on multiple levels in full view of the actors and the audience—actual happenings external to theater events instantaneously communicated to a waiting audience—"making everyone a participant," as Kiesler explained.[48] There were projection screens throughout the theater. The Universal Theater was an Endless Theater as far as vision, sound, and movement were concerned; it provided an endless array of enfolding event spaces.[49]

The Universal merged theater with everyday working life. Actors and spectators melded with the world of corporate America. Kiesler's urban theater combined the main lobby of a business skyscraper with the foyer of a 600-person theater alongside a series of smaller stage halls each for up to 300 people.[50] Workers became spectators, if not actors. As a vast cultural enterprise, the Universal provided opportunity for art to influence the world of business as business supported the world of art. The sophisticated relations among art, action, play, and

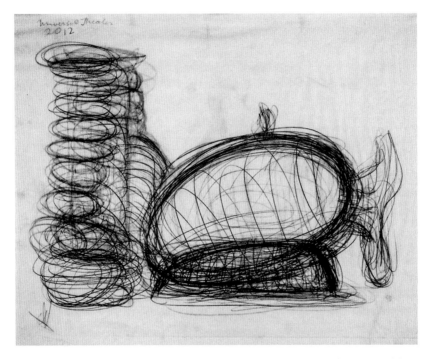

Figure 6.18 Frederick Kiesler, Universal Theater, 1959–1961. Process design sketch. Courtesy of the Harvard Theater Collection, MS Thr 729. Houghton Library, Harvard University, Cambridge, MA.

Figure 6.19 Frederick Kiesler, Universal Theater, 1960–1961. Balcony seat drawing. Courtesy of the Harvard Theater Collection, MS Thr 729. Houghton Library, Harvard University, Cambridge, MA.

Figure 6.20 Frederick Kiesler, Universal Theater, 1960–1961. "Typical Balcony— Seating & Standing." Courtesy of the Harvard Theater Collection, MS Thr 729. Houghton Library, Harvard University, Cambridge, MA.

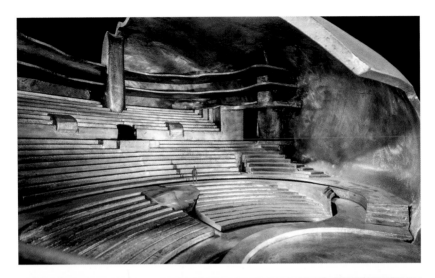

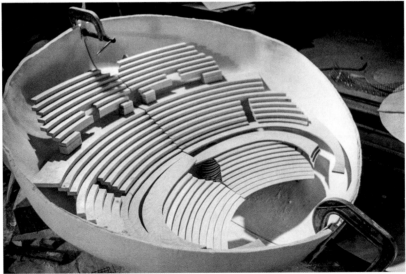

Figure 6.21 Frederick Kiesler, Universal Theater, 1960–1961. Auditorium model. © 2017 Austrian Frederick and Lillian Kiesler Private Foundation, Vienna.

Figure 6.22 Frederick Kiesler, Universal Theater, 1960–1961. Auditorium model. Courtesy of the Harvard Theater Collection, MS Thr 729. Houghton Library, Harvard University, Cambridge, MA.

Figure 6.23 Frederick Kiesler, Universal Theater and Rainbow Sculpture, 1960–1961. Frederick Kiesler with "Rainbow of Shells to Walk Through." Courtesy of the Lillian and Frederick Kiesler Papers, Archives of American Art, Smithsonian Institution, Washington, DC.

everyday working life, along with business production and capitalist expansion, created a unified environment where it was ultimately unclear whether the artists were free to affect the lives of the workers, or to what extent business would define the role of art. Intermixing cultural and business communities in symbiotic coevolutionary relationship through mass-mediated communication created event spaces that were intended to invoke discourse, interaction, and debate. Although temporal regulations imposed by any one species or agenda (as Deleuze might fear would occur in a controlled society) might dominate the system at any given time, in such a highly distributed manifold environment as Kiesler was proposing, unexpected or opposing forces would still have space to adapt, reconstitute, or mutate to resist and evade such governing structures.[51] Plays on stage may in fact be commercialized, but dispersed venues of varying sizes distributed unexpectedly and openly throughout the Universal might still prove space for resistant if not revolutionary interaction.

"If we could convert our static functions of design into design-flows of life forces and thus replace defunct functional architecture with: *Process Architecture* we will have done our share as social beings and conceded our conceit as pseudo functionalists," Kiesler insisted.[52] Process architecture, as he held, evolving from a vitalist perspective, attempts to generate forms in response to intrinsic life forces, internal and external. Although it is hard to accept any essential basis for motivation in life, as a vitalist might propose, Kiesler's environmental design practice generated architecture modulated to the rhythms and sounds of everyday live performances. His structures ideally responded to unseen programmatic forces while evolving with ever-changing sets of varied parameters. Although Kiesler's humanist design approach often failed to incorporate extrinsic relationships of site or detailed structure in his designs, his buildings were never intended to be amorphous; they were not free-for-all forms. They were derived through a complex and lifelong generative process of insightful research in support of more freely engaging and liberatory living environments.

Kiesler saw the world as always evolving—in a constant state of flux. He conceived the Universal Theater as an organism of complex program with a vast network of spaces that could expand and contract through multimedia technology. He created illusive boundaries of dreamlike intensities that diffused walls into riotous arrays of endless spatial atmospheres. The Universal provided spatial multiplicity for varied social and psychological experiences—it

generated the ultimate illusory condition in which the body, mind, and spirit of a vast crowd of people correlated in synchrony to the rhythms of music, sound, and dance, amid the routine actions and events of everyday working lives. Although it is not often recognized as his greatest achievement, it was perhaps his most synthetic and altruistic. It brought the arts, architecture, business, theater, film, and everyday life together inside an ever-changing, endlessly contracting and expanding, elastic spatial condition in the hope of supporting a more sociopolitically engaging, morally and economically valued, multicultural and progressive world culture.

Figure 7.1 Frederick Kiesler, poster for exhibition at Yale University, 1967. Courtesy of Harvard University Theater Collection, MS Thr 729, Houghton Library, Harvard University, Cambridge, MA.

7 Architecture and Its *Robota*

The Android ... has all the elasticity of the real thing, its human
movement to the life ... (... both resistant and flexible) that graceful
yielding quality, that firm undulation ... which is so seductive.
—*Villiers de l'Isle-Adam*

"Art-tricks, or elec-trics or mechano-clicks or the temptations of new materi-
als in architecture cannot save the artist from his responsibility," wrote Kiesler
in September 1960.[1] Nearing the end of his career, Kiesler voiced his wariness
about relying on machine technology to achieve vital form. "The performances
of mechanical art-toys unfortunately are, by their very nature, as repetitious
and limited as push-button releases of jukeboxes."[2] "Sculptures as electronic
marionettes, architecture as engineering antics, amusing as they may be in
themselves," he argued, "must not lure us from the real issue[s]."[3] Instead, "in an
age of falling boundaries, separatism, segregation, [and] isolation in our social
life must make way as never before to integration of purposes in all fields of
endeavor."[4] For Kiesler, art and architecture could not achieve adaptability, flex-
ibility, and continuity on scale with the demands of an evolving and more inclu-
sive society by relying on new materials and new technologies alone. Instead,
he proposed elastic architecture that might modulate to the human body in
motion to respond to changes rapidly occurring in everyday modern life.

Proving a powerful metaphor, as I have argued throughout this text, elasticity can be traced through varying disciplinary fields during the nineteenth and twentieth centuries, resulting for Kiesler in the promise of a new spatial condition. Envisioning elastic architecture as a responsive system, he believed buildings could be designed to better interact with everyday social life and work flow. New structural strategies derived through research into the natural sciences and psychoanalysis could generate new forms of architecture that might perform in correlation with the ever-changing demands of organic life. Elastic architecture, he hoped, could be used to generate more productive, open, and liberating modern environments. To this end he predicted the coming of a new spatial structure—continuous tension-shell technology—a second modern order that would enable a new conception of space: the Endless.

Endless space, for Kiesler, comprised a variety of spatial structures and organizational strategies that conflated distractive haptic techniques discovered in modern film and early experimental animation with everyday human habits. Developing provocative relationships that suggested the sensation of *moving space*, he envisioned endlessness as vibrations perceived between the intervals of continuously unfolding planes wrapping around an *a*conscious viewer in motion. Suggesting a new form of architecture no longer bound to a static grid of fixed place in time, endlessness was imagined through qualities perceived between continuous surfaces correlated with the actions of distracted bodies in motion. In order to design such a space that would be able to shift, adapt, and evolve with the habits of the viewer, Kiesler invented a new form of architecture not limited to interiority or entirely bounded by surfaces such as traditional walls.

Challenging perceptions, Kiesler's work, from his early interests in film and stagecraft to his most sophisticated housing and theater designs, investigated coextensive relationships between images and surfaces brought together in continuity with the body. In effect, everything, he hoped, would appear to be moving: the body would be moving, the structure could also be moving, or at least light and imagery projected onto complex curvilinear surfaces might create the illusion of something indefinite and/or moving. Curving surfaces surrounding the animate body provided no precise outline for perceiving definitive spatial forms, no sense of separation nor precise space of measure. Kiesler's architecture thus aimed to seam together a series of part objects in continuum, by fusing

complex curvilinear architecture with distractive cinematographic techniques.[5] In this manner he aimed to achieve *a total work of art of effects*.

To invent multifarious environments, he employed a wide range of multimedia effects. He united walls, roofs, and floors in endless topologies that could be adapted to changing temporal parameters, and he merged structure and skin alongside projection technology to create illusionary spaces that provided no sense of boundary but were still able to shelter. Conflating time with space, he generated varying programs for multiple uses, people, and conditions.

Endlessness was not merely a spatial configuration of illusory environment with a tectonic solution, but included an organizational plan to achieve elasticity—one that could create open environments that could shift, alter, and move in response to variable conditions, indeterminately. Elastic architecture ideally created shifting spatial contiguities and programmatic overlappings that promoted dispersive relationships for variable human engagement beyond the structural limits of any singly bounded form. For architecture not to break down while resisting shock in the face of internal and external pressures, Kiesler understood, it was not going to be enough for a building to simply move or appear to move. Elastic architecture would need to be derived from a clear spatial and organizational strategy that aimed to create multivalent interactive programming schemes.

Although built form often remains static, Kiesler hoped to create architectural environments that might prove spatially open, physically active, and visually dynamic. He aimed to invent an architecture that could respond to changes in environmental conditions with the natural flexibility that occurs in organic life. Architecture, however, unlike nature (at least still for now), does not readily bend, grow, or evolve its form on its own; elasticity, though a sophisticated programming strategy, provided more of a guiding principle for form and structure than any specific solution, at least in Kiesler's proposals. Twentieth-century desires to create elastic spaces were perhaps more informative of modern latent drives, human conflicts, and artistic ambitions than they were producers of a viable tectonic proposition. It was nonetheless an ambitious project, which challenged normative building practices and set a surprising precedent for future generations to follow.

If admittedly somewhat specious in its overall ambition, elastic architecture performs an ideological condition. It sets a trajectory of hope, idealism, and

fantasy beyond normativity. For Kiesler, the concept of elasticity proved very productive; it invoked the search for structural and organizational precedents that could be adapted to naturalize modern technology and its spatial forms. Elasticity as a building concept was not in itself going to solve societal problems, but it might inspire more flexible and adaptable topological constructions that better conform to human nature and our relationship to the environment.

But it would be unfair to Kiesler's legacy if we were not more critical of the architecture and values he had imagined. By creating a distracting environment, these spaces, as Kiesler imagined, aimed to stimulate autonomic reactions in the viewer. Subjects and objects were to be modulated into an endlessly unified whole that motivated the body and mind to wander autonomically—unconsciously—without disruption. Creating a sense of endlessness in many of his early stage designs as well as his shop windows, houses, and theater projects, Kiesler at times approached Kracauer's condemnation of "the total artwork [*Gesamtkunstwerk*] of effects," simultaneously "rais[ing] distraction to the level of culture aimed at the masses" while at the same time "glu[ing] the pieces back together after the fact and present[ing] them as organic creations."[6] Through contraction and expansion of the architectural body, Kiesler manufactured a false sense of perception to motivate the body to move fluidly, instinctively, and effectively unconsciously—in continuity and habit. If the ancients had composed the visual and temporal field and the modern sciences had decomposed it, through his naturalized structures and responsive elastic systems Kiesler made a synthetic attempt to put it back together.[7]

His project, whether intentionally or not, appears to undermine critical theory and its attempt to educate the masses through aesthetic practices, continuity here challenging any critical effort to inform society of what is being experienced as it creates environments that motivate viewers unwittingly to action. Kiesler's plastic forms and auratic spaces served to facilitate fluid autonomic motion—supporting bodies moving about endlessly as if automatons guided by instincts—flowing through life without disruption of habit, devoid of active conscious thinking.

Architecture like film, as Benjamin best observed, can serve as a covert training ground for changes in apperception—motivating action—but it can also fall prey to the politics, ethics, and economics of capitalist society and world culture. It can be used as a "borrowed" weapon, as Baudelaire suggested,

in an ongoing struggle for power and control that affects our everyday lives by motivating our habits of action. But there is no guarantee of the effects or any way to ensure that avant-garde tactics will not be borrowed back—with ever more increased efficacy. Continuity creates spaces of least resistance, which in the face of what Deleuze described as "control societies" are incapable of eliciting revolutionary action.

Kiesler's project, however, notably suggests another approach to engaging modern power structures than merely designing continuous forms of architecture. Elastic systems responding to varying evolving parameters can both confront and relieve pressures of everyday life. Performing perhaps similarly to the interiors of Art Nouveau, which used the plasticity of wrought iron and concrete as a naturalized casing to "confront the technologically armed environment" (in Benjamin's words), elastic architecture uses varied tactics to challenge evolving perceptions of technological aggression.[8] Elastic architecture provides the structures to yield to, while at the same time the space to resist, work through, and respond to, shifts occurring in evolving cultural conditions. It ideally creates an inclusive spatial system in which everyone might move about en masse without discrimination, providing space as needed for both meeting in crowds and seeking solace for gathering individual strength. As represented best in Kiesler's diagram for the Universal Theater, elastic architecture does not solely rely on machinic assemblages to achieve complex interactions of tectonic spatial form, but also poses innovative organizational strategies that generate simultaneity between multifarious interdisciplinary environments.

Often the study of architecture is limited to a discussion of formed materials or purely aesthetic spatial concerns, and we do not sufficiently discuss organizational diagrams as they affect humanity, particularly in covert ways. If Foucault's interpretation of Bentham's Panopticon educated architects about one thing specifically, it is that our buildings do have an enormous impact on society and culture, not only through aesthetics (optics) but also through use (tactics). Architecture affects human habits, which are by their very nature rendered unconscious—autonomic. There is very little study of how the optical and physical world in which we construct buildings affects our apperceptions motivating our everyday actions—our human behavior.

Architecture can serve to engage if not obstruct aconscious ways of being. Looking closely at subject-object relations and the problems surrounding

automatism and objectification, set against the promise of criticality in the construction of personality and choice, provides some options for further consideration. Concerns for free will and architecture's aim of opening up spaces of revolutionary action through the organization of new spatial paradigms—what might be described as a building's formal and spatial performance—have considerable potential as well. But it cannot be assumed that architecture is not complicit in the training of our own subjectivity—or the objectification of our buildings as well as our bodies. Architecture does play a role in our cultural determinacy worthy of further inspection.

We are not always in control of our relationships to the built world; it does have an impact on us—individually and en masse. This is both exciting and disconcerting and cannot be taken as a matter of fact, but something we need to research and study carefully. As architects, we produce worlds that train our human habits. These habits are not entirely derived in response to existing needs nor are they consequent on clear motivations. Embedded in a building program or brief is a complex matrix of ideas impacting human lives that is not outside the architect's intellectual domain. Human habits are subject to wide-ranging cultural, economic, and sociopolitical conditions that must be challenged or at least well considered. It is important to recognize that architecture is not only about aesthetics but very much about power, and not an overt power of iconography and image alone but a covert power defining our habitual actions. Our behavior is constructed as much as it is instinctive. The world in which we live motivates us and moves us. It responds to us, and at times may be entirely in control of us.

Deconstructivism as a movement in architecture was born in part as a response to such covert normativity embedded in our discipline, in the hope of challenging accepted everyday spatial, material, programmatic, and formal conditions. An experimental model in its time, its forms and practices have since become regularized, normalized, and institutionalized. Experimental practices initiated by Kiesler have also become quite normal in design schools and at the pinnacle of high-design culture. Although not the subject of this book, as a community we will need to address what it means to institutionalize experimental practices. Originality and innovation as demonstrable as Kiesler's may only be possible on the periphery of the profession—in a marginalized territory. Once habitualized and normalized through education and

Figure 7.2 Gilbert Dias, Museum of Religious Relics, Goa, India. Thesis project, Cornell University, 1964. Section, elevation, and roof plan. Work application letter to Frederick Kiesler, February 10, 1964. Courtesy of the Lillian and Frederick Kiesler Papers, Archives of American Art, Smithsonian Institution, Washington, DC.

professional practice, experimentation loses its invention. Constantly trying to push the limits of aesthetic fashion, buildings often fail to shock or impress as they become normalized and aestheticized—customary—through mass media.

Equally there is little value in experimental design practices that ultimately cannot affect society through built form. Experimental practices remaining on the cutting edge have only a marginal impact on everyday lives. One might criticize Kiesler for supporting interests that were too loosely related to the building profession to be readily constructed in his lifetime, if not inherently unbuildable. But as a visionary he invented new spatial forms that put pressure on the profession and still motivate innovative building more than half a century later.

Being multidisciplinary in nature, Kiesler's visionary research practice aimed to stay abreast of contemporary ideas in other fields well outside the limits of his professional practice, which is perhaps the reason for his work's lasting interest. Of course, remaining *inner-disciplinary* has its strengths; it ensures one's practice is concerned with interests most directly relevant to normatively sustained production in one's field. Kiesler's interdisciplinary work, however, proposed a strong correlation between the liberal arts, architecture, and science, suggesting a strong relation to our broader society and world culture. Leaders in one's field are often those most capable of comprehending our lived world through the study of other fields. This does not negate the need for specialization, but simply recognizes the value of generalized knowledge and how architecture can work to combine multiple interests. Moreover, a generalist is able to find inspiration for spatial, material, and formal practices through a wide range of resources. Inspiration in architecture is not readily understood, and the broad scope of interests that motivate designers leads to the extreme variety and originality possible within design.

In contemporary practice we have moved perhaps too far away from a liberal education in architecture toward more prescriptive models limiting the potential for diversity and creativity in our field. While formally experimental, we may be focusing too closely on inner-disciplinary object-oriented practices that no longer seek inspiration from broader understanding. On the other hand, this type of specialization provides stronger formal building and detailed development than Kiesler was ever able to achieve on his own. His greatest built work—the Shrine of the Book—was achieved through collaboration, which was not easy for him. Architecture is a collaborative practice.

The life of the experimental architect such as Kiesler is neither a simple nor a financially promising career path. Digital designers following this impractical model in the past few decades (except the extremely fortunate and persistent) have committed their efforts to experimental practices without much hope of building anything substantive in their careers. The model of a hybrid teaching and working research practice such as Kiesler pursued at Juilliard, Columbia, and Yale poses moral questions that should not be dismissed. We should be grateful for the model's creative and pedagogical merits, as well as the potential for broader class cultures to engage in innovative design, but it is not going to prove successful for everyone. Architecture is a labor of love, especially at the experimental extreme.

Architecture is itself a form of *robota*. It is created through an act of labor, but also serves as a doubling of ourselves in the world. Besides providing shelter, structure, shape, and form, it is dialectically engaged in the production of human culture. This book is focused not on robots per se but on what I have described as *robotic culture*, and the embedded social politics that underlie our behavior and way of being in the world. Robotics invokes the discussion of capitalist labor and the technological determinism that motivates our society toward a new ideal in the face of new industry. Challenges facing humanity during the twentieth century involved fears and fantasies of the inorganic versus the organic. The relationship between humans and their doubles, between the animate and the inanimate, is made manifest in the buildings, artifacts, and spaces studied in this text. The culture of robots involves not only the complex doubling of ourselves in the world as inanimate objects, naturalized with our likeness out of fear—whether of dying, being replaced, or being alone—but also our hope of exceeding ourselves in some way. Ultimately we are seeking evolutionary longevity and intellectual promise through our technological fetishes, by giving ourselves over to a future beyond our mortal being.

Our need to double ourselves in the world, through our machines, artifacts, buildings, or children, is driven by natural pragmatism, by the instinct to live and to exceed the limits of our separate existence. A posthuman condition is one embedded in the promise of technology to challenge our own mortality—accepting nature's drive to be animate and live as long as possible in support of future generations. The concept of an elastic architecture is embedded in the human desire to sustain if not outperform mortal existence through both a resistant and resilient liberatory practice.

Kiesler certainly was not afraid of technology to achieve his goals. He did not design architecture to escape from life, but to support if not supplement our humanity; he simply lacked the technical proficiency to be a leader in building technologies or material production. He was more of an artist and an intellectual, able to grasp possibilities and innovate at the edge of the profession but not collaborate to work out the technical details. In his defense, it has taken generations even to get close to building his structural and technological provocations, and it required innovations in the fields of computer science and digital fabrication to approximate the complexity he was able to achieve in artistic expression.

Kiesler was never a technological materialist either—he did not believe that technology or materials solely drive human creativity, and his work fundamentally opposes any idea that digital technologies and new materials dictate the future of our design profession, formally, spatially, or materially. Of course technology and the invention of new materials do change the world to some extent, but form, space, structure, and design are not precisely dictated by technology or material acquisition. It is more a complex nonlinear matrix of technocultural performance that leads to innovation, which is not the same as cultural materialism either.

Design intentions often if not always precede actions. Technological innovation comes to answer the challenges of the human intellect embedded in our evolving cultural milieu. This is not to diminish the accomplishments of technology but to recognize the dialectic at play between conception and production. Production inspires future innovations, which motivate new conceptions. In the case of Kiesler, the cultural desire to invent endless space, coupled with an interest in elasticity as embedded in modern cultural history, provided in part the ideas and ambition to experiment with new spatial forms for theater and housing. One might argue that technological innovations in the history of film, through the work of experimental animators Richter and Eggeling, gave the spatial inspiration behind Kiesler's invention. Yet Richter and Eggeling were inspired in part by a reinterpretation of Bergson's philosophical theories on endlessness, which were notably born in response to Étienne-Jules Marey's studies in chronophotography, and so on. The art of creation, innovation, and experimentation is a multidisciplinary act requiring both interest and engagement in a wide range of discourse alongside inner-disciplinary expertise.

In recent decades, specialization has arguably hurt the profession of architecture, and the chasm between history/theory and design/practice has been growing. If I have a hope in writing this book, it is to remind us that there is a history to invention that supports engagement with evolving culture and technology—a technocultural materialism—while not excluding philosophical, sociopolitical, and economic interests as well. Kiesler, for example, experimented with a wide range of design media, but he also had an intellectual practice. He wrote, produced books, and read philosophy, science, psychoanalysis. Although a self-made intellectual with limited education and loosely researched pseudo-scientific interests and philosophic ideas, he was nonetheless able to combine creative intelligence and design talent within his practice.

There is a rich history of architects writing about their work and others', whether through poetry, critical prose, or creative fiction—Vitruvius, Alberti, Semper, Loos, Le Corbusier, Frank Lloyd Wright, Vittorio Gregotti, Louis Kahn, Charles Moore, Peter Eisenman, Rem Koolhaas, Ben van Berkel and Caroline Bos, Greg Lynn, Stan Allen, Mario Gandelsonas, Diana Agrest, Robert Venturi, Denise Scott Brown, Alison and Peter Smithson, and Eric Owen Moss, to name only a few. The synergy possible between history/theory writing and building/design practice cannot be underestimated. Kiesler's writing, however, is about as convoluted as his design oeuvre, and for me, his research practice still remains rich with ideas and concepts that informed his work, and inform our understanding of his work in ways yet to be explored. To suggest that his practice is eclectic and lacks a clear set of interests and design principles is to misunderstand the intensity and contemporaneity of his effort as an architect and intellectual.

To understand Kiesler, first and foremost we have to recognize that he was an architect. From his stage sets, shop windows, and laboratory experiments to his exhibitions, catalogs, articles, books, drawings, furniture, sculptures, galleries, and museum and theater projects, he used practically every available medium to advance architectural ideas. Throughout his life—though his designs far outnumbered his built work—architecture remained his true passion and interest. He always referred to himself as an architect.

In a way that was novel for his time, Kiesler developed his design ideas on the edge of the profession, always looking at contemporary culture and its potential significance for building practice. Perhaps this makes for the variety

of work he produced in the course of his lifetime, but it also presents a substantive historical and cultural explication of his time, as well as of the future he saw before him and the past he imagined behind him. Kiesler was a visionary; his building concepts, intangible in his lifetime, have yet to be achieved, despite similar promises from recent technicians of digital design and fabrication. As such he still remains a provocateur, motivating artists and architects seeking adaptability, flexibility, and interactivity toward greater multiplicity, inclusivity, and free will within a highly structured and controlling advanced capitalist society.

Figure 7.3 Frederick Kiesler, Space House, 1933. Letter with illustration to unidentified recipient, November 20, 1958. Courtesy of the Lillian and Frederick Kiesler Papers, Archives of American Art, Smithsonian Institution, Washington, DC.

Notes

Preface

1. Kiesler used his Austrian first name Friedrich until he was 36 years old. After arriving in the United States, he referred to himself almost exclusively as Frederick. I have adopted the same approach when referring to his first name.

Introduction

1. See Philip Johnson, "Three Architects," *Art in America* (March 1960), 70.

2. Douglas Haskell, "In Architecture, Will Atomic Processes Create a New 'Plastic' Order?," in "Building in the Atomic Age," *Architectural Forum* (September 1954), 100.

3. Philip Johnson to Reid Johnson, March 1, 1965, Lillian and Frederick Kiesler Papers, [circa 1910]–2003, bulk 1958–2000, Series 2, Frederick Kiesler Papers, Box 41, Correspondence Jan-Mar 1965 Folder 21, Archives of American Art, Smithsonian Institution.

4. Paul Rudolph to Reid Johnson, January 5, 1965, Lillian and Frederick Kiesler Papers, [circa 1910]–2003, bulk 1958–2000, Series 2, Frederick Kiesler Papers, Box 41, Correspondence Jan-Mar 1965 Folder 21, Archives of American Art, Smithsonian Institution.

5. Walter Benjamin, "Paris—the Capital of the Nineteenth Century," in Benjamin, *Charles Baudelaire: A Lyric Poet in the Era of High Capitalism*, trans. Harry Zohn (London: NLB, 1973), 168. This passage was revised to "confronted by the technologically armed world," in Walter Benjamin, "Paris—the Capital of the Nineteenth Century," in Benjamin, *Selected Writings*, vol. 3, *1935–1938*, ed. Howard Eiland and Michael Jennings, trans. Edmund Jephcott and Howard Eiland (Cambridge: Harvard University Press, 2002), 38.

6. See Gilles Deleuze, *Le Pli: Leibniz et le baroque* (Paris: Éditions de Minuit, 1988); English translation, *The Fold: Leibniz and the Baroque*, trans. Tom Conley (Minneapolis: University of Minnesota, Press, 1993), particularly chapter 1.

7. Deleuze, *The Fold*, 3, 7, 8, 9.

8. Greg Lynn, *Animate Form* (New York: Princeton University Press, 1999), 34.

9. See "Will the Computer Change the Practice of Architecture?," *Architectural Record* (January 1965). See also "The Computer and Architecture," *Architectural and Engineering News* (March 1965).

10. Raphael O. Roig, "The Continuous World of Frederick J. Kiesler," master's thesis, University of California, Los Angeles, Department of Industrial Design, June 1, 1965, 92, Frederick Kiesler Papers, Museum of Modern Art, Archive Item #10 box 51.

11. Ben van Berkel and Caroline Bos, "A Capacity for Endlessness," *Quaderns d'Arquitectura + Urbanism* (1999), 93.

12. Ibid.

13. Philip Johnson to Reid Johnson, March 1, 1965.

14. Ben Schmall, "Design's Bad Boy: A Pint-Sized Scrapper Who, after Thirty Years, Still Challenges All Comers," *Architectural Forum* (February 1947), 88–92.

15. Kiesler substantively characterized his work and legacy in "Kiesler's Pursuit of an Idea," interview by Thomas Creighton, *Progressive Architecture* (July 1961), and Frederick Kiesler, *The "Endless House": Inside the Endless House: Art, People and Architecture: A Journal* (New York: Simon and Schuster, 1966).

16. As early as 1958, Burton Weekes had already written a master's thesis on Frederick Kiesler's 1932 Universal Theater and its implications for contemporary theater design. In 1958, with Kiesler's second wife Lillian Kiesler's support, Katsuhiro Yamaguchi produced a substantial catalog on Kiesler, published in Japan. In 1965, Roig, completed the second master's thesis on Kiesler, and by 1970 Elaine Schwartz completed her thesis documenting and positioning Kiesler's life, ideas, and works. Art historians soon began to look more closely at Kiesler, and by the end of the 1970s he became the subject of several studies and critiques that sought to position his innovations or expose the many influences at play in his work. In 1979, Cynthia Goodman was perhaps the first art historian to study his work with consistency. In 1981, Michael Sgan-Cohen produced a large dissertation that cataloged all of Kiesler's best-known works. In 1982 and 1984, Barbara Lesák and Roger Held reconstructed and historicized Kiesler's theater projects, particularly his early works. And with support from Lillian Kiesler, Lisa Phillips produced a substantial exhibition and catalog of Kiesler's projects for the Whitney Museum in 1989. Dieter Bogner produced one of the most accurate and complete art historical surveys of Kiesler's work prior to the 1990s, which helped to fuel wider interest in Kiesler and his designs. In addition, architectural historian Anthony Vidler in 1992 offered a brief note on Kiesler's work in *The Architectural Uncanny* that suggested avenues for further architectural research and investigation. See: Burton Weekes, "Analysis of Frederick J. Kiesler's 'Universal Theatre' and Implications of Flexible Theater in America Today," M.A. thesis, Syracuse University, 1958 (microfilmed, Syracuse, N.Y., 1966); Katsuhiro Yamaguchi, *Frederick Kiesler, Environmental Artist* (Tokyo: Bijutsu Shuppan-sha, 1978); Roig, "The Continuous World of Frederick J. Kiesler"; see also Ellen Jane Schwartz, "Frederick Kiesler: His Life, Ideas and Works," M.A. thesis, University of Maryland, 1970; Cynthia Goodman, "The Current of Contemporary History: Frederick Kiesler's Endless Search," *Arts Magazine* 54 (September 1979), 118–123; Cynthia Goodman, "Frederick Kiesler: Designs for Peggy Guggenheim's Art of This Century Gallery," *Arts Magazine* 51, no. 10 (June 1977), 90–95; Cynthia Goodman, *Frederick Kiesler (1890–1965): Visionary Architecture, Drawings and Models, Galaxies and Paintings, Sculpture, December 9–January 3, 1979* (New York: André

Emmerich Gallery, 1978); Michael S. Sgan-Cohen, "Frederick Kiesler: Artist, Architect, Visionary—A Study of His Work and Writing," Ph.D. dissertation, Art History Department, City University of New York, 1989; Lisa Phillips, ed., *Frederick Kiesler* (New York: Whitney Museum of American Art in association with W. W. Norton, 1989); Dieter Bogner, *Friedrich Kiesler: Architekt, Maler, Bildhauer, 1890–1965 / Frederick Kiesler* (Vienna: Löcker, 1988). See also Yehuda Safran, "Frederick Kiesler 1890–1965: AA Exhibitions Gallery, Members' Room & Bar 8 November–9 December 1989" (exhibition review), *AA Files*, no. 20 (Autumn 1990), 83–88; Yehuda Safran, "Frederick Kiesler, 1890–1965: In the Shadow of Bucephalus," *AA Files*, no. 20 (Autumn 1990), 83–88; Yehuda Safran, ed., *Frederick Kiesler 1890–1965* (London: Architectural Association, 1989); Anthony Vidler, *The Architectural Uncanny: Essays in the Modern Unhomely* (Cambridge: MIT Press, 1992), 153.

17. Lisa Phillips, "Environmental Artist," in Lisa Phillips, *Frederick Kiesler*, 108.

18. Chantal Béret, ed., *Frederick Kiesler, artiste-architecte*, Collection Monographie (Paris: Centre Georges Pompidou, 1996).

19. Denis Connolly, "Rewriting the History of Modernism" (exhibition review), *Architects' Journal* 204, no. 3 (July 18, 1996), 45.

20. See Beatriz Colomina, "La *Space House* et la psyche de la construction," in Béret, *Frederick Kiesler, artiste-architecte*, 67–77; Mark Wigley, "Towards the Perforated School," *Archis* 20, no. 1 (2005), 36–50. See also Mark Wigley, "The Architectural Brain," in Anthony Burke and Therese Tierney, eds., *Network Practice* (New York: Princeton Architectural Press, 2007), 30–53; Detlef Mertins, "Where Architecture Meets Biology: An Interview with Detlef Mertins," in Joke Brouwer and Arjen Mulder, eds., *Interact or Die!* (Rotterdam: V2 Publishing, 2007), 110–131; Roland Lelke, *Der endlose Raum in Frederick Kieslers Schrein des Buches* (Aachen: Shaker, 1999), originally presented as the author's doctoral thesis, "Dead Sea Scrolls. Museums Israel Jerusalem 1950–2000," Technische Hochscule Aachen, 1998; Gunda Luyken, "Frederick Kiesler und Marcel Duchamp—Rekonstruktion ihres theoretischen und künstlerischen Austausches zwischen 1925 und 1937," Inauguraldissertation, Staatliche Hochschule für Gestaltung, Karlsruhe, Berlin, 2002.

21. Herbert Muschamp, "Art/Architecture; A Surrealist and the Widow Who Keeps the Flame," *New York Times*, August 19, 2001, 30.

22. I am not here ignoring the accomplishments of architects such as Le Corbusier or those members of the Bauhaus who maintained vital practices alongside artistic explorations in the arts. I am instead recognizing that the exemplary architectural production of those architects predominantly evolved through building practices, while Kiesler achieved something notably different.

23. See Maria Bottero, "Ideas and Work," in *Frederick Kiesler: Arte architettura ambiente* (Milan: Electa, 1996), 190; and Valentina Sonzogni, "Bibliography," in Dieter Bogner, *Friedrich Kiesler: Art of This Century* (Vienna: Hatje Cantz, 2003), 94. Kiesler and others gave varying dates for his birth in Vienna, from December 9, 1890, to 1892, 1896, or 1898. See Lisa Phillips, "Frederick Kiesler Chronology 1890–1965," in Lisa Phillips, *Frederick Kiesler*, 139. Lillian Kiesler, "Frederick Kiesler Biography," New York, October 31, 1980, 165, Frederick Kiesler Papers 1923–1993, microfilm reel 127, Archives of American Art, Smithsonian Institution; Guenther Feuerstein, "Friday January 14, 1966 (Vienna …): Frederick Kiesler Died in New York," Frederick Kiesler Papers 1923–1993, microfilm reel 128, Archives of American Art, Smithsonian Institution; Friedrich Achleitner, "Fascination of Space: The Work of a Lifetime, of the Recently Died Architect Frederick John Kiesler," Frederick Kiesler Papers 1923–1993, microfilm reel 127, Archives of American Art, Smithsonian Institution; R. L. Held, *Endless Innovations: Frederick Kiesler's Theory and Scenic Design* (Ann Arbor: UMI Research Press, 1982), 7.

24. See Bottero, "Ideas and Work," 190.

25. See Lillian Kiesler, "Frederick Kiesler Biography," 165.

26. See Held, *Endless Innovations*, 8.

27. See Bottero, "Ideas and Work," 190.

28. See "Translation from the French of the Editorial of *L'Architecture d'aujourd'hui*," June 1949, Frederick Kiesler Papers 1923–1993, microfilm reel 127, 2, Archives of American Art, Smithsonian Institution.

29. Kiesler had kept the artwork he produced prior to moving to the United States in storage in Vienna, which included drawings of the human body, landscapes in different techniques, sketchbooks, woodcuts, etchings, and lithographs. During the Second World War, he attempted to salvage his boxes by shipping them through Switzerland and then London. By all accounts, they never arrived. See Frederick Kiesler to Mr. M. S. Henderson, British Consulate General, October 28, 1940, Lillian and Frederick Kiesler Papers, [circa 1910]–2003, bulk 1958–2000, Series 2, Frederick Kiesler Papers, Box 40, Correspondence 1940 Folder 12, Archives of American Art, Smithsonian Institution.

30. See Lisa Phillips, "Frederick Kiesler Chronology," 139. Also see Sonzogni, "Bibliography," 94.

31. See Lillian Kiesler, "Frederick Kiesler Biography," 166; Bottero, "Ideas and Work," 176; Sgan-Cohen, "Frederick Kiesler, Artist, Architect, Visionary," 422.

32. In my research, I have typically found some truth in all of Kiesler's statements, or if not the truth, at least a reason for making them. Though he may have occasionally shifted about the dates of his early works, every questionable incident, association, or anecdotal comment I researched, even when most doubtful, led to a fascinating truth.

33. Kiesler, "Kiesler's Pursuit of an Idea," 106.

34. Ibid., 105.

35. Ibid., 106, 109.

36. See Lisa Phillips, "Frederick Kiesler Chronology," 139. See also Sonzogni, "Bibliography," 94.

Chapter 1

1. Friedrich Kiesler, "Foreword," in Friedrich Kiesler and Jane Heap, eds., *Exhibition Catalogue of International Theater Exposition* (New York: Steinway Building, 1926), 5.

2. Friedrich Kiesler, "Debacle of the Modern Theater," in ibid., 18.

3. See C. J. Bulliet, "Pompous Prophets with Some Wisdom," *Evening Post* (Chicago), April 13, 1926, in Frederick Kiesler Papers 1923–1993, microfilm reel 127, Archives of American Art, Smithsonian Institution. See also "Theater Exposition Is Comprehensive," *Brooklyn Eagle*, March 5, 1926 in Frederick Kiesler Papers 1923–1993, microfilm reel 127, Archives of American Art, Smithsonian Institution.

4. See Stark Young, "The International Theatre Exposition," *New Republic*, March 17, 1926, in Frederick Kiesler Papers 1923–1993, microfilm reel 127, Archives of American Art, Smithsonian Institution.

5. "Old Theater Is Dead, Says Kiesler," *Brooklyn Eagle*, March 7, 1926, in Frederick Kiesler Papers 1923–1993, microfilm reel 127, Archives of American Art, Smithsonian Institution.

6. Ibid.

7. "Stage Decorations at Steinway Hall," *American Art News*, New York City, March 6, 1926, in Frederick Kiesler Papers 1923–1993, microfilm reel 127, Archives of American Art, Smithsonian Institution.

8. Frederick Kiesler, "The Future: Notes on Architecture as Sculpture," *Art in America* 54 (May-June 1966), 61; emphasis in original; see also Frederick Kiesler, "Die Kulisse explodiert," *Pásmo = La zone = Die Zone = The zone = La zona*, no. 5/6 (Brno: A. Černík, 1925), in Getty Research Institute, Research Library, Special Collections and Visual Resources, Los Angeles, #87-S908, 1.

9. See "The Lobby Gossip," March 14, 1926, in Frederick Kiesler Papers 1923–1993, microfilm reel 127, Archives of American Art, Smithsonian Institution.; see also "The Theater of the Future," *World* (New York), February 28, 1926, in Frederick Kiesler Papers 1923–1993, microfilm reel 127, Archives of American Art, Smithsonian Institution.

10. Kiesler, "The Future: Notes on Architecture as Sculpture," 61.

11. See Maria Gough, *The Artist as Producer: Russian Constructivism in Revolution* (Berkeley: University of California Press, 2005).

12. Kiesler, "Foreword," in Kiesler and Heap, *Exhibition Catalogue of International Theater Exposition*, 4; see also "The International Theater Exposition New York 1926, Special Theater Number, February 27 to March 15," organized by Jane Heap and Friedrich Kiesler, *Little Review* (Winter 1926), 6, 15.

13. See Frederick Kiesler, "Project for a 'Space-Theatre' Seating 100,000 People," in K. Lönberg-Holm, "New Theater Architecture in Europe," *Architectural Record* (May 1930), 495.

14. Marc Dessauce, *Machinations: Essai sur Frederick Kiesler, l'histoire de l'architecture moderne aux États-Unis et Marcel Duchamp* (Paris: Sens & Tonka, 1996). See also Chantal Béret, ed., *Frederick Kiesler, artiste-architecte* (Paris: Centre Georges Pompidou, 1996).

15. See Gunda Luyken, "Frederick Kiesler und Marcel Duchamp—Rekonstruktion ihres theoretischen und künstlerischen Austausches zwischen 1925 und 1937," Inauguraldissertation, Staatliche Hochschule für Gestaltung, Karlsruhe, Berlin, 2002.

16. Frederick Kiesler, "Mobile Setting (1922), Space-Stage (1923), The Endless (1924) Woodstock," 1, Text Box 03, Folder Man/Type Various L-M-N, Austrian Frederick and Lillian Kiesler Private Foundation Archive, Vienna; document must have been written and annotated after 1961.

17. Frederick Kiesler, "Lecture by Frederick Kiesler on His Use of Film in 1922 Production of R.U.R. by Karel Čapek Delivered to Yale School of Architecture, 1947," in *A Tribute to Anthology Film Archives' Avantgarde Film Preservation Program: An Evening Dedicated to Frederick Kiesler …* (New York: Anthology Film Archives, 1977), 30; reprint from unpublished lecture: "Yale School of Architecture—1947," 13, Kiesler Lectures Folder, Austrian Frederick and Lillian Kiesler Private Foundation Archive, Vienna. See also Kiesler, "Mobile Setting (1922), Space-Stage (1923), The Endless (1924) Woodstock," 1.

18. Kiesler, "Lecture by Frederick Kiesler on His Use of Film in 1922 Production of R.U.R.," 30.

19. Ibid.

20. Lillian Kiesler, "Frederick Kiesler Biography," New York, October 31, 1980, 167, Frederick Kiesler Papers 1923–1993, microfilm reel 127, Archives of American Art, Smithsonian Institution. See also Kiesler, "Yale School of Architecture—1947," 14, 15.

21. See R. L. Held, *Endless Innovations: Frederick Kiesler's Theory and Scenic Design* (Ann Arbor: UMI Research Press, 1982), 11–17.

22. Hans Richter, "Koepfe und Hinterkoepfe," Museum of Modern Art Archives, New York, Frederick Kiesler Papers, Item 48, n.d, n.p., 1.

23. Ibid.; see also Kiesler, "Yale School of Architecture—1947," 15.

24. "Gegonstrueerd en uitgevoerd door Kiesler (meerdere aanzichten en beschrijving volgen): Tooneel-front voor 'W.U.R.' van Capek (opgevoerd April 1923 te Berlijn)," *De Stijl* 6, nos. 3/4 (May-June 1923), 43. Futurist set designer Enrico Prampolini also became an influential supporter of Kiesler. He published the *R.U.R.* sets in his magazine *Rivista d'Arte Futurista*, nos. 1–2 (1924), 42.

25. See Richter, "Koepfe und Hinterkoepfe," 1.

26. Frederick Kiesler, "Kiesler's Pursuit of an Idea," interview by Thomas Creighton, *Progressive Architecture*, July 1961, 111.

27. A. Tairov, L. Lukyanov, and A. Vesnin, "Zrelisca" (Spectacles), September 5, 1922 as quoted in Selim Omarovich Khan-Magomedov, *Alexander Vesnin and Russian Constructivism* (New York: Rizzoli, 1986), 91.

28. Kiesler, "Kiesler's Pursuit of an Idea," 111.

29. See Richter, "Koepfe und Hinterkoepfe," 1.

30. Frederick Kiesler was involved in *G* from its inception, as implied by a hand-written letter from Hans Richter to Frederick Kiesler on October 19, 1962, asking for support to affirm the historic facts concerning Werner Graeff's role in the magazine. See Hans Richter's letters to Frederick Kiesler, Briefe R, Mappe 2, Austrian Frederick and Lillian Kiesler Private Foundation Archive, Vienna.

31. See Hans Richter, "As I Remember Mies," unpublished, undated, Getty Research Institute, Research Library, Special Collections and Visual Resources, Los Angeles, Hans Richter Papers 1929–1968 #880428 Box 1, "Typescripts of articles and lectures," Folders 1–17 3 3125 00880 3823, Folder 13, 1.

32. Ibid., 2, 3.

33. Richter later marginalized Kiesler's editorial contribution to *G* on the occasion of Kiesler's passing in 1965. Richter argued that he only "reserved a place for him [Kiesler] on the editorial board" of *G* as "compensation for the fact that the pictures of his works had been printed too small" in the magazine. This explanation is inaccurate, however. Kiesler was only listed as an editor in the June 1924 publication, and his work was not presented in *G* until two years later in March 1926. The small images in 1926 had nothing to do with Kiesler being an editor in 1924. Kiesler's specific contribution to *G* from 1923 to June 1924 is most likely as stated originally in the magazine. See Richter, "Koepfe und Hinterkoepfe," 1. See also *G: Zeitschrift für elementare Gestaltung*, no. 3 (June 1924).

34. See *G*, no. 3 (June 1924), 8–11. For a recent English translation of *G*, see *G: An Avant-Garde Journal of Art, Architecture, Design, and Film, 1923–1926*, ed. Detlef Mertins and Michael W. Jennings (Los Angeles: Getty Research Institute, 2010).

35. Hans Richter, "Easel-Scroll-Film," *Magazine of Art* (February 1952), 81.

36. For Eggeling's transcriptions of "Dehnung in der Zeit Ausdehnung im Raume" from *Creative Evolution* by Henri Bergson, see Louise O'Konor, *Viking Eggeling 1880–1925: Artist and Film-Maker Life and Work* (Stockholm: Louise O'Konor and the Eggeling Family, 1971), 95.

37. See Hans Richter, "Step by Step: An Account of the Transition from Painting to the First Abstract Films 1919–1921," *Studies in the 20th Century*, Getty Research Institute, Research Library, Special Collections and Visual Resources, Los Angeles, Hans Richter papers 1929–1968, Folder 13, Typescripts of articles and lectures, Folder 13, 9. See also Richter, "Avant-garde Film in Germany," unpublished, undated (1948?), Getty Research Institute, Research Library, Special Collections and Visual Resources, Los Angeles, Hans Richter papers 1929–1968, Folder 13, Typescripts of articles and lectures, Folder 13, 1, 2. See also O'Konor, *Viking Eggeling 1880–1925*.

38. Ibid., 9–10.

39. Hans Richter, "My Experience with Movement in Painting and Film," in Gyorgy Kepes, ed., *The Nature and Art of Motion* (New York: Braziller, 1965), 144.

40. See Kiesler, "Yale School of Architecture—1947," 15. Kiesler knew Eggeling's studio well, as described in Kiesler's 1934 lecture at the Wadsworth Athenaeum. Frederick Kiesler, "Wadsworth Athenaeum Lecture," unpublished, December 16, 1934, 2, Txt 06 Man/Typ Box, Man/Typ Various V-Z Folder, Austrian Frederick and Lillian Kiesler Private Foundation Archive, Vienna.

41. See Lillian Kiesler, "Frederick Kiesler: In Search of … Quintessence of Cinema, Compiled by Lillian Kiesler, September 1977," in *A Tribute to Anthology Film Archives' Avantgarde Film Preservation Program*, 30. See also letters from Hans Richter to Frederick Kiesler, March 17, 1937, Briefe R, Mappe 2, and letter from Frederick Kiesler to Mr. John E. Abbott, Museum of Modern Art Film Library 485 Madison Avenue, NYC, April 21, 1937, Briefe A, Mappe 4, Austrian Frederick and Lillian Kiesler Private Foundation Archive, Vienna.

42. In Kiesler's lectures he noted that "rhythm by Hans Richter is a studio experiment to test the illusion of depth in motion picture presentation. … The limitation of spaces expansion and contraction by the motion picture frame is studied." Kiesler, "Wadsworth Athenaeum Lecture," 4.

43. Kiesler, "Wadsworth Athenaeum Lecture," 3–4; my emphasis.

44. Henri Bergson, *Creative Evolution*, trans. Arthur Mitchell (New York: Henry Holt, 1911; rpt., New York: Dover, 1998), 255; originally published as *L'Évolution créatrice* (Paris: Alcan, 1907).

45. Ibid., 317, 319.

46. See the exhibition catalog: *Internationale Ausstellung neuer Theatertechnik. Konzerthaus. Unter Mitwirkung der Gesellschaft zur Foerderung moderner Kunst* (Vienna: Verlag Wurthle & Sohn, 1924). Friedrich Kiesler completed the design (envelope, typography) and Walter Neurath edited the catalog for the publisher.

47. See Kiesler, "Debacle des Theaters," in *Internationale Ausstellung neuer Theatertechnik*, 53; the English translation is from Friedrich Kiesler, "The Debacle of Modern Theater," in "The International Theater Exposition New York 1926," *Little Review* (Winter 1926), 18.

48. Ibid., 57, 58; English translation, 22, 23.

49. See Lisa Phillips, "An Environmental Artist," in Lisa Phillips, ed., *Frederick Kiesler* (New York: W. W. Norton, 1989), 109. See also Barbara Lesák, *Die Kulisse explodiert: Friedrich Kieslers Theaterexperimente und Architekturprojeckte 1923–1925* (Vienna: Locker Verlag, 1988); and Held, *Endless Innovations*, 34.

50. See Walter Benjamin, "On Some Motifs in Baudelaire," in Benjamin, *Selected Writings*, vol. 4: *1938–1940*, ed. Michael W. Jennings (Cambridge: Harvard University Press, 2003), 328.

51. For English translation of quote from the *Neues Wiener Journal*, October 3, 1924, see Held, *Endless Innovations*, 34.

52. See Held, *Endless Innovations*, 30–36. See also Lesák, *Die Kulisse explodiert*, 112–120; and Rudolf Hönigsfeld, "Offener Brief an die Redaktion 'Der Tag,'" *Der Tag* (Vienna), September 11, 1924, found in "Die Kulisse explodiert, Texte zur Raumbühne, Forschungsprojekt Dr. Barbara Lesák," original research by Barbara Lesák for *Die Kulisse explodiert*, Austrian Frederick and Lillian Kiesler Private Foundation Archive, Vienna.

53. See J. L. Moreno, *The Theater of Spontaneity* (New York: Beacon House, 1947), 3. See also Held, *Endless Innovations*, 32, 33; J. L. Moreno, *Das Stegreiftheater* (Potsdam, 1923), tafel 1.

54. Held, *Endless Innovations*, 32, 33, 35.

55. Enrico Prampolini, "L'atmosfera scenica futurista," in *Internationale Ausstellung neuer Theatertechnik*, 74; English translation, Enrico Prampolini, "The Magnetic Theatre and the Futuristic Scenic Atmosphere," in "The International Theater Exposition New York 1926," *Little Review* (Winter 1926), 18; italics in the original English translation.

56. Richard Wagner, "The Art-Work of the Future," trans. William Ashton Ellis, in *Richard Wagner's Prose Works*, vol. 1 (New York: Broude Brothers, 1892), 69–213; originally published as "Das Kunstwerk der Zukunft" in Wagner, *Sämtliche Schriften und Dichtungen*, Teil I (Leipzig: Breitkopf et Härtel, 1849), 194–206.

57. Filippo Marinetti, "The Variety Theater: September 29, 1913," in *Marinetti: Selected Writings*, ed. and trans. R.W. Flint (New York: Farrar, Straus and Giroux, 1972), 117.

58. Filippo Marinetti, Emilio Settinelli, and Bruno Corra, "Futurist Theory and Invention, January 11, 1915," in *Marinetti: Selected Writings*, 128; emphasis in original.

59. Enrico Prampolini, "The Futurist Stage (Manifesto) 1915," in *Futurist Manifestos*, ed. Umbro Apollonio, trans. Robert Brain, R. W. Flint, J. C. Higgitt, Caroline Tisdall (New York: Viking Press, 1970), 201.

60. Ibid.

61. Ibid.; emphasis in original.

62. In Italian, see Prampolini, "L'atmosfera scenica futurista," 71, 77. See also Enrico Prampolini, "The Magnetic Theatre and the Futuristic Scenic Atmosphere," "Polydimensional Scenic Space," "Electrodynamic Polydimensional Architecture of Luminous Plastic Elements Moving in the Center of the Theatrical Hollow," and "Polyexpressive and Magnetic Theatre," draft essays combined together in English, Little Review (Chicago, Ill.) Records, 1914–1964 UWM Manuscript Collection 1, University Manuscripts Collection, Golda Meir Library, University of Wisconsin-Milwaukee, General Files, Enrico Prampolini, Box 8, Folder 47, 3, 5, 6, 7, 10. See also in English: Enrico Prampolini, "The Magnetic Theatre and The Futuristic Scenic Atmosphere," 103, 104, 105, 106, 108; emphasis in original.

63. Ibid., 6, 8.

64. Ibid., 5.

65. Ibid., 7.

66. Hans Richter, "Rhythm," in "The International Theater Exposition New York 1926," *Little Review* (Winter 1926), 21.

67. See Frederick Kiesler, "Manifest: Vitalbau-Raumstadt-Funktionelle Architektur," *De Stijl* 6 (July 1925), 10–11.

68. Friedrich Kiesler, "Das Railway-Theater," in *Internationale Ausstellung neuer Theatertechnik*, ii.

69. See Barbara Lesák, "Visionary of the European Theater," in Lisa Phillips, *Frederick Kiesler*, 40.

70. Kiesler, "The Future: Notes on Architecture as Sculpture," 61.

71. See Kiesler, "Als ich das Raumtheater erfand: Dokumente um das Jahr 1924," in "Die Kulisse explodiert, Texte zur Raumbühne, Forschungsprojekt Dr. Barbara Lesák," Austrian Frederick and Lillian Kiesler Private Foundation Archive, Vienna, 3. Document includes dated information up to 1929.

72. See Kiesler, "Als ich das Raumtheater erfand," 2, 3.

73. See Franz Ehrlich, "Bauhaus und Totaltheater," *Wissenschaftliche Zeitschrift. Hochschule für Architektur und Bauwesen* 29, nos. 5–6 (1983), 424; see also Walter Gropius cited in Erwin Piscator, *Das politische Theater* (Berlin: Adalbert Schultz Verlag, 1929), 126–127. Although Kiesler did meet with Piscator in New York, on December 19, 1936, the depth of their relationship and the accuracy of Kiesler's entire claim are unclear; see Steffi Kiesler's diary, Austrian Frederick and Lillian Kiesler Private Foundation Archive, Vienna.

74. Frederick Kiesler, "The Future: Notes on Architecture as Sculpture," 61. See also L. Moholy-Nagy, "Theater, Zirkus, Varieté," in O. Schlemmer, L. Moholy-Nagy, and F. Molnár, eds., *Die Buhne im Bauhaus 4* (Munich: Albert Lagen Verlag, 1924), 47; English translation, "Theater, Circus, Variety," in *The Theater of the Bauhaus*, trans. Arthur S. Wensinger (Middletown, CT: Wesleyan University Press, 1961), 52.

75. See "The International Theater Exposition New York 1926," *Little Review* (Winter 1926), 50.

76. See Moholy-Nagy, "Theater, Zirkus, Varieté," 47; English translation, "Theater, Circus, Variety," 52.

77. Adolf Loos, "The Theater," in "The International Theater Exposition New York 1926," *Little Review* (Winter 1926), 92, 94, 96. See also Adolf Loos, "Theater," in Kiesler and Heap, *Exhibition Catalogue of International Theater Exposition*, 6–7; Adolf Loos, "The Theater," Little Review (Chicago, Ill.) Records, 1914–1964 UWM Manuscript Collection 1. University Manuscripts Collection. Golda Meir Library. University of Wisconsin-Milwaukee. General Files, Adolf Loos, Box 8, Folder 11, 1–3.

78. See Beatriz Colomina, "The Split Wall: Domestic Voyeurism," in Colomina, ed., *Sexuality and Space* (New York: Princeton Architectural Press, 1992), 76. See also Stanislaus von Moos, "Le Corbusier and Loos," in Max Risselada, ed., *Raumplan versus Plan Libre: Adolf Loos and Le Corbusier* (New York: Rizzoli, 1988), 23.

79. See Moholy-Nagy, "Theater, Circus, Variety," 57.

Chapter 2

1. Walter Benjamin, "The Work of Art in the Age of Its Technological Reproducibility: Third Version," in *Walter Benjamin: Selected Writings*, vol. 4: *1938–1940*, ed. Michael W. Jennings (Cambridge: Harvard University Press, 2003), 267, 281.

2. Ibid., 268.

3. Ibid. See also earlier version, Walter Benjamin, "The Work of Art in the Age of Its Reproducibility: Second Version," in *Walter Benjamin: Selected Writings*, vol. 3: *1935–1938*, ed. Michael W. Jennings (Cambridge: Harvard University Press, 2002), 120.

4. Ibid., 281.

5. Frederick Kiesler, "Manifesto of Tensionism," in *Contemporary Art Applied to the Store and Its Display* (New York: Bretano's, 1930), 48.

6. Ibid., 49.

7. Ibid.

8. Ibid., 48.

9. Ibid., 49.

10. Ibid., 48.

11. Ibid., 41, 55.

12. Walter Benjamin, "Naples," in *Walter Benjamin: Selected Writings*, vol. 1: *1913–1926*, ed. Michael W. Jennings (Cambridge: Harvard University Press, 1999), 417.

13. Ibid., 416.

14. Ibid.

15. Ibid., 419.

16. Unlike the 1924 Vienna exhibition, neither Kiesler's International Theater Exposition nor the array of avant-garde theatrics it displayed impressed American newspapers or audiences. Many promises, especially financial, did not come through for the Kieslers when they arrived in the United States. Steffi found temporary work in the Anderson Gallery curated by Katherine Dreier, who became a close and influential friend for their future, while Kiesler found work in Harvey Wiley Corbett's architecture studio upon Dreier's recommendation: "From what I can gather he [Kiesler] is really very able and understands how important it is to confirm our building laws, but as a European he cannot gauge and differentiate between who will use him and whom he can trust … if you could advise him on how not to appear too suspicious and yet protect himself it would help matters, after all their ghastly experiences here in America, they are on the verge of starvation, and I'm talking actual starvation." Starving, anxious, and in need of support, Kiesler found himself trying to make a career in architecture in New York. On a yearly salary of one thousand dollars, he and Steffi barely survived. See Maria Bottero, "Ideas and Work," in *Frederick Kiesler: arte architettura ambiente* (Milan: Electa, 1996), 192.

17. Kiesler throughout his American career had an amazing ability to get himself and his work featured not only in industry journals but also in popular magazines and newspapers—especially *Vogue*. He was not hesitant to sell himself to mass culture as the glamorous avant-garde artist for financial and career opportunity.

18. Kiesler, *Contemporary Art Applied to the Store and Its Display*, 67.

19. Ibid., 68.

20. Leonard S. Marcus, *The American Store Window* (New York: Whitney Library of Design, 1978), 21.

21. See Janet Ward, *Weimar Surfaces: Urban Visual Culture in 1920s Germany* (Berkeley: University of California Press, 2001), 208.

22. Kiesler, *Contemporary Art Applied to the Store and Its Display*, 110.

23. Ibid., 68, 70, 71.

24. Ibid., 68.

25. Ibid., 69.

26. Ibid., 71; my italics.

27. Walter Benjamin, "Little History of Photography," in *Walter Benjamin: Selected Writings Volume 1: 1913–1926*, ed. Michael W. Jennings (Cambridge: Harvard University Press, 1999), 523. See also Walter

Benjamin, "Paris Diary," in *Selected Writings*, vol. 1, 348; Benjamin, "The Work of Art in the Age of Its Technological Reproducibility: Third Version," 253–254.

28. Theodor W. Adorno and Max Horkheimer, *Dialektik der Aufklarung* (New York: Social Studies Association, 1944); English translation, *Dialectic of Enlightenment*, trans. John Cumming (New York: Continuum, 2000), 145. Siegfried Kracauer, *Das Ornament der Masse: Essays* (Frankfurt: Suhrkamp, 1963); English translation, "The Mass Ornament," in Kracauer, *The Mass Ornament: Weimar Essays*, trans. and ed. Thomas Y. Levin (Cambridge: Harvard University Press, 1995), 75.

29. See John Ruskin, *The Seven Lamps of Architecture* (1849; New York: Farrar, Straus and Giroux, 1979).

30. Kiesler, *Contemporary Art Applied to the Store and Its Display*, 73.

31. Ibid., 78.

32. Ibid., 73.

33. Ibid.

34. Ibid., 82–83.

35. Ibid., 81.

36. See Ward, *Weimar Surfaces*, 210–211.

37. Kiesler, *Contemporary Art Applied to the Store and Its Display*, 107.

38. Ibid.

39. Ibid., 108.

40. Ibid., 107.

41. Ibid., 108.

42. Hans Richter, "Easel-Scroll-Film," *Magazine of Art* (February 1952), 81.

43. Henri Bergson, *L'évolution créatrice* (Paris: Alcan, 1907); English translation, *Creative Evolution*, trans. Arthur Mitchell (New York: Henry Holt, 1911), 272, 295, 306.

44. "New Saks-Fifth Avenue Window Sets Reflect Ultra in Display Background," *Women's Wear*, March 24, 1928, as found in Frederick Kiesler Papers 1923–1993, microfilm reel 127, Archives of American Art, Smithsonian Institution.

45. Kiesler, *Contemporary Art Applied to the Store and Its Display*, 22, 25.

46. Ibid., 25.

47. Ibid., 103.

48. Ibid., 102.

49. Ibid., 103.

50. Ibid., 115.

51. Ibid., 21, 27.

52. Walter Benjamin, "Surrealism," in *Walter Benjamin: Selected Writings*, vol. 2: *1927–1934*, ed. Michael W. Jennings (Cambridge: Harvard University Press, 1999), 217.

53. See Walter Benjamin, "On Some Motifs in Baudelaire," in *Selected Writings*, vol. 4, 340.

54. Kiesler, *Contemporary Art Applied to the Store and Its Display*, 103.

55. Ibid.

56. Ibid., 120–121.

57. Ibid., 120.

58. Walter Benjamin, "The Paris of the Second Empire in Baudelaire," in *Selected Writings*, vol. 4, 31.

59. Walter Benjamin, "Experience and Poverty," in *Selected Writings*, vol. 2, 734.

60. Walter Benjamin, "Return of the Flâneur," in *Selected Writings*, vol. 2, 264.

61. Ibid., 265.

62. Benjamin, "Surrealism," 216; Benjamin, "Return of the Flâneur," 265. Benjamin had hoped that without the ability to leave traces, the aristocracy or bourgeoisie would be unable to possess and territorialize their property structures with the permanent memory and authority of their history, thereby ensuring an emptied-out image and material space for the new body politic of the masses.

63. E. M. Benson, "Wanted: An American Institute for Industrial Design," *American Art Magazine*, June 1934, 306–312.

64. Aura existed for Benjamin as a semblance of the communication between two people; the "experience of … aura … rests on the transposition of a response common in human relationships to the relationship between the inanimate and animate or natural object and man. The person we look at, or who feels he is being looked at, looks at us in turn." (Benjamin, "On Some Motifs in Baudelaire," 338.) We feel aura sensuously as the *anticipation* of that interaction—that touch or gaze. We project that anticipatory feeling onto inanimate objects—we psychically inscribe them with sensations and images which we feel and experience. See also Hal Foster, *Compulsive Beauty* (Cambridge, MA: MIT Press, 1997), 196.

65. Walter Benjamin, "Short Shadows II," in *Selected Writings*, vol. 2, 701.

66. Even Kiesler's use of steel in the American Institute for Industrial Design project symbolized modernism as a billboard, marking the building's surface character as advertisement, more than it really served as a break with archaic nineteenth-century notions of dwelling.

67. Harry Francis Mallgrave, "Introduction," in *Gottfried Semper: The Four Elements of Architecture and Other Writings*, trans. Harry Francis Mallgrave (New York: Cambridge University Press, 1989), 39.

68. Walter Benjamin, "Hashish, Beginning of March 1930," in *Selected Writings*, vol. 2, 328, 329.

69. Benjamin, "Return of the Flâneur," 264.

70. Benjamin, "Surrealism," 216.

71. Theodor W. Adorno, "The Schema of Mass Culture," in Adorno, *The Culture Industry: Selected Essays on Mass Culture*, ed. J. M. Bernstein (New York: Routledge, 1991), 69.

72. Theodor W. Adorno, "On the Fetish Character in Music and the Regression of Listening," in Adorno, *The Culture Industry*, 32.

73. Siegfried Kracauer, "Calico-World," in Kracauer, *The Mass Ornament*, 281–288.

74. Kiesler, *Contemporary Art Applied to the Store and Its Display*, 87.

75. Federick Kiesler, "Building a Cinema Theatre (1929)," in *Frederick J. Kiesler: Selected Writings*, ed. Siegfried Gohr and Gunda Luyken (Ostfildern bei Stuttgart: Verlag Gerd Hatje, 1996), 16.

76. Ibid., 17.

77. Ibid.

78. Ibid.

79. Benjamin, "The Work of Art in the Age of Its Reproducibility, Second Version," 117; see also an earlier translation draft by Michael Jennings of "The Work of Art in the Age of Its Technological Reproducibility, Third Version," 11.

80. Ibid., 10.

81. Ibid., 12, 13.

82. Kiesler, "Building a Cinema Theatre (1929)," 17.

83. Ibid.

84. Ibid.

Chapter 3

1. See William Emerson, FAIA, to Dean Leopold Arnaud, May 6, 1940, in Laboratory for Design Correlation (LDC), REC 10 Box, Unmarked Folder, in Austrian Frederick and Lillian Kiesler Private Foundation Archive, Vienna. See also "The Ann Arbor Conference," *Pencil Points* (March 1940), 70.

2. See "Plans Laboratory of Modern Stage: Former Vienna Director Says He Will Develop 'Fourth-Dimensional Theatre' to Exemplify Democracy—'Psychological, Scientific, and Artistic' Instruction Will Be Given," *New York Times*, March 15, 1926, in Frederick Kiesler Papers, microfilm reel 127, Archives of American Art, Smithsonian Institution.

3. "International Theatre Arts Institute," course description and program, n.d., 6, in Austrian Frederick and Lillian Kiesler Private Foundation Archive, Vienna; emphasis added.

4. See Lillian Kiesler, "Books in the Personal Library of F. Kiesler," in Lillian and Frederick Kiesler Papers, [circa 1910]–2003, bulk 1958–2000, Series 1, Lillian Kiesler Papers, Box 19, Inventory Folder 7-9, February 21, 1983, 1–127, Archives of American Art, Smithsonian Institution. See also Walter Russell, *The Russell Genero-Radiative Concept or the Cyclic Theory of Continuous Motion* (New York: L. Middleditch Co., 1926; rev. 1930). An original signed by Matchabelli is in the Frederick and Lillian Kiesler Private Foundation Archive, Vienna.

5. "International Theatre Arts Institute," 12.

6. Ibid., 8.

7. Bess M. Mensendieck, *It's Up to You* (New York: Mensendieck System, 1931), 33; capitalization in original.

8. Mensendieck, *It's Up to You*, 104–105. See also "International Theatre Arts Institute," 8.

9. Kiesler taught at the American Union of Decorative Artists and Craftsmen (AUDAC) from 1928 to 1929 as a lecturer on "Modern Architecture." See letter from Edgmont Arens to Kiesler, May 22, 1930, Lillian and Frederick Kiesler Papers, [circa 1910]–2003, bulk 1958–2000, Series 2, Frederick Kiesler Papers, Box 40, Correspondence 1930–1932 Folder 8, Archives of American Art, Smithsonian Institution; Kiesler also taught more extensively from 1929 to 1931 at the School of Contemporary Arts and

Crafts in New York City on show window and stage design. See letter from Beatrice Doane Craig to Kiesler, May 19, 1930, Lillian and Frederick Kiesler Papers, [circa 1910]–2003, bulk 1958–2000, Series 2, Frederick Kiesler Papers, Box 40, Correspondence 1930–1932 Folder 8, Archives of American Art, Smithsonian Institution.

10. "American Opera Designs," *Architectural Forum* 76 (January 1942), 16.

11. See Theodore Rohdenburg, *A History of the School of Architecture: Columbia University* (New York: Columbia University Press, 1954), 38–39. This is available in the University Archives and Columbiana Library, Columbia University, New York.

12. Frederick Kiesler, "First Report on the Laboratory for Design Correlation," 1937, 3–4, in LDC, REC 03 Box, Activities/Reports, Reports on the LDC Folder, Frederick and Lillian Kiesler Private Foundation Archive, Vienna. See also Frederick Kiesler to Wells Bennett, May 1, 1940, LDC, REC 10 Box, Unmarked Folder, Frederick and Lillian Kiesler Private Foundation Archive, Vienna.

13. Kiesler, "First Report," 2.

14. Frederick J. Kiesler, "Notes on Architecture: The Space-House," *Hound and Horn* (January–March 1934), 292.

15. Frederick Kiesler, "A Laboratory for Social Architecture," n.d., 1, in LDC, REC 03 Box, Activities/Reports, Reports on the LDC Folder, Frederick and Lillian Kiesler Private Foundation Archive, Vienna.

16. Frederick Kiesler, "On Correalism and Biotechnique: A Definition and Test of a New Approach to Building Design," *Architectural Record* 86 (September 1939), 67; emphasis in original. Geddes used the word *biotechnics* in 1925 to define a new field of applied biology. See Patrick Geddes and Sir Arthur Thomson, *Biology* (London: Henry Holt, 1925), 245–246.

17. Lewis Mumford, *Technics and Civilization* (New York: Harcourt, Brace, 1934), 353–356.

18. R. H. Francé, *Plants as Inventors* (New York: Albert and Charles Boni, 1923), 6–8. The work was originally published as *Die Pflanze als Erfinder* (Stuttgart, 1920).

19. See Detlef Mertins, "Living in a Jungle: Mies, Organic Architecture and the Art of City Building," in Phyllis Lambert, ed., *Mies in America* (Montreal: Harry Abrams, 2001), 590–642. See also Oliver Botar, "Prolegomena to the Study of Biomorphic Modernism: Biocentrism, László Moholy-Nagy's 'New Vision' and Ernő Kállai's Bioromantik," Ph.D. diss., University of Toronto, 1998, 238; and Philip Steadman, *The Evolution of Designs: Biological Analogy in Architecture and the Applied Arts* (New York: Cambridge University Press, 1979), 163.

20. See László Moholy-Nagy, *The New Vision: Fundamentals of Design, Painting, and Sculpture*, trans. D. M. Hoffmann (New York: Brewer, Warren and Putnam, 1930), 53, 120. The work was originally published as *Von Material zu Architektur* (Munich: Langen, 1929) and written in 1928.

21. For the Space House as modern advertisement, see Beatriz Colomina, "La Space House et la psyche de la construction," in Chantal Béret, ed., *Frederick Kiesler, artiste-architecte* (Paris: Centre Georges Pompidou, 1996), 67–77; English translation, "De psyche van het bouwen: Frederick Kiesler's Space House," *Archis* (November 1996), 71.

22. Kiesler, "Notes on Architecture," 296. See also Christina Cogdell, *Eugenic Design: Streamlining America in the 1930s* (Philadelphia: University of Pennsylvania Press, 2004), for a possible relationship between eugenics and architectural streamlining. Although not a proponent, Kiesler was aware of eugenics, and was certainly interested in architecture design as an evolutionary process.

23. Patrick Geddes, *Evolution* (New York: Henry Holt, 1911); and R. S. Russell, *Form and Function: A Contribution to the History of Animal Morphology* (1916; Chicago: University of Chicago Press, 1982).

24. Buckminster Fuller, "Correlation," *Shelter* 2, no. 4 (May 1932), 3.

25. See William W. Braham, "Correalism and Equipoise: Observations on the Sustainable," *Arq* 3, no. 1 (1999), 58. Kiesler used *correlation* and *correalism* interchangeably beginning around 1934.

26. Kiesler, "On Correalism and Biotechnique" (1939), 61, 69.

27. Ibid., 61.

28. Frederick Kiesler, "From Functional Design to Service Design," n.d., in Design Correlation Drawing Folder, Frederick and Lillian Kiesler Private Foundation Archive, Vienna.

29. Kiesler, "Notes on Architecture," 293. See also Frederick Kiesler, "Progression-Chart of Architecture," n.d., Miscellaneous Sketches, Notes, and Drafts, Space House Folder, Frederick and Lillian Kiesler Private Foundation Archive, Vienna.

30. Frederick Kiesler, "On Correalism and Biotechnique," unpublished manuscript, 1938, 1–95, in Design Correlation Manuscript Box, Frederick and Lillian Kiesler Private Foundation Archive, Vienna. See also Kiesler, "On Correalism and Biotechnique" (1939), 60–75.

31. Frederick Kiesler, "Second Report of the School Year, 1937–38 of the LDC," 1937–1938, 1–2, in LDC, REC 03 Box, Activities/Reports, Reports on the LDC Folder, Frederick and Lillian Kiesler Private Foundation Archive, Vienna.

32. Frederick Kiesler or students, original sketches, n.d., in LDC, REC 07 Box, Student work/Plates, Box Folder no. 6, Frederick and Lillian Kiesler Private Foundation Archive, Vienna.

33. See "Multiple Unification, a Study by: Ideographic Disintegration," Student Report, n.d., 2, in LDC Files, Box 8, Series 11, Frederick and Lillian Kiesler Private Foundation Archive, Vienna. Clark conducted a study of library arrangement based on a painting by Carpaccio misnamed *St. Jerome in His Library* (more correctly the *Vision of St. Augustine*); Kiesler and his students reiterated the misidentification. See Spyridon Papapetros, "Saint Jerome in His Modernist Study: An Afterword to Adolf Behne's *Eine Stunde Architektur*," *Pidgin* 6 (January 2009), 249. See John Willis Clark, *The Care of Books: An Essay on the Development of Libraries and Their Fittings, from the Earliest Times to the End of the Eighteenth Century* (Cambridge: Cambridge University Press, 1901; reissued 1909), fig. 143.

34. See "St. Jerome's Library, Contact Cycle Studies: Chance Description for Graphic Mutation of J. W. Clarks' *The Care of Books* Page 300 from a Painting by Vittore Carpaccio," Student Report, n.d., 1, in LDC Files, Box 8, Series 11, Frederick and Lillian Kiesler Private Foundation Archive, Vienna.

35. Kiesler, "Second Report," 2. See also "Student Work/Plates: Fatigue Measurement," n.d., in LDC, REC 07 Box, Box Folder no. 2, Photostat Series 2–13, Frederick and Lillian Kiesler Private Foundation Archive, Vienna.

36. Frederick Kiesler, "Energy and Time-Saving Circular Desk at Harvard Law School," n.d., in LDC, REC 07 Box, Box Folder no. 6, Frederick and Lillian Kiesler Private Foundation Archive, Vienna. See also Kiesler's notes on *Das Möbel* and *Gute Möbel*, n.d., in LDC, REC 07 Box, Box Folders nos. 5–6, Frederick and Lillian Kiesler Private Foundation Archive, Vienna. For original images see Herbert Hoffmann, *Gute Möbel: Zweite Folge, Band 3* (Stuttgart: Julius Hoffmann Verlag, 1934), and Adolf G. Schneck, *Das Möbel als Gegrauchsgegenstand* (Stuttgart: Julius Hoffmann Verlag, 1929).

37. Kiesler, "On Correalism and Biotechnique" (1938), 12, 14.

38. Kiesler, "On Correalism and Biotechnique" (1939), 66; emphasis in original.

39. Ibid., 65–66; emphasis in original.

40. Kiesler, "From Functional Design to Service Design"; emphasis in original.

41. See Mensendieck, *It's Up to You*, 293.

42. Kiesler, "On Correalism and Biotechnique" (1939), 64; emphasis in original.

43. Kiesler, "On Correalism and Biotechnique" (1939), 71.

44. See Alden Thompson, "Contact Cycle Study Oct. 31 1938," and "Another Contact Cycle Study at United Metal Work Co. Oct. 25, 1938," Design Correlation Laboratory, REC 10 Box, Final Folder Thompson, Frederick and Lillian Kiesler Private Foundation Archive, Vienna.

45. Kiesler, "On Correalism and Biotechnique" (1939), 68–69.

46. See Gilles Deleuze, "Postscript on Control Societies," in Deleuze, *Negotiations: 1972–1990*, trans. Martin Joughin (New York: Columbia University Press, 1995), 178–179. This essay originally appeared in *L'Autre Journal*, no. 1 (May 1990), and is included in *Pourparlers* (Paris: Editions Minuit, 1990) and *October* 59 (Winter 1992), 3–7.

47. Kiesler, "On Correalism and Biotechnique" (1938), 64.

48. Ibid., 93, 94.

49. Ibid., 64.

50. Ibid., 93.

51. See Henri Bergson, *Time and Free Will: An Essay on the Immediate Data of Consciousness,* trans. F. L. Pogson (New York: Dover, 2001). The work was originally published as *Essai sur les données immédiates de la conscience* (1889).

52. Kiesler, "On Correalism and Biotechnique" (1938), 85, 90.

53. Ibid., 76, 78.

54. See Frederick Kiesler, "Report on the Work of the LDC Nov. 13, 1939," 6–8, in LDC, REC 03 Box, LDC Activities/Reports, Frederick and Lillian Kiesler Private Foundation Archive, Vienna.

55. Walter Rautenstrauch, "The Role of Organization in Attaining Optimum Productivity: Reprint of Synthese Maandblad voor het geestesleven van onzen tijd April 1939: Paper Submitted to the 1938 Study Conference of the International Industrial Relations Institute, The Hague, on the Subject of Productivity and Standards of Living as Influenced by Industrial Relations," in LDC, REC 08 Box, Series 11, 1–13, Frederick and Lillian Kiesler Private Foundation Archive, Vienna. Rautenstrauch was a professor in the department of industrial engineering at Columbia University.

56. See Mario Salvadori, "Time and Motion Study Lectures," in Frederick Kiesler, "Fourth Report on the LDC," February-March 1940, 7, in LDC, REC 03 Box, LDC Activities/Reports, Frederick and Lillian Kiesler Private Foundation Archive, Vienna. Salvadori was a professor of engineering at Columbia.

57. Kiesler, "Report on the Work of the LDC Nov. 13, 1939," 7–8.

58. D. Newman, "Report on 'Time-Motion' Lecture by Mr. Salvatore," n.d., in LDC, REC 08 Box, Series 11, Frederick and Lillian Kiesler Private Foundation Archive, Vienna.

59. Salvadori, "Time and Motion Study Lectures," 7. See also Henry Balisky, "Theory of Form, Function, and Structure," March 10, 1941, in LDC, REC 08 Box, Series 11, 1–3, Frederick and Lillian Kiesler Private Foundation Archive, Vienna.

60. Salvadori, "Time and Motion Study Lectures," 7.

61. See Lillian Kiesler, "Books in the Personal Library of F. Kiesler," 112–114.

62. William James, *The Principles of Psychology*, 2 vols. (1890; New York: Dover, 1950), 1:105.

63. Ibid., 107, 114.

64. Ibid., 107.

65. Ibid., 122.

66. Ibid., 122–123; emphasis in original.

67. Rautenstrauch, "The Role of Organization in Attaining Optimum Productivity," 9.

68. Ibid., 2–3.

69. See Kiesler, "Second Report," 6.

70. See "Advisory Board," n.d., in Vision Machine Box, VM_Descriptions and Memorandum, Frederick and Lillian Kiesler Private Foundation Archive, Vienna.

71. See "Brief Description of Vision Machine," n.d., in Vision Machine Box, VM_Descriptions and Memorandum, Frederick and Lillian Kiesler Private Foundation Archive, Vienna.

72. Frederick Kiesler, "Manuscript: Dream-Recorded," n.d., 10, in LDC, REC 10 Box, Columbia School of Architecture Envelope, Frederick and Lillian Kiesler Private Foundation Archive, Vienna.

73. Frederick Kiesler, "Some Testimonial Drawings of Dream Images," *VVV Almanac*, no. 1 (1942), 29; emphasis in original.

74. Kiesler, "Manuscript: Dream-Recorded," 6–10.

75. Frederick Kiesler, original sketch, n.d., in Vision Machine Box, VM_Iconographic Images Folder, Frederick and Lillian Kiesler Private Foundation Archive, Vienna.

76. Henri Bergson, *Matter and Memory* (New York: Zone Books, 1988), 38–39. Originally published as *Matière et mémoire* (Paris: Presses Universitaires de France, 1908).

77. See Frederick J. Kiesler, "Magic Architecture: Origin and Future—The Story of Human Housing," unpub. ms., n.d., Part 1, Introduction, 1, in Magic Architecture Manuscript Box, Frederick and Lillian Kiesler Private Foundation Archive, Vienna.

78. Paul Virilio, *The Vision Machine* (Bloomington: Indiana University Press, 1994), 59; emphasis in original.

79. Buckminster Fuller to F. J. Kiesler, April 14, 1939, in Frederick Kiesler Letters, microfilm, Getty Research Institute, Los Angeles.

80. Eugene Raskin, "Cerebrationism and Vacuotechnique: The Great Architect Evolves a New Theory," *Pencil Points* (December 1939), 791–792.

81. "Notebook by Benjamin B. DuPont September 30 1952 Architecture 21 Mr. Kiesler," 1952, in LDC, REC 10 Box, Frederick and Lillian Kiesler Private Foundation Archive, Vienna.

82. Kiesler, "Report on the Work of the LDC Nov. 13, 1939," 8; Kiesler, "Second Report," 3; and Kiesler "Fourth Report," 1–2.

83. Frederick Kiesler to George Howe, 21 June 1952, in Lillian and Frederick Kiesler Papers, [circa 1910]–2003, bulk 1958–2000, Series 2, Frederick Kiesler Papers, Box 40, Correspondence 1951–1952 Folder 22, Archives of American Art, Smithsonian Institution.

84. See Sven-Olov Wallenstein, *Bio-politics and the Emergence of Modern Architecture* (New York: Princeton Architectural Press, 2008).

Chapter 4

1. Nicolas Calas and Frederick Kiesler, *Bloodflames 1947*, exh. cat. (New York: Hugo Gallery, 1941), 16, held in Austrian Frederick and Lillian Kiesler Private Foundation Archive, Vienna.

2. See Henry McBride, "Modernism Rampant: The New Sculptors and the New Painters Exalt the New Freedoms," *New York Sun*, Art section, March 7, 1947, 29, Blood Flames Box, Blood Flames Clippings Folder, from the Hugo Gallery Exhibition scrapbook, Austrian Frederick and Lillian Kiesler Private Foundation Archive, Vienna.

3. See letter from Frederick Kiesler to Alexander Jolas, April 15, 1947, Briefe M, Mappe 3, Austrian Frederick and Lillian Kiesler Private Foundation Archive, Vienna. See also Steffi Kiesler Diary, Austrian Frederick and Lillian Kiesler Private Foundation Archive, Vienna.

4. Frederick Kiesler, "Magic Architecture: The Story of Human Housing," most complete version, unpublished, undated, part 1, chapter 9, pp. 1, 3, Austrian Frederick and Lillian Kiesler Private Foundation Archive, Vienna.

5. See Joseph Rykwert, *On Adam's House in Paradise: The Idea of the Primitive Hut in Architectural History* (New York: Museum of Modern Art, 1972).

6. Kiesler, "Magic Architecture," part 1, chapter 8; pp. 5, 7, 9.

7. Ibid., part 1, chapter 9, pp. 2–4.

8. Ibid., part 1, chapter 8, p. 4.

9. Ibid., part 1, chapter 9, p. 1.

10. Ibid., part 1, chapter 8, pp. 5, 6; emphasis in original.

11. Ibid., part 1, chapter 8, p. 6; emphasis in original.

12. Ibid., part 1, chapter 8, pp. 7, 8.

13. Ibid., part 4, intro., pp. 3, 4.

14. Frederick Kiesler, "On Correalism and Biotechnique," 1938, most complete unpublished manuscript, 49, in Design Correlation Manuscript Box, Austrian Frederick and Lillian Kiesler Private Foundation Archive, Vienna.

15. Kiesler, "Magic Architecture," part 10, chapter 8, p. 1; emphasis in original.

16. Ibid., part 10, chapter 8, p. 1, and part 10, chapter 9, p. 1.

17. Kiesler and Duchamp purportedly first met at the 1925 Exposition Internationale des Arts Décoratifs et Industriels Modernes in Paris. See Jennifer Gough-Cooper and Jaques Caumont, "Frederick Kiesler and the Bride Stripped Bare," in Yehuda Safran, ed., *Frederick Kiesler 1890–1965* (London: Architectural Association, 1989).

18. See Steffi Kiesler Diary, Austrian Frederick and Lillian Kiesler Private Foundation Archive, Vienna. See also Mark Linder, "Wild Kingdom," in R. E. Somol, ed., *Autonomy and Ideology: Positioning an Avant-Garde in America* (New York: Monacelli Press, 1997).

19. Frederick Kiesler, "Design-Correlation: From Brush-Painted Glass Pictures of the Middle Ages to [the] 1920's," *Architectural Record* 81 (May 1937), 53–59.

20. See Steffi Kiesler Diary, Austrian Frederick and Lillian Kiesler Private Foundation Archive, Vienna.

21. See Frederick Kiesler to Mr. Man Ray, February 8, 1937, Lillian and Frederick Kiesler Papers, [circa 1910]–2003, bulk 1958–2000, Series 2, Frederick Kiesler Papers, Box 40, Correspondence 1937 Folder 10, Archives of American Art, Smithsonian Institution.

22. See Katherine S. Dreier to Frederick Kiesler, July 9, 1937, Lillian and Frederick Kiesler Papers, [circa 1910]–2003, bulk 1958–2000, Series 2, Frederick Kiesler Papers, Box 40, Correspondence 1937 Folder 10, Archives of American Art, Smithsonian Institution.

23. Ibid.

24. Ibid.

25. Kiesler, "Design-Correlation: From Brush-Painted Glass Pictures," 55. See also Frederick Kiesler, "Design-Correlation, Marcel Duchamp's 'Big Glass,'" in *Frederick J. Kiesler: Selected Writing*, ed. Siegfried Gohr and Gunda Luyken (Ostfildern bei Stuttgart: Verlag Gerd Hatje, 1996), 40.

26. Kiesler, "Design-Correlation: From Brush-Painted Glass Pictures," 55.

27. Ibid., 57–58; my italics.

28. Frederick Kiesler, "On Correalism and Biotechnique: A Definition and Test of a New Approach to Building Design," *Architectural Record* 86 (September 1939), 67.

29. Ibid. See also Kiesler, "Design-Correlation: From Brush-Painted Glass Pictures," 58; Kiesler, "Design-Correlation, Marcel Duchamp's 'Big Glass,'" 40.

30. Kiesler, "On Correalism and Biotechnique" (1939), 67.

31. Kiesler, "Design-Correlation: From Brush-Painted Glass Pictures," 57. See also Kiesler, "Design-Correlation, Marcel Duchamp's 'Big Glass,'" 40.

32. Kiesler, "Design-Correlation: From Brush-Painted Glass Pictures," 58. See also Kiesler, "Design-Correlation, Marcel Duchamp's 'Big Glass,'" 41.

33. See Steffi Kiesler Diary, Austrian Frederick and Lillian Kiesler Private Foundation Archive, Vienna.

34. Ibid.

35. Ibid.

36. Frederick Kiesler, "Murals without Walls: Relating to Gorky's Newark Project," *Art Front* 2 (December 1936), 10–11.

37. Ibid., 10.

38. Ibid.

39. See Gottfried Semper, *The Four Elements of Architecture and Other Writings*, trans. Harry Francis Mallgrave (New York: Cambridge University Press, 1989).

40. Kiesler, "Murals without Walls," 10.

41. English translations by Frederick and Steffi Kiesler, in varying versions from 1925 to 1930, of Frederick Kiesler, "Ausstellungssystem Leger und Trager" (*De Stijl* 12, nos. 10–11 [1924–1925], 146), in the Austrian Frederick and Lillian Kiesler Private Foundation Archive, Vienna; emphasis in original. See also Frederick Kiesler, "Manifesto of Tensionism," in *Contemporary Art Applied to the Store and Its Display* (New York: Bretano's, 1930), 49.

42. For more on the Art of This Century Gallery see Milton Gendel, Eva Kraus, and Valentina Sonzogni, *Friedrich Kiesler: Art of This Century* (Munich: Hatje Cantz, 2003); see also Susan Davidson and Philip Rylands, eds., *Peggy Guggenheim and Frederick Kiesler: The Story of Art of This Century* (Venice: Guggenheim Museum, 2005).

43. Comparison between these two exhibitions was made by journalists at the time; see "Interiors of Chaos," *Time*, November 2, 1942, 47, Frederick Kiesler Papers, microfilm reel 127, Archives of American Art, Smithsonian Institution. For an analysis of the exhibitions see Lewis Kachur, *Displaying the Marvelous: Marcel Duchamp, Salvador Dalí, and Surrealist Exhibition* (Cambridge, MA: MIT Press, 2001).

44. See Cynthia Goodman, "Frederick Kiesler: Designs for Peggy Guggenheim's Art of This Century Gallery," *Arts Magazine* 51 (June 1977); also Cynthia Goodman, "The Art of Revolutionary Display Techniques," in Lisa Phillips, ed., *Frederick Kiesler* (New York: Whitney Museum of American Art, 1989), 57–83. For an alternative interpretation see T. J. Demos, "First Papers of Surrealism, 1942," *October* 97 (Summer 2001), 91–119, revised in Demos, *The Exiles of Marcel Duchamp* (Cambridge, MA: MIT Press, 2007), 190–242.

45. Kiesler owned an original copy of the 1940 "Organic Design in Home Furnishings," exhibition catalog, which featured the Eames plywood furnishings. See Lillian Kiesler, "Books in the Personal Library of F. Kiesler," in Lillian and Frederick Kiesler Papers, [circa 1910]–2003, bulk 1958–2000, Series 1, Lillian Kiesler Papers, Box 19, Inventory Folder 7-9, February 21, 1983, 112–126, Archives of American Art, Smithsonian Institution. The original library of books is held in the Austrian Frederick and Lillian Kiesler Private Foundation Archive, Vienna.

46. Along with Alexander Dörner, Bayer designed the "Bauhaus 1919–1928" exhibit in 1938 at the Museum of Modern Art in New York. He suspended paintings from the wall and ceiling and painted the path along the floor. See Arthur A. Cohen, *Herbert Bayer: The Complete Work* (Cambridge, MA: MIT Press, 1994), 292. See also Beatriz Colomina, "Enclosed by Images: The Eameses' Multimedia Architecture," *Grey Room* 1, no. 2 (2001), 20; Mary Anne Staniszewski, *The Power of Display: A History of Exhibition Installations at the Museum of Modern Art* (Cambridge, MA: MIT Press, 1998), 25–28; Demos, *The Exiles of Marcel Duchamp*, 277–278; Richard A. Etlin, *Art, Culture, and Media under the Third Reich* (Chicago: University of Chicago Press, 2002), 297; Joan Ockman, "The Road Not Taken: Alexander Dörner's Way beyond Art," in Somol, *Autonomy and Ideology*, 112.

47. Maria Bottero, "Kiesler and the American Avant-garde," in *Frederick Kiesler: arte architettura ambiente* (Milan: Electa, 1996), 213.

48. For more details on Kiesler's shadow box devices in the Art of This Century gallery see Gendel, Kraus, and Sonzogni, *Friedrich Kiesler: Art of This Century*; also Davidson and Rylands, *Peggy Guggenheim and Frederick Kiesler: The Story of Art of This Century*.

49. Kiesler summarizes the viewer's experience of his shadow box devices in "Design Correlation as an Approach to Architectural Planning," *VVV Almanac*, nos. 2–3 (March 1943), 78–79.

50. Ibid., 79.

51. Ibid. See also E. R. Jaensch, *Eidetic Imagery and Typological Methods of Investigation: Their Importance for the Psychology of Childhood, the Theory of Education, General Psychology, and the Psychophysiology of Human Personality* (New York: Harcourt, Brace, 1930), part I, pp. 1, 2, 13, 15, 16; as held in the Vision Machine Box, VM_Research excerpts Folder, Austrian Frederick and Lillian Kiesler Private Foundation Archive, Vienna.

52. For more on the study of a *zone of indeterminacy* see Henri Bergson, *Matière et mémoire* (Paris: Presses Universitaires de France, 1908); English translation, *Matter and Memory* (New York: Zone Books, 1988), 32, 36.

53. Henri Bergson, *Creative Evolution*, trans. Arthur Mitchell (New York: Henry Holt, 1911), 306.

54. Hans Richter, "Easel-Scroll-Film," *Magazine of Art* (February 1952), 81.

55. Ibid.

56. See Edgar Kaufmann, "The Violent Art of Hanging Pictures," *Magazine of Art* (March 1946), 108, Blood Flames Box, Blood Flames Clippings Folder, from the Hugo Gallery Exhibition scrapbook, Austrian Frederick and Lillian Kiesler Private Foundation Archive, Vienna.

57. Ibid., 109.

58. Ibid.

59. Frederick Kiesler, quoted in "Isms Rampant: Peggy Guggenheim's Dream World Goes Abstract, Cubist, and Generally Non-Real," *Newsweek*, October 2, 1942, 66, Blood Flames Box, Blood Flames Clippings Folder, from the Hugo Gallery Exhibition scrapbook, Austrian Frederick and Lillian Kiesler Private Foundation Archive, Vienna.

60. Edgar Kaufmann, "The Violent Art of Hanging Pictures," 109.

61. Ad Reinhardt, "Neo-Surrealists Take Over a Gallery," *New York, PM.*, March 11, 1947, 10, Blood Flames Box, Blood Flames Clippings Folder, from the Hugo Gallery Exhibition scrapbook, Austrian Frederick and Lillian Kiesler Private Foundation Archive, Vienna.

62. Henry McBride, "Modernism Rampant," *New York Sun*, March 7, 1947, Art [section], p. 29, Blood Flames Box, Blood Flames Clippings Folder, from the Hugo Gallery Exhibition scrapbook, Austrian Frederick and Lillian Kiesler Private Foundation Archive, Vienna.

63. "Pictures on Ceilings," *New York World-Telegram*, Art and Antiques section, March 8, 1947, 6, Blood Flames Box, Blood Flames Clippings Folder, from the Hugo Gallery Exhibition scrapbook, Austrian Frederick and Lillian Kiesler Private Foundation Archive, Vienna.

64. Henri Bergson, *The World of Dreams*, trans. Wade Baskin (New York: Philosophical Library, 1958), 39. Kiesler was certainly familiar with Bergson's writings and the work of Eggeling and Richter as they were inspired by Bergson's writings; Steffi Kiesler's "Dream Book Research" also has a few quotes from Bergson's *Matter and Memory* and *Mind and Energy*. See Steffi Kiesler, "Dream Book Research," Box 1, Folder 4 and Folder 7, Austrian Frederick and Lillian Kiesler Private Foundation Archive, Vienna. Steffi Kiesler maintained a large scrapbook of quotes from a wide range of sources, including Freud, Spinoza, Bergson, Tzara, and Baudelaire.

65. Bergson, *The World of Dreams*, 56; my emphasis.

66. Bergson, *Matter and Memory*, 70.

67. Ibid., 59, 71.

68. Ibid., 70–71.

69. Ibid., 70.

70. Ibid.

71. Ibid., 232, 244.

72. Walter Benjamin, "On Some Motifs in Baudelaire," in Benjamin, *Selected Writings*, vol. 4: *1938–1940*, ed. Michael W. Jennings (Cambridge: Harvard University Press, 2003), 330.

73. Ibid., 315.

74. Ibid.

75. Ibid., 318.

76. For Freud, Bergson, and Otto Rank, dreaming is a state in which our conscious mind remains to some extent active. See Bergson, *The World of Dreams*; Sigmund Freud, *On Dreams*, trans. James Strachey (New York: W. W. Norton, 1952); Otto Rank, *Seelenglaube und Psychologie* (Vienna: Franz Deuticke, 1930); English translation, *Psychology of the Soul* (Baltimore: Johns Hopkins University Press, 1998).

77. Frederick Kiesler, "Pseudo-Functionalism in Modern Architecture," in Safran, *Frederick Kiesler 1890–1965*, 57.

78. Walter Benjamin, "The Work of Art in the Age of Its Reproducibility: Second Version," in Benjamin, *Selected Writings*, vol. 3: *1935–1938*, ed. Howard Eiland and Michael Jennings, trans. Edmund Jephcott and Howard Eiland (Cambridge, MA: Harvard University Press, 2002), 118.

79. André Breton, "Manifesto," in *Manifestoes of Surrealism*, trans. Richard Seaver and Helen R. Lane (Ann Arbor, 1972) 26. For a study of automatism and Surrealism see Hal Foster, *Compulsive Beauty* (Cambridge, MA: MIT Press, 1993), 3, 221.

80. See André Breton, "Le Message automatique," *Minotaure* 3–4 (December 14, 1933); English translation, "The Automatic Message," in André Breton, Paul Éluard, and Philippe Soupault, *The Automatic Message, The Magnetic Fields, The Immaculate Conception*, trans. Antony Melville (London: Atlas, 1997), 7–32.

81. Breton, "The Automatic Message," 22.

82. Ibid., 32.

83. Ibid.

84. Like Kiesler, Breton acknowledged William James and his interest in F. W. H. Myers's study of the imagination, automatism, and subliminal processes. Breton, "The Automatic Message," 17, 32; see also William James, "Frederic Myers's Service to Psychology," in *The Works of William James: Essays in Psychical Research*, ed. F. Burkhardt and F. Bowers (Cambridge, MA: Harvard University Press, 1986). Within Surrealist literature and its critique, there is debate as to the extent to which Myers's theories rather than those by others impacted Breton's original ideas on automatism. For additional contributing theories to this debate see Foster, *Compulsive Beauty*, 3–4.

85. See Jaensch, *Eidetic Imagery*; Kiesler transcribed part I, pp. 1, 2, 13, 15, 16 (Vision Machine Box, VM_Research excerpts Folder, Austrian Frederick and Lillian Kiesler Private Foundation Archive, Vienna).

86. "Continuity of Optic Perception, Semi-conscious Sight and the Psychic Image," 1–7, unpublished, undated, unknown author, Vision Machine Box, VM_Research excerpts Folder, Austrian Frederick and Lillian Kiesler Private Foundation Archive, Vienna; emphasis in original.

87. See Lillian Kiesler, "Books in the Personal Library of F. Kiesler," 112.

88. Ibid., 113, 115.

89. Kiesler, "Magic Architecture," part 1, chapter 4, "Enigma of Birth." See also in prior draft of text: Frederick Kiesler, "The Enigma of Birth," in "Magic Architecture," part four, chapter four, 4/128, Austrian Frederick and Lillian Kiesler Private Foundation Archive, Vienna.

90. Peter Gay, "Freud: A Brief Life," in Sigmund Freud, *Beyond the Pleasure Principle*, trans. Joan Riviere and James Strachey (New York: W. W. Norton, 1989), xx.

91. Sigmund Freud, *The Ego and the Id*, trans. Joan Riviere and James Strachey (New York: W. W. Norton, 1960), 38.

92. Marcel Jean, *History of Surrealist Painting* (New York: Grove Press, 1967), 118.

93. Ibid.

94. See Otto Rank, *Der Doppelgänger* (1914, 1925); English translation, *The Double, a Psychoanalytic Study*, ed. Harry Tucker (Chapel Hill: University of North Carolina Press, 1971).

95. For an analysis of Breton, Surrealism, automatism, and nirvana, see Foster, *Compulsive Beauty*, 5.

96. See André Breton, "Declaration VVV" (1942), reprinted in Breton, *What Is Surrealism?*, ed. Franklin Rosemont (New York: Pathfinder, 1978), 337. See also Demos, *The Exiles of Marcel Duchamp*, 204, 279.

97. See Sigmund Freud, "The Uncanny" (1919), trans. James Strachey, in *The Standard Edition of the Complete Psychoanalytic Works of Sigmund Freud*, vol. 17 (London: Hogarth Press, 1955); see also Anthony Vidler, *The Architectural Uncanny* (Cambridge, MA: MIT Press, 1992), 17–44; Foster, *Compulsive Beauty*, 7–17; Demos, *The Exiles of Marcel Duchamp*, 203.

98. Frederick Kiesler, "Art: Or the Teaching of Resistance," Commencement address give by Frederick Kiesler at the Art Institute of Chicago, June 12, 1959, and presented at the "Art and Education" conference, University of Michigan, October 18, 1958, 6, Txt 01 Man/Typ Various A, Folder Art or the Teaching of Resistance lecture Materials, Austrian Frederick and Lillian Kiesler Private Foundation Archive, Vienna.

99. "Remembrance of Things Past," *Time*, Art section, July 21, 1947; in Expo 1947 Box: Halls of Superstitions, Clipping exp_47 clip folder, Austrian Frederick and Lillian Kiesler Private Foundation Archive, Vienna.

100. Ibid.

101. Kiesler, "Art: Or the Teaching of Resistance," 6.

102. Ibid.

103. Ibid., 7, my emphasis.

104. Ibid., 6.

105. Ibid., 7.

106. Demos, *The Exiles of Marcel Duchamp*, 212–220.

107. Calas and Kiesler, *Bloodflames 1947*, 16.

108. "Remembrance of Things Past."

109. André Breton in *Exposition Internationale du Surréalisme: Le surréalisme en 1947*, exh. cat. (Paris: Galerie Maeght, 1947), 135; as cited in Goodman, "The Art of Revolutionary Display Techniques," 71.

110. Jean [Hans] Arp, "L'oeuf de Kiesler et la Salle des Superstitions," *Cahiers d'Art* 22, no. 9 (1947), 283; as cited in Goodman, "The Art of Revolutionary Display Techniques," 73.

111. Kiesler, "Magic Architecture," part 1, chapter 8, p. 5; emphasis in original.

112. See Frederick Kiesler, *Totem for All Religions,* 1947, in Lillian and Frederick Kiesler Papers, [circa 1910]–2003, bulk 1958–2000, Series 1, Lillian Kiesler Papers, Box 26, Contact Sheets Folder 19, Archives of American Art, Smithsonian Institution.

113. "People in the News," in Expo 1947 Box: Halls of Superstitions, Clipping exp_47 clip folder, Austrian Frederick and Lillian Kiesler Private Foundation, Vienna.

114. See Frederick Kiesler, *Black Lake*, photograph, Paris 1947, Box: Halls of Superstitions, Expo 1947 Reproduction Folder, Austrian Frederick and Lillian Kiesler Private Foundation, Vienna. See also *Exposition Internationale du Surréalisme*, 134; as cited in Goodman, "The Art of Revolutionary Display Techniques," 73.

115. See *Exposition Internationale du Surréalisme*, 134; as cited in Goodman, "The Art of Revolutionary Display Techniques," 73.

116. Ibid.

117. "Remembrance of Things Past."

118. Ibid.

119. John Devoluy, "Art News in Paris," in Expo 1947 Box: Halls of Superstitions, Clipping exp_47 clip folder, Austrian Frederick and Lillian Kiesler Private Foundation Archive, Vienna.

120. Frederick Kiesler, "Dead Sea Scrolls," in *The "Endless House": Inside the Endless House: Art, People and Architecture: A Journal* (New York: Simon and Schuster, 1966), 318.

121. Ibid., 323.

122. Ibid., 318.

123. Quoted by Marlin Levin, "The Shrine of the Book," *Hadassah Magazine* 46, no. 9 (May 1965), frame 249–250, clipping found in Frederick Kiesler Papers, microfilm reel 128, Archives of American Art, Smithsonian Institution.

124. For history of the scrolls discovery, see Kiesler, "Dead Sea Scrolls," 319. See also clippings "On the Hill of Zion," *Newsweek*, and Levin, "The Shrine of the Book," in Frederick Kiesler Papers, microfilm reel 128, Archives of American Art, Smithsonian Institution.

125. See Kiesler, "Dead Sea Scrolls," 320.

126. See Levin, "The Shrine of the Book."

127. Ibid. The Gottesman Foundation, which also funded Kiesler's Endless House models in 1958, was established after the death of David Samuel Gottesman in 1956.

128. Bartos had married Gottesman's daughter Celeste in 1935.

129. Kiesler, "Dead Sea Scrolls," 323, emphasis in the original.

130. Ibid., 325.

131. Frederick Kiesler, "Dome's First Act," in *The "Endless House,"* 328.

132. Frederick Kiesler, "Airplane Flight," in *The "Endless House,"* 331.

133. Ibid. The local architects argued with Kiesler that there were only seven scrolls to display, and thereby no need for his extravagant design. They suggested that he rethink the problem.

134. Ibid., 334.

135. Ibid.

136. Ibid.

137. See "The Sculpture Garden," *Supplement to Israel Digest*, 1965; also "Symbol of State: Ian Nairn Looks at the New Israel Museum," *Observer*, Weekend Review, May 14, 1965; clippings found in Frederick Kiesler Papers, microfilm reel 128, Archives of American Art, Smithsonian Institution.

138. Levin, "The Shrine of the Book."

139. "On the Hill of Zion"; see also "Dead Sea Scrolls 'Shrine' Opened," *Israel Digest* 3, no. 9 (April 23, 1965), 2; clippings found in Frederick Kiesler Papers, microfilm reel 128, Archives of American Art, Smithsonian Institution.

140. "Dead Sea Scrolls 'Shrine' Opened"; see also "Israeli Museum to House Jewish Historical Testaments," *New York Times*, May 9, 1965, and Levin, "The Shrine of The Book"; clippings found in Frederick Kiesler Papers, microfilm reel 128, Archives of American Art, Smithsonian Institution.

141. See "Symbol of State: Ian Nairn Looks at the New Israel Museum"; also John Russell, "Gesture of Great Confidence," *Sunday Times*, May 16, 1965; clippings found in Frederick Kiesler Papers, microfilm reel 128, Archives of American Art, Smithsonian Institution.

142. See "Symbol of State: Ian Nairn Looks at the New Israel Museum."

143. Sigmund Freud, "Aus der Geschichte einer infantilen Neurose" (1918); English translation, "From the History of an Infantile Nerosis," trans. James Strachey, in *The Standard Edition of the Complete Psychological Works of Sigmund Freud*, vol. 17, 7–122; reprinted in *Three Case Histories*, ed. Philip Rieff (1963; New York: Macmillan, 1996), 133–280.

144. Frederick Kiesler, "Dead Sea Scrolls," 319.

145. See chapter 5; also Frederick Kiesler, "Chestnut," in *Frederick J. Kiesler: Selected Writings*, 21–22.

146. For more on the study of the "Wolf Man," "The Uncanny," and the caul or lucky hood, see Vidler, *The Architectural Uncanny*, 153, 241.

Chapter 5

1. See Anthony Vidler, *The Architectural Uncanny: Essays in the Modern Unhomely* (Cambridge, MA: MIT Press, 1992), 150.

2. Tristan Tzara, "On a Certain Automatism of Taste," *Minotaure*, nos. 3–4 (December 1933), 84, as translated in Marcel Jean, ed., *Autobiography of Surrealism* (New York: Viking Press, 1980), 337.

3. Ibid.

4. Ibid.

5. Roberto Matta Echaurren, "Sensitive Mathematics—Architecture of Time," *Minotaure*, no. 11 (May 1938), 43, as translated in Jean, *Autobiography of Surrealism*, 339.

6. Ibid.

7. For more on alloplasticity (changing or molding the external world to reflect the unconscious) versus autoplasticity (changing one's body), see Otto Rank, *Trauma der Geburt* (Leipzig: Internationaler Psychoanalytischer Verlag, 1924); English translation, *The Trauma of Birth* (New York: Dover, 1993), 101. The terms "alloplastic" and "autoplastic" originated with Sandor Ferenczi, who later collaborated with Rank.

8. Tzara, "On a Certain Automatism of Taste," 337. Tzara and Kiesler had been friends since 1924. They were in close contact between 1925 and 1931; Tzara received several letters from Kiesler. See research conducted by Valentina Sonzogni, "Correspondence Frederick Kiesler–Tristan Tzara in the Bibliothèque Littéraire Jacques Doucet," Austrian Frederick and Lillian Kiesler Private Foundation Archive, Vienna. Matta and Kiesler became friends in the 1940s.

9. Quoted in Dalibor Vesely, "Surrealism and Architecture," *Architectural Design* 48, nos. 2–3 (1978), 94. See also Vidler, *The Architectural Uncanny*, 153.

10. See "Curriculum Vitae, Frederick J. Kiesler Architect," 1920 to 1933 with additional years 1934 to 1937 added to the text at a later date, 1–2, Maxwell Levinson Archive: vertical file, Frederick Kiesler Folder, the Canadian Centre for Architecture Collections, Montreal. According to Levinson and Fuller, these were the first slum-clearing projects for the city. See "Frederick Kiesler," n.p., n.d., Maxwell Levinson Archive: vertical file, Frederick Kiesler Folder, the Canadian Center for Architecture Collections, Montreal. This text is likely a draft of Fuller's introduction to Frederick Kiesler, "Festival Theater: The Space Theatre for Woodstock, N.Y.," *Shelter* 2, no. 4 (May 1932), 42.

11. Lisa Phillips, ed., *Frederick Kiesler* (New York: Whitney Museum of American Art, 1989), 140.

12. See letter from Kiesler to Tzara, October 12, 1925, research conducted by Valentina Sonzogni, "Correspondence Frederick Kiesler–Tristan Tzara in the Bibliothèque Littéraire Jacques Doucet," 3, Austrian Frederick and Lillian Kiesler Private Foundation Archive, Vienna.

13. Kenneth Frampton, "Introduction," in Yehuda Safran and Wilfried Wang, eds., *The Architecture of Adolf Loos* (London: Arts Council of Great Britain, 1985), 12. See also Krzysztof Fijalkowski, "'Un Salon au fond d'un lac': The Domestic Spaces of Surrealism," in Thomas Mical, ed., *Surrealism and Architecture* (London: Routledge Press, 2004), 22.

14. Frampton, "Introduction," 12. See Fijalkowski, "'Un Salon au fond d'un lac'," 22.

15. See letter from Kiesler to Tzara, March 3, 1925, research conducted by Valentina Sonzogni, "Correspondence Frederick Kiesler–Tristan Tzara in the Bibliothèque Littéraire Jacques Doucet," 3, Austrian Frederick and Lillian Kiesler Private Foundation Archive, Vienna.

16. See letter from Steffi Kiesler to Tzara, November 29, 1925, research conducted by Valentina Sonzogni, "Correspondence Frederick Kiesler–Tristan Tzara in the Bibliothèque Littéraire Jacques Doucet," 3, Austrian Frederick and Lillian Kiesler Private Foundation Archive, Vienna.

17. See letter from Kiesler to Tzara, October 12, 1925.

18. See Gottfried Semper, "Style in the Technical and Tectonic Arts or Practical Aesthetics: A Handbook for Technicians, Artists, and Patrons of Art (1860)," in Semper, *The Four Elements of Architecture and Other Writings*, trans. Harry Francis Mallgrave (New York: Cambridge University Press, 1989), 190; also Semper, "The Four Elements of Architecture: A Contribution to the Comparative Study of Architecture

(1851)," in ibid., 102–104. See also Adolf Loos, "The Principle of Cladding (1898)," in Loos, *Spoken into the Void: Collected Essays 1897–1900*, trans. Jane O. Newman and John H. Smith (Cambridge, MA: MIT Press, 1982), 66–69. For more on Loos and Semper, see Beatriz Colomina, *Privacy and Publicity: Modern Architecture as Mass Media* (Cambridge, MA: MIT Press, 1994), 265.

19. Loos, "The Principle of Cladding (1898)," 66.

20. See Colomina, *Privacy and Publicity*, 32–33. See also Adolf Loos, "Architektur" (1910); English translation "Architecture," in Safran and Wang, *The Architecture of Adolf Loos*, 104–109.

21. Adolf Loos, "Ornament und Verbrechen," trans. "Ornament and Crime" (1908), in Ulrich Conrads, ed., *Programs and Manifestoes on 20th-Century Architecture* (Cambridge, MA: MIT Press, 1975), 19–24.

22. Ibid., 24.

23. Ibid.

24. Tristan Tzara cited in Safran and Wang, *The Architecture of Adolf Loos*, 78, as found in Fijalkowski, "'Un Salon au fond d'un lac'," 23.

25. Valentina Sonzogni, "Biography," in *Friedrich Kiesler Designer: Seating Furniture of the 30s and 40s* (Ostfildern-Ruit: Hatje Cantz Verlag, 2005), 122. See also Adolf Loos, "Ornament and Crime," trans. Frederick Kiesler, n.p., n.d., Austrian Frederick and Lillian Kiesler Private Foundation Archive, Vienna.

26. Loos, "Ornament and Crime" (1908), 24.

27. Frederick Kiesler, "On Correalism and Biotechnique: A Definition and Test of a New Approach to Building Design," *Architectural Record* 86 (September 1939), 68.

28. See Martin Bressani, "The Life of Stone: Viollet-le-Duc's Physiology of Architecture," in *ANY*, no. 14, "Tectonics Unbound" (New York, 1996).

29. Frederick Kiesler, *Contemporary Art Applied to the Store and Its Display* (New York: Bretano's, 1930), 48.

30. Sigfried Giedion, *Space, Time and Architecture* (Cambridge, MA: Harvard University Press, 1941; 5th edition, reprinted 1997), 450–476.

31. Ibid., 461. Concrete has had a long history since antiquity, but it was not used in thin tension shells until Robert Maillart in 1926 and Freyssinet in 1929. See also David P. Billington, *Robert Maillart and the Art of Reinforced Concrete* (Cambridge, MA: MIT Press, 1991).

32. See Frederick Kiesler, "Project for a 'Space-Theatre' Seating 100,000 People," in K. Lönberg-Holm, "New Theater Architecture in Europe," *Architectural Record* (May 1930), 495.

33. Frederick Kiesler to Steffi Kiesler, January 15, 1933, Austrian Frederick and Lillian Kiesler Private Foundation Archive, Vienna; translated from German in Harald Krejci, "Seat Furniture as Architecture," in *Friedrich Kiesler Designer*, 33.

34. Frederick Kiesler to Steffi Kiesler, January 10, 1933, Austrian Frederick and Lillian Kiesler Private Foundation Archive, Vienna; translated from German in Krejci, "Seat Furniture as Architecture," 33.

35. "And Now It's the Space House: Latest Thing in Dwelling Likely to Leave You Gasping with Surprise," *New York Sun*, 14, Clippings, Space House Folder, Austrian Frederick and Lillian Kiesler Private Foundation Archive, Vienna.

36. Frederick Kiesler, "Notes on Architecture: The Space House—Draft," 1933, 2, unpublished miscellaneous sketches, notes, and drafts, Space House Folder, Austrian Frederick and Lillian Kiesler Private Foundation Archive, Vienna; emphasis in original.

37. Ibid., 1. See also Frederick J. Kiesler, "Notes on Architecture: The Space-House," *Hound and Horn* (January-March 1934).

38. Krejci, "Seat Furniture as Architecture," 21.

39. Ibid., 27.

40. Kiesler, "Notes on Architecture: The Space-House," 294.

41. Ibid.

42. Ibid.

43. Frederick Kiesler, "Metabolism Chart of the House," 1933, unpublished miscellaneous sketches, notes, and drafts, Space House Folder, Austrian Frederick and Lillian Kiesler Private Foundation Archive, Vienna.

44. See Kiesler, "On Correalism and Biotechnique" (1939), 61.

45. Kiesler, "Metabolism Chart of the House"; emphasis added.

46. Frederick Kiesler, "Architectural Solution," 1933, 1, unpublished miscellaneous sketches, notes, and drafts, Space House Folder, Austrian Frederick and Lillian Kiesler Private Foundation Archive, Vienna.

47. Ibid.

48. Kiesler, "Notes on Architecture: The Space House—Draft," 1933, 1.

49. Frederick Kiesler, "Space House," *Architectural Record* 75 (January 1934), 44–61.

50. Kiesler, "Notes on Architecture: The Space-House," 295.

51. See Kiesler, *Contemporary Art Applied to the Store and Its Display*, 87.

52. See Colomina, "De psyche van het bouwen: Frederick Kiesler's Space House," 76.

53. See Peter Gay, "Freud: A Brief Life," in Sigmund Freud, *Beyond the Pleasure Principle*, trans. Joan Riviere and James Strachey (New York: W. W. Norton, 1989), xx. See also Sigmund Freud, *The Ego and the Id*, trans. Joan Riviere and James Strachey (New York: W. W. Norton, 1960), 20, 36.

54. See Freud, *The Ego and the Id*, 18.

55. Ibid., 38.

56. Freud, *Beyond the Pleasure Principle*, 43. See also Freud, *The Ego and the Id*, 38.

57. Freud, *The Ego and the Id*, 61.

58. Ibid., 18, 20. Freud described the bodily ego as the "cortical homunculus."

59. Karl Sierek and Barbara Lasák state that the Space Stage actually served as the organizing principle for Dr. Siegfried Bernfeld's film project that attempted to illustrate Freud's 1923 theories of the ego and the id. Bernfeld refers to Kiesler's Space Stage in an attempt to diagram Freud's convoluted matrix of these psychical constructs that function within the projected surface of a perceiving mind. See Karl Sierek, *Der Analytiker im Kino: Siegfried Bernfeld, Psychoanalyse, Filmtheorie* (Frankfurt: Sroemfeld, 2000).

60. Frederick Kiesler, "Magic Architecture: The Story of Human Housing," most complete version, unpublished, undated, part 2, chapter 4, p. 1; part 2, chapter 4, p. 5, Austrian Frederick and Lillian Kiesler Private Foundation Archive, Vienna.

61. Kiesler, "Architectural Solution," 1933, 2.

62. Ibid.; emphasis in original.

63. Ibid.; see also Kiesler, "Notes on Architecture: The Space House—Draft," 1933, 2.

64. Kiesler, "Notes on Architecture: The Space-House," 296; emphasis added.

65. Ibid., 295. See also Kiesler, "Notes on Architecture: The Space House—Draft," 1933, 27–28.

66. For more pragmatic solutions to constructing the Space House, see Frederick Kiesler, "Construction Outline," 1934, unpublished miscellaneous sketches, notes, and drafts, Space House Folder, Austrian Frederick and Lillian Kiesler Private Foundation Archive, Vienna.

67. Lillian Kiesler, "Kiesler Observed by Lillian Kiesler," in Maria Bottero, ed., *Frederick Kiesler: arte architettura ambiente* (Milan: Electa, 1996), 208.

68. Frederick Kiesler, "Chestnut," in *Frederick J. Kiesler: Selected Writings*, ed. Siegfried Gohr and Gunda Luyken (Ostfildern bei Stuttgart: Verlag Gerd Hatje, 1996), 21.

69. Ibid.

70. Ibid.

71. Ibid.

72. Ibid., 22.

73. Ibid.

74. Ibid.

75. Gregory Bateson evokes environmentally conscious themes very similar to Kiesler's with Bateson's strong emphasis on unity, ecology, psychoanalysis, and evolutionary theory. See Gregory Bateson, *Steps to an Ecology of Mind* (Chicago: University of Chicago Press, 1972); also Bateson, *Mind and Nature: A Necessary Unity: Advances in Systems Theory, Complexity, and the Human Sciences* (Cresskill, NJ: Hampton Press, 1979).

76. Kiesler, "Magic Architecture: The Story of Human Housing," part 1, chapter 5, p. 3.

77. Ibid., part 1, chapter 5, p. 1.

78. Ibid., part 1, chapter 5, p. 3; and part 1, chapter 3, p. 2.

79. For Loos on the tomb, see Loos, "Architecture," 104–109. See also Hubert Damisch, "Toward a Tomb for Adolf Loos," *Grey Room 01* (Fall 2000).

80. Otto Rank, *Seelenglaube und Psychologie* (Vienna: Franz Deuticke, 1930); English translation, *Psychology and the Soul: A Study of the Origin, Conceptual Evolution, and Nature of the Soul*, trans. Gregory C. Richter and E. James Liberman (Baltimore: Johns Hopkins University Press, 1998), 16, 28.

81. Rank, *Psychology and the Soul*, 5, 7–8.

82. Ibid., 19.

83. Ibid.

84. Kiesler, "Magic Architecture: The Story of Human Housing," part 1, chapter 4, p. 1.

85. Ibid., part 1, chapter 4, pp. 1–2.

86. See chapters 3 and 4 for an evolution of Kiesler's interest in psychoanalysis.

87. Benjamin first observed aura while on hashish. Aura, he observed, constituted a sense of space that surrounded the body, which could be "wounded." Aura was quite personal for Benjamin, and formed through anticipation of a violent bodily intrusion—his friend Ernst Bloch reaching into his personal space. Aura for Benjamin, formed as a protective zone or atmosphere aroused in the psyche as a response to anxiety of potential physical trauma. See Walter Benjamin, "My Second Impression of Hashish," in *Walter Benjamin: Selected Writings*, vol. 2: *1927–1934*, ed. Michael W. Jennings (Cambridge: Harvard University Press, 1999), 88.

88. Walter Benjamin, "The Return of the Flâneur," in *Selected Writings*, vol. 2, 264.

89. See Le Corbusier, *New World of Space* (New York: Reynal and Hitchcock, 1948).

90. Kiesler, "Magic Architecture: The Story of Human Housing," part 2, chapter 2, p. 2.

91. Ibid., part 2, chapter 2, pp. 1–2.

92. Ibid., part 2, chapter 2, p. 1. See also excerpt text and images published in "Frederick Kiesler: Magic Architecture, 1940s," in *Friedrich Kiesler: Endless House* (Ostfildern-Ruit: Hatje Cantz Verlag), 16–17.

93. Kiesler, "Magic Architecture: The Story of Human Housing," part 2, chapter 12, p. 2.

94. "Frederick Kiesler: Magic Architecture, 1940s," 16.

95. Kiesler, "Magic Architecture: The Story of Human Housing," part 2, chapter 1, p. 3.

96. "Frederick Kiesler: Magic Architecture, 1940s," 19–21.

97. Kiesler, "Magic Architecture: The Story of Human Housing," part 1, chapter 7, p. 3.

98. See Lillian Kiesler, "Books in the Personal Library of F. Kiesler," in Lillian and Frederick Kiesler Papers, 1920s–2001, Box 21, Inventory Folder, February 21, 1983, 112, 113, 115, 116, Archive of American Art, Smithsonian Institution, Washington, DC. See also Steffi Kiesler Diary, Austrian Frederick and Lillian Kiesler Private Foundation Archive, Vienna.

99. See LET 3489/0 Frederick Kiesler to William Hartmann (Graham Foundation), August 14, 1958, Austrian Frederick and Lillian Kiesler Private Foundation Archive, Vienna.

100. William Reich, *Selected Writings: An Introduction to Orgonomy* (New York: Farrar, Straus and Cudahy, 1960), 116–117. Reich compiled his essays into this one complete edited book, which included varied texts originally published beginning in 1942 by Orgone Institute Press.

101. For more on organic concepts of contraction and expansion, see Reich, *Selected Writings*, 133.

102. Ibid., 136.

103. Ibid.

104. Ibid., 117–118. Reich viewed sexuality and anxiety of the "orgasm formula: tension—charge—discharge—relaxation" as the same "life formula" running between "Pleasure (Expansion) and Anxiety (Contraction)."

105. Ibid., 137.

106. Ibid., 142.

107. Ibid., 189; emphasis in original.

108. Ibid., 190.

109. Ibid., 5, 216.

110. See Frederick Kiesler, "The Laboratory of Design-Correlation," New York City, March 21, 1946, unpublished, 2, Laboratory for Design Correlation, REC 03 Box, Activities/Reports, Reports on the Laboratory for Design Correlation Folder, Austrian Frederick and Lillian Kiesler Private Foundation Archive, Vienna. See also Frederick Kiesler to Holm, November 27, 1948, in Lillian and Frederick Kiesler Papers, [circa 1910]–2003, bulk 1958–2000, Series 2, Frederick Kiesler Papers, Box 40, Correspondence 1949 Folder 20, Archives of American Art, Smithsonian Institution.

111. Kiesler, "The Laboratory of Design-Correlation."

112. Frederick Kiesler, "Manifeste du corréalisme," *Architecture d'aujourd'hui*, special issue "Arts plastiques" (1949).

113. See letter Frederick Kiesler to William Larned, July 9, 1949, in Lillian and Frederick Kiesler Papers, [circa 1910]–2003, bulk 1958–2000, Series 2, Frederick Kiesler Papers, Box 40, Correspondence 1949 Folder 20, Archives of American Art, Smithsonian Institution.

114. Ibid.

115. See letters in Lillian and Frederick Kiesler Papers, [circa 1910]–2003, bulk 1958–2000, Series 2, Frederick Kiesler Papers, Box 40, Correspondence 1949 Folder 20, Archives of American Art, Smithsonian Institution.

116. See letter Frederick Kiesler to Alfred Barr, May 14, 1949; Alfred Barr to Frederick Kiesler, June 1, 1949, in Lillian and Frederick Kiesler Papers, [circa 1910]–2003, bulk 1958–2000, Series 2, Frederick Kiesler Papers, Box 40, Correspondence 1949 Folder 20, Archives of American Art, Smithsonian Institution.

117. See William Poliner to Frederick Kiesler, October 23, 1949. Johnson and Kiesler had a strong friendship after 1950, which included the exchange of many letters. Kiesler generously built Johnson an outdoor *Galaxy* sculpture for his garden in New Canaan, Connecticut, in 1953 which Barr and Johnson both felt was "a new art form of surpassing nature." See Philip Johnson to Kiesler, June 8, 1953; Kiesler to Philip Johnson, September 14, 1952; Richard Kelly to Frederick Kiesler, February 14, 1953; Kiesler to E. M. Benson, April 25, 1953; and Philip Johnson to Frederick Kiesler, June 8, 1953, in Lillian and Frederick Kiesler Papers, [circa 1910]–2003, bulk 1958–2000, Series 2, Frederick Kiesler Papers, Box 40, Correspondence 1949 Folder 20, Correspondence 1951 to 1952 Folder 22, Correspondence 1953 Folder 23, Archives of American Art, Smithsonian Institution. See also letters between Frederick Kiesler and Philip Johnson from 1951 to 1955, Briefe J, Mappe 4, Austrian Frederick and Lillian Kiesler Private Foundation Archive, Vienna.

118. See Frederick Kiesler to David Hare, June 28, 1950, in Lillian and Frederick Kiesler Papers, [circa 1910]–2003, bulk 1958–2000, Series 2, Frederick Kiesler Papers, Box 40, Correspondence 1950 Folder 21, Archives of American Art, Smithsonian Institution.

119. Frederick Kiesler, "Frederick Kiesler's Endless House and Its Psychological Lighting," *Interiors* (November 1950), 122–129.

120. Ibid., 125.

121. Ibid., 124.

122. Ibid., 125.

123. Ibid., 122.

124. Ibid., 126.

125. See Frederick Kiesler to Mr. Markel, September 14, 1952, in Lillian and Frederick Kiesler Papers, [circa 1910]–2003, bulk 1958–2000, Series 2, Frederick Kiesler Papers, Box 40, Correspondence 1951 to 1952 Folder 22, Archives of American Art, Smithsonian Institution.

126. "Frederick Kiesler: Magic Architecture, 1940s," 19.

127. Kiesler, "Frederick Kiesler's Endless House and Its Psychological Lighting," 127. See also Frederick Kiesler, "Die Kulisse explodiert," *Pásmo = La zone = Die Zone = The zone = La zona*, no. 5/6 (Brno: A. Černík, 1925), in Getty Research Institute, Research Library, Special Collections and Visual Resources, Los Angeles, #87-S908, 1.

128. Valentina Sonzogni, "Frederick Kiesler, la Endless House come infinita ricerca dello spazio infinito," master's thesis, Università di Roma "la Sapienza," 1999, 196.

129. See Stephen Phillips, "Plastics," in Beatriz Colomina et al., eds., *Cold War Hothouses* (New York: Princeton Architectural Press, 2004), 91–124.

130. Douglas Haskell, "In Architecture, Will Atomic Processes Create a New 'Plastic' Order?," in "Building in the Atomic Age," *Architectural Forum* (September 1954), 100.

131. Ibid.; emphasis in the original.

132. Kiesler, "Manifeste du corréalisme"; signed copy held in the Douglas Putnam Haskell Papers, 1866–1979, Box 112, Folder 6, Misc. Frederick Kiesler, Department of Drawings and Archives, Avery Architectural and Fine Arts Library, Columbia University, New York.

133. Frederick Kiesler, "Towards an Endless Sculpture," in Kiesler, *The "Endless House": Inside the Endless House: Art, People and Architecture: A Journal* (New York: Simon and Schuster, 1966), 21.

134. Ibid., 21, 23.

135. Ibid., 24.

136. Ibid., 28.

137. Ibid., 27.

138. Frederick Kiesler, "Kiesler's Pursuit of an Idea," interview by Thomas Creighton, *Progressive Architecture* (July 1961), 114.

139. Ibid.

140. Frederick Kiesler, "How Things Hold Together," in Kiesler, *The "Endless House,"* 214–215.

141. Ibid., 214–215.

142. Frederick Kiesler, "Heliose," in Kiesler, *The "Endless House,"* 231.

143. Ibid., 232.

144. Beatriz Colomina makes a similar observation in "The Medical Body in Modern Architecture," in Cynthia C. Davidson, ed., *Anybody* (Cambridge, MA: MIT Press, 1997), 237–238.

145. See Arthur Drexler to Paul Nelson, May 28, 1959, Douglas Putnam Haskell Papers, 1866–1979, Box 14, Folder 9, Paul Nelson, Department of Drawings and Archives, Avery Architectural and Fine Arts Library, Columbia University, New York.

146. Frederick Kiesler, "Scarpita Endless House," in Kiesler, The "Endless House," 281–282.

147. Ibid.

148. Ibid.

149. For more on "intuition as method" and Bergson's theories on Endlessness, see Gilles Deleuze, Le Bergsonisme (Paris: Presses Universitaires de France, 1966); English translation, Bergsonism, trans. Hugh Tomlinson (New York: Zone Books, 1988), 13–35. See also Henri Bergson, Creative Evolution, trans. Arthur Mitchell (New York: Henry Holt, 1911), 317. Endlessness—the elusive nothing that creeps between ideas (forms), as discussed in chapter 1—for Bergson was the intuitively perceived temporal quality of duration, i.e., the multiplicity that perpetually oscillated between intervals.

150. Frederick Kiesler, "The 'Endless House': A Man-Built Cosmos," in Kiesler, The "Endless House," 566.

151. Ibid., 568.

152. Ibid., 567.

153. Frederick Kiesler, "The Endless House: A Man Built Cosmos," in Kiesler, Selected Writings, 130.

154. Ibid., 126, 127.

155. For more on the story of the Minotaur see Marcel Jean, History of Surrealist Painting, trans. Simon Watson Taylor (London: Weidenfeld and Nicolson, 1960), 231. See also Pierre Grimal, The Dictionary of Classical Mythology, trans. A. R. Maxwell-Hyslop (New York: Basil Blackwell, 1986), 124, 292; Adrian Room, Room's Classical Dictionary (London: Routledge and Kegan Paul, 1983), 108.

156. Rank, Trauma of Birth, 153–154.

157. Ibid., 72, 176. Only a hero (for example Cesar, who was born through a cesarean and thereby not subject to the trauma of birth), we are told by Rank, has the wherewithal to maintain clarity and recognition of exterior and interior relationships in the face of the illusions and demonstrations of the labyrinthine condition. Thus, in the confines of an architectural manifestation of fantastic intrauterine experience, arguably a critically paranoid and artistically hysterical battle between hero and monster can attempt to explicate unconscious and conscious relationships through dream work; this battle between the conscious and the unconscious, the critical and the artistic, is considered an awakening state within Surrealist discourses.

158. Frederick Kiesler, "The Broadcasted Decoration," in Kiesler, Selected Writings, 19.

159. Kiesler, "Kiesler's Pursuit of an Idea," 116; emphasis in the original.

160. Ibid., 117. Sylvia Lavin's reading of the Austrian-American architect Richard Neutra's postwar houses contends with Kiesler's observation; she argues that illusionary psychical space can be achieved inside box-shaped houses. See Sylvia Lavin, "Open the Box: Richard Neutra and the Psychologizing of Modernity," Assemblage, no. 40 (1999), 6–25.

161. See Melanie Klein, "Symbol Formation in Ego Development," in The Selected Melanie Klein, ed. Juliet Mitchell (New York: Free Press, 1986), 98.

162. According to Julia Kristeva "the mother's body acts with the child's as a sort of socio-natural continuum." See Julia Kristeva, "About Chinese Women," in *The Kristeva Reader*, ed. Toril Moi (New York: Columbia University Press, 1986), 148.

163. Introjection for Klein is not limited to the physical experience of sucking up the mother's internal fluids, for it also occurs with all other real objects and people as well. See Melanie Klein, "Weaning," in *Love, Guilt and Reparation and Other Works, 1921–1945* (New York: Delacorte, 1975), 291.

164. Melanie Klein, "Notes on Some Schizoid Mechanisms," in *The Selected Melanie Klein*, 184.

165. At moments, Klein believed, this is a sadistic phase in which "phantasies and feelings of an aggressive and of a gratifying, erotic nature … are to a large extent fused together (a fusion which is called sadism)." At other moments it is a reparative stage, as the split ego reconfigures identity and spatial relationships and resolves its negative and positive feelings. For Klein the "desire to restore" is a creative labor that helps to reconcile embarrassing feelings of guilt associated with sadistic moments of both love and hate. Klein, "Weaning," 293.

166. "Translation from the French of the Editorial of *L'Architecture d'Aujourd'hui*," June 1949, Frederick Kiesler Papers 1923–1993, microfilm reel 127, 1, Archives of American Art, Smithsonian Institution.

Chapter 6

1. Hubert Houssel, "Adventures in Space: The Future Theatre as a Museum Study," *Houston Post*, April 8, 1962, Frederick Kiesler Papers, microfilm reel 128, Archives of American Art, Smithsonian Institution.

2. See W. McNeil Lowry, "Introduction," in *The Ideal Theater: Eight Concepts* (New York: American Foundation of Arts, 1962), 7.

3. Arthur Miller, "The Ideal Theater," in *The Ideal Theater: Eight Concepts*, 8.

4. Ibid.

5. Teams included: producer, designer, and stage director Ralph Alswang working with architect Paul Rudolph; stage designer Eldon Elder and architect Edward Durell Stone; designer Barrie Greenbie and choreographer Elizabeth Harris; New York stage designer David Hayes and architect and *Architectural Forum* editor Peter Blake; Yale Drama School professor and designer George C. Izenour with the head of the Department of Architecture at Carnegie Institute of Technology, architect Paul Schweikher; designer Jo Mielziner and architect Edward Larrabee Barnes; and New York stage designer Donald Oenslager with theater consultant Ben Schlanger.

6. See William Wolf, "Futuristic Theater to Combine Movies and Living Stage," *Milwaukee Journal: Green Sheet*, February 19, 1962, clipping in Frederick Kiesler Papers, microfilm reel 128, Archives of American Art, Smithsonian Institution.

7. See Milton Esterow, "Theatres of Tomorrow Shown at Contemporary Museum Here"; see also "Models of Things to Come? 8 New Theaters Going on the Road," *Herald Tribune* (New York), January 26, 1962, clippings in Frederick Kiesler Papers, microfilm reel 128, Archives of American Art, Smithsonian Institution.

8. For more on the seven other schemes, see *The Ideal Theater: Eight Concepts*. See also *New York World Telegram*, January 27, 1962; Ann Holmes, "The Spotlight, Alley Group Goes Shopping; Will Theater Look Like These?," *Houston Chronicle*, June 10, 1962; clippings in Frederick Kiesler Papers, microfilm reel 128, Archives of American Art, Smithsonian Institution.

9. Kiesler's Universal Theater drew on his studies of termite houses to elaborate cellular chamber structures in the form of a naturalized skyscraper alongside an egg-shaped auditorium that produced cinematic atmospheres he described as a "sheltering sky." He completed the design for his Universal Theater in nine months, including large plans, sections, elevations, and a ¼-inch scaled model in plaster and wood that he cast for $6,000 in aluminum (now at the Harvard Theater Collection). See Thomas H. Creighton to Frederick Kiesler, August 27, 1959; also Thomas H. Creighton to Frederick Kiesler, August 20, 1959, both in Lillian and Frederick Kiesler Papers, [circa 1910]–2003, bulk 1958–2000, Series 2, Frederick Kiesler Papers, Box 41, Correspondence August-September 1959 Folder 6, Archives of American Art, Smithsonian Institution. See also Frederick Kiesler to Carlo Scarpa, July 18, 1960, in Lillian and Frederick Kiesler Papers, [circa 1910]–2003, bulk 1958–2000, Series 2, Frederick Kiesler Papers, Box 41, Correspondence June-July 1960 Folder 10, Archives of American Art, Smithsonian Institution.

10. See Norman Nadel, "Ideal Theaters Envisioned in Crafts Museum Display," *New York World Telegram*, January 27, 1962; see also Creighton Peet, "'Ideal' Theaters Mingle Actors," *Virginian-Pilot* (Norfolk, Virginia), February 18, 1962; clippings in Frederick Kiesler Papers, microfilm reel 128, Archives of American Art, Smithsonian Institution.

11. Frederick Kiesler, "The Universal Theater: Poetry versus Automation," in Kiesler, *The "Endless House": Inside the Endless House: Art, People and Architecture: A Journal* (New York: Simon and Schuster, 1966), 491; emphasis in original.

12. Ibid.; emphasis in original.

13. "Curriculum Vitae, Frederick J. Kiesler Architect," 1920 to 1933 with additional years 1934 to 1937 added to the text at a later date, 1–2, Maxwell Levinson Archive: vertical file, Frederick Kiesler Folder, the Canadian Center for Architecture Collections, Montreal.

14. For a rich history of Vienna housing projects and Loos during the interwar years, see Eve Blau, *The Architecture of Red Vienna 1919–1934* (Cambridge, MA: MIT Press, 1999), 102–109.

15. Raoul Hausmann, "Optophonics," *G*, no. 1 (July 1923), 3.

16. The original design for Kiesler's Optophon was published on the cover of the *Little Review*, February 1926.

17. Frederick Kiesler, "In the Year 1923 … ," undated, unpublished, Text Box 05, Folder: Manuscripts,/Typescripts, Various, as held in the Austrian Frederick and Lillian Kiesler Private Foundation Archive, Vienna.

18. Originally published in German as Frederick Kiesler, "Ausstellungssystem Leger und Trager," *De Stijl* 12, nos. 10–11 (1924–1925), 146. Translated by Frederick and Steffi Kiesler in varying English versions from 1925 to 1930, held in the Austrian Frederick and Lillian Kiesler Private Foundation Archive, Vienna; emphasis in original. See also Frederick Kiesler, "Manifesto of Tensionism," in Kiesler, *Contemporary Art Applied to the Store and Its Display* (New York: Bretano's, 1930), 49; emphasis in original.

19. For more on Kiesler's theatrical lighting effects for the City-in-Space project, see Bruno Reichlin, "The *City in Space*," in Chantal Béret, ed., *Frederick Kiesler, artiste-architecte* (Paris: Centre Georges Pompidou, 1996), 11–21.

20. Lillian Kiesler, "Frederick Kiesler Biography," Frederick John Kiesler Papers, New York, October 31, 1980, 169, as originally held in the Frederick Kiesler Papers 1923–1993, Archives of American Art, Smithsonian Institution.

21. Reyner Banham, *Theory and Design in the First Machine Age* (Cambridge, MA: MIT Press, 1999), 198. Alfred H. Barr equally praised Kiesler's City-in-Space project, calling it "technically and imaginatively the boldest creation in the *de Stijl* tradition." See Alfred H. Barr, *Cubism and Abstract Art* (New York: Museum of Modern Art, 1936), and as quoted by Ben Schmall in "Design's Bad Boy: A Pint-Sized Scrapper Who, after Thirty Years, Still Challenges All Comers," *Architectural Forum* (February 1947), 89.

22. Theo van Doesburg, "Elements of Creation," originally published in *G*, no. 1 (July 1923).

23. Theo van Doesburg, "The Will to Style: The New Form, Expression of Life, Art and Technology (Lecture Held in Jena, Weimar, and Berlin)," in Joost Baljeu, *Theo van Doesburg* (New York: Macmillan, 1974), 126 (originally published in *De Stijl* 2 [February 1922], 23–32; 3 [March 1922], 33–41).

24. Theo van Doesburg, "The New Aesthetics and Its Realization," in Baljeu, *Theo van Doesburg*, 129 (originally written in Weimar, 1922, and published in *De Stijl* 6, no. 1 [March 1923], 10–14). See also Theo van Doesburg and Cornelis van Eesteren, "Towards Collective Construction," in Baljeu, *Theo van Doesburg*, 148 (originally written in Paris, 1923, and published in *De Stijl* 12, nos. 6-7 [1924], 89–91).

25. Van Doesburg, "The New Aesthetics and Its Realization," 129. See also Theo van Doesburg, "Painting and Plastic Art: On Counter Composition and Counter-Plastic Elementarism (A Manifesto Fragment)," in Baljeu, *Theo van Doesburg*, 159–160 (originally written in Rome, July 1926, and published in *De Stijl* 13, nos. 75–76 [1926], 35–43).

26. Architect Cornelis van Eesteren met van Doesburg while teaching his De Stijl course at the Bauhaus; together they produced the next three iterations of complex space-time architectural models exhibited at Leonce Rosenberg's Gallery in Paris October 1923. For an extensive study of the impact of Einstein's theories of relativity on modern art and architecture, see Linda Dalrymple Henderson, *The Fourth Dimension and Non-Euclidean Geometry in Modern Art* (Princeton: Princeton University Press, 1983). See also Sigfried Giedion, *Space, Time and Architecture: The Growth of a New Tradition* (Cambridge, MA: Harvard University Press, 1941).

27. Van Doesburg spoke on "The Development of Modern Architecture in Holland," a presentation he had also given in Prague and Berlin earlier that year. See Baljeu, *Theo van Doesburg*, 66.

28. Theo van Doesburg, "Evolution of Modern Architecture in Holland," 3, Box 6, Folder 22, Little Review (Chicago, Ill.) Records, 1914–1964 UWM Manuscript Collection 1, University Manuscripts Collection, Golda Meir Library, University of Wisconsin-Milwaukee, General Files, Theo van Doesburg; draft of English translation for *Little Review*; emphasis in original. (Originally written in Paris, 1924, and published in *De Stijl* 12, nos. 6–7 [1924], 78–83.) See also Theo van Doesburg, "Towards Plastic Architecture," in Baljeu, *Theo van Doesburg*, 142.

29. Van Doesburg, "Evolution of Modern Architecture in Holland," 1, 4.

30. Ibid., 5.

31. Ibid., 6.

32. Ibid., 4, 5.

33. In my use of the term "auratic," I am specifically referring to Walter Benjamin's development of the term in his later writings; see "On Some Motifs in Baudelaire," in Benjamin, *Selected Writings*, vol. 4: *1938–1940*, ed. Michael W. Jennings (Cambridge: Harvard University Press, 2003), 186, 188. See also Walter Benjamin, "Little History of Photography," in *Selected Writings*, vol. 2, *1927–1934*, ed. Michael W. Jennings (Cambridge: Harvard University Press, 1999), 514–517.

34. Published in *De Stijl* from 1925, Kiesler presents images of his *Leger und Trager* display system, Space Stage, and City-in-Space projects alongside his first article on "Vitalbau" that he would later describe in 1930 as his "Manifesto of Tensionism." See Kiesler, "Ausstellungssystem: Leger und Trager;" also Frederick Kiesler, "Erneuerung des Theaters," *De Stijl*, 7, nos. 75–76 (1926–1927), 51–53; and "L'Architecture élémentarisée," *De Stijl*, 7, nos. 79–84 (1927), 101–102.

35. Theo van Doesburg, "Painting and Plastic Art: Elementarism," in Baljeu, *Theo van Doesburg*, 163 (originally written in Paris, December 1926–April 1927, and published in *De Stijl* 13, no. 78 [1926–1927], 82–87).

36. Ibid., 164.

37. Tension in biology and engineering sciences represents a structural force that resists material fracture, as opposed to compression which keeps materials from collapsing together. Russian Vladimir Grigorievich Shukhov (1853–1939) was likely the first to develop tensile structures in steel, including complex curved hyperbolic structures.

38. See Piet Mondrian, "Neoplasticism as Style," "The New Plastic as 'Abstract-Real Painting: The Plastic Means and Composition," "The Rationality of Neoplasticism," "From the Natural to the Abstract: From Indeterminate to the Determinate," in Hans L. C. Jaffé, ed., *De Stijl* (New York: Harry N. Abrams, 1971), 36–88.

39. Hans Richter, "Koepfe und Hinterkoepfe," Museum of Modern Art Archives, New York, Frederick Kiesler Papers, Item 48, n.d, n.p., 1.

40. Ibid.

41. Ibid.

42. Ibid.

43. See Schmall, "Design's Bad Boy," 89.

44. Kiesler, "Festival Theater," 42.

45. Ibid., 43. Kiesler published his extensive research for the Space Theater for Woodstock in *Shelter* and also in Morton Eustis, "A Universal Theater, Frederick Kiesler's All-Purpose Community Playhouse," *Theater Arts Monthly* (June 1933), 447–447. See also "The Universal," *Architectural Forum* 57 (December 1932), 536–542.

46. See "The Universal," 542.

47. Introduction to Frederick Kiesler by Buckminster Fuller in Kiesler, "Festival Theater," *Shelter*, 42.

48. Kiesler, "The Universal Theater: Poetry versus Automation," 491.

49. Ibid., 489.

50. Ibid., 488.

51. See Gilles Deleuze, "Postscript on Control Societies," in Deleuze, *Negotiations: 1972–1990* (New York: Columbia University Press, 1990), 178–179.

52. Frederick Kiesler, "The Electric Switch or the Switch to Process Architecture," in Kiesler, *The "Endless House": Inside the Endless House*, 383.

Chapter 7

1. Frederick Kiesler, "Towards the Endless Sculpture," in Kiesler, *The "Endless House": Inside the Endless House: Art, People and Architecture: A Journal* (New York: Simon and Schuster, 1966), 30.

2. Ibid.

3. Ibid.

4. Ibid., 29.

5. See Anthony Vidler, "The Explosion of Space: Architecture and the Filmic Imaginary," in Dietrich Neumann, ed., *Film Architecture: Set Designs from "Metropolis" to "Bladerunner"* (New York: Prestel, 1996), 24.

6. Siegfried Kracauer, "Cult of Distraction: On Berlin's Picture Palaces," in Kracauer, *The Mass Ornament: Weimar Essays*, trans. and ed. Thomas Y. Levin (Cambridge: Harvard University Press, 1995), 324.

7. Anson Rabinbach, *The Human Motor: Energy, Fatigue, and the Origins of Modernity* (New York: Basic Books, 1990), 114.

8. Walter Benjamin, "Paris—the Capital of the Nineteenth Century," in Benjamin, *Charles Baudelaire: A Lyric Poet in the Era of High Capitalism*, trans. Harry Zohn (London: NLB, 1973), 168. Quote revised to "confronted by the technologically armed world," in Walter Benjamin, "Paris, the Capital of the Nineteenth Century," in Benjamin, *Selected Writings*, vol. 3, *1935–1938*, ed. Howard Eiland and Michael Jennings, trans. Edmund Jephcott and Howard Eiland (Cambridge, MA: Harvard University Press, 2002), 38.

Index